THE HAROLD
LETTERS

BOOK NEWS

COUNTERPOINT

717 D STREET NW, SUITE 203, WASHINGTON, D.C. 20004

PHONE: 202.393.8088 FAX: 202.393.8488

Publicity contact: John McLeod
John.mcleod@perseusbooks.com

THE HAROLD LETTERS 1928-1943
THE MAKING OF AN AMERICAN INTELLECTUAL

By Clement Greenberg
Edited by Janice Van Horne

The Harold Letters tells the story of the formative years of critic Clement Greenberg whose taste would revolutionize the art world of his time and ours. Greenberg's story

hoof, a fast-paced, informal account of his travels, sexual adventures, and emotional highs and lows, all set against the turbulent backdrop of the Depression, the New York Intellectual scene, and the wartime years.

Here in *The Harold Letters*, is all the fascination of watching a great taste-maker form his own taste. But above all, here is the passion and pain of being twenty-something with a dream to follow and a world to conquer—anytime, anywhere.

About the Author

Clement Greenberg was born in the Bronx in 1909. He burst onto the art scene as an unknown critic in 1939 with his landmark essay "Avan-Garde and Kitsch." In the years that followed he presided over New York's ascendancy over Paris as the world's art capital. His books include the groundbreaking *Art & Culture* (1961), *The Collected Essays and Criticism* (in 4 vols.), *Matisse, Joan Miro, and Hans Hofmann. Homemade*

THE HAROLD LETTERS 1928-1943: The Making of an American Intellectual

By Clement Greenberg, edited by Janice Van Horne

Publication date: June 1, 2000

310 pages / $27.50 cloth

ISBN 1-58243-068-3

Clement Greenberg was America's most perceptive, prescient, and influential art writer. More than any other, it was he who, in those heady years between the end of World War II and the emergence of Pop Art, defined what was happening on the contemporary art scene. Greenberg's taste and judgment established the reputations of such Abstract Expressionist stars as Pollock, de Kooning, and David Smith.

Before all that, however, Greenberg was a young man of intellectual ambition with an unquenchable curiosity and artistic appetite. He read everything and looked hard at the world around him as he plunged into art, culture, politics, and life, putting down roots that would feed his adult career. His closest confidante was Harold Lazarus, his classmate at Syracuse University. From 1928, when both were nineteen, the two exchanged over four hundred frank, funny, and intimate letters. Now Greenberg's widow has gathered and edited his side of the correspondence. The result is intellectual autobiography on-the-

—over—

THE HAROLD

LETTERS

1928-1943

THE MAKING OF AN

AMERICAN INTELLECTUAL

BY CLEMENT GREENBERG

EDITED BY JANICE VAN HORNE

COUNTERPOINT WASHINGTON, D.C.

Library of Congress Cataloging-in-Publication Data

Greenberg, Clement, 1909–1994
 The Harold letters, 1928–1943: the story of a
 young intellectual / Clement Greenberg
 p. cm.
 ISBN 1–58243-068-3 (HC : alk. paper)
 1. Greenberg, Clement, 1909—Correspondence.
 2. Greenberg, Clement, 1909—Knowledge and
 learing. 3. Lazarus, Harold, 1909–1983. I. Title.

N7483.G73.A3 2000
709'.2—dc21
[B]
 00–027936

FIRST PRINTING

Jacket design by Wesley Tanner / Passim Editions

Text design by Victoria Kuskowski

Printed in the United States of America
on acid-free paper
that meets the American National
Standards Institute
Z39-48 Standard.

COUNTERPOINT
P.O. Box 65793
Washington, D.C. 20035-5793

Counterpoint is a member of the
Perseus Books Group

10 9 8 7 6 5 4 3 2 1

CONTENTS

PREFACE

My husband, Clement Greenberg, died May 7, 1994. He was eighty-five. The following summer, our daughter, Sarah, and I started going through his papers and found a box of over four hundred, mostly handwritten, letters. They were all from Clem to his best friend and only confidant at that time, Harold Lazarus, whom he met when they were freshmen at Syracuse University. The letters start in 1928, when they were both nineteen, and stop in 1943, except for a few letters from the later 1940s. There are, unfortunately, only a few existing letters from Harold to Clem, and those I include in the Appendix—however his presence is on every page.

Clem would become an art writer of renown. Harold would turn to academia after the war, teaching English literature at Temple University in Philadelphia until his death in 1983 at age seventy-four. But the letters aren't really about that. I believe they comprise a rare document that affords an intimate, day-by-day look into the lives of two young men coming of age in the 1930s, having committed themselves to the art of learning—to becoming Intellectuals, Highbrows—with all the emotional and material precariousness that would encompass.

Clem and Harold graduated from Syracuse University in 1930 as the Depression closed in. Clem would find and lose a variety of office jobs, eventually taking off across the country to sell neckties wholesale for his father's company. On the side, Clem wrote a few pulp stories and did some translating. Harold got his M. A. at Harvard but couldn't find a teaching job. They lived at home—Harold in Syracuse, Clem in Brooklyn—until, in 1936, they both secured government jobs. The $30 a week opened up the escape hatch that enabled them, at last, to move out of their parents' homes and into the World: Clem to Greenwich Village, Harold to Washington, D.C.

The sheer plottiness of the material kept us turning the pages. Clem seldom spoke of his early life and war years. But here, drawn in immediate and

personal detail were his family life; travels here and abroad in the thirties; a brief early marriage and absentee parenting of his son; sexual adventures and the continual search for The Girl and the Vita Nuova; the New York Intellectual scene, his breakthrough success in 1939 with the publication of "Avant-Garde and Kitsch" in *Partisan Review,* and the ensuing disillusionment with the literary and expatriate high life of New York; and his recurring bouts of depression, and the wartime Army experience that culminated in a mental breakdown. Underlying all is the quest to satisfy his seemingly unquenchable curiosity about everything and his ability to immerse himself completely while on the journey. (In 1994, on one of Clem's last visits to the emergency room, barely able to breathe, he sat on the gurney rereading a shredded volume of Heidegger, in German of course, impervious as the tubes and needles invaded.)

Throughout the 1930s, the letters sustained and nourished Clem and Harold. They show the passionate highs and lows of youth as they egged each other on—Clem the bully, the caring friend, the admirer, the competitor. Who could learn more faster and put it to better use? Who could Discover (a word Clem liked to capitalize) the latest genius? Clem would boast of devouring all of Nietzsche in a night, of learning Portuguese in a week. More far-reaching, they were each other's finest critics, the only critical eyes and ears they trusted.

What particularly amazed and endeared us to the letters was their richness, filled as they are with drawings, poems, and lots of "O-pinions," as Clem called them—on everything, from Sally Rand's thighs to why the history of art has never been written. There is also rage, disillusion, and bitterness—as well as judgments and behavior that are sad, destructive, and ugly. Again and again, Clem would reach out to Harold for help through difficult times, and Harold would come through for him as best he could. I knew how Clem's story ended, now I would know how it began.

Clem wrote to Harold in March of 1933, when they were twenty-four: "Nobody else in the world ever made me feel that I was living in company; that there were other travellers on earth." But it was company at a distance. They seldom saw each other and when they did, the occasions appear to have been awkward and bumpy. This was a friendship that, in fact, may be said to have thrived on distance, but it in no way diminished the deep undercurrent of interdependency that was clearly fundamental to the pursuit of their personal and intellectual goals. I have wondered how different—on many levels—their lives might have been had they not connected in college. For amidst a pattern of splintering family relations, friendships and sexual

relations, this bond with Harold was the primary and only steadfast foundation in Clem's life during those fifteen formative years.

I am so grateful for the gift Harold made to us. He had saved all the letters (with envelopes), returning them to Clem in 1961. Clem, typically, made little of them, shoving them into his office closet after glancing through them, thereby allowing Sarah and me our own Discovery thirty-three years later.

To create a story of appropriate length and accessibility, I have edited the letters. (I assure you, in no way have I sanitized them.) And I have added a postscript that provides additional information about some of the major players in the letters. I have also gathered some additional photographs and compiled an appendix that includes relevant documentary material: the few extant letters from Harold, some of Clem's journal entries, some early poems, and a few relevant letters from others.

An editorial aside: I have made the choice not to use ellipses to indicate cuts. (The unedited, original Harold material can be viewed among the Greenberg papers held at the Getty Research Institute in Los Angeles.) Nor have I corrected numerous spelling, grammar, and punctuation errors, preferring to let the spontaneity and exuberance speak for themselves. As Clem writes to Harold in a postscript September 23, 1932, "I never read my letters over either. Why worry? Who would think of it?"

And so, dedicated to the passion and pain of being twenty-something with a dream to follow—anytime, anywhere—I send these letters into the World with love.

<div style="text-align:right">

Janice Van Horne (Greenberg)
NEW YORK CITY, 2000

</div>

1

COLLEGE SUMMERS

"I've resigned myself to the fact that things, from cabbages to kings and sealing wax, are all one glorious, actually glorious, mess. Deum vivamus, vivamus."

1928

This is Clem's first letter to Harold. They are nineteen and have just completed their sophomore year at Syracuse University. Clem is home at 736 Riverside Drive, Apt. 6D, in New York City, where he lives with his father, Joseph; stepmother, Fan; and his two brothers, Sol (16) and Martin (12). The stationery is from his father's company, Majestic Metal Specialties. Harold lives at home with his parents and sister, Dorothea (16), at 306 Maple Street, Syracuse, New York.

JUNE 11, 1928

Dear Harold,

We had a wonderful trip down. After the break up dance which was quite a wet affair and lasted to 2:30, we went back to the house [the ETA chapter of Sigma Alpha Mu], put our baggage into Joe's car and at 4:30 in the morning pushed our prow thru the "ever-climbing wave" towards N.Y.

At 5 o'clock we saw the sun coming over the Onondaga hills—it was freezing cold. By the time we got into Albany at 10 we were boiling and dirty, but we decided to keep on going down the Hudson instead of waiting and taking the night boat. Nothing more eventful than two flat tires, and at 5:45 we drew up in front of 736—fast asleep, I was. Joe pulled me out by the nape of my neck, a mumbled good-by, and I awoke to find myself on the sidewalk surrounded by my grip and a lacrosse stick. Ho-hum, to bed at 8 and up bright and cheery at 2 the next afternoon, and so on for the last two days.

How are things with you, my soul-mate? I saved $10 on the trip and bought some books before I had a chance to spend it elsewhere—"The Satyricon" of Petronius Arbiter, one of the most obscene and at the same time best written books I have ever read, a book of Sophocles' plays and some of Molière's plays in French at a quaint truck bookstore on Sixth Avenue.

Best regards to your folks and anybody I may know.

<div align="right">

Yours ever,
Clem

</div>

P.S. Now working for my father—in the plating room, temp. 95°.

<div align="right">

JUNE 18, 1928

</div>

Dear Harold,

Writing in pencil again—I never can find a pen when I want one.

When you say that Galsworthy writes propaganda you make me scream—in your eyes. Anything that makes a particular accusation must be propaganda then? God damn it—art is for man's sake not for art's sake! All Galsworthy does is direct a "lamp of pity" at certain things that he sees as injustice in man's treatment of man.

Why do you really have to make up your mind about "Strange Interlude"? I'm sure even Kipling wouldn't ask you to make up your mind about a work of art. I haven't made up my mind about either Wordsworth or Byron yet, nor do I ever expect to—so there!

I've been sweating and swinking this last week as I told you—real factory hand job—I finally quit as the acids were making my head even balder. About Camp High Lake, I don't know—if "reason and the will of God prevail" I shall go [as a counselor], if anarchy has any merits, I shan't. It's me against the family.

<div align="right">

Yours ever,
Clem

</div>

Dear Harold,

Alas, I'm going to camp. Ah, woe is me! Squalling Jew bastards from the "very best homes on Long Island" (as the owner told me) are my fate for two long months of an adolescent existence. "Oh, weep for Adonais. . . ." My grief is rapidly reaching Promethean heights for I, too, have been caught in the toothed wheels of inevitability.

The worst part of it is that I shan't be able to do any reading for it is becoming increasingly apparent that a literary life is only compatible with leisure. So you see, you're not so bad off even if you are getting disgusted with yourself—which by the way only shows that you are intelligent. Cease to bewail your lot, cast off your cloak of dejection—go swimming in the Thornden Park Public Pool! That is but a purely subjective prescription—that's what I'd do.

About propaganda. It's hard sometimes to draw a line between propaganda and universality—there always were the oppressors and the oppressed. And the downtrodden always sent up a wail for justice—if in the past their wail hasn't taken the form of art, it doesn't presuppose that their present and future wail shouldn't.

Have you seen the new "New Masses"? It's taken on quite a new form; from a literary and artistic magazine it has metamorphosed into a small-sized thing of heavy black type, coarse paper and a general atmosphere of massivity, solidity and metallic appearance, all representative of the workman in his naked unassumingness. Instead of being contributed to by "pink radicals proud of their intellectual intelligence and collegiate expression" it is written up by heavy handed coal-heavers, lumberjacks, garbage collectors, etc. Anyhow, what I'm getting around to is this: in one of their articles something was said that I thought applied very acutely to ourselves. It was speaking about Maxwell Bodenheim—"He is the perfect vague 'liberal' of indefinite intelligence. Like all the pseudo intelligentsia and individualistic high school students, he is probably afraid of being classified." You have to admit that we both shy at labels and are tremendously insulted if any are applied to us. Is the "New Masses" right or do I take it too seriously?

You're almost as bad as Matthew Arnold in attempting to set standards for things. I haven't investigated the validity of your criterion, but aren't you liable to hamper your appreciation by that? I'm afraid one gets a little narrow. Why, because Eugene O'Neill writes in 1928 A.D. should you ask more of him than one who wrote in 450 A.D. with even more perspiration?

But I'm not claiming anything for O'Neill. Just be just. (Where on earth have I acquired this pedagogic attitude?)

Anyhow I'll shut up with my regards to you folke.

As ever,
Clem

P.S. I bought books today at Macy's—a Modern Library "Philosophy of Spinoza" and the Everyman edition of Keats that you have. I paid 59 cents for the M. L. which was a gyp as I can get it for 45 cents on Fourth Avenue. Now you can be envious for a change.

P.P.S. You know that I've just decided that you are the only person who I can bear speaking with for more than an hour at a stretch. That's my subtle way of saying that I miss you. We must be soul-mated after all.

Naively,
Clem

Clem is now a counselor at Camp High Lake, Lakewood, Pennsylvania. Harold lives at home and takes summer courses at Syracuse University.

JULY 7, 1928

Dear Harold,

It's so hard to write letters at camp with a book for a desk, a cot for a couch and hayseed for atmosphere. Especially when it's just after dinner as it is now. You know what Emerson said, "After dinner, arithmetic is the only science."

Sympathize with me, my friend. Immersed in my environment, I struggle, gasp, sink, I am unconscious—Get on that bed, you lousy brat!—Bobbie, if you don't behave, I'll strike you!—and so goes it. There's a girls camp across the lake and we're prohibited from seeing them, therefore little Clem puts on his blazer and a pair of loud green socks and sneaks out every night for vicarious sex-satisfaction. It's more fun than going to a discussion meeting and looking at Jeannette Saunders' legs.

And I'm supposed to be a water man. I lounge around the dock all day seeing that no children of the circumcised fall into the lake. So far I've gotten an awful coat of sunburn and my baldness has increased its area.

Surprising enough, I have managed to do some reading. I've finished Keats' "Endymion" and decided that it didn't deserve even its own author's censure. Then I reread "Oedipus Rex" and came to the conclusion that it

was one of the greatest tragedies ever conceived in the brain of a man. Probably it was because I had the Greek right next to me, and so could get some of its real flavor. By the way, the "Victorian Anthology" was put to a very utilitarian use yesterday. I had to quiet my bastards and so I read them the humorous selections. Lewis Carroll went over big.

So Oshinsky has a Packard coupe. Ugh I'm jealous!

That Romantic Prose course must be great. But why in hell read the essays in class? Hasn't he got enough to say to kill an hour?

I'll draw you a picture of how I look at present.

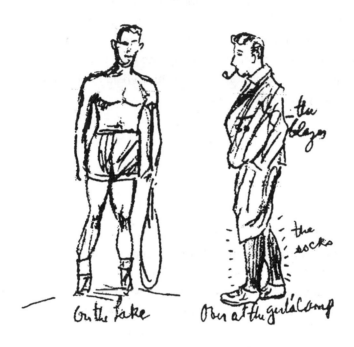

Well, Harold, I've got to end. The chief is calling me and I, "schlaf" that I am, have to answer.

As ever,
Clem

JULY 12, 1928

Dear Harold,

Listen, you introspective introvert, all you have to do is to psychoanalyze yourself in psychological "shibbolethery" and I shall make a special trip to Syracuse with a morphine hypodermic needle. Why have qualms

about yourself? Alright, acknowledge that you bewail your selfishness, indifference and all that, but don't for heaven's sake be disgusted with your<u>self</u>. Self-disgust belongs to unattractive women, not to a nose-picking, alert and clear-thinking soul like yourself! In truth, one who can be disgusted with so many different things (a sign of a true open mind) as you can is the last one to become disgusted with himself. And after a lecture in this patriarchal fashion, you should have become so disgusted with me that you forget to be disgusted with yourself.

I've gotten over my sunburn but have contracted a headache. Nevertheless, everything is "très jolie" and I have a date with a sweet young thing tonight—an ash-blond by the name of Helen Van Alten, a Dutch Jewess. That's pretty unusual, isn't it? Born in Holland, too, and speaks Dutch. Anyhow she'll do for a summer's loving. She goes to Adelphi.

And if you're ever at lack for something to read try the Victorian James Thomson's "City of Dreadful Night."

<div align="right">

As ever,
Clem

</div>

<div align="right">

JULY 18, 1928

</div>

Dear Harold,

Aw hell! That's the way I feel now—in the throes of cleaning up a tent and goading my refractory bitches into increased activity. If there is anything that is anathema to me it is handling children. God how I hate it! Ugh, the little savages, the little sons of bitches! Some <u>disgusting adult</u> perversions would be very very refreshing in the present circumstances. I've reached the point where I spend my nights trying to seduce the waitresses at the girls camp and the days thinking of "how to do it."

Camp is beginning to wear down my resistance. Hedged in by a solid circle of stupidity, miles from a single interesting person, encompassed by a loathsome routine, my mental state is one continual panegyric of self-pity. What's more, I've found out that I am basically conceited. Perhaps I'm not worthy of an interesting person? But I don't believe it!

Now I'm going horseback riding over to Camp Tioga with two fair damsels to see "Chink" Barnett [schoolmate]. It should be a good time. I'm not even taking a book with me.

I've read some of Matthew Arnold lately. He's more satisfactory than Emerson.

Just as I finished this, I received that copy of Hazlitt. Thanks an awful lot, Harold. I've read just a few things by him and what they are I like immensely.

I've been reading some of T. S. Eliot's poetry. Do you know him? He's a modern. Try and get him.

As ever,
Clem

My Moss and Redemption,

You did me an injustice by saying that I probably wouldn't know what your last letter was all about. Fathoming you isn't easy, but understanding what you say—you forget that I know you intimately over two years.

I seem to have done one thing that you haven't (I don't know whether it's desirable or not)—I've resigned myself to the fact that things, from cabbages, to kings and sealing wax, are all one glorious, actually glorious, mess. Deum vivamus, vivamus. Who knows & who gives a god damn! But, Oh Harold, a lot of good it does me! The trouble with resignation is that once you've resigned yourself you begin to form a practicable philosophy, and is anything more absurd than a practicable philosophy at the age of 19?

No, Harold, you have the right idea; let's get at the bottom of things whether they have any or not. Let's not be tempted by ready-made acceptances or even try to pass on those we have made (and how we do). How can Hazlitt say, "Living to ones self is being in the world but not of it"? It savors too strongly of a life's philosophy which he himself followed but poorly. He on "hearing the tumult" was not still—he was the purest sort of cynic who ever ventured to stick his nose into the affairs of men.

By the way, have you noticed how fond of Titian Hazlitt is? I think it is he who was responsible for the Venetian's great popularity with the Victorians. The same is the case with Correggio. But I wonder who is responsible for the recent elevation of Michelangelo to the post of the world's supreme artist?

I drowse, and my head falls between my knees where a little rivulet wets my hair.

As ever,
Clem

Dear Harold,

It's raining and consequently I have a free period—it's too wet for the water, thank God.

The chatter of children just reaches my ears from the recreation hall—soon the brats will come in and disturb my peace and rob my blessed seclusion (such a precious gem at camp).

With all my lethargy and indolence, I nevertheless don't get into bed until one every night. The nights are all I have to look forward to. Then "for curled Jewesses with ankles neat" I go a-seeking over to Winona. Last night we had the most magnificent full moon. It had just reached its apogee, and the lake and shore were illumined to such a degree that one could read by the silvery light. The best way I could describe its quality would be strained daylight. Oh what a night it was! A canoe, a blond (this is going to be a recital), a glenny cove and the rest of the conventional setting. God, I had to get up at seven the next morning to face a dreary drizzle!

Well, tomorrow I go horseback riding. There's exhilaration for you. Oh, the pleasures of an animal life—but not for long. Gallop, gallop, trot, trot, jounce, canter and so on thru miles of red clay road under the green arch of the overhanging trees. A fidgety mare and the sense of mastery once you have whipped her away from the hay for which she is always striving.

See, I am in a good mood now. In half an hour I'll be cursing the cruel fate that relegated me to a youth to be spent in mothering snotty brats with names like Seymour (ugh), Alvin, Stanley, Irving, Sidney, etc. Those names are so typical of a certain type of Jew. Jews that wear jewelry, golf hose, smoke cigars, play pinochle, spoil their children and indulge in loud horseplay. What parents they are to cope with. "There you go, my heart's abhorrence."

Incidentally to complete the animal cycle, I seduced one of the waitresses at the girls camp twice in the last week. However, sad to relate, she doesn't satisfy. A corn-silk haired, wide-lipped wench, stupid as an ox and as affectionate as Balzac's lioness, she didn't require much persuasion.

It's an awful thing to do; write of one's conquests. But I've got to tell you everything. And tonight I've a date with a perfectly respectable girl whose greatest indulgence is a maidenly kiss. Don't be bored Harold, one must live.

I think I'll read Browning just as a sedative.

Here come the sons of bitches now. I'll swear at the first one that comes into the tent.

It's stopped raining and I suppose the kids will have a swim. That means I work. Where's my suit?

<div align="right">
As ever,
Clem
</div>

<div align="right">
AUGUST 30, 1928
</div>

Dear Harold,

I feel like a chump, but honestly I couldn't get writing. Maybe it was because I was in love. I think it was. But, Harold, I always thought of you. It was just the grip of that "dolce far niente" that seems to go hand in hand with love that prevented my writing.

Anyhow, I am out of it now. I've stopped reading Ernest Dowson, Swinburne and Bridges and am turning back to Arnold & Sophocles. Oh! but it was sweet while it lasted!

Day after tomorrow we're going home; summer's romance dissipates to the chug chug of the train. I had a good time—in spots—a brutish good time. Her name is Marcia. I have to confide in you. I loved (honest) her till I found out that all she was doing was necking with me. The loving stopped, but the necking keeps on. In fact, it's a habit. The affection is all blown away, consequently we each go about things in a more business-like manner. I'm boring you, but I'd rather tell it to you than anyone else—she's tall, blond and rangy—pretty as sin. She is Sin.

> "All women born are so perverse
> No men need boast their love possessing."

I intend to be back at school around the 20th. I'm having my tonsils amputated when I get back to the city. That will knock a week out of my program.

Tell me what 3 Modern Library books do you want most at present. I can get them for .40 in N.Y. and I do want to bring you some when I come up.

The moonlight nights are wonderful—and women's breasts are so soft. With that final erotic statement I'll close. It shows my state of mind.

Yours till we meet in front of Liberal Arts.

<div align="right">
Clem
</div>

1929

Home again after their junior year: Clem on Riverside Drive, Harold in Syracuse.

JUNE 15, 1929

Dear Harold,

Pardon my lateness in writing. I just couldn't get around to it with all the business of getting home and looking for a job, etc.

Four neat little postcards greeted my eager eyes the first thing I stepped into our sumptuous apartment. Of course (!) I got As in the two English courses—Eaton wrote "excellent exam!" on the 112 card. Holywarth the old weazened little bluffer gave me a B and I took a B in Collins' course. So far O.K. My male parent was very pleased. He said "if only you were sure of $15 a week after you graduate I'd be satisfied." So would I.

I'm reading "Vanity Fair" (a great novel without any great characters— not even Becky Sharp). So between Thackeray and lamb chops my health and mind are lolling around in the shade with white carnations in their button holes.

At Macy's the interviewing lady (a charming hag) asked me what I majored in at college. "English" I said all abashed. She laughed "Yeh, it's too bad" she said, "heh heh."

I wrote a poem:

> The sun over the Palisades
> Is like a Florida orange
> But the stink
> In the subway
> Is
> Awful
> Besides
> There are
> Too many Jews
> In N.Y.

When you want to get rid of "fine writing" please put it in your diary.

And for Gogges sake try some other language beside French! I, at least, try things a bit—Latin, Greek, German, etc. There's a spice of variety, and you can't guess which I took most in college.

Suggested by Harold P. via Herr Kirchhofer.

The Chanticleer

N.Y. is as hot as Pratt's rooming house and the subway smells as bad. Down south the Negro women have a quaint habit of carrying sweat sponges around with them; that's what I needed here this last week. I sleep till 12 every morning and when I don't sleep I smoke and speculate as to how I'll spend the money I earn when I do get a job. Otherwise there's just clean tablecloths and bacon for breakfast every morning.

I saw "Journey's End" [by Maurice Browne] Thursday and hardly enjoyed it. But it's the sort of play you appreciate the day after. And oh was the crowd doggy! Everybody drove up in limousines and the women all had short haircuts.

Then tonight I heard the Goldman band on the N.Y.U. campus—one of the series of pop-concerts donated by the generous Guggenheims—open-air, mobs of kids and middle-aged ladies in their aprons.

Your rhapsodical exclamations à propos "Point Counter Point" were kind of stale especially since I'd said all that two months ago. Spandrell, Bosola, Hamlet and Baudelaire make up my all-American backfield anyhow. If I ever lost the habit of taking exercise I'd want to be a Spandrell—he's one of the elect, he carries vine-leaves in his hair. Mark Rampion is my father's idea of a good camp counsellor. By the way, all the girls down in Greenwich Village are becoming Lucy Tantamounts. It's the rage. But if Huxley were more moral he'd mention the fact that she had the clap. I don't see how she could have avoided it.

I've finished "Scarlet Sister Mary," a book of adventure stories by Conan Doyle (they were the nuts, all about pirates, box-fighters and soldiers) and I'm finishing "Swann's Way." Also T.S. Eliot says that Arthur Symons is a lousy critic and that his sensibility is acute but blind. Well, I told you his essay on Keats was moth-eaten.

My father says I'm a lazy son of a bitch and a disgrace to my heredity but I don't care, because I like him too much. Sometimes I want to feel hurt and misunderstood (cf. Betty Shookhoff [classmate]) but somehow I can't. My bed is too soft and clean, my meals agree too well, the shower-baths are too fragrant, everything conspires with lamb chops to make me feel that as long as I've got my hair life is O.K. Can you imagine, Harold, writing poetry and feeling too good to be poetic? And then in the morning the haze comes in from the Hudson and the Palisades get red in the face and the maid makes the coffee just the way I want it. As Horace says my mission in life will be to "Iocunda atque idonea dicere vitae."

Send "Wasteland" when you get through with it. According to the N.Y. literati T.S. Eliot's single editions will someday be worth as much as the "Hours of Idleness."

The check for $2.50 will be sent at my convenience.

[Antoine] Barye's "Archer" is as good as anything Rodin ever did.

Give my regards to your folks, and congratulate Dorothea [Harold's sister has graduated from high school.]

δ Παῖς Καλός Clem

JUNE 25, 1929

Mein Gelehrter Freund!

Wail for the world's wrong, I've got a job! I am now connected with the firm of Plante and Abrahams, attorneys-at-law; position, clerk; salary, $12 a week with carfare and accessories, and the net proceeds, gains and advantages will be the loss of ten pounds and an acute ability to distinguish between an execution and a judgment, not to mention the damages to my pride. But if I decide to take law, it will count towards my clerkship, which benefit is about as comforting as Shelley's poetry. Yes, yes how the world has turned, and all of Zion's harps have been hung upon the trees while the elders have gone off into the bushes to see if they can masturbate one last time before they die. Sunt lachrymae rerum—oi oi oi.

Sunday I went swimming at Far Rockaway and read John Gould Fletcher in the bath house. Monday I started work and read "Edgar Allan Poe as a Critic." Monday night I had a curious dream. It was mid-summer midnight, the landscape was indeterminate and diverse, orange lights shot up into the sky between rifts in the clouds and stained the countryside a gloomy, sombre orange. I sat on a very real fence smoking. I remember this as if it happened to me a moment ago. Then an enormous gray female wolf with long, long jaws, white, white teeth and two fuzzy, fuzzy cubs glided in my apprehension from an alley of poplar trees. The she-wolf made a deliberate, ominous, leisurely swerve in my direction. Her teeth were on my head, they shut out everything, nothing remained but teeth and long, long jaws. Then I yelled "muh!" and woke up to dawn and the realization that I had had a very beautiful dream and that it was better than either Poe, Baudelaire or Goya could've done.

It was so damn real, I didn't imagine a single bit of it; it happened genuinely in my "soul," and was so absurd that it must mean something tremendous. I've been thinking about it all day. The wolf, being female, could represent my suppressed voluptuosity, the cubs, my propagenitive conscience, while the white, white teeth are symbols of the illogical amount of money you spend on girls in order to be able to kiss them—tho' it isn't that way with me—but then we're not always as crass as we like to think we are.

As I have to get up at 8 tomorrow I'll drool to a close. It is evening Senlin says and in the evening everybody takes off clothes and goes to bed. In the evening I become beautiful. In the evening I see the vermilion breasts of two and twenty sun-tan powdered stenographers shaking up and down to the rhythm of the subway train.

If you're bored read Thomas Lovell Beddoes and manicure your toenails. There's nothing like that for self-preoccupied diversion.

As ever,
Clem

July 3, 1929

Dear Harold,

When Adam delved and Eve spun who was thus the gentleman? Certainly I wasn't. So far has my gentility declined that I go around all day with dirty finger-nails and muddy shirt sleeves and don't even feel self-conscious about it. I'm sunk. I'm a proletariat now for good and earnest, and I

take orders from a man who never read Shakespeare. For my magnificent $12 a week, I sit around on my can all day long drawing pictures that shock the office-girls, and once in a while I go up to court and give a superannuated female clerk a rose, a yellow rose for refined passion in dignified legal terminology.

It's bad, Harold. I read John Gould Fletcher in a dusty office and go home at night to sleep. It shows you what wrecks we seekers-after-romance turn into once we wet our pant-ends in the gutter.

How is lousy summer school? If you came down to N.Y. I could talk to you about affidavits, executions, judgments, writs of mandamus and the awful stink in the subway at 5 o'clock. I could tell you the reason why Rose don't get along so well with her boy-friend since she started throwing the ritz and saying that Roxy's wasn't good enough for her any more. I could tell you many things.

The office-force had an outing Sunday on the Hudson River. One of the amiable clients owns a motor-launch, and he took the whole gang of us for a ride up to Interstate Park where we ate lunch and squeezed the breasts of all the girls. Then I took an oily swim and steered the boat all the way back home, even down thru the Harlem River. Tomorrow is the Fourth of July and I'm going to shoot off some fire-crackers at Far Rockaway. And maybe squeeze some more breasts. Speaking of breasts, I saw my gray wolf on Fifth Avenue today, wearing a sleeveless flower-dress, made up with sun tan powder and with lips dyed sheep's guts red. But I lost her in the crowd, it was so hard to keep up with her swift-slinking gait.

I met Irv Goldman [classmate] in the Library with his intendant wife. His shirts are as dirty as ever but I like him still for his earnest feeling of inferiority.

<div align="right">

As ever,
Clem

</div>

<div align="right">

July 8, 1929

</div>

Dear Harold,

The hot Hammarattan wind rages outside unchecked and my sweating heart is like to filling my pajama jacket full of boiling lymph. The fog over the Hudson is like a humid exhalation from Hell. Even the Palisades are wan and bleary with the heat. Only apostrophes like that can cope with the way I feel now. Therefore after putting talcum powder on my crotch I'll go

to bed on the window ledge, and if I fall the air will be so thick that I'll bounce up into the Great Dipper and serve the Dog Star with a Summons for the radio he bought at Bloomingdale's Department Store and never finished paying for. Then I'll descend in miasmas of tin filing cabinets and Italian Surnames like Di Marca, Capabianca, Marsiglione, D'Urgollosa and Cohen. Have you noticed the eternal providence and forethought of God in making women's legs harmonize with the expressions of their faces? Curve for curve and pimple for pimple.

That's what I'm like after two weeks at Plante & Abrahams, attorneys-at-law. But it's not quite as bad as that. The stenographers are fair, and at night I go to the concerts at Lewisohn Stadium. By the way, N.Y. has gone daft over Rimsky-Korsakov. It goes good with the weather. Hot and sometimes tingling. All of the women smoke and go without stockings and say, exquisite. Ugh, I can't stand people who <u>look</u> intellectual!

I've Discovered the origin of the incomprehensibility of modern poetry! It's none other than Arthur Rimbaud and poems like the "Bateau Ivre." He's as far ahead of Paul Verlaine as Verlaine was ahead of Hugo. Ahead—why, it'll take the English poets two hundred years to catch up to him. You can't imagine the thrill I got from reading him, a weirder thrill than I ever got from Baudelaire. He out-Baudelaires Baudelaire at times.

It's 2 A.M. Having gotten rid of these extravagant, juicy dictums I feel much better.

Probably my last letter <u>was</u> embarrassed, but I didn't feel so—it's just the way I am with you—my tongue always in my cheek.

And for God's sake don't say "mon vieux."

How's Greek? Just think, what a learned correspondence we can carry on!

> Your fellow-devotee,
> Clem

AUGUST 1, 1929

Dear Harold,

I've been squeezed senseless, dumb and mouthing by routing. It galls me to see the way people congratulate me on the fact that I am at last earning money by hard work. O the stars would howl for this! The cruelty of doing the things you don't feel like doing and not feeling like doing the things you want to be doing.

All this yammering only means that I don't think that I'll ever study law nor will I ever be a successful business man. My heart's not in anything but enjoying myself and I can't get enthusiastic about things that haven't any pleasure in them. My greasy soul is a wise 'un and knows just what's good for it. But it's awful for my father. He spends sleepless nights over the fear that I may turn out to be a weakling in life. He actually does, and God, but it harrows him. If he only had some religion, he could at least think about God; but being what he is, he can only think of the glory and sweet fruition of the strong man who stands on his own two feet and batters the moon with his fists. To make a half-million in Wall Street and never harbor an anomaly, to be complacent with knowing that even God himself—if there is a God, as Donne says—can't laugh at you. O, papa, if you could only read poetry.

And you, Harold, shall be a professor. Is that a way out? At least nobody says to you, fill thy purse, get thyself money, fill your belly and say boo to the world. The toughest part is that I don't want to eat in the Automat for the rest of my life. Like [Jules] Laforgue, I'm looking for the "Inclusive Sinecure." Funny thing about Laforgue. It's said that an extreme change of climate when he was six (he was born in Uruguay and then moved to the Hautes-Pyrénées) permanently deranged his <u>senses</u>, distorting his sensual reactions to the ordinary things of life. Not a bad up-bringing for a poet?

You've heard of "Transition" of course. I sacrificed a dollar and a half to my curiosity and wasn't disappointed. It starts off with a "manifestation" declaring that the undersigned are irreconcilable enemies of syntax and the English language. Here's a specimen:

"The lilygushes ring and ting the bilbels in the ivilly. Lilools sart slingslongdang into the clish of sun."

That's the way I'm going to talk to you when I see you next.

Clem

P.S. Till Thursday morning at the latest.

2

DOING THE PROLETARIAT

*"I have tasted thereof and found little that is good and much
that is soul-stupefying as only American business can be."*

1930
Clem and Harold, both Phi Beta Kappa, have graduated with B.A.s in literature and
are once again living at home.

<div align="right">JULY 7, 1930</div>

Dear Harold,
I spend my mornings looking at the Hudson River and wishing I were
some place else.

> "—Schön ist es anderswo,
> Hier bin ich sowieso—"

But that was in another country, and besides, the canaries are all dead.
I haven't a job yet, not even the illusion of one. I shall probably spend
the summer at Far Rockaway among the lower middle class and excessive
tides. Mr. Watt of the Employment office sent me a telegram telling me to
apply to the International Business Machines for a position editing their
weekly newspaper. I wasn't very sanguine but I did go up to see them and
received an indefinite promise pending the approval of the vice-president.
My languages impressed them.
Far Rockaway, swimming, milky maids and a diet of straight lines; rail-
road tracks, telephone poles, wires and piers—otherwise the lousy Long Is-
land pettinesses, and I'm happy. But sick of straight lines. I've been reading
Emily Dickinson's further poems, "Samain," the Iliad, Aldous Huxley's new
book of essays [*Do What You Will*], Conrad, Trollope, German poetry, and
Pierre de Ronsard, who is much better than I had thought him to be (as you

said). "Samain" is sweet and good. It came from Paris: Three brochures (the fine white ones). I enjoy the remarkable heaviness of those paper covered books. Trollope has talent, not genius, which is all I wish to say.

I'm starting on Italian again—my vocabulary is rotten. And maybe Spanish which I'll need if I get this job.

I went to the Modern Art Gallery again and spent more time. Gauguin is over-rated, Karfiol is usual, Pascin is French and Rouault's big canvas in blue, black and glaze is the best picture in the house with Matisse, Cézanne and Dufy next in that order. "Picasso is simply Decadent!"

Betty Shookhoff committed suicide a few weeks ago. I heard it Saturday from one of her sorority sisters. Her brother and sister had kicked in from T.B., her father was afflicted with a cancer in the throat and besides this, Betty was bored—revolver. Don't mind the matter of factness with which I tell this. It's such a rotten, rotten shame. Poor Betty—keep the suicide business to yourself—after the canaries perish the blackbirds begin to die.

Regards to the family and Sargent [Dr. Irene Sargent, their art history professor].

Yours ever,
Clem

AUGUST 2, 1930

Dear Harold,

The job with IBM fell through. Never believe a skinny Irishman. I'll take Dr. Sargent up on her offer to help find a job. What's her address this time of the year?

Meanwhile I live in epical loneliness. A long poem should be written about the heroic qualities of summer loneliness in N.Y.—with a double rebound, no straight or even T.S. Eliot-ish presentation but a bounce off two walls. I live in dust, dust on everything, dust on French, German and English, dust on my anus, my penis, my nose, my mouth, and if not my heart, my liver. "But who can blame

us if the heart live on"? As Laforgue would say, that is literature. And what next, if not literature?

Some day I'll gather up my volition and sur-prize them all. You'll see. I'll eat breakfast on an Eisenbahn yet, as I once told you. I'll make money and smother "mes parents" who will offer me the drinks of their cellar. Then you'll get that $3.75.

Von Hofmannsthal died a few months ago. It's a shame English-speaking periodicals are so reluctant to deal with modern German literature. "The New Freeman" was the only one to run a notice and a eulogy. von H. was also a Jew and rich.

I finished Gide's "Faux-monnayeurs." (Wow!) Everybody has copied from him. Huxley has practically translated it, linguistically and temperamentally. But what a novel! Read it in French.

Here is my temporary Pantheon of the Modern German poets: George, v. Hofmannsthal, Dehmel, Lasker-Schüler, Trakl, Heym, Holz, Hasenclever, Hatzfeld, Werfel and E. W. Lotz. Maybe Rilke and Max Dauthendey. Try to read some of them.

<div style="text-align:right">

Yours ever,
Clem

</div>

<div style="text-align:right">

August 18, 1930

</div>

Dear Harold,

You can see that your letters are interesting by the promptness with which I reply. But they are becoming more and more symptomatic and less and less manifestory. You remind me of a captured flounder that perpetually turns itself over in a shallow pan of water. You mean to say all you read is that constant succession of novel and poetry, poetry and novel? And all you do is regard your soul and marvel at its sensibility? And you'll start writing in ten years? Look out, you'll turn into a sterile suspicion.

Excuse all this; I'm not immune either, but your letter irritated me. This business of refreshing a sweetened Proust, spending your time with your own mind like "a kid with a clock"! Gathering those romantically exerted memories. Oh Harold. That's all so modish and sensitive, so brainlessly Sonia—if you know what I mean. So far as caring to know what you are and not being disgusted—why don't you dare to know what you are? (This is very very serious) and with sympathy above all—you know I'll never kid you in a letter.

I've been feeling the same way about myself more or less and I've quit reading novels and poetry for awhile—except late at night. I do what I used

to do when I was 14 & 15; explore some incident or fact to the furtherest limit, track it down thru every lair and then eat it for two or three days. I ran through Nietzsche in a week: "Thoughts out of season," his life "Ecce Homo," miscellaneous writings and finally "So Sprach Zarathustra"—like you, I can only talk, I can't write about him. When you read Laura Riding's prose remember that she was profoundly influenced by Nietzsche; not so much by his ideas but by his cast of mind.

Then I've been reading the Russian half-mystic Ouspenski. Inter alia, Heraclitus and German history. Wonder at my industry.

Furthermore I've gotten a lousy job; investigating for the "Credit Clearing House" at $25 a week, to begin work next Monday. I have tasted thereof and found little that is good and much that is soul-stupefying as only American business methods can be.

Tonight I'm going to the Stadium to see the Denishawns [Ruth St. Denis and Ted Shawn] dance. It's very cool and they should be good. Furthermore they're going to give the figures from the Angkor-Wat bas-reliefs, the conventionalized gestures, about whose mystic denotations all the aesthetes have been raving. As long as no one does the "snaky-arm" I will be satisfied.

Write soon.
Clem

SEPTEMBER 9, 1930

Dear Harold,

I have been in the throes of the lousiest job ever conceived by the million commercial demons of America. If you know what checking credits means and what personal contact with those leprous persons means—well enough. I was fired a week ago this last Saturday, three hours before I was going to quit, which caused me much mortification.

If I could ever tell the agonies of those five days of my life spent as an investigator I should reach the apogee of expression. The older I get, I fear, the more it will haunt me.

I spent a week-end full of hurry & scurry to discover how happy I actually am. You know it's funny, but without some shreds of diurnal nostalgia I would die. Down at the beach I saw a plot of sun-bitten grass close to the sand and suddenly I had a mystic revelation—I knew completely & all

at once that my "true happiness" lies in sitting on my ass and letting life, as they call it, come to me slowly, reasonably, weighed on each side by right & wrong, ballasted by regret and made beautiful by indecision and German poetry—not to enjoy, to fuck, to go, to feel cold and hot, to fiddle with personality. That scrams my inside surface out, makes me "falls" (false). This is an authentic vision and no literature but rhetoric.

How come you're going to Cambridge so early? [Harold is going to Harvard for his M.A.] Even to look for a room you're rushing yourself I think. I envy you your expectant palpitations though they are only caused by the paltry unknown of what a Harvard will be. Think of it, to be standing on the brink of Cambridge! Of such moments is our life made up. What an anticipation of nothing to be anticipated. I'm afraid you'll find it a sink of shitheelery.

I am alone too. So demoniacally alone. So shittingly alone. Not fed up, not fed down. (I want Cybele to mother me, if not Cybele, Ste. Catherine and if not her, Aimee McPherson. I want to laugh or cry. I don't want to be anything. I don't want to make anything. I don't want nostalgia or acedia. If I had a thousand dollars I'd be happy.)

If only N.Y. were subject to catastrophes. An earthquake, a blizzard or a revolution would give me a mission. Otherwise I see no way out.

> Yours ever,
> Clem

Addressed to Harold at 25 Ellery Street, Cambridge.

SEPTEMBER 22, 1930

Dear Harold,

By this time you must be deeply in Experience, or at least I hope so. After all I can't get away from the illusion or delusion that there is something to be deeply in at Cambridge. Keep your pecker up as they say in Liverpool—there are sure to be more consequences than inconsequences to be gotten out of Harvard.

Thanks a hell of a lot for "Les Enfants Terribles." I started it on the trolley and finished it between 8 & 2 and went to sleep to dream of a sister (step) named Elizabeth. It's too bad Cocteau has gone Catholic. He has the mythological genius, or rather, knack.

Everything is the same. No job, I don't want any and yet I hope for one. I sleep till 12 every day, shower leisurely and change Purgatory for Hell on the footpaths of Mammon's midwives. I find myself turning into genius otherwise. Lately I've been meditating on killing my stepmother. [Clem's mother, Deborah Brodwin, died in 1925 when he was sixteen. In 1927, his father, Joseph, married Fanny Greenberg, a second cousin. Clem's half-sister, Natalie, has recently been born.] But the objection seems to be that my father will lose what little brains he has left when he sees my hands stained with the officially maternal blood. You see I'm a moral coward and, as I've always told you, Hamlet too.

How many miles is Cambridge from NY? Who knows, I may be up. My father, Lord bless him, is chary of the car. He fears my genius. Also he is trying to drain the brains out of my head with a funnel made from a dollar bill. I don't blame him though; he's too bored to be the father of a genius. I'll turn Rimbaud and steal the car.

Yours ever,
Clem

The Greenbergs have moved to a two-family house at 539 Ocean Parkway, Brooklyn.

OCTOBER 1, 1930

Dear Harold,

From your letter you seem to be fairly equable, or was it just a mood? I'll bet you like Harvard after all. Henry Adams animadverted plenty upon it but he loved it—respectable above all other things. Amusing? Aren't there any circles or things like that in the neighborhood or a place where they sell snooty poetry magazines? Sure they're not all eager, eager or German-serious; poets and editors of the "New Republic" must be produced, Senators from New Mexico and Lee Higginsons too. Wait, you'll find them if you don't talk too much.

We've moved to Brooklyn, and I've a room of one's own according to the lady essayists. Much better than the Drive; more trees, more lawn, more garbage, less places to go to. My stepmother doesn't like the class of people here, but I prefer them to walking in dog-shit. The main thing is they have babies instead of dogs.

It's peculiar that you wrote the same things I was about to write you

concerning "Pagany," etc. Fakers all of them. [Paul] Bowles is bilge. Style, you know in their case, violates what Leibnitz postulated; i.e. between what is conceived and what is imagined there must be an inner correspondence. Cocteau says in a letter to [Jacques] Maritain that the moderns are enslaved by Lautréamont and Rimbaud as much as Racine was by [Nicolas] Boileau.

Cambridge, you say, is eight hours from N.Y. by auto? It can probably be made in four. The bus ride would be terrific. If you come down there's plenty of room now. Big house. Seven rooms and a day-bed.

For my sake go to a football game. I miss them.

> *Yours ever,*
> *Clem*

<p style="text-align:right">OCTOBER 9, 1930</p>

Dear Harold,

I am in the imminent danger of getting a job for which I don't give a damn. I need money badly awful badly and I must get some somehow, therefore I am again prepared to suffer for a few months doing the proletariat as outside clerk for a paper and twine company—the customer's man has weak eyes and needs somebody to do clerical work for him. Going around to the cloak and suit houses, etc. amanuensis for a pleasant dodderer. Don't despise me—means, means, means—to buy a revolver, to kill my stepmother (I can't do it with a knife), to finally justify my contempt for everything I hear, see, smell, eat and feel. Jobs on ships simply can't be gotten.

How is the tea in Cambridge? Are there pretty girls around? Is the fall mild? Where do you eat? Do you wear your hat in the street? How are the Jews? Are there plenty of trees? What happens in the afternoon? Tell me, go ahead.

I received a surprising graduation gift from my Aunt Becky's son-in-law—a year's subscription to T.S. Eliot's "Criterion."

I met Mickey Newmark [college friend] downtown a few days ago. He lives in Bklyn too, quite near. We're going out riding together some Sunday and maybe eat Hot dogs in Coney Island and talk about Georg Kaiser. I'll pay for the gas, he for the Hot dogs. O it'll be jolly.

I read James' "The Europeans." Someday I'll like him a lot but not yet—except the short stories in "The Finer Grain," they are something.

I finally tracked Leibnitz to his lair. He too helps to explain why Ger-

many is Goethe and Dehmel and Kaiser. Just the slightest bit of misplaced emphasis in that country, and the negroes become white and the white man black. Vide Hitler and the "Stahlhelme." Again read Kaiser.

Yours ever,
Clem

P.S. I'm reading Isadora Duncan's "My Life." They should have taken what brains she had in her head out and filled it instead with quicksilver. Probably she was the greatest single dancer we know of, but I, who like consequence in all things and to believe that the mind makes everything worth making, must "regret" that Isadora ever allowed herself to say a word. She's the result of a mind that fails to live up to the personality it lives with and of the dangers of too-highly seasoned intellectual companionship for a back-woods American. You have never read such arrant nonsense in your life! With maybe now & then a real flash of something that her dancing is supposed to have stood for. I feel strongly about her.

(It's further disillusioning to notice that she shaved the hair on her armpits.)

OCTOBER 16, 1930

Dear Harold,

The Harvard program according to you reminds me a lot of certain winter afternoons in Norfolk. And they're probably a lot alike. The long alternate greasings and dustings that Anglo-Saxons generally give to their environment after living in the same place a hundred years.

The girls are stout you say. Do you know why? I hadn't thought of them like that. Something entirely different, more New England, more Radcliffian. Anyhow the girls in N.Y. this fall are very scarce and very haggard. It looks as if it's going to be a hard winter. There are a variety of reasons but the chief one seems to be the disintegration in the search of vice and pleasure. We, as they say, are going through a period of transition; between 476 A.D. and 1930 we were fucking belly to belly, henceforth it will be belly to back as the pagans and Neanderthal man practiced it. The benefits which will accrue therefrom are enormous. We are fucking from the side this winter and Lord knows the consequences to our nerves and general health.

You won't learn that by reading the Morning World, Harold. But it's a fact and many people are seriously arguing about it.

Don't judge Else Lasker-Schüler by the anthology pieces. No she's not as good as I thought she was, but she's still a great poetess.

I was in Westermann's a few weeks ago and struck up an acquaintance with the salesman, who it turned out, was a German poet on his own right—Hans Geifel. He gave me all of his confidence and poured out the latest opinions on German lit. Richard Dehmel's "Zwei Menchen" is the greatest thing ever. Werfel is not as good as he once promised to be. Kleist is a miracle. Expressionism is softening up. Lasker-Schüler is too judisch a passion but he considers her to be one of Germany's greatest women poets and already accepted as such by the modernists. So far as my own taste went, it was gratifying to see how ridiculous it wasn't, when it might have been so much so. And it was exhilarating—he's just a young chap, about 25, short, goodlooking and blond, more like a member of the Turnverein than Parnassus.

You never saw the German picture "The Cabinet of Dr. Caligari," did you? Well, it's possible.

Yours ever
Clem

OCTOBER 30, 1930

Dear Harold,

My job fell through, as I had expected, and again I'm in midstream.

Guess who I saw? Harold Jonas [fraternity brother], his presence—at Columbia Law School, at the International House. I had dinner with him and we went to see Jinxie three blocks away who's rooming with Rose Lipitz [classmates] and both going to secretarial school, etc. It was a dingy night. Jinxie is so curious about your fate, she's fatter and more lymphatic than ever.

I'm glad you like Georg Kaiser, though you shouldn't criticize so glibly without having read the originals. I am almost through with Mann's "Magic Mountain." Almost a great novel, but not, as shitheels like us say. Worth reading in all cases—the peculiar influence of Proust. Villiers' short stories are excellent in the same tone of voice. Read for your sake, "Akedysseril"—it's diamond prose.

I saw the Daumier-Corot show at the Modern Museum and it was so good. That old bugaboo of subject troubles neither, because if you're good you're good: especially D.'s etchings, and Corot's earlier pre-silver landscapes with the aqueducts and Italy. There were three or four genre paintings by D. which gave me that artistic thrill of plucking every chord. Who-

ever it is that arranges the pictures of the museum certainly shows good taste.

As you may notice from this letter I am slightly ecstatic. I have a bad cold and cough in the three cardinal colors not counting the phlegm itself. I feel like Ernest Hemingway.

About Harvard: if there are any Sanhedrin around I don't think you'll find them studying English. Maybe they're over in Egyptian Eschatology or Bacteriology

(for you)
Biographical
Sketch —
" Brooklyn ".

since 1910 or the Kinetic Life of the Atom. Incidentally as long as you're going into Philology you might as well be scientific about something that hasn't such nauseating effect. In other words, if you are willy-nilly absorbing a Method, why not let it be a valuable method like astronomy? The only philologist I've heard of who ever came to good was Nietzsche. Honest, the mere connotations you brought up in your letter gave me a disgusting sensation. We'll hope you forget it soon.

Thusly Hyperion to Diotima.

Forgive the disquisition.

Yours ever,
Clem

NOV. 13, 1930

Dear Harold,

I've got a job—a good job too, as menial jobs go—with The Home Title Insurance Company. "Brooklyn's Atlas" in their advertising department. I'm supposed to be a knowing lad etc. and they needed an assistant at $15 a week who would be learning the advertising racket at the same time.

I run around to the libraries and gather antiquarian facts connected with Brooklyn and Long Island. I'm already an authority on old-fashioned farmers' almanacks and Dutch tradition in N.Y. State. Then I interview captains of industry for inspirational material which is good fun. Yet at

the same time everything's barbaric, civilization becomes so far away between 9 and 5 that it almost becomes unimportant. Here we deal with money in the absolute sense, not for its value in commodities or power but money pure, transcendental and superior, its awful simplicity and woeful complexity. And everywhere Yahoos and Yahoos, not even Jewish but Gentile and outrageous because the Jews never could see the absolute in money, but I do. O Harold it's so absolute that I almost decided to give up writing poetry and switch to 5, 10, 20% debentures, due in 1940, 5% certificates, gold bonds and morale.

If I'm still lyrical after almost two weeks you can see how "wichtig" it is. Seven hours a day does that.

I've bought your French painters and you'll get them within a few days. If it weren't for the size of the plates the book wouldn't be worth the money. And you'll be getting your 3.75 selah! as they say in the almanacks.

My boss—isn't it wonderful—is a Harvard man, magna cum laude, and a lot of other crap, who originally set out to Write but soon became commercialized and now is 3/4 barbarian. He wants me to write my copy with life in it and wonders where did I ever get such a matter of fact and understating style. Where I say, "They sneaked up to the camp and nobody heard them till the sentries fired their muskets," he will say, "Panther like, they crept toward the slumbering camp. Suddenly there was a challenge! a shout! a scream! and the rest was drowned in the rattle of musketry as the British officers jumped out of bed and pulled their drawers on." Anent a Revolutionary war myth that we feature in our almanack. He can't see that "sneak" is highbrow. But what the Hell.

Meantime I'm reading Villiers' "L'Eve Future" as an antidote, for which I blush—for the necessity I mean. There's nothing as shabby and mean as Beauty after working hours. But I need guts and maybe someday I'll acquire them.

<div style="text-align: right">

Yours ever,
Clem

</div>

<div style="text-align: right">

NOVEMBER 20, 1930

</div>

Dear Harold,

Grusse dich wieder, though how you'll get here on three bucks I don't know. I'm anxious to see you, honestly, and I've got a lot to tell you which will probably never be told for lack of sufficient apropos. But then I'll tell you something else which I haven't got at present, yet may be more pertinent. So between that and this, civilization will once more be more than more.

I'm still in Thrace, and as we do in Thrace, thriving—comparatively. The days of the week have their old significance again and the seasons also. Like Goethe, I begin to sorrow, now that the shortest day of the year is so close. Philip made Thrace Greek and I too.

This week I discovered one of the first written mortgages ever known— Greek inscription from the time of Demosthenes which I deciphered all by myself. That is, it was in a book but nobody had ever noticed it before. I copied it in the old-style letters, irregularities and everything, and now it's going to be in the newspapers. But it's not as good as it sounds—the "Research Department of the Home Title" gets all the credit. The fact that it was a mortgage gives me particular satisfaction. Who'd ever have thought it—Greenberg & mortgages? And so another facet in Greenberg's Great Childishness, or as my boss says, why he feels young when he looks at me.

Otherwise I've learned how to judge good printing from bad, and how to make photographic composition, something very different from creative composition. That's all to the good, but there's more to the rotten, because working is rotten, and for me who can outrotten pretty rotten things, compulsion for the sake of money is, of all, the rottenest. And how white collarish! How infallibly have my circumstances produced their true results. What could be sweeter than to be almost 22, white and educated, and connected with a financial house in old Brooklyn? To wear a clean shirt every day and shit in the executives' toilets. You talk about Harvard!

I'm reading Richard Burton; have you ever heard of him? You ought to.

Let me know when you get in. And bring along that new book by Laura Riding [*Though Gently*]. I want to see it.

Wear a light blue tie and shave without cutting yourself.

Yours ever,
Clem

1931

Dear Harold,

I'm not a dope, and you know why I haven't written for two weeks— the reason for not writing the other two weeks only I know because it had something to do with a refusal of the spirit and such crap. Maybe this is a corresponding reconciliation, but I think no, since there was nothing to be reconciled; it was simply an excursion in winter.

I'm a bitch for making you think all sorts of things, as I know you did— but then you're a bitch too. What went thru your head I realize without

your telling me. You can't endure the silences, that was lousy on my part, but I was comfortable for the time being, and now apologizing, if I could only tell you how much I still like you which you would not believe but is true as long as you affect to be something less affected than yourself that is possibly not yourself but Rochester, Syracuse and Cambridge.

My clumsy sincerity makes this letter unusually lucid and elegant. Or whom on earth would I write it to? I'm not down on my knees but in a position which is the equivalent, standing on my head because you're lying on your stomach.

Write and give me hell hell hell ironically and then forthrightly justified and betrayed. Sock it in heavy, my tail is already hanging, I've gotten over a lot of things.

And when you get through with that pray for me that God will cure the scurvy that has encompassed my soul for the last two months, that He will save me soon, that myself won't become the lace of trivial essentials that it is now. I've been in a trance—I still am—I've flibbertigibbeted for eight weeks and O the shit I consented to adore for the moment.

This is a letter, Harold.

Otherwise I've seen Kreutzberg & Georgi, "Tristan & Isolde," Mary Wigman, "The Vanities of 1931," "King Lear," etc. The reason I'm telling you this is because I haven't read a book except e.e. Cummings, and I want to change the subject and that I should shame.

How was your vacation, how was you, how was one, two and three, how was the fifteen boredoms you must have had, how was your anger for me; how was December?

Yours ever, as ever,
ein armes Knabe das alles werden lässt sich.
Clem

JANUARY'S MIDDLE DAYS, 1931

Dear Harold,

Tomorrow I begin my last week of work—they're firing me. Have to cut expenses, they say, thank God and maybe. No one but you would ever believe it's a relief. Then my ex-boss says he'll get me a job on the Brooklyn Eagle or with a magazine, at least.

Which reminds me that I've now bumped into Micky Newmark twice. How time justifies me! He's everything I have ever—in my dreariest forebodings—suspected him to be about to become to be. God knows, he was bad enough—for me, not for you—before. And to see the <u>trivial</u> there

where there can be no <u>trivial</u> because it's all Micky and Micky is a Jewish homo. You would never have heard about that if I hadn't told you—since you can, or have liked Micky Newmark. How lucky you are to have me to tell you—Greenberg's theory of the High Superficial—three times how lucky you are!

But above my bestial nature there always arises some aureola to remind me that my home is with God, dem Herrn. Even in my most thoughtless moments I will feel a tap on my elbow, and then I turn, and there stands God with His infinite Grace manifest in a shining erection seen through the celestial robes, all to remind me that once in a while I can lay a beautiful girl, who, to the bargain, eats no meat on Friday and gives me that wonderful pleasure of feeling sacrilegious because once upon a time she almost became a nun.

Yours ever,
Clem

JANUARY 19, 1931

Dear Harold,

I've got a new job writing piece news for the Bklyn Eagle—nothing hot or even profitable but better than many other things. While the assignments I get are stupid, like the monthly meeting of the Gagem Cashem Hebrew Democratic Club of Southeast N.Y., there is a delightful inefficient hard guy atmosphere which fits me closer than anything I've ever come across in the line of mass endeavor. With luck & space I might make $12 a week.

Did you hear that Oshinsky died? Last Sunday after an operation on his throat—sickening when I remember his dirty feet and glad hand, and the intimacy with which I looked at one and received the other. There was a piece in the paper, telling how his fiancee, Lillian Roth, got the news while dancing at the Palace. Oshinsky and Shookhoff—death gives them a kind of symmetry.

Chet [Leopold, fraternity brother and junior-year roommate], writing to me about it, said, "all is now a curious memory," and Oshinsky is even more curious as a memory than as Oshinsky.

It's depressing though—more depressing than Betty's death—it's probably because Oshinsky was something miasmic.

I'm beginning to wear stiff collars.

Most of the time I work nights. Tonight, for instance, I will listen to and tell how Judge Pennycock tells about the World Court to all loyal Republi-

cans who generally have more refreshment and less Jews than the Democrats. When I get back to the newspaper office the fun begins, what with the highbrow tramps and Bohemian women-reporters. The idea is to look and dress as ragum tagum as possible. That's why I'm wearing stiff collars because they do make me look Seraphic like the Prince of Wales at a lecture. Somehow I suit that way. Otherwise, a bunch of comparative ignoramuses—the style is there but no conceptions.

<div align="right">
As ever,

Clem
</div>

<div align="right">Feb. 4, 1931</div>

Dear Harold,

I can see that nobody's kidding at Harvard. Everything is on a Plane or rather a Level—according to those exam papers which left me so disconsolate: that you should be expected to know that stuff from a sense of duty and not by inclination.

I'm still a newspaperman. Very little dough but not bad. Good English is resented everywhere. But it's fine all the same; everybody's poor and everybody's inefficient. Even the editors believe in the efficacy of waste, fat waist, thin waist and money waste. As I said, it fits me close! I work till 3 A.M. and sleep all day, and at the office there's fun from 4 to 5.

I'm looking around, officially, and "getting experience." As T.S. Eliot says, the test of a great mind is in the quickness with which it forgets what is called "experience."

Aber I'm still thirsty.

There was a Rousseau, le Douanier, show in N.Y. this last month. There were only 4 decent paintings in the whole exhibit. The remainder was pure junk.

Mary Wigman also wasn't so hot. She is a great composer—almost—but her legs are forty years and wilted and are naturally shapeless. Only the "monoton drehtanz" was good: it was wonderful and the first genuinely modernistic composition I've ever seen. But there's too much German lyricish—"the dancing because I must express myself." Disgusting hooey.

About Harvard again—my anent boss, with whom I've become very intimate since being fired, went to Harvard with e.e. Cummings, John Dos Passos, Robert G. Nathan, Watson, who was editor of the Dial, Robert Hillyer, and S.N. Behrman; and wrote on the same literary magazine—the

"Monthly." In fact they were all one gang, so he says. Anyhow he has plenty of stories to tell about them. How Dos Passos changed from an aesthete to a Communist rough-neck, how Cummings was a taciturn he-man, how Hillyer was abashed and grateful to anyone who said hello to him. He showed me old copies of the "Monthly" (1915) which have poems by Cummings in youthful rhetoric. It was peculiar to see. They were all hot & bothered about Baudelaire at that time and how childish. Using the 1914–1916 "Harvard monthlies" as a spring-board, a good man would be able to write an incriminating encyclopedia. In case you should look up the files in the library, my boss' name is Ben Sion Trynin—you'll find his stuff in there elbow to elbow with Dos Passos & Cummings.

And ever,
Clem

FEB. 22, 1931

Dear Harold,

I was fired from the Eagle, ostensibly for misspelling the name of a prominent judge (of all names, Moscowitz). But there's a funny story connected. It was snowing that night, and I had to drive the car from furtherest B'klyn to the Eagle office—miserable tension, skidding and everything. When I arrived I was woozy in the eyes and sweaty, enough to relax my self-control. I proceeded to type my story on a wretched type-writer which contributed causes. I hardly looked at it, the story, after finishing and handed it in to the night-desk and left without waiting. Next day I was hauled up before the city-editor, who was as sore and at the same time as "non-plussed" as it was possible for a man to be at the same time. What was wrong—I had written the story in what you so admirably called, "the close harmony of modern poetry." It had to be totally rewritten, and I had to be fired. As the public knows it, the reason is the misspelling, but the close harmony was the real and scandalous reason. I didn't try to explain, the city-editor thought I was insane as it was.

As for yourself, young man, those two A- were repaying and I agree with you. It is just what I would want.

In no connection at all, have you ever seen any cubistic still-lifes by a German named [Arno] Mohr? I saw 2 in water-color, the best ever and I never got such a kick before. He's my own Discovery. I've been seeing many pictures lately being as it's the cheapest thing to do. Also look up Otto

Lange, very good, Willard Nash's latest still-lifes, Bertram Hartman's nudes, and 3 water-colors & pastels by Klee: "drohende Schneesturm," "Frau R. auf einer Reise im Süd," "Dorf im Süd." I have to catalogue these things because they're genuine Discoveries.

Now, immediately, there's nothing ahead in a financial way, but I'm as vaguely indifferent as ever. Yet my God how I want money in order to get out of everything. I had my first squabble with my stepmother, which further complicates things. I was teasing my father about something or other, and she came to his defense, thinking in her usual pathetic manner that I was serious. I told her to keep her nose out until her language was more respectable, and she herself, if possible, was not so dumb, which is impossible. She began to call herself a damn fool for tolerating the things she does from me, such as late-arising, complaints about the cooking, etc. I said that I agreed with her except for different reasons, i.e. that she is a damn fool. There was some fun after that. I began to handle the carving scissors in a savage way referring to Hamlet and his uncle. She had never read Hamlet, but my father had, and, of course, that was too much for him. So you can imagine what happened. It was all funny as hell, but I couldn't laugh until long after.

Anyhow, the house is uncomfortable.

To change the subject, have you ever read the epilogue to Robert Graves' "Goodbye to All That"? What a great episode his unspecified relations with Laura Riding will make in literary history hereafter. There's so much in it that I'd like to discover it myself. I can't get it off my mind; especially the hint of an attempt at suicide wherein Laura Riding (Gottschalk) broke her spine by falling from a "fourth storey" in April, 1929. Look into it.

You were very right about the H & H [*Hound & Horn*] essay on e.e. Cummings' language. Let him stick to writing nugar, such as in the latter parts of "Is 5." To try to incorporate the Zeitgeist the way he does one should be more stolid, more brutal, more pedantic. Besides, incorporating the Zeitgeist is a lousy job for a poet. Even if he is a tough guy. Why doesn't Marianne Moore get more credit and notice? She takes the Zeitgeist in her stride, which is much different from making a job of it, and keeps on to do a hell of a lot more.

Enough, Lazarus, I leave you in Bethany.

As ever,
Clem

SEARCHING FOR A METHOD

"I need something so that I will be able to stand off and slap the world from a position.*"*

Dear Harold,

About Easter: though I don't see why you want to come to N.Y. you're welcome, and I'd like to see you. How long is your vacation? Sometimes I think I don't want to see you, but in main (and it would be better if I didn't see you) I do.

I've finished Gide's "Les Caves du Vatican." Gide is no more of moralist than Leo X—and why should so many gens talk of morals, morals, like a filthy new literary fad? He uses moral questions like a painter uses the color blue or the cylindric basis of a tree: It's part of his trade and stock. If he is ever a genuine moralist (nasty word) it's when he's trying to justify his own homosexuality by illuminating l'amour grec as a social prophylactic to keep our daughters ideal more than pure. Pugh!

I'm going South with my Pa this Friday to revisit the scenes of my boyhood [Clem's family had moved to Norfolk in 1914 when he was five, returning to New York in 1920. His father was still part owner of a clothing store there.] I look forward so much that it's a miracle what outside actions have the power to become in my cantering day-to-day. Seeing Norfolk after 11 yrs will be like visiting the authentic scene of a book read. As you know, geography has, not strange, but rare emotions to furnish me. I expect to ride horses, play golf and feel spring 2 months ahead of time.

I'm still in Streit with the stepmother. She won't sit in the same room with me; a state of affairs that has its good points. My father however refused to explain to her just what connection my references to Hamlet had to her.

Yours ever,
Clem

MARCH 3, 1931

Dear Harold,

My boyhood scenes are a disappointment. What I wanted was not only Norfolk, but the year 1918; actually it was more a nostalgia of time than of place. Norfolk, alas, is in the year 1931 and has become Americanized. Enough of the Old South remains nevertheless to make it a decent human place to live in for at least 6 months.

About morality: "I know little and care less about problems of society..." ("homo sum et nihil humani alienus mehi puto....") "The Anglo-Saxon notion that morality and sex are the same—is the worst?" Aren't you ashamed of yourself? "Problems of society!" even Oscar Wilde couldn't have said that, and in so far as sex and morality being synonymous, it's an outgrowth, and very obvious one, of St. Augustine's theology (he, himself, didn't make that mistake) and besides being Anglo-Saxon, it is German, Dutch & Scandinavian, etc. and was never very basic except as a "capitalistic method of insuring women." The trouble with you is that you don't read enough.

Excuse me if I talk like an Episcopal bishop, but it is most part solicitude for your well-being.

Otherwise read a play by Kleist, preferably to start, "Der Prinz von Homburg," and see beauty in aeroplanes, look at the architecture of Frank Lloyd Wright, tell me what is wrong with Le Corbusier, another architect, and learn to know why Rouault is not a pure modern. There is a "method" (in the Asiatic sense).

Yours ever,
Clem

Clem is home again in Brooklyn.

MAR. 13, 1931

Dear Harold,

My last letter got the expected reaction. Sure I'm telling you things, and there are others. But since you still insist that you're not an aesthete, at least 75% is justifiable.

And I don't know what you mean when you say "I know what I'm saying"—if so tell me, yourself, why isn't Rouault a pure modern? The basis for a criticism of Wigman is naturally the same as for criticism of (especially) modern art. That prattle about "the inevitability of movement," etc. is O.K. except that no matter how sincere it is, it can't help remaining a catch-word of the sort that messrs Rosenfeld, Stark Young, etc. love to lave their too-quickly tired brains with. The intellect, saith St. Thomas, hath in its charge Art. And there are so many inevitable things.

But see what I've gone and done—written a letter with a chip on my shoulder.

I saw the Toulouse-Lautrec, Odilon Redon show: the first leaves me comparatively cold (there are 4 <u>good</u> pictures) and the latter you may have; you'd like him, I think.

As for myself, I won't get a job, I'm writing genderless prose and lately rotten poetry. The guts have been taken out of me: I see poetry written somewhat as I want to write it, and yet it isn't good and there is no salt and no savour and nowhere vernal subjects. There is such a scramble & the juice is so quickly drained and to no end and I can't believe anymore that language alone is poetry.

Or I need, like Matthew Arnold's romantics, a critical atmosphere.

The Fr. poetry you quoted was very good and got me excited about [Paul] Eluard of whom I've read a little here and there which also seemed like ticker-tape sprinkled from the sky.

> Yours ever,
> Clem

P.S. I'll state you another problem merely to show you how much and with what little effort I know: why are the objects of Rouault & [André] Segonzac so opposite, while at times their techniques are so similar?

APRIL 5, 1931

Dear Harold,

Come Thursday night. My stepmother will be away until the following Sunday, and thereby we'll have more room. She's making her periodical pilgrimage to her closer relatives, an interlude for which both she and I are very grateful; I to her and she to herself.

Yeah, we need a lot of talking. You are still the only Greek in my life.

As to your letter: I don't believe in touchstones, except that if you're

sincere (I mean it) and patient you will in time arrive at the true opinion that 9/10 of everything you've written is not good. Touchstones, abstractly and obviously, I think, are only good for other people's poetry, not your own—whether the touchstone depends on sound, sense or metaphysics. In our culture there are no Methods, no formulas for reaching yogi; only in Hindustan and China perhaps the philosopher's stone is ever found. They're used to Method.

Bring down, if it doesn't take up too much room, the last volume of that parallel languaged Dante you have.

<div align="right">

Yours ever,
Clem

</div>

<div align="right">

APRIL 20, 1931

</div>

Dear Harold,

About the M.A., let me tell you. I went to Columbia Monday. First I spoke to a chap who takes care of those things; a fellow who gave me disheartening suggestions of disheartening memories—you know the type, of course. Then I went outside and sat down on a stone bench on the campus to look the Grad. Sch. Catalogue over. After a while I had gotten up and walked around a bit, & it all came out. Up to then I had still been in N.Y. City. But when I felt all of [a] sudden that this was this, N.Y. or no N.Y. that this was so very, so heart-sickeningly this—well I just ran for the subway-station.

Also I went to the Jonas' party. Both were very scratched-up about you and what they called your "wrapped-up pose." And of course they blamed you on me—but very amicably. There were a couple of iddy-biddy girls with whom I had a fairly good time, considering. (And I can't understand why I'm so callous to my own despising of Harold & Jinxie.) Neither can you, or if you can, explain it to me—I mean this.

In the light of your letter, this sounds as egotistic as ever—this is not defensive self-recrimination—but: I can like the person who wrote it (your letter, I mean), not specifically you, not necessarily; thus you are a gift-bearer of whom I don't beware, in spite of what you think I think. As to your gender, it doesn't matter a damn, n-n-not a d-d-damn! Insults, bodily and verbally, are matters of exchange even as a 1st mortgage is.

<div align="right">

Yours ever,
Clem

</div>

MAY 2, 1931

Dear Harold,

For the first time in my life, I think, I want to be understood. In one direction I've already come to a blind alley—and so soon. And now I have to start on a new path, a new direction—and so soon. For I must be understood, God damn it. Or at least approximated. To such a state have things come that things no longer hold true to me; and I must have people.

I did see La Shelley. O very nice evening, so nice that I didn't know which of my selves to be, and was amazed when I found that I had finally slipped into one self, effortlessly. We both talked our heads off. And even kidded around! That is, after she abandoned her stance (like a boxer: a left jab with Keats and right hook with a new method of playing the piano with one's whole body). I was invited again, which she never does—she told me—unless the person is a sure bet on the interesting side. I could fall in love if she where a trifle plumper and her petticoat didn't slide down. Even at that, it would only take some persuasion, because she is a Woman and Womanly.

It's now 1 o'clock in the morning, and I'm reading "The Anatomy of Science" under the delusion that I might find a Method, for I need something else besides Boris Bogoslovsky's dynamic logic to put the firmness of earth under my feet; so that I will be able to stand off and slap the world from a Position.

Soon I'll take a shower, then I'll read some more and then I'll go to bed.

Yours ever yours
Clem

P.S. Warning: whatever you write don't try to make it conform to your own idea of yourself. I have a right to say this.

MAY 13, 1931

Dear Harold,

Nanny [Clem's half-sister, Natalie, now age two] sends her greatest thanks to Hahwold, the bestower of so many gifts. She likes particularly the rag-doll. As for the music box, that present went to me since its mournful sound made Nanny cry; for my part I play it all day, and it certainly gives

me sensations. There is a lot in it of outlived tragedy, illogical tragedy, something, I don't know what, that's great.

I have definitely decided that I won't get a job. Yeah, I'd like to be independent, but not to change dependencies.

> "I hate to see that ev'ning sun go down. . . .
> Because if I'm feeling tomorrow
> Like I feel today
> I'll pack my grip
> And make my getaway."

—St. Louis Blues

That is not commodity poetry; Millay is and much of [Elinor] Wylie is.

Whether I am still ὁ Παῖς Καλός I don't know, but you are becoming der Sonnenjüngling more & more every day.

——next day——

After speculating till 3 o'clock per morning alone with the most alone of all my selves (selva: singular.)

First, the furniture.

(a) Leonie Adams: I am reading her poetry again and finding it better than before; also Louise Bogan. 1,000 yrs from now their lines will be as essential of the year 1930 as, and more than, T.S. Eliot's—not that he isn't much better than they; but in the same manner as Beaumont & Fletcher are more essential of 1620 than Donne.

(b) And now—read Faulkner, read him, read him. First "The Sound & the Fury" and then "Sanctuary." The former has a 1st chapter, what a thing in itself! See, for example, why the remainder of the "S & F" is a failure. See in "Sanctuary" how he tries furiously to ruin his book and never succeeds.

(c) Read—you—Dostoyevsky's "Possessed"—that's all.

(d) Suggestion for future study: a comparison of the subject-matter of Gottfried Benn & Ezra Pound: a crisis in two nostalgias.

I shall be home alone all summer.

Come down.

To rest your eyes look at Djuna Barnes' photographs. They look like this.

And best of all, don't read prose. Aesthetics are eyes and ayes.

In a little wild (while)

Clem

P.S. Deciphering your letter some more I noticed that you want taste to be ascetic, and you're right. But even if ascetic, I say, it doesn't have to be according to doctrine. Here's where I pronounce a "watch yourself." I remember yr saying about Jeffers "he's just Whitman." Of course, what of it? It's a quantity of good poetry, in spite of the fact that you & I had made up our minds that stuff written like that couldn't be good poetry. That's a painful lesson—for me it was.

also this: 3 *cigars*

apron

Washing dishes

 The idea is that poetry is produced and aeroplanes are beautiful.

Harold has completed his M.A. and is home in Syracuse.

JUNE 16, 1931

Dear Harold,

 Spring is frantic down here now, it persists in laying a warm rug-fuzzy hand on my face.

 (I hear that Wallace Stevens is publishing a new book, "Harmonium.")

There's a great show at the Mod. Art Gallery, the Lizzie Bliss collection. Wonderful Cézannes, one great Gauguin, 3 or 4 Picassos in the cubistic period which were equally as good, then Seurat, Walt Kuhn (not so hot), 1 good & 1 fair Matisse and Arthur Davies who is a good artist gone wrong. Also discovered a good man by the name of [Moholy-Nagy] Laszlo, a Hungarian in a one-man show at the Balzac Galleries. Nudes, particularly.

And so—and so.

About yourself—what?

Advice: Stew in Syracuse. Be factually uncertain—which you have never been until maybe now. It doesn't matter. Don't be about to be.

I know that it's easy to say this and hard to do but it's been even the same for me. According to you, I have benefited; so for your case we can take that as a premise.

As usual it's drear days down here—until the kids go to camp and the wife of my father to Far Rockaway. Oh! will I frizzle in idleness and savagery then.

> Ever,
> Clem

JUNE 30,1931

Dear Harold,

So you're coming down the third—that's O.K. But you want to stay too long a time, for your good and mine. Once a prick always a prick I am, but we are after all "on other, higher planes" and can say these things. But for Christ's sake don't think I'm not happy you're coming. Having for the last 2 weeks swum in the wake of summer-season you'll be just in time to pull me out.

As for James, read him half-aloud—you won't sweat then and you'll see how clear he comes. After a while you'll get into his tempo. Notice, too, his Method: the peeling off of layers of ignorance to get at the novel; I'd say he wrote <u>about</u> novels rather than wrote them. The purest conception of novel as an organic form: all parts relate to one center and to each other mutually, nothing enters but what is strictly necessary to make the novel <u>move</u>. Notice, again, the buttering-on of social subtleties: James' adventurousness, a skirmish of volitions ruled by scruples is equal to a cowboy-Indian fight.

Then you tell me what's rotten about him.

Till on the view.

<div align="right">

Ever,
Clem

</div>

Harold decides not to visit.

<div align="right">

JULY 8, 1931

</div>

Dear Harold,

Thanks a hell of a lot.

That you know what writing that letter was like.

I haven't time to be summer-seasonal; I see things, people; I bathe (myself) and drive the car everywhere. It's a good life, the pleasures of motion and writing poetry about it, about Sunrise Highway.

I still want like the devil to see you.

I've just visibly justified my existence by washing the car and eating breakfast and taking a shower and taking my clothes off and reading 2 chapters from "Wilhelm Meister," and I'll write to you—until I go to Rockville Center.

Incidentally you don't know what real loveliness is until you've been alone a whole summer in a big, empty house and have eaten your meals in restaurants and followed women home from the subway station.

I've discovered that the only <u>good</u> German philosophers who weren't poets manqué were Leibnitz, Wolff and Kant. That means something. Also discovered (for myself) that Hölderlin is, isn't he, the greatest (pardon) German poet. Read him in the mass and you'll see. That Stefan George and Rilke are also great poets, greater that anything so far in English & French since 1900. I'm wildly enthusiastic about Rilke's "Sonnette au Orpheus" and the Elegies. Wildly is the word for it. At first I couldn't believe that it was so perfect, that it could be honestly so perfect. I waited and read again. How it rings! It is something we must honor. Also Hofmannsthal. That Werfel is not as good as 15 poets I can name who write in English right now. That Benn is only for special occasions. But someday he'll write something that might make him the best German poet of his day. That thing, the deutsche Geist; there is nothing else like it in the world. Hamlet + Stavrogin = Faust.

<div align="right">

Searching for a Method 43

</div>

Have I got you wrong? In some things? We'll see. I'd say it this way: that I haven't got all of you.

The page gives out and I go to Rockville Center.

Yours and yours as ever,
Clem

Dear Harold,

I'm stale, and I think you are too. As for my mind, I feel better when I whisper to myself: "Goethe." And that's bad. Suggest thou to me something better to say. (As I think I told you, it's all part of my search for a Method.) I need something stable & appropriate to say at various and unforeseen moments. Words to bless occasion.

About my German judgments you're twisted. They were neither vague nor flooding. Exactly the opposite. To say Hölderlin is the best German poet is a correction not a "fundament." Understand it that way. As for the philosophers, I know very well whereof I speak. And Rilke, George & Hofmannsthal: what I said is only too obvious. The 2 articles on Rilke in the Hound & Horn prove by quotations from the "Duineser Elegien" that Rilke is a g-g-great Poet, greater than anybody outside of Germany suspected.

Began to read the II part of Faust. One has to be equal to it. It's the antecedent of all literary virtues since. For instance, Eliot would never have been able to do the "Wasteland" without Goethe's precedence. He wd have been content to just write good poetry. Faust II is good poetry (without punch, though; you can't mention it in the same breath as Daunty or Shksp.). What makes it is the significances, the indications, echoes and pointers.

Only as a whole it's no good, as a <u>whole</u> it means little, or worse, it means wrong. Which leads me to say that Goethe never did attain the idea or the execution of a whole. Read that over-rated "novel," "Wilhelm Meisters Lehrjahre."

So that's all I do.
What else <u>can</u> I do?
I'm disgusting; a man who lives for his art.
For living this way I make an expiation.

I let myself be miserable from loneliness
which is an abortion for I'm not miserable
from loneliness but only let myself be so.
I have a feeling that I am the object of a revenge.
Meanwhile I'm escaping it. So far all it does is
hinder. Within bounds I can escape.
Now tell me what this means.
I'm important alright I think.

> *Yours ever,*
> *Clem*

P.S. Write soon. You don't know what moments for me your letters are beginning to make. Not for what's in them but for the fact that they are.

Dear Harold,

You are either very busy or are having an ex-purience or have discovered a new kind of disgust because you loathe to write a letter—for the first time that I can tell.

By your picture I see that you're grown up. I <u>really</u> took a good look at you. Excessively the Adult: what an unattainable height. See what the world has done! You look as if you've settled to your true water-line like a new ship that's loaded for the first time. You have substance.

And me; I look, yeah, as if I hadn't yet decided: Is Suicide a Way Out?

Also I'm, it may be, about to fall in love. It's the Type, as I read in some French novel. This girl has your order mind: "When do we see <u>each other</u> again?" "You're bad for me." "I'm really not like this with other people." "You're such a louse." "If there's anything I hate, it's. . . ."

One night we stood outside of a house and watched the people inside through the parlor window and listened to what they were saying. And she, like you would have done, wondered and was excited at her own wonder; and when the wonder had no more food left, made it to feed on itself. It's the Type, I mean. And very much a victim of <u>my</u> (as you say) glee.

Coney Island: ensconced in the sand, surrounded by maidens and reluctant to leave. For sure there's no better way to spend your time than watching girls in bathing suits—trying to make one sense do the work of two. So that I say: O that I had fingers in my eyes!

The Beach

Read Empson's "Seven Types of Ambiguity."
Sign your name more legibly when you write your applications.

Yours ever,
Clem

Dear Harold,

I wonder at your "dying." I don't get—I know—the full force. I don't get the facial expressions (I'm not trying to be funny). If you'll pardon the expression, I sympathize. That you can't call it even an experience is the worst thing of all and convinces me that I don't get the full force.

Your words about the Winter almost broke my heart. This year its coming on is sad, summer dies to no death, autumn fades to no dead leaf: only chilliness and a cold rain. But I'll find words to

> celebrate autumn's brighter dress
> and the late earth's heaviness
> . . . these coughing streets,
> and coldness coming on the world . . .

You know.

In Argentina, when we have winter they have summer.

Lift high the bowl.

"Buy the 'Daily Worker'—the only paper! Rise from slavery and degradation!" They can still say that. I mean it. They <u>can</u>.

I was sitting by a fire and Amy—that's the girl I know and like—saw I was rather morose and said that all of a sudden she was afraid that I was sad because I felt that I was "beginning to be like everybody else"—and she was sad too, thinking that I was going to seed. So I said to her, "Amy, while I have you I'll always be something."

So she said, "yeah oh yeah!"

While I'm with her I have a heavy consciousness of an original sin: the worst moral sensation I've ever had. And then a little regret because she's not good-looking enough for my father's taste.

Thereafter there's love, a word I never say.

Rosh Hashana, also, is over with all the dreariness and shabbiness that Jewish holidays have in this country. Especially in N.Y. What can a dead year mean on Ocean Parkway? What can it? It is possible to admire my father for his grand indifference to both Rosh Hashana and the dead year.

What do you think of the Eugenie hats?

Yours ever,
Clem

Dear Harold,

Plenty makes me less. You're better off than I. Your letter was good, good to read and good. Good that you have faith in me, what I am now losing, now that you have it. Not exactly faith but the ultimate and ulterior self-respect which means to know when you're simple and straightforward you're best, and I'm not. Because the trivial thing of wondering where my next cent is coming from begins to bother me. And it begins to bother me that I haven't produced as the World knows it. That is, if you were to meet me for the first time you'd say "an interesting prick but I could push right through him with my little finger and meet air on the other side." Which isn't true at all, nevertheless.

My father, who never placed much in the spirit, is under the delusion that he worries about me and accordingly and very stupidly tries to transfer the same worry to me—the same worry he's got. What the hell do I want with it? But it's enough to make things lousy when I come home.

Still I might be happy tomorrow or even tonight.

I tremble every day on the brink of Love. Love spelt with a capital and pronounced slowly. Com—pli—cat—ions. Like you and me she has no convictions and yet assumes everything.

Do you remember Danny Fuchs [counselor at Camp High Lake], the fellow who swam for C.C.N.Y. whom you met 2 years ago in Syracuse? Well he crashed into the "New Republic"—last week's—with a journalesisch artikul. Not bad—for him.

I received a sweet note—mind you—note from our friend Harold Jonas telling me that he and "Munke" are engaged, and in answer I said "it's so hard to believe that one of my friends is old enough to get married." (I have to count up on my fingers to 22, and then I look at myself and am always surprised that I already have hair on my crotch and in my armpits, that people in stores call me Mr., and that mothers say to their children when I bump into them "get out of the man's way!" none of these things belong to me; from hair to Mr. they're as remote as the Empire State Building, and are <u>official</u> parts of things; pubic hair is like money and language, a great commonplace and just for that reason estranged—for me.)

"diamond bracelets Woolworth's doesn't sell, baby."
"it was a lucky April shower," etc.

This is good poetry alright because there is no other so poignant for my circumstances, this being the year 1931. It touches. Also describes. "Baby," that word. You'll find out.

I'm going to Virginia Saturday. Don't know for how long.

Your's ever,
Clem

Clem stays with his aunt, Fanny Galin, at 624 High Street, Portsmouth.

SEPTEMBER 29, 1931

Dear Harold,

I'm writing this from the lavatory of an office building in Portsmouth at 3 o'clock in the morning. I don't want to wake my aunt at this hour and the house is locked. The nearest I get to adventure is wandering around the southern part of Virginia late at night and having a cop pull a gun on me as I squatted on my aunt's doorstep looking to this world dark and shady-some. I watched him pull the gun and didn't say a word, then a fellow who was with him flashed a search light on me. Now you know how respectable I always appear. Anyhow the policeman didn't shoot: he said, "What's this heah?" So I said, "I guess I'll have to explain." After it was all over he sent me to this place where there's a chair and a light and urinal: showing that in the South they know how to treat strangers which they certainly do.

You see, I fell into Portsmouth this way: I came down in a friend's car from N.Y. to Richmond where he stayed while I took the bus which got heah at 2:40 A.M. So what could I do? Anyhow the moon shone all the way and all the way was covered with moonstream translucent and mother of pearlish. And we crossed an arm of the Chesapeake on a bridge 5 miles long and had a version of the moon shining on the waters. It was so wonderful that I'll just say so.

I realize that I'm woozy. Besides I've pissed twice in the moonlight—on the way—and I fancy that has something to do with your state of mind. Isn't there any superstition at all about pissing by the light of the moon? There should be, as you'll see when you happen to do it yourself, feeling prickly along the spine and shivering more than usual.

Yours ever,
Clem

Dear Harold,

For not writing sooner you're a bastard. Down here I've got to receive letters to endure. <u>Dur</u> Portsmouth is a stinking sea-crack town where ships have their holes patched, while their sailors stuff up other holes, white and black, on shore. Norfolk isn't so fetid but is arid. Outside of my aunt's family I know only the worst white trash in both towns. The old-time quality has been dying out. Quality-folks don't have many children, you see. If there's a Geist down here it resides in the old buildings in the old befoh the woah swell section but has no flesh to inhabit. Land is good, scenery is good, water is good but the autumn is a fake. Only crocodile tears for the dying summer which really doesn't die but goes to bed among the lacquer leaves of the Magnolia trees on Freemason St.

If it weren't for the negroes the south would be withered away by the Lord. Their grace redeems the sins of the white brethren. On Queen St back of our house they pray for our souls every night—mine and mine and even yours. Near Cape Henry their united voices ululate among the dune-grass and whistle out to sea, headed for Jerusalem, our first and our fathers' happy happy home. On Duke Street the spirit presides. But on Granby St, on Colonial Ave they sing:

> "You never seem to care for my romancin
> the only time you hold me is when we're dancin."

Then watch the sailors being tattooed on Main St. And the angling sluts on City Hall Ave; they use alum so that it puckers below and raw gin so it puckers above.

I turned South, L—o—r—d, I turned South.

The greenery is half-tropical with a dank course sea-coast effect. Tar pine, sycamore, etc. All afternoon I watched the World Series scoreboard. This is an old-time baseball town. At least that's good about it.

Read Joyce in Portsmouth and you'll find that in the long run literature doesn't pay. Not in the colonies. In the colonies we must have work, hard work.

So Jonass was in town. And the Bleyler writes ads, the serene, womanly thing. Tell her that Chet owes me $5. Maybe she has influence on him. But he <u>is</u> a success in the best sense of the word. Look at you & me—two wastrels; and at Jonass, the idle heir of millions. Whereas Chet, Chet started from the bottom as I <u>know</u>. Jonass stayed there. We were never near it, because where we are it's bottomless—also topless. As the song has it

"We never knew the meaning of repentance.
You're the jury, so here's our sentence."

<div align="right">
Yours ever,
Clem
</div>

<div align="right">
OCT. 14, 1931
</div>

Dear Harold,

The South is more than what you said it was. You misunderstood. The negroes are still here. Yesterday I drove from Portsmouth to Suffolk thru the cotton fields. It's harvest time and the black folk were out picking cotton. You can believe all the baloney about Dixie now—especially then. Five black black adolescents looking up at me from among the cotton blossoms. Teeth and cotton, and one hand with the fingers spread apart lifted, just lifted to wave but not waving, only held there above the head for a moment, motionless. The women wear green, pink, and purple shapeless dresses, the men, brown and blue. They often lie down flat near the road to rest, and when I pass, wave and grin. It's all there, Harold. Believe in the South Seas, now, and that men go to Africa to forget. Believe everything.

I send you a piece of original cotton with the seeds still inside. Coming back from Suffolk by a side road a big black pig crossed the road languidly and stopped. I stopped too. Two negro girls came to the door of a cabin about 50 feet back from the road and one of them said, "Lordy, 'ats Louise!" I stopped the motor and got out of the car to look closer at Louise, who was very fat and vigorous, groaning and snuffling, and not even afraid of me. Then I asked the girls if I might pick some of the cotton that was in the fields. "Sho'," they said, "'ats cheaper 'n dirt." So I got a few blossoms and I send you a piece.

Read Hakluyt's "Voyages" when everything else fails.

Have faith in women and read the "New Republic" too.

You told me to be noble. I've been so long before your command. Now I'm striving for charity. I told you I lived for my Art. Now I live for my Ideals. I mean this even as you someday might mean it. Honest, honest, honest. You'd be dismayed if you knew how firmly steadfastly and truly I believe that the spirit is better than the flesh. Believe it with all my heart. No backhand, no reservations.

<div align="right">
Yours ever,
Clem
</div>

Dear Harold,

I'll sho'ly be back in Bklyn by next week, for I can't stay heah any longer. I'm not settling anything in this place nor even being contented. I live too close to the town and too close to white trash. I deliver myself by playing golf, but that's a lousy deliverance, bad as it is for the state of the spirit—like gambling, seeing bad movies and talking too much.

In Queen St. they arrange things better. In Effingham St. they can at least say "I will arise." In Bute St. they don't need words: every little movement has a meaning of it's own. Only when you get to Tripoli St. and Princess Anne Ave. does the true west of life meet you in the face. At Elizabeth City there is the Pasquotank R. on whose waterfront life's face is painted brighter colors.

Norfolk was full of French sailors tonight who came from le bateau "Suffren" which was here for the Yorktown celebrations. They raised hell in the town and everybody had fun. Most of them were short and devilish with often baby-faces concentrated on trouver des femmes, they made me think (alas it always comes to that) of Rimbaud and the heroes out of Gide. They wear white bonnets with red pompoms and have a kind of impishness about them. A lodge was having a parade with the members dressed up as Indians and the Frenchmen thought they were the real thing and got excited and then were disappointed, for though some of the lodge members had reddened their faces and wore horsehair others were blond and bald, had eyeglasses and wore gray felt hats, whereat the sailors yelled "où sont les vrais rouge-peaux?" "Bah," one said, just like you read "bah" in the books, "je m'en fous de cet espèce-là!"

The policemen were very much afraid that they'd shit in the street, having heard that about Frenchmen, so had signs put up in French wherever there was the slightest chance of there being a toilet. But the Gauls were too busy at trouver la putain and boire le gin emmerde to take the time to relieve themselves on Norfolk's streets. In truth I was disappointed to see how clean their necks were and how few women they "insulted" and how few obscene gestures they made with their hands and behinds, thinking now to find out the real French, having believed so far most of what I read.

I'm rather shitty today and if you were here I would be a prick. I'm stuffed with tough steak and eloquence.

Yours ever,
Clem

4

SOMETHING MUST HAPPEN

"Not enough surrounds my vision to give me the idea of a complete world."

Clem returns to Brooklyn from Portsmouth.

Nov. 12, 1931

Dear Harold,

The time has come when I must act. The vigil is over and having prayed over my armor I arise and look abroad. What to do that's right? That's the question. I would do only that that is right, good and noble. But you see, I lack direction. I haven't even a categorical imperative. Whence it is that I still stew in the lime. This at least I know anyhow: I must act.

Allow me to chatter:

Pardon, it's 1 A.M. and having been reading the "Voyages of Capt. Cook" I'm very much occupied with direction. For lack of maps I've been forced to draw my own—though my compass doesn't show the "true east of life."

Incidentally the only good travel literature was written between 1500 and 1775. Once romanticism came in, travel lit. steadily degenerated (or, rather, vice versa, when travel lit. stopped, rom. came in) into Richard Halliburton and Burton Stevenson. Curious. (I know Hakluyt by heart and through him have discovered that there were only 2,000 Elizabethans living at the time of Queen Elizabeth.)

When Amy said hello to me she was so overcome by the actuality of what in her expectation was to be a Moment that she lost her voice and could only form the motions of the word with her lips and tongue. Poor Amy, who lives so much by the heart. Please, everybody, be good to her.

Respect Claude Lorraine.

<div align="right">Yours ever,

Clem</div>

<div align="right">DECEMBER 17, 1931</div>

Dear Harold,

I'm never equal to meetings and departures. Though you couldn't know, I really said goodbye to you about 3 hours after you left. Now it's as if you were gone 2 years ago. Since then I've slept to 1 every afternoon and stayed in the house all day. I am visif comme un crapaud and much older.

Your bounty overwhelmed Nanny so that she hasn't gotten over it yet. Aluminum dishes—just what she <u>needed</u>; a basket-crib and doll—just what she <u>wanted</u>; beads—exactly right for feeding time; the harmonica—Marty [Clem's youngest brother, now 13] grabbed it. To tell truly I'm in wonder at your accurate estimation of her taste. Everybody thanks you. Seeing Nanny's joy, my father felt that we were all unequal to your present and to yourself.

After New Year's I'll begin to think seriously about your invitation. Just now I'm unequal to that. That is, I'm always economical of myself and my capacities. I need both always, I'm learning, and they're too valuable for me to be the hedonist I've for so long imagined unconsciously I was.

All this is a thin truth—like everything I ever say about myself. Caution. I should have told you that years ago. Or you should have known it. You, at least, are better. When you talk about yourself I can deduce from the postulates you give me.

I've festered since you left with the results in abundant larvae.

I wrote 2 poems since you left. The Fire-bringer. I sent a 2 page vision to "Pagany," and I wrote a great poem about the oscillation of the electrons, how out of death you get life and immortality. I have an awful craving to see this thing in print. I'd even send it to the "Saturday Evening Post" if they would print it. Maybe it will gain me fame. I want fame, then I'll have money, then I'll take my father out to a swell dinner and introduce him to swell blondes, then I'll sleep till 3 o'clock instead of noon, till next January even. I also wrote about what sleep means to me seen from the outside— strictly prose. I've read German and the Bible. And once in a while I put my breast against a thorn and sing.

When I discover that I can play up and down in a poem I first realize that there's something solid in me, something "erwerben" (acquired) and demonstrable. Then with a blazing blush I say faintly to myself, "poet." (This is so thin I'm blushing again.)

Thank your sister for me. What devotion to the fact of typewriting it needs to type my Satzen [his Sweet novel]!

Incidentally the Whitney museum is rotten—arrangement. The best pictures I think are by three or four unknowns like Alexander Brook and Rafael Soyer. Private taste should never make a museum out of itself. And Marin's watercolors would be much better if hung alone; watercolors I find out can't stand each others company.

Read Racine over again. You'll go crazy about him, I promise you. Allow a space of 3 days between each play for best results.

The new constellation in the German sky that I've found now is Bertolt Brecht. I've read "Im Dickicht der Städte" where two men struggle in the giant-city of Chicago. "Look not for motives," Brecht says in his foreword, "but watch their fighting-form and wait for the Finish." The lines swarm with that dramatic "play" that you see in Webster. Out of an interchange of swift aphorisms you have suddenly a great moment and a great scene, that aren't in the least necessary to the rest of the play. Brecht also writes ballads that I haven't been able to get hold of. He's even more of a surprise than Kaiser was. He's catastrophic, he's everything! He writes, I think, a German approximation of American slang.

At times like this I've a great deal of self-confidence. When I long to read something rhetorical about myself in the "World-Telegram."

You see, I'm 3 stages removed from myself.

Yours severally,
Clem

Dear Harold,

I'm badly in love and my face twitches. This will be a carping letter. When an emotion has insufficient cause, I say, find some more causes. Amy is worth the richness of the earth, but she doesn't deserve my being in love with her.

Don't use the word "trust" in connection with me, as to art. It's a rotten word. It's 2 weeks & "Pagany" hasn't sent my poem back. Probably wrong address. About a man who grabs the leg of a girl who is eating a cheese sandwich on the street car. Then there's a panic in 2 sentences. It doesn't give a damn where it's printed.

Marin's water-colors sell for $350, his oils from $3500 up. The best of the former are already bought up. There's an old doddering white-haired bird who takes care of the place and buys the best pictures for himself. One after another I found that the good water-colors already belonged to him.

I recommend to you Bernard Shaw's prose-style. Read F. Scott Fitzgerald's short-story in the Satevepost and see how the prose that works for its living is beginning to wear clothes.

Last night I refused a N. Year's invitation out of remorse. Tonight I accepted another one. I stain and ruin my N. Year's Eves always. If you were here we'd manage it better. You see, the New Year gives me pangs, I take it for exactly what it means, believing that the revolutions of the earth concern me immediately.

You know the rest. Happy New Year.

Yours ever,
Clem

1932

Dear Harold,

With your usual adeptness you sent the straight Dante [Clem's birthday, January 16]. Croyez à mon "merci." As ever I feel abashed. It's too good. The bookstall labels came off perfectly, without peeling.

They're drawing out that war in China; they've got no guts, that's the trouble. What an apathetic universe—the only alternative to starving is dying, and they don't want to die. I'm willing, take me.

The words always turn out to be the same. Boredom, despondency, acedia. They even have the effrontery to write plays about it. I saw Barry's "Animal Kingdom." You know.

Not enough surrounds my vision to give me the idea of a complete world, and I've been getting the feeling lately that the universe is incomplete, half-assed, not even infinite. As you should know, that's bad.

As to my future, something must happen. Either more of literal solitude or whole hog the other way. I don't ask much (like you): conversation, sociable meals, that I be taken for someone else instead [of] one son, brother, cousin, nice fellow, his father's son, Jewish boy, etc., that the murmurs of each [of] my (3) hearts fade not into the air, unheard and unremembered, and of course, that someplace a woman waits for me.

Your Dante saves me. I read from 1 to 3 Cantos a day, very carefully, reading all the notes in Vandelli as well as in Cary. Being typical of myself, I also write my own commentary, draw my own diagrams, judge my own judgments. (For instance, Croce is half right. Vossler is the best there is on the subject, but he makes me prickly.)

Try reading Shakepeare on top of Dante. It's a queer sensation.

I've read a lot of books, I've seen foreign movies, I've been treated to shows, I've seen pictures, I go out a lot—comparatively. Why should I write about that. I should write about how I'm in and out of love:

This is an incredibly naive letter. Like some of yours. But I like it in you and not in myself.

A number of days later when I feel much easier about writing O-pin-ions.

I wish you were down here to see the Diego Rivera show at the M.A.M. He's a great artist. Fellows like Matisse, Picasso et al. pale when you look at his murals. The canvases are weak—except one or two early cubistic ones where he beats the French at their own game—except Braque. Two water colors outdo Marin. Just imagine, even two! Three's all they show. THE FIRST GREAT NORTH AMERICAN ARTIST. Really.

Saw the American primitives and was let down. One or two are fair to good. The rest are almost, not quite, junk. What does everybody talk about?

The old fish at the Marin show was Stieglitz, the photographer, the famous photographer. Also husband of Georgia O'Keeffe, the hothouse weed. She is lousy by the way, as I have just seen.

But THERE ARE GOOD AMERICAN ARTISTS.

Some of the verses in the new mus. comedy "Of Thee I Sing" remind me of Bert Brecht—who by the way, did Marlowe's Edward II into good original German verse and changed the plot. Keep your eye on Brecht.

Where Kaiser is a closed system, not containing any faults, except those that might condemn him in toto, Brecht is full of defects, but the best defects. Brecht, you see, is in the Kleist-Büchner tradition; so he has to have some faults.

And that is that. Remember me.

Yours severally,
Clem

FEB. 15, 1932

Dear Harold,

I don't know what peeved you, myself or Dante. Really, why were you so angry—or not angry but irritated? It does you harm. Especially to begrudge me—I don't know what. After getting up at 9 Saturday morning and whistling and taking a shower, I got your letter. Then I screwed my face up and thought of Sylvia. As I don't know anybody by that name I wondered.

Read Michelangelo's sonnets. Some are as good as Shakespeare's—incandescent.

Medieval literature was Gothic in the Gothic river. But when they made it flow through Greek and Roman canals it became muddy. (German literature flowed in its own channel the longest, therefore it is the healthiest in

Europe right now; as it shows by being such a perfect translating language. Goethe once hinted at this when he advised Crabbe Robinson to study German as a means of learning world literature the quickest way.)

Enclosed find a picture I intend to use as an illustration for Sweet. Hotsy totsy as you would say. But hotsy totsy is 1915–1925.

Yours ever,
Clem, soi sage.

P.S. That question of med. lit. is fascinating. Write some more arguments contradicting me. Then we'll have fun.

<div align="right">February 24, 1932</div>

Dear Harold,

I write soon to tell you that I can depend on your disagreeabilities even as you can depend upon my snottiness—a sort of equilibrium that two pricks like us can't disturb, even. When it comes to that, letters are vicious. No gestures, and worst of all no revisions. That's why it's necessary to fill them up with furniture which is yet more than furniture, being meaning-ful. What I mean is that it's like a medium, a conductor; it does for us what ether does for light-rays (or at least, the hypothesis of ether).

I stumbled across a find in the N.Y. Library: Camões' "Os Lusiádas" with a parallel English translation. It's g-r-r-eat!! It's so good, Harold, that I'm ready to start learning the kicked-in-the-corner language. It's like Dante somewhat, if D. were writing for a modern audience. It's a shame not to have known him before, because he Counts. Counts more than Milton, I'll hazard, if you'll excuse the word. Renaissance literature that I bet the Italians can't match. When Camões' ship was wrecked off Cochin-China he swam ashore with the manuscript of the "Lusiádas" in one hand.

It was good of you to tell me that Dr. Sargent calls me Clem.

What agencies in N.Y.? What jobs? Anything with the syllable "ag" is an abomination. Much evil has come from agents. But then all things stink in the eyes and nose of any decent Lord. So will any job you or I get.

Do you want that Camões for Geburtstag—if it's still in print? It was published in 1877. (If only Arnold had known Portuguese we would have all read the "Lusiádas" long ago.)

<div align="right">Yours ever,
Clem</div>

<div align="right">March 12, 1932</div>

Dear Harold,

There were pictures in the paper showing Syracuse all choked up with snow, Euclid Ave. looking like a gulch and Genesee St. like the plains of Kansas. Was it true? It's like ether when I think of getting up mornings at

Mrs. Williams' [boarding house where Clem roomed his senior year] and looking out on the park, the lamps still lighted and the sky so dark and gray.

It is also relevant that I sit home most of the time in fair weather and go out when it's bad. I read a lot.

I've learned Portuguese. That is, I know how to read it, but I've only a vague idea of how it sounds. So I content myself by saying "owng" with the g left off. Gil Vicente I like, and the Spaniards, Lope de Vega and Calderón.

Which leads me to Robt. Frost about whom you are quite likely right, but who can otherwise write the following:

> "The bird would cease and be as other birds
> But that he know in singing not to sing."

He is another one of the might-have-been who dies denying Rhetoric. Like E. A. Robinson, practically the whole substance of his poetry consists in the fact that it's a negation of Rhetoric. But you can only fight Rhetoric by embracing it or poisoning it. See T.S. Eliot for the first, Eluard for the second. If there were no Rhetoric to deny 75% of modern poetry wouldn't exist—or wouldn't be considered poetry. But take that for what it's worth.

Last week I saw what was for me the best exhibition since Diego Rivera, one of the best I've ever seen: "Italian Painting of 15th, 16th, & 17th Centuries" at the Metropolitan (not museum) galleries. There was a "Family Group" (dated 1549) by Jacopo Tintoretto, done in what was fairly subdued tones—for an Italian—that is perfect, perfect. Then the "Four Seasons" by a virtuoso named Giaquinto (1693–1765), four distinct pictures that are a lesson in how to paint, if that's all you actually want to do. Also a portrait by Giulio Campi (1500–1572), a "Madonna & Child" by del Sarto, "St. Cecilia" by Caravaggio, and a curious "Flight into Egypt" by Francesco Albani (1578–1660). Others too—Veronese, Titian, Bronzino, Tiepolo, Canaletto, Ghisolfi, etc. one or two pictures each. The point is, I'm jerked into balance. Despite my profound ignorance I'm tempted to say that Braque is the greatest living painter in Europe, and that Rivera is even greater, and that Orozco is not far behind. That's that, as my stepmother says.

Whew! My face is twitching.

Sometimes I don't go out of the house for 3 days. Then I can see myself putrefy, my hair fall out and my breath stale. Unconsciously I've be-

come a yogi (without a Method). I might look at my belly-button, but never for any definite purpose. As the Portuguese say, "Não faças tocar a trombeta deante de ti." From your best deeds be in a certain sense absent. To have patience like a Chinese hermit is one of my best qualities.

Yours ever,
Clem

MARCH 29, 1932

Dear Harold,

My aunt says she saw you walking in the street during the snowstorm and that you were very pale. You didn't see her. She says also that you looked sad and—giving my own word—febrile. Why? Once you had pink cheeks. There are a lot of things but still I can't see why you should look as bad as my aunt said. I have a pasty face and I grimace continually and yet everybody says I look healthy. (I am also unhappy.)

If you knew what I know. There are moments when all secrets are open. The best known of which moments is post coitum—triste.

Portuguese incidentally is a good language for prose. Some people say it is the most poetic of all languages and that every Portuguese writes poetry without effort. Others, among them Ezra Pound, that it is a hard and difficult language, unamenable to verse, etc. jagged. I don't know. For me it's not so much smooth as sonorous. The prose has something firm.

The Portuguese don't know how to value their own literature. Having naturally a sense of inferiority, they prize in their own literature that which it has most in common with the rest of European literature; Renaissance rhetoric. They neglect their folk-songs, the autos and the medieval tales. They say that the archaisms make them too difficult for such a degenerate folk as the Portuguese to read. So the Germans have to teach them how to respect their own literature by publishing the definitive editions, by writing their histories, by discovering texts. And as usual the German translations of Portuguese are the best.

I'm reading [Edmund] Spenser and being agreeably surprised, monotony, "ludicrosity" and all. Spenser and Camões play ball in the same yard.

—I go ouside once in a while.

Yours ever,
Clem

Dear Harold,

You're a dawg! as they say in Harlem. I want to come up. And am. My aunt & uncle are coming down by car April 25. I'll let you know definitely when they're going back for I'm going with them. I'll answer questions, eat butterscotch pie—please—and we'll go out into the country where you'll rest your eyes and I my head. For I've headaches lately and feel miserable in body. One cheekbone throbs at night—incidentally, wd. you use the word, throb, in a sentence?

In Bklyn the trees wear that light green which Southerners affect to despise.

But to weave garlands in a letter is bad taste.

I'm reading books by Leo Frobenius, a German. His Fach is Africa. But Frobenius is a Kulturmann; Africa is merely the springboard. Creates a new science: to borrow Spengler's word, the physiognomy of human results. The conclusions are amazing. This is only a rough idea of 2 marvellous heads Frobenius dug up in Nigerian Africa. And the figures. And the tinted rock-

paintings in Rhodesia! And the cone-theme architecture. He proves what we call African sculpture is only a degeneration of the <u>classic</u> style of an old, oh so old, high "civilization."

The Russian movie "The Golden Mountains" is the first example of pure form on the screen I've ever beheld. Knowing how to conserve a moment, a juxtaposition, a sentiment so that it simultaneously flashes on everything that's gone before and everything to come. A watch as a symbol, "Russia, mother!" as a slogan, anathema and a line of poetry.

I believe those people who have distrusted music because they found musical people untrustworthy, Meshach, Abednego, etc., were sent into the fiery furnace accompanied by the sounds of the sackbut, flute, dulcimer and harp, as Walter Cobbett says. Other crimes were done to the sound of music. That's why the French are always nervous about the Germans. Listen to it, but have nothing to do with it. But what makes me say this is a secret, an uncommunicable secret. I remember an essay by Th. Mann I once read about how much trouble music gave Nietzsche.

But I'll tell you all this viva voce and you'll tell me more—much more, oh too much more. Hey—what the hell, huh? I'm suspicious of myself when I listen—you know.

——two days later——

The interruption was a toothache and finally I've had one of my precious nerves plucked out. An evil steel wire goes into an unknown grotto of my jaw and comes out again and again stained red with little bits of something clinging to it. The inviolate violent. To say nothing of a tooth pulled 1 1/2 weeks ago which was the biggest in my mouth and tore away one of my flying buttresses and now makes one side of my nave a sorry sight. The dentist said I inherited my soft teeth from my mother, and that made me feel better.

Then I read Frobenius' German aloud with one side of my mouth still blubbery and dreamily-big from the novocaine. With a little twist I remembered suddenly how when I was about 10 yrs old I'd dream that different parts of myself were growing bigger than myself; a lip or a thought.

As the novocaine wore away my whole face-side began to ache fiercely, viciously, intense—and immensely. And I drove home from the library sixty miles an hour yelling out loud and punching the windshield. When I arrived I began to dance up and down in the living-room until my father went out and brought me some dope. That didn't do much good but it gave me hope and I needed that the most. In the end I lay down with an ice bag and after

wrestling for a few hours it became endurable. But what a what! I'm a changed man. I whine for my brothers to go out and buy me cigarettes. I whine for Nanny to love me, but she's afraid of me when I have a toothache. I'm still whining, I can hear myself whimper. Maybe you'll hear me too.

Sunday night, almost def-definitely. Yes.

Yours ever,
Clem

P.S. Nannie is getting to be a tall girl and somewhat impertinent, saying such things as "Auvre (you're) dumb!" and "nertz." When she scribbles up the woodwork with a pencil she says Marty did it.

P.P.S. Here's a Thing.

Hart Crane Drowned at Sea; Poet Had Threatened Suicide

Guggenheim Prize Winner Goes Overboard From Orizaba on Way to New York From Vera Cruz

Officials of the Ward Line today received a radiogram confirming the death at sea of Hart Crane, poet, who won the fellowship of the Guggenheim Memorial Foundation last year.

The radiogram, which was dated yesterday, and which was signed by Captain J. E. Blackadder, of the steamship Orizaba, read:

"Hart Crane went overboard at noon today. Body not recovered."

Officials of the line estimated the Orizaba, which is en route to New York from Vera Cruz, was about 300 miles north of Havana at the time of Mr. Crane's death.

The possibility that the poet ended his own life was strengthened by an Associated Press dispatch from Mexico City, which stated that he had been deeply affected by the death of his father last summer. Last week, his friends there asserted, Mr. Crane threatened to kill himself, and a friend accompanied him on the voyage home to prevent a possible attempt at suicide.

Mr. Crane, who was thirty-three, was one of the better known of the younger American poets. He was born in Garretsville, Ohio. His father, Clarence A. Crane, a wealthy candy manufacturer, died last summer.

The poet, whose first name was really Harold, began writing verse when he was thirteen. At fifteen his first poem was published in Bruno's Bohemian. When he was sixteen his work attracted the attention of Mrs. William Vaughn Moody, wife of the author of "The Great Divide."

Mr. Crane moved to New York in 1922. His first position was writing advertising copy.

Then he moved to an old house at 110 Columbia Heights, Brooklyn. One *Look for This Sign ♥ on Page Nine*

Hart Crane, Poet, Is Drowned at Sea

From ♥ ♡ ♥ Page ♥ ♥ ♥ One

of the earliest owners of the house had been Washington Augustus Roebling, builder of the Brooklyn Bridge.

Working in the room Mr. Roebling had occupied while broken in health from his work, Mr. Crane began writing "The Bridge."

Assistance from Otto H. Kahn enabled him to obtain the leisure, and five years later, after having worked in the Isle of Pines, Cuba; France, and finally Brooklyn, the poem was completed.

An earlier volume of Mr. Crane's poems, "White Buildings," was published in 1926.

Just previous to his death, Mr. Crane was in Mexico writing a long historical poem of that country.

Harold's family has moved to 565 Westmoreland Avenue, Syracuse.

JUNE 12, 1932

Dear Harold,

I should have stayed with you another week. I didn't know it, but I was having a good time. Everything was good, even your father's car. Whenever I hear the starter of a car that has the same sound I get a pang of memory.

The ride down was fairly good. We went through the Catskills and saw better scenery than was possible. The air was so sweet. I should [have] stayed there with a certain russet cow and become fabulous.

Anyhow I read the Seventeenth Canto and felt, for an unrelated reason, the goodness of being home. There is also Nanny. She's taller and thinner. When she gets older she'll be reedy. But she already knows what she's supposed to do. I have doubts about her.

I'm thinking of a character by the name of Horace Ka, an Egyptian. Horace, who is my kaa, gets up after I go to bed, and as if I were a mummy, sits by my pillow and whistles. When I am up and around, he sneaks off and goes to sleep in a corner. Often I trip over him. Yesterday he got into the auto somehow.

Horace looks like this.
. . . .

On Sunrise Highway I had to throw him out into the road where he was frightfully mangled by a 16 cylinder Cadillac, reputedly belonging to Vannie Higgins, beer baron of Bay Ridge. But Horace will recover—the lucky stiff, he doesn't deserve it. When he recovered consciousness and the detectives asked him to admit that it was Higgins who ran him over, he could only reply wearily, "Though a thing may be necessary it isn't always important. How should I know?"

Don't be too impatient with Camões. Some of the sonnets have to be lived into. You go in, in, in. Some of them.

It's almost certain that I'm going to Virginia with my father soon. To think of a Southern summer is a great adventure that has much meaning. It's earnest weather.

Does Eddee still come around to see Dorothea? How does your mother feel? Thank them for me, and your father too.

Tell Dr. Sargent I preserve a cool antique vision of her. The best kind for old age. Without wax (sine + ceros)

Yours ever,
Clem

AUGUST 10, 1932

Dear Harold,

If you wrote I didn't receive your letter. Anyhow it seems like a month since I heard from you—and maybe it is. I'm back from the South more than a week. It was a vacation from myself. I saw the air die and the earth

live. So quiet and motionless that the dull shimmer and re-shimmer of the sun on surfaces was like breathing.

I saw other things: a hothouse park in Richmond, the veterans leaving Washington, target-practice at Virginia Beach, negroes swimming in a ditch near Suffolk, High St. frizzling in the sun, old Petersburg and the dying fields, the Fredericksburg road, too, at 6 in the morning.

Once I ate supper by myself in the late afternoon in a cottage in Virginia Beach, after bathing. I sat on the back porch facing a thick pinewoods and felt clean after bathing. There was a crow cawing and a whispering sound of the surf. ——That's about all there was.

Last Tuesday I went up into Connecticut to see my brothers at camp. For a moment I was alone on the lake. I was stripped and only the faintest breeze tickled me. The water lapped: lub, lub, plap, plap. ——I chase after things like that.

Allen Tate has a verse that fits everything that happens down South in the summer.

"When on a child's long day a dry storm
Burst on the cedars by the sunlight hurled."

You must be waiting for Catullus. When I finish Doughty [Charles Montagu Doughty, *Travels in Deserta*], I'll send you both, and excuse. If you've finished Brecht, send him down. The library's beginning to bother me.

Anyhow tell me what you do every day, who you see, and what you hear. I want petty details.

Ever,
Clem

Dear Harold,

Received Brecht and your letter. I'm glad you liked him. It's ver-r-ry important that he should be read. He has oodles of what they call contemporary significance; which is really something, but not what it's mostly thought to be. His "Hauspostille," too. They're ominous, fateful, something we don't know—and "vital," if that word is ever meant and can mean what it means. I ordered it for you at Westermann's. I got his "Lindbergh" and other "Ver-

suche" for $.50 paper covered—the only one there was to be gotten.

You know why your letter went wrong? Do you want to know? Well you addressed it to Norfolk instead of Portsmouth!! Two different places! There's a river between them!

It's so hot here that I can't keep my fingers dry. There are even little drops of moisture on the pencil-wood. A warm haze makes it worse, a haze that's been here 3 days now and through which I had to see the eclipse. The green foliage was dark and eerie then, the best of all.

Thanks so much for the "Vita Nuova." I haven't begun it seriously yet. I'm waiting for the Dog-Star to pass and for myself's least distraction. Now Hesse's "Der Steppenwolf" is better and Brillat-Savarin and Tibullus' 1st Elegy and German war reminiscences, and best of all, Hakluyt.

I was at White Lake in the Catskills for a day. Coming back, I called on H. Jonas and his wife. He gave me an Indian flint arrow-head that was plowed up near Goshen. He also wore a nicely-cut pair of Oxford bags, gray. Florence is fat and unclean. They liked England best.

It's so hot!

Excuse me——

I just showered and changed into white flannels, which are much cooler. Should I go naked right now it would be demoralizing. I must set an example.

I had an attack of stomach-trouble, almost exactly a year since the last one. I went to bed early and slept until evening of the next day and managed to head it off. It is probably a kind of weak malaria that I am susceptible to in August.

Are you going to Crystal Beach? There are no more decent beaches around N.Y. They are all dirty and crowded. Lakes are the best of all. At White Lake everyone goes naked. You get a row-boat and row to a quiet spot and then jump in. There are paradises, I know, and they're not expensive. For $20 a week you can get seclusion, nature, exercise and sex. You must not be too particular, however, about the last. As usual it's the one thing most taken for granted. Solitude—that's a specialty, nature is a feature and exercise is an attraction.

<div style="text-align:right">

Yours ever,
Clem

</div>

<div style="text-align:right">

SEPT. 7, 1932

</div>

Dear Harold,

I'm sorry to hear about Dr. Sargent. Don't let her die, please. I won't be able to make up my mind. I never could decide whether people have the

smell of death about them or the smell of longevity. It's always one or the other. Dr. Sargent somehow isn't meant for it, she's too good.

I was half out of sleep when I read your letter. When you gave me instructions as to how to write my letters I got sore—in an early-morning manner. You have crust. The fact is, you're becoming a professor. Tit for Tat.

Now, I'm tired of reading poetry in Latin and Romance tradition. Why aren't you? Oh I done read the Saturnine and Fescinnine verse and they prove whatever I claimed. But whatever I claimed is unimportant because THERE ARE NO BEGINNINGS IN LITERATURE. THERE NEVER WASN'T LITERATURE AND NEVER WON'T BE. Try and separate the classical and the Italian in Catallus. You try, for instance, to tell why Anglo-Saxon verse is decadent. It ain't; it's something else (what I've read of it is over-taxed, out-functioned—b-b-but not decadent.) All literature, "Dichtung," is something else, not young, not old, but just here, just there. And even that's not true. To tell the truth I'm fed up with long-range theories, especially my own; and yours.

Now rawtther!

So you're going to be a professor, you're going to teach High School in N.Y.! Faugh, as Hamlet says. The Home Title Ins. Co. is better than that. Yet I'll find out for you. I don't think you need Education with a M.A. But I'm far from sure. I have a cousin who's a H.S. teacher, Ile arsk 'im.

Anyhow don't forget all this or chirrup or shrug shoulders, etc. Be humble—like me.

Look: I've never found anything as good as the first page of Benvenuto Cellini's Autobiography in a novel. And Henry James' "A Small Boy" is better than the "Ambassadors." And Doughty is the best prose book of the 19th Century in England.

<div style="text-align:right">

Yours ever,
Clem

</div>

P.S. I telephoned your ad in to the Times. I took the liberty to omit "anything." It means you're restless, intellectual and "hungry for life"—which is true but not so good.

P.P.S. We're not going to move. The rent was knocked off $30, the place is going to be painted and we're going to stay.

<div style="text-align:right">

Sept. 23, 1932

</div>

Dear Harold,

I read about Dr. Sargent's death in the paper, and failed to be surprised. I took it callously for granted. I just remembered that I knew Dr. Sargent and

liked her—like other people I've known and liked, and will never see again. They're still living, "I knew them well"—<u>once</u>, and Dr. Sargent joins that <u>once</u>. Death for the living is only death when there's a deep hunger after the funeral, when your heart's teeth close on emptiness.

They should have cremated her. Why didn't they?

I felt pity for her though. Why not monuments, garlands, "Opferrauch," poems, multitudes? Why not?

I wasn't half as worked-up over that mis-addressed letter-business as you thought. I was just kidding slightly—but of course, you can't show that on paper.

Your ad [for a job] was in the "Times." I enclose the lone answer. When they handed me the letter I had a quick hunch as to what it was. Impudence everywhere. The lay-out was $1.95. I advise you to discontinue; and until I hear from you again I'll let it go at that (I'll save you money).

Your M.A. qualifies you for N.Y. High Schools without "Ed." But you haven't a chance in hell. The waiting-list is jammed, and getting more jammed every minute. Try anyhow.

The house is being painted and meanwhile it's chaos. I sleep in my hair. I'm beginning to decay again. Last week I was filched of $25 for speeding, and I'll be bitter for the rest of my life. There wasn't even adventure in it, except when for the first time I caught sight of the motorcycle in my mirror and tried to wiggle away in the dark.

I'm writing an adventurous story about a girl named Bunny. The difficult thing of course is to believe in my own viciousness.

Incidentally Gide's "L'Immoraliste" is the best thing of his I've read; one of the greatest novels I've ever read in fact. What a surprise! And at the same time so much of his usual bag of tricks. Except that his fingers weren't so sticky, his moral <u>draughtsmanship</u> not so nastily shown off. The parallel lines of husband & wife; one goes up while the other down, one sucks health from the other's disease, the fearful finish; all that stunned.

Saw two great Russian movies, old silents, "New Babylon" and "China

Dr. Irene Sargent Dies; Syracuse U. Professor

With College of Fine Arts for 36 Years and Noted as Critic

Special to the Herald Tribune

SYRACUSE, Sept. 14.—Dr. Irene Sargent, a professor in Syracuse University's College of Fine Arts for thirty-six years and a widely known art critic, died here in the Hospital of the Good Shepherd today.

Dr. Sargent was born in Boston and was a piano teacher there before coming to Syracuse University in 1896, was an accomplished linguist, made several translations into French Italian and German, and became teacher of romance languages. she taught Victorian literature the history of fine arts.

Dr. Sargent was the second woman to receive honorary membership in the American Institute of Architects and Allied Arts. The membership was presented to her in 1926.

Express." I'd like to discuss them for hours. The last, particularly, has a drive and a punch that carries you right out into 42nd St. before you wake up. That sort of clenched-teeth rhythm that nails you in the belly. The motion, the motion, you rattle through switches, past stations, teeter on a curve, soldiers fire from beside the track, you fire back, then Bang! the train roars into the distance, fades; and suddenly the title flashes in big letters, "Whither China?" The picture is over.

It's enough to start one talking about Great Art and Community Genius. It seems so easy to make a good movie—and it is—and that's why movies are good and plays are rotten. In some respects Genius is a matter of permanent Conscience.

To be the understanding of an age is a grand mission—Spengler might say it's the only possible path for a really great poet nowadays. (Maybe that's what Rilke is—but no. Ezra Pound might have been it, but it's too late now.)

I suppose you know that they've closed up our burlesque house, and Minsky's too. Yesterday I saw the indignant protest they put up outside of the closed doors. Snakes in the grass and envy were involved. But they'll come back. They have to—everywhere in N.Y. people are sick with sex-starvation. They write it on the walls.

Have you ever seen the carvings of the Koryaks in Northern Siberia? Little figures in wood, done mostly in action. I've never seen any African stuff that comes near it for gracefulness and accurate realism. I found out too that these Siberians manage to keep their reindeer herds from wandering away only because the reindeers "have a passion for human urine." Doughty's Arabs on the other side wash themselves in camel's urine, water being too precious.

Any time you're ready Sol will take "Si le grain ne meurt" [Gide]. He's almost as greedy as I am. He weighs 183 lbs., Marty weighs 155, he's 5'8" now. I'm 5'10" and weigh 163. I'm the bell-wether.

The only music I can listen to at this stage is 18th century. Mozart, Mozart, wieder Mozart that's all I want. Handel too, Gluck encore. Hesse's Steppenwolf meets Mozart who tunes in Handel on his radio; then explains it to him. Mozart also knows how to make radios. Hofmannsthal's poetry is like Mozart's music.

Yours ever,
Clem

P.S. I never read my letters over either. Why worry? Who would think of it?

Dear Harold,

The best season of all in Bklyn. You can smell the burning leaves. And in Manhattan the air has that raw angularity which is the most typical thing of all in N.Y. It's N.Y. quintessential. Rosy cheeks, baby-carriages, a smutch of cloud and insolent planes of asphalt and concrete.

Nanny is home now and I once more—once more!—I begin to share her routine: lunch, lamb-chop and mashed carrots and then the nap outside. A clean dress and the front lawn; at 6 o'clock supper, potatoes, apple-sauce and amusement. Pajamas and the sweet goodnight kiss. It's like a magazine-story by a Jewish old-maid.

My Pa offers to send me to Europe if I can support myself there. Canst thou suggest anything? The express-companies don't want me, neither do the press-bureaus. Where I aim to go is Spain or Portugal. If it were the 18th century I'd go to Germany, or if I knew of some place in Germany where the 18th century is guaranteed. Marty got some of E.T.A. Hoffmann's stories from the library and I read them with empressment. The 18th century in Germany is all music and it's all in Hoffmann. The richness of it is one of my most Important Discoveries.

Do you know how a body can make a living in Europe? A definite something and I'd go off in a delirium. I'd pack 3 books and 5 shirts and leave steerage. I'd wipe my nose on my sleeve and shit in the open. But not on the bum. Not that.

All I know about the respondee of your ad is that he has fine blond hair. Tell me what you find him.

The house was painted, and the walls in my room are a dull light green that flushes darkly under electric light. With time I'm beginning to like it. It has a funny effect on myself. Like living chastely.

> *Yours ever,*
> *Clem*

Dear Harold,

This fall-weather is propitious for voyages of Discovery.

I'm translating the 1st act of Kleist's "Prinz von Hamburg" into a free kind of blank verse. It's even greater than before, I find, when I go digging into it. A swaggering headlong mystery, an enigmatic sleep-walker.

Translating is always a mystery & a mess for me. But I'll keep on. Kleist as well as Schiller makes his blank verse in the Elizabethan tradition so I think I'm right in method.

About Europe, where to in Washington shd I write? Will I teach English conversation!! I'm already studying up on gangster-slang, for, since I won't be able to offer the best accent, I'll have to offer at least one specialty.

Knowest thou that the Nazis (the brown-shirted organization proper) are said to be riddled with homosexualism, especially Hitler's closest friends, among whom a Capt. Rohm is distinctly mentioned. I've heard about it for a long time but knew nothing definite until I came across a smear in "The Nation." Since the Nazis are so strong for old-fashioned wholesomeness their homosexuality makes it even more of a circus. It's something curiously true.

I have also registered. It was in a church (Lutheran) basement, and on the walls sentences from the Gospel were painted. "My God hath sent his angel, and hath shut the lion's mouth." David 7, 22. It was enough to comfort me for two days after.

I don't nnow why I drew This.

Have you visited Dr. Sargent's grave?

Do.

I'll tell you about Nanny. She tells me stories in a singing voice, gibberish, and she beats time to it by raising each of her feet alternately. But that's only when she's had enough sleep and is rested, because Nanny, too, sings when she feels good.

Yours ever,
Clem

Dear Harold,

You ought to date your epistles. It's a jejune business, this writing the day of the week. All my girl-friends do it. A kind of coziness. You oughtn't.

I'll aunser you.

1. Read "the Portrait of A. as Y. M." over. You're talking nansence. As I said, there's godawful writing in it, but Jesus those chapters are good, Hawold, good! (TAKE EACH CHAPTER AS ITS OWN UNIT) Somebody you think a lot of must have said something not good about it. Your gravest (bitte) fault: to want always to be "up," correct, etc.

I have "Ulysses." In a week of hard reading I've read 250 pages of it. Don't ask! But I'll tell you, Joyce is the greatest living wr–r–riter. Agreed. Why? Because—I hate to write this, I'd rather say it—he boils down to general truths, universal truths, not his personal ones. Gide, etc. are all private, personal, i.e. if you're not like them you don't understand them. But Joyce accepts tradition, the only tradition we've got now: the body of available knowledge that he knows his audience has.

2. Kleist is a great playwright. That's all. What I need? The memoirs of Henry James. And after I read them I still need them.

3. Do I know about the swastika! They've found it before Troy, in Sumer, I think.

You remember that fellow, Danny Fuchs? He called me up last week and I've seen him two or three times. He's been secretly married and he's writing. It was he who lent me "Ulysses." He has letters from publishers asking for novels. Hoks zivios! He's been printed in the magazines. Knoweth where and knoweth whom.

The dub, he likes me in spite of my never calling him. So right now I dwell on that—why do discerning people like me? And undiscerning don't? Because the undiscerning use their instinct, and as Bergson says, the instinct possesses the only deep truths. If Danny, for instance, would stop thinking for a moment that he likes intellectual guys who are regular at the same time, he'd spit when I came near him, when I smiled agreeably, when I said "that's

the truth," when I chucked his wife under the chin (she's nice, I'd like to lay her), when I said "goodnight, call me up," etc. I'm a deep truth.

Yesterday he took me over to some fellow's by the name of David Ewen who's a music critic—New Repub., et al. Had a mountain of records and a good orthophonic. I slavered myself in Mozart and then his wife played for me the music to Bert Brecht's poems. He told me of counterpoint, Kurt Weill and folk-songs. He told me that Spain was the best pays in Europe. That he's sure German music is very close to their folk-songs. And so on. Watery, aesthetic bloke.

I see myself journeying from one duplex apartment to another. There's no wisdom anywhere, only information.

Danny's a damnice kid though. And I always wanted to meet highbrows. And get close to bigwigs.

I'm reading Lucretius again. He's worth a dozen of the Virgils I've read. He's serious, he's Northern. Do I know Latin!

Have you gone to Dr. Sargent's grave? And—yeah—how's that fat Tartar, Polly Phillips?

Joyce— "Ulysses" should be printed in the wonderful vividness of half-uncials.

This is the illustration to "Ulysses." Stephen is the Spirit; Bloom, half-earth, half-spirit; Mrs. Bloom all earth. Bloom shields her and loves

Stephen. She's not half so much frightened of her own death as Bloom is. Bloom doesn't want to grow old.

And thus.

<div align="right">

Yours ever,
Clem

</div>

<div align="right">

November 8, 1932

</div>

Dear Harold,

Wednesday I went to Reading: After Easton it was the plains of Thuringia. Everything is German. Pennsy Dutch. Ugly people with pasty faces and features out of kilter. Even the policemen talk German. The houses are all gabled and big-windowed. Reading itself stands good—at the foot of a steep bluff in a hollow and all around are swelling hills, swelling teats and swelling cheeks. My pa and I had apple-fritters for lunch, and kuchen.

Why so pettish about the Joyce business? If I was caustic I didn't mean to be; I was only disappointed—and irritated at the way you infallibly, when you get a hold of something, push it to the bitter end, overdo it and ride it to death.

Did you hear the Philharmonic play Bach's Prelude in E and fugue, arranged by Schonberg, over the radio? The fugue was wondrously strange. It was pitching spires into space, thousands simultaneously. Like this:

I mean the actual musical phrases, the constructions. I wonder how much of it was which— Bach or Schonberg?

I'm reading a book on ancient writing. Finding out about Semitic alphabets, early Greek etc. and all kinds of script. How to tell the Visigothic, for inst., from the Beneventan hands. Goodly stuff.

I saw the Jonasses several weeks ago. They live on Riverside Drive in 3 nice rooms and their own new, hand-made, hand-carved, Chippendale, lousy furniture. I must come over. I did and finding them as slimy as ever, did no more. But I probably will again on account of my home-lonely curiosity. In their bedroom they have two tinted French drawings on the wall, one of a little boy pissing against a tree while a little girl watches him curiously, the other of a little boy sitting on a chamber-pot looking at

his picture books. In the presence of these pictures I can see them fucking like two water-lizards. Enough of them!

Today I pulled levers for the Socialists. The deed's too anonymous to perform more than 3 or 4 times in your life. If at least you could leave your handwriting on a piece of paper. This way it's lowly.

Do you remember any paintings by Alexander Brook? I'm liking him more than ever. He's not afraid to imitate, earnest Jew. And this [Glenn] Coleman, at the Whitney, is almost great within his subject, and only within his subject; gray New York, I mean, N.Y. on drear days and drab evenings. He gives it a thrill. Modern painting is like modern poetry: a score of painters with 2 or 3 good paintings apiece.

Did you hear that André Gide has turned Communist?

I was heard telling a Polish girl that I was named after a Pope, and roundly laughed at.

> Yours ever,
> Clem

Dear Harold,

Since Monday I've been stuck in the house with a bad cold. Several times at night I was ready to die. I hadn't been so sick since I had the grippe in 1929.

I had spent all Saturday evening in the art room of the Library looking at Etruscan art. Then coming home my feet got wet. Anyhow the Etruscan tomb murals beat everything.

I read a book by a Russian poet named Vladimir Pozner. It seems that 2 or 3 Russians before 1914 had already anticipated "Ulysses." Andrei Biely, Aleksei Remizov and others were writing stuff that they later called montage-style. But what they did with poetry is even more interesting. They were way ahead of everybody else in fiddling with language. The reason or one of the reasons I think is that Russian is still in, what for us, is an early stage of break-up. But you know that—5 cases, superfluous prepositions, a lot of verb-moods, etc.

Anyhow I'd like to know more about this fellow Boris Pasternak, and Aleksandr Blok and Vladimir Maiakovski. There's something there. Something maybe as exciting as Rilke. As foreboding as Eluard.

And write soon.

> Yours ever,
> Clem

P.S. In the 5th Duineser Elegien notice the descriptions of fornication and the different moods—I mean moods—of the penis. Rilke can make poetry out of anything.

1933

Dear Harold,

I got home late last night and found your letter. That you typewrote it was significant.

Anyhow, so far as you to me, I know and always have known why and how you like me. And I know I'm a stinker to you half the time. And when you don't resent it you're a stinker, and when you do resent it you're more of a stinker. If you could go off and resent it by yourself you'd be the Worthy you properly are—by yourself. But you resent it to me womanishly, weakly, perversely—to me you resent it.

To make you feel this much better I should write a long letter: then you'd have that much satisfaction. But I won't.

For Christ's sake believe me! I'd lose a hand for you, but I wouldn't move a finger for you. Disliking and being disgusted by so much of you, to yet surrender myself as I've done to you, should show where I am. Lord, how little you ever know! either about yourself or that part of me that has to do with contemning you—which perhaps is also yourself. All you see is complacence and a mean kind of fish-eyed fear. My complacency?!!? I am better than you know, for all your miseries.

Yours inevitably,
Clem

P.S. I saw the Maillol exhib. and found it grand. Except he's one-track and easy to overbid. I also got a pleasant disillusionment when I saw how good some of the Pissarro paintings were. You should see the latter.

Dear Harold,

I would have written much sooner, very much sooner, but for falling sick the second time this winter. It jumped on me Tuesday night, and when

the Dr. came 2 days later he found me running 104 degrees. It was as dangerous as influenza. Anyhow I was ready to die for 3 days straight; night and day, my head splitting, not knowing the passage of time, in a daze, groaning, and my throat clamped tight as the lips of a clam. The Dr. saved me by having me gargle, take fever-powders, nose-drops and fresh alcohol compresses every 3 hours. I'm still in bed but I expect to get up tomorrow.

I'm all disillusioned with sickness. I never thought I shd want to die about it, but here twice this winter I've been ready to, once for nothing more than a cold.

Thanks such a hell of [a] lot for good choosing in sending me Frazier's "Adonis." The Hakluyt, of course, will be my joy; even in the fever I looked forward to it.

Let me finish now.

Yours ever,
Clem

5

ON THE ROAD

"I'm afraid the world has promised me millions."

ST. LOUIS

Dear Harold,

Think of me as of one who is about to go some place.

I'm going to St. Louis to try to run a wholesale necktie store-loft for my father. I don't know just why St. Louis, but the business is good and I don't have to be a counter-clerk or anything else but a Manager. I don't think I'll like St. Louis but at least it's a place to be in and look at. I'm all mixed up inside and not excited so I think I'll make a fortune. I've never had the omen before. I'm due to leave Saturday.

The joke is that I was just beginning to get going. I'd finished up the Communist episode in Sweet and was going good on the Washington part. I'm also in the middle of typing out an article that I consecrated to Bert Brecht. (I discovered him, really I did; some of his straight stuff is as good as Goethe.) I'm intending to send it around. And I have dozens of things in my head that only have to be written down. So—just when I get wise to myself I have to go out West and become a rich man.

While I was sick I almost grew a beard. I still have a washed away look under my eyes, and then I looked like an Arab prophet. I've been up since Tuesday but I still have a rough edge in my throat and I'm haunted by the smells of my sickness: almond oil that I put in my ears, the nose-drops and the whiff-whiffy scent of the alcohol I put round my neck in a compress.

Anyhow it seems so impertinent and below the question of what I do with my time when you tell me to read articles in the Hound & Horn, Beroul's "Tristan" and go to see pictures by a fellow named Louis Eilshemius. La ci darem—pewmilly (milieu) pugh pugh. Demote these questions and let's improve our minds. Should you speak of Michelangelo I assure you I'd listen.

Shamus on you, you little busybody. One letter he tells me he's reached the Ultimate and the next he chatters about light reading, always careful (he is) about the goodness of his taste. Gracious! Suppose his taste was bad!?

I hereby serve you notice that I have abdicated my sense of humor; so don't henceforth, take me seriously. I can't do the same for you.

It said in the papers Harold Jonas inherited $1,147,000; more than he expected, I think.

The literary section of this letter I will devote to Isaak Babel. Read him: "Red Cavalry." He's a Russian.

And forgive the frivolity of this letter. You know me dontcha? There are so many things my disobedient memory remembers and itches me with.

Yours ever,
Clem

FEB. 4, 1933

Dear Harold,

St. Louis is not really the South. In the winter it's colder than N.Y. People think St. Louis is in [the] South because it's in Missouri, and anything that begins with a Miss sounds as if it should be. And among baseball players it's supposed to be the hottest place on earth in the summer. Maybe. I'd like to see. But I probably won't, since if the place goes good we'll open another store in N. Orleans or Los Angeles within 4 or 5 months—and to those places I will go.

When I get to St. Louis I'll find out what the catch is. Most likely long hours. That'll be plenty of catch. About the loneliness business—it's overrated. Knowest thou me? Desolation I fear, and like the long hours that'll be plenty.

The ties (wholesale, nothing less than 1/2 doz. sold) will be cheap for the most part. A few higher-priced "lines." (That's how it's said.) I'll send you examples later. The assumption is that they starve in the Middle West. I love that assumption. My father's business afflatus, his genius for business, is in it. I'd invest $1,000,000,000,000 in it quicker than in Aristotle's theory of Happiness.

St. Louis is supposed to have more whores than San Francisco. I'll find that out too.

——OLD BUSINESS——

Your letters are lousy. Please, Lazarus, write better ones. You can, you can write good ones but you have no control (in the Soviet sense) most of the time.

P-s-s-t I shan't kid you any more. You jump like some one who's been goosed.

I, when I say taste, I mean TASTE. I'm worrying about you for fear you won't amount to anything.

Am I on my way! I wrote a short story in 3 hours about Pancho Villa; how a fellow refuses to recognize his brother and they shoot him against an adobe (get that) wall. Get all of that, somebody, quick! First I'll send it to the Saturday Evening Post, then to the Argosy—under the name of R. (Rafael) H. (Herrmann) Torres—then to Scribner's. If I sell it I'll buy you a de luxe edition of the "Sonnette au Orpheus." And Babel's "Red Cavalry."

I saw tuh [Bernard] Karfiol show. His smaller canvases are damn good. I got a kick. What a waste of genius I say. All those guys: they're so good and they won't amount to anything. Karfiol handles 2 figures better than one; he can get a blue against a <u>tan</u> rose, and after looking at it 15 minutes you slowly rise.

There's a great [William] Zorach bust of his daughter in the Whitney. There are also 7 or 8 good pictures, but what a mess! I'd like to run tuh place for a week. There's a rotten [Robert] Laurent nude.

Write soon, I'll need it.
Clem

P.S. Brecht's "Dreigroschenoper" ["Three Penny Opera"] is going to be produced in N.Y. in April, so the papers say. Myself I don't believe they'll get around to it. It'll be tough as hell to translate the lyrics into English. Try and keep a straight face—not alone writing it but singing it.

Send me my Anna Livia.

Clem is in St. Louis at the Hotel Missouri "absolutely fireproof popular price European, 300 rooms with private or connecting bath" at Locust and Eleventh.

FEBRUARY 9, 1933

Dear Harold,

At the last minute my fath. decided that I should take the N.Y. Central to St. Louis, and it was too late to let you know that I was passing through Syracuse. There I was smoking on the station platform and you were only a mile and a half away. The train made a 10 minute stop, and all the while I kicked myself and thought how shitty it was. Anyhow what were you doing

and where were you at 2 o'clock Tuesday? (As the train came into Syracuse I saw one of the hills in back of your house and the water-tower in Thornden Park.)

Now I'm in St. Louis and can't believe it. It took twenty-four hours, and I woke up Wednesday morning to see the gentle swelling plains of Illinois outside the Pullman window, covered with snow and inconceivably flat all the way to the horizon; and square cut fields and spaced-off farm-houses, a dot here, a dot there. It wasn't to be believed: I didn't think landscape would change geometrical premises like that. (It's a matter of geology in the end; N.Y. State, etc. and the South are all of one piece: they belong to a slope. All my life I've lived on a slope. But here it's flat, flat, flat.) Where the land swells or slips down into a gully it's so gentle and easy and soft curving— you've never seen such gentle curves—especially underneath the snow. And the trees, I pitied the trees. It was no place for them. I wallowed.

Anyhow stick along with me: what I saw was more than that. The trouble is I can't write you anything about myself. The whole business makes me abstract, general. So far as seeing new country and opening a wholesale necktie store is concerned I might just as well be somebody else, anybody else. None of it concerns me myself. And that's the way I am now.

Do you care for descriptions?

It was 8 underneath zero when I arrived. The cold had sucked all of the color out of the world. Everything was bluish rimy gray. I lugged the ton-weight of valise out of the station and shrivelled into the air, rustling like a dead leaf on the back-seat of the taxi-cab until I fell out in front of the store which was much sweller and on a sweller street than I expected. I unpacked the goods, arranged the displays a little bit and went out and ate a lettuce and tomato sandwich. Meanwhile the partner (you met him once at our house—his name's Nagle) farted around at me for not showing up sooner. When the night came down I went to the hotel and for money's sake got a room without a bath. But it was cosy and I had a shower across the hall all to myself. The place is sort of Southern and the rooms have lattice doors outside of the regular ones, which you can leave open at night for fresh air. I have all kinds of service and the bed-clothes are changed every day. Still it's half of a dive, lousy with whores, actors and travelling salesmen.

There's the swellest night-club in town on the roof, and at night in bed I hear the music effervescing and Sophie Tucker, who's the chief-attraction, bellowing "Some of These Days You're Gonna Miss Me Honey." The joint is called the Club Moue, but Sophie is a swell woman whom I see around the lobby often. I think that's a good name for a night-club, don't you?

Do you want to hear about St. Louis?

The streets are the widest on earth. The buildings are the thickest, solidest and squarest I've ever seen. They average about 9 stories and are massive like dungeons. In the streets you have a cavern-feeling you don't get in N.Y. where all the buildings are light-weight and surrender to the air giving you the feeling of being in a slot. Here you're in a cavern. The houses bulge out at you and darken, not over, but on you.

And in the air there's always the taste of smoke because they burn soft-coal here. Down by the Mississippi they have a complete industrial age outfit that I'll set up against Utica and Buffalo for black ugliness. But still it's on the grand style. You have to hand it to them.

The Mississippi was a failure, full of squalid cakes of ice and slimy green-yellow water as smooth and currentless as oil. And not half wide enough. But maybe that was because I saw it from the r.r. bridge, and it was very low.

(Right now the orchestra is playing "St. Louis Blues.")

Do you want me to tell you about business?

I think we'll make it go. The stuff sells in bulk and doesn't malinger. The customers so far are rough & tough peddlers, and you don't have to be Jewish for them. Best of all you don't have to be what-can-I-do-for-you. And yet I have to exert myself to talk; things like that I can't fake—just when it's most honorable to fake. It's for money after all.

The most fortunate thing of all is that I can picture myself doing what I am; that is, picture myself without farting in my face.

Yeah I'm serious about it. I have a doom there. Something to cook me good and proper.

Well, write and be fancy—for me.

I go now and read Dante in bed.

<div style="text-align: right">

Yours ever,
Clem

</div>

<div style="text-align: right">

FEB. 15, 1933

</div>

Lieber Lazarus,

By this time they've gotten me all ready for the cooking. I'm pretty well salted and it only remains to add some pepper and cloves. This fucking business is on my mind night and day. It's got me quirked. I even talk about it. In the end I'll even make money out of it. Does the "Hound & Horn" make allowances for that? Tell me quick.

I'm sitting in the hotel-room (I don't dare to say <u>my</u> hotel-room yet) and killing the evening by talking about myself. Oh Geschaft! to become abstract, to become you know not what. I've never in all my life felt so free and footloose, so independently, compactly an entity (ee ee ee) as when I walk thru the streets in St. Louis alone. Joy, joy, nobody knows me, where I'm from, what language I talk, how I do, what I do. Nobody knows anybody who knows me. A whore in a red roadster brought up beside me as I was walking to the Hotel around 1 o'clock at night, walking like a prize fighter and giving a penny to every beggar. I talked to her as I'll talk again some-times when I'm in heaven an angel. "Listen Babe," I said. "I'd like to fuck you but I'm afraid of bugs (literally & figuratively). My room no. is 522 at the Missouri. Send your friends up." Just like that. Poor wench: "Screw yourself," she said.

FEB. 18

I'm finishing this. I received the delicious cookies, the books (unexpect-edly) and then your letter. Your mother has a golden heart, and the quick-ness of it is like mercury. The fruit cake all by itself was enough to brighten up my evenings. And thanks for sending the right books. There are only certain things I can read here: Dante, Hakluyt, Dostoevsky and medieval light (like a steam-bead) poetry. I'm plundering "Brothers Karamazov;" not being a novel but a tale it goes good. They have a good library in St. Louis and I took out "English 13th Century Lyrics." There's good stuff I hadn't seen before in it.

Will you say anything funny to me if I say something funny to you? Well, I have other things on my mind. I have to work myself into location. I still don't sincerely realize I'm 900 miles away from where I've always been before. I still don't get St. Louis. And then there are the neckties; I always think about them. On the street when I pass a haberdashery place I look per-tinently at the ties displayed and come to a conclusion. You show me your tie and I'll tell you how much it's worth. I'll tell you about grosses and dozens and turnover and profit; income and net, cash off and on the spot.

I need women badly. At present they seem the only possible compensa-tion for having surrendered these days' freedom. In the evening a woman would make the day that went before shine. She would be a safe pleasure.

The partner is a slob and I have to watch him slobber. But he's agreeable in the fact that he knows nothing about me and doesn't want to; that he

leaves me alone when I want to be left alone and that I'm enough interested in the business to suit him. I've already met several people through him—filed-teeth Communists (he's been to Russia) who almost robbed me of my dear anonymity but not quite, for I refused to take their daughters out, and two music-loving old-maids who talked about books.

There are 65,000 warm-hearted Jews in St. Louis, and 'tis they I have to fear. They would seat soft-spoken polite young strangers from N.Y. so swiftly in their bosoms. And there's the real foolishness of the Wandering Jew business; wander, hell! wherever there's another Jew it's home.

Another time I'll tell you what I do every day. It's Saturday night and I'm sleepy for bed. Another time I'll tell you about the air in St. Louis which is a mixture of mist and soft coal smoke that's called "smoggy," a word everybody uses. How it's impossible for buildings to have details here for the smog reduces every shape to its most general simplicity as you can see by the 3 or 4 modernistic skyscrapers they have, on which all the crappy details are wasted fortunately.

Thank your mother with a thanks that's never enough.

<div style="text-align: right">

As ever,
Clem

</div>

P.S. I changed my room for a better one fronting the street and now I can't hear Sophie Tucker any more.

<div style="text-align: right">

MARCH 3, 1933

</div>

Dear Harold,

I write to you on the evening of your birthday. Yours as ever—but I'm late. Anyhow you're twenty-four and you were never made to be twenty-four, so be twenty-five quick and amount to something.

I'll tell you what I do: the phone-girl rings my room at 7:15 every morning; I hop out of bed and say thank you to the mouthpiece and hop back in again. Fifteen minutes later the partner who's in the room next to mine hammers on the wall and I hammer back. It takes me a long time to dress, what with the misery of getting up early and looking at my face in the washbasin mirror for ten minutes. Then I go downstairs and waver out into the gusty morning air of St. Louis where there is no wind, only draughts sucked down from between the little hills that surround the place. I walk 2 blocks to the store and find the partner already there, the lights turned on and yellow and the goods uncovered. I fart around until

9 o'clock when I gather up the money and start for the bank. The traffic is terrible because there are very few red lights here; and I have to spend too much anxiety dodging automobiles. Finally I get to the bank 6 blocks away and fumble around with the money until I have it counted out correctly. It takes me 20 minutes and I sweat. Then I go around the corner for breakfast. I sit at a counter, have orange-juice, toast (with butter separate) and coffee and after, smoke the best cigarette of the day. Feeling torpid and having the burnished taste of the cigarette in my mouth mixed with the coffee-taste, I relax and walk back to the store, all my joints and entrails loose. There I go to the rear and difficultly sit down and shit in utter darkness, prey to all kinds of dreary whimsies, remembering lines of poetry and wondering about what's going to happen to me. After that I wait on customers or go out to the retail stores with samples to try to make them come down and buy from us. (The telling sounds dreadful but it's not as bad as that.) I walk through St. Louis and wherever I see a place that sells cheap enough neckties I go in and say "I'm from the Continental Neckwear, etc. I'm not trying to sell you anything." I take the ties out of my box and talk aggressive in my childish way. When I get fed up on my own chatter I leave and walk some more.

I manage to see a lot of St. Louis. It's full of Germans and they go in for dull-red brick houses, and live on streets with French names like Gravois (called Gravoy). There are big breweries and going past them I smelled the soddeness of malt and hops and the urine smell of fresh beer. All the Germans smell of beer.

But to get back—I eat lunch around 12:30 in a Jewish place (there are always Jewish places to eat where there are stores) and have cheese blitzes or a cheese sandwich or a dish of cheese and cream. I travel better, I found out, on that stuff. Around 3 I take the trolley back to the store and wash away the rest of the day-light looking at my toes and doing arithmetic in my head. I sit on a desk and watch the door for customers. At 6 we close and I am forced to watch the partner's filthy table manners at dinner. Then I go back to the hotel, wash up and begin to feel legendary. I go to the library, I walk the streets, I go to a movie, I sit in the room with a pitcher of ice-water, a bar of chocolate and cigarettes and write rubbish. I don't read much.

Last Saturday night I went to the Symphony, conducted by a Jew named Golschman, and both were lousy. Tomorrow I'm going to see the stock-company. They have a fair museum here with good medieval collections, especially sculpture and Italian primitives and some modern sculp-

ture, Despiau, Milles and Bourdelle and a very good painting by Alexander Brook. And so. T.S. Eliot, you know, was born here, and all the bookstores display his books and books about him—real local-boy stuff—and all the book sales ladies know about him. And so. A lot of streets here are named after poets: Goethe, Schiller, Longfellow. And so. They also have a statue of Robert Burns. And there is a Little Theatre that gave Georg Kaiser's "Gas." And there are 5 art dealers who put Westerman–style copies of Van Gogh, Cézanne and Gauguin in their windows. But the bookstores are poor; they haven't even got German books in the Germanest of places.

I'll tell you some more some other time. About the great zoo they have here.

Thanks for the list of movies. I need them. I've already seen "Farewell to Arms" but I'll chalk it up as your accidental mistake. The shots were all faky-flaky. The point is that Vidor conceives his shots in the sense of a framed picture—painted picture, a lot of plastic and shadow effects. That's all wrong. Anyhow I don't like Helen Hayes' teeth. I do like the way Gary Cooper walks.

In your next letter ask me about business. I can talk about it, really, in an expert way. I can spot the price of any tie under $6 a dozen. I yank the tip and crush the fabric. I look at the stitching, poke my finger under the lining. I'll show you.

<div align="right">

Meanwhile,
Clem

</div>

P.S. You'll like this; the best yet:

> Erthe leyde erthe in erthene throh—
> Tho hevede erthe of erthe erthe ynoh.

They date this before 1300.

<div align="right">

MARCH 23, 1933

</div>

Dear Harold,
 Your letter came at the so exquisitely right time that I've come to believe that your weaknesses have the only tact there is in the world for me. Nobody else in the world, unless it was a girl or two, ever made me feel that I was living in company: that there were other travellers on earth.

Now, by the way I've written—cadenced—what I've written just now, you can tell how many minutes this egg has been in the water—water that's now beginning to simmer. You, having the living kindness to talk about my poetry at this time, are seen by me transfigured. I have to lift my shoulders from the grill to look at you.

CODA: Worst misery in the world—absolutely—lowest period of my life so far—darkness all around me—like a dog, from necktie to necktie—anonymity no longer precious—read the Gideon bible at night—go to the movies 3 times a week—am positively suffering—no life at all—don't even get layed despite March my rutting month—am going to ask for salary raise—put candle in window at night—terrible.

St. Louis, Armpit of the West, city flowering smoke, who sticks her dirty fingers into the craintive sky: all cooking with a lot of spices (probably Mexican influence—Chili con carne is the biggest dish in town); signs are all mispelled or the letters formed wrong. I never saw anything like it (garantee, repiaring, qualty, etc.); hootchy kootchy burlesque shows in vacant stores in downtown section; whores in roadsters, thick as lice; Jews are still called sheenies instead of kikes, and lots of low Jews who eat their own snot (I often wonder what made so many Jews come to St. Louis); German spoken on trolleys (called street-cars here) mostly Bavarians and a lot Catholics; great zoo with eagles, magnificent condor, loads of big snakes (22 ft. python), performing chimpanzees, 2 sea-elephants, 3 orangutans, 2 Cape Buffaloes, black swans, hyena (who lets me scratch his neck with a stick by standing on his hind legs and pressing the underside of his neck against the bars), all kinds of bears (separated from public by only a ditch), half-grown lions and cubs playing around with only a low fence to keep them in; art museum with great French 15th century Madonna (rosy stone, life-size, once painted, queenly buxom madonna and fat child), great Greek funeral stele with woman's bust in relief, wonderful painting of girl in pink dress by Alexander Brook (whom I think more and more of), very good, faded Tintoretto (faded—that's why it's in St. Louis), modern watercolor show with 2 good Pascins, good Glenn Colemans, good Cikhonovski (do you know him), poor Marin.

Of course, you'll understand that it's worse than it sounds. And therefore being miserably sleepy let me sleep. . . .

I've heard thunder here twice already. And the rain patters like summer rain. It's warmer for the time of year than in N.Y.

Treeless place: I shan't greet spring in the old way here. Oh the fat trees of Brooklyn! All there is here are skinny ash, scanty maple and slender poplar—not even a fuzz of trees.

Instead of saying "what?" when some one fails to hear, they say "sir?" I say it myself now: and pardon me, sir, and right here, sir, and why to hell, sir, etc.

And don't tell people that my father gave me a tie factory. All my father has ever given me is money. Tell people I'm in the wholesale business in St. Louis—and instead of saying ties, say dry goods. I like it better. And if you want ties I'll send you some but you'll have [to] overlook the skimped ends and the gaudy linings and the wrinkles after you tie them. (You know, in Yiddish they say a shoemaker always goes around "borvis" (barfuss); that's me. I'm short of ties myself.) I'll send you a charvee silk.

What you said about business was wonderful. "Make cheaper, etc." Your saying a thing like that proves my theory about Trotsky. A good man is a good man wherever you put him. Say some more things like that.

——Clem

APRIL 23, 1933

Dear Harold,

Xαîρε. Your letters still support me. I read your last sitting in the midst of piles of neckties, and I forgot about them, something I never do now either by desire or accident. If I didn't regard the decor as temporary I should go crazy.

The vacuum surrounding me is terrible and for that reason worth Going Through. To find out how much—not how little—I need. The hotel-room is insane; the streets are enemy; no kind words are said except in the cozy speakeasy across the way—a momentary salvation after 10 P.M. The facades frown directly at me and I'd trade all my anonymity to know at least one detail about the people who made them. All the time I see myself so precisely doing and being what I am.

Also the vicious point I hang on: I'm in earnest about the business. The Jew coming out and the generations of my fathers before me. I love to turn

over a dollar, to make its head show where its tail was before. I figure out profit percentages on the table cloth and contrive to sell what won't sell and to keep what should sell (a fine truth). Since my partner left I've increased business more than $100 a week. My own punctuality disheartens me: I see myself opening the store on the dot of 8 each morning and staying in the evening later than I should stay. The authority makes my eyes swim.

Oh Harold, I'm afraid the world has promised me millions.

When you see me next don't look at the heaviness around my jowls. And my head tilts back in a way it never did before and that I hate.

But I'm still all right. I mean I'm not perdured. The saving fact is that I'm doing all this for myself, myself alone and nobody else, and being a Jew you'll understand. Being a Jew you'll understand everything.

You see, Solly, my brother, Solly, isn't a Jew and now he hates me. He'd never do the things I'm doing. Neither would Harold Jonas, for instance; but you would.

Does the emotion exceed the object? It does.

It's Sunday night and I'm tired. Today I walked across Eads Bridge to East St. Louis and saw the Industrial Age and ragged negroes sleeping in the sun on the scrabbly banks of the river, and white hoboes stealing rides on freight trains and the big slanting cobble-stoned levees. So I'm sleepy and I'll finish the letter tomorrow.

———————

APRIL 25

I read over the bilge I've written on Tuesday with lighter colored eyes. The miasma here, you see, gets into everything. The noise and look of the hotel lobby creep up into my room and I let go.

To tell the truth, everything I feel and do here is so superficial that I begin to believe that underneath in me something very profound lives. It must be profound to live at such a great distance from the rest of me, and to show its indifference by sleeping.

Turn the gas light up 1/16 inch and I'm ready for eating.

Do you get what I mean? Do you? Do you get it? How can I show you?

There's a Yogi in the hotel. He has an office on the 3rd floor and advertises a daily meditation at 1 P.M. There is a theosophic cult and they sing hymns. He calls himself Yogoda Sat-Sanga. His best customers are the lobby-whores. One of them told me about how his finger nails aren't cut.

There is a wondrous Masonic Temple in Egyptian modernistic on the top of a hill.

In the library I look at pictures of Jacob Epstein's sculpture and let myself be convinced that he is the only great modern sculptor. I mean it: a New Revelation.

Horace Gregory's new book of poems is very good.

Danny Fuchs wrote me that the "Dreigroschenoper" was very good.

I don't read the newspapers and I don't know what's going on in the world. All I know is that every Jew is shamefully indignant about Hitler. Are you indignant too? I'm not. The reason Jews are not good human beings is because they have no resignation. To be well-bred you must be resigned.

I'm lately full of things like that. Me and my Jewish father; you and your symbolism (to be correct, you should say imagery—no Jew ever had anything to do with a symbol).

Allow me to end on a Note: The third half-hour of one's waking day is the most important of all. It contains in minuscule what the rest of the day will show majuscule.

<div align="right">

nochmals,
Clem

</div>

<div align="right">

MAY 2, 1933

</div>

Dear Harold,

The cakes and candy came, for which a thousand thanks to your mother and you. To be remembered twice with such exactitude is more than I have gestures and words for.

I'm sending you your "Tristan" of which I've read near 15 pages and can't see why you are so steamed up about translating it. There's nothing in it that's possible in an English version, and you will find that out when you write the words down.

I'm also sending you some half-wool neckties with skimped necks that I like. Find out how they wear and tell me. I distrust them. Anyhow I think narrow neckties go good with your neck even as wide ones with mine.

The future brightens. Maybe I'll be in Cleveland by June, in shuffling distance of Buffalo, although I'm sure I won't like the place. My faagher is having visions and I'm seen in every one. Καλόs ἀδὲλφόs, Solly writes that my Real Apparition as a business man has at last made my father into a hopeful old man where before he was a querulous, middle-aged one. As nei-

ther is typical of either of us I begin to tremble for fear that something actual has happened. Maybe truths have been revealed to God who judges me.

In the Botanical Gardens they have a great hot-house dedicated to the tropics, and I almost went delirious with the green smells inside. You have no idea! it was something (you know what I mean) that had vaguely-precisely happened to me before. And I ate my stomach out with the longing, realizing at last what the hot lands smell like. There's one other smell in St. Louis almost as good—the buffalo smell in the zoo.

I couldn't get hold of any reviews of "Dreigroschenoper," but I'm willing to bet already that it'll flop. I have an idea for a good story—the Nazis ransacking Brecht's apartment, then Brecht in the RR station about to take a train to Bodensee in Schweiz. But to appreciate the idea you'll have to read the two "Versuche," I and II, that I read.

I'm 3/4 though the cake now and the candy is all eaten up. Ancora grazie. Graçao.

—Clem

MAY 15, 1933

Dear Harold,

I shall probably leave for Cleveland this Saturday or Sunday. God couldn't have been any better to me. Three and a half months have turned out to be the exact dose for this place, filling me up to the sinuses with the desolation of living in one place too much a place.

At the end of this week I'll clean up the loose ends of the neckties, take a final inventory, make an earnest speech to the fellow I'm leaving here, send my heavy overcoat to N.Y. and find out what time a bus will be going to Cleveland—half-way home from here! How many miles from Syracuse? 200? I'll see the middle West in the daytime.

All this is at one and a half removes from myself. I'm back on the front porch at Ocean Parkway reading "Vita Nuova" with an eggy taste in my mouth, and the sunlight is not really sunlight. You're still in one place taking showers in the middle of the afternoon.

Your last translation of Brecht I did not like. You should have used your ears instead of your fingers to count syllables. As it is I can hardly read it aloud. But the language was good and that's a lot.

I cede you "voice" on "Tristan." But you should see anyhow that it's 3rd class poetry, good or not good.

And don't get sore about my opinions. O-pinions! You should never get peeved any more about them if only as a compliment to yourself.

La Sir, my mouth is getting all pursy.

The ties I sent you were not the ones I had originally intended. They had just come and the tan and gray caught my fancy so I switched. If anybody asks you, they are made up of a very close and fine crinkled crepe containing only a little rayon. If you give them 24 hrs rest after wearing they should stand up.

Do you know rayon smell? Do you know the feel of neck cloth? Can you tell a crepe from a taffeta and a mogadore from a rep? A jacquard from a print? I can. To tell a good tie yank its large end and see how much it gives. If it gives a lot it's a good tie.

It's fun watching styles. Plaids, which I detest, are all the go now. But this fall I predict wide stripes and perhaps perpendicular stripes. Plaids are no good for ties because you can't get a bias look to them. Every pattern shd

Continental English 'a cheap tie is cut this way

look as if it were put inside and shaped to the shape of the tie, not as if it were only cut out of a large piece of goods. French and German ties are cut much differently from English ties whose cut we use.

Are there any tie-peddlers in Syracuse?

Read Gertrude Stein's "Autobiography" in the Atlantic Monthly.

——*Clem*

CLEVELAND

"I've lost all yearning, all hunger, all compulsion."

Clem stays at the Allerton Hotel.

Dear Harold,

I'm here. Write to me as Clement Green at the above. I have to be called Green for business reasons—I'll explain later. Anyhow they're very shabby—the reasons.

I have an almost modernistic room in pastel colors for $30 a week, and there's a pool downstairs to go swimming in for nothing. That's just the way Cleveland is. Marble splashings, or if it's not marble, imitation marble in sandstone.

Our business here, nevertheless, is much shabbier than it is in St. Louis. And we do more of it here.

I live on the 10th floor. You can see by the stationery it's a snootier place than the tear-stained old Missouri.

And the library here even has St.-John Perse's "Eloges" for which I had to leave $2 before taking out. The library, itself, smells like the N.Y. one but is much sweller.

My heart is sick here because I have to start the store all by myself. I'm always afraid I've forgotten something, and I write agenda on big sheets of paper. Oy weh!

Please, Harold, write soon for my own self-pity's sake.

——*Yours ever, as ever,*
Clem

Dear Harold,

A piece of me for you. I can't explain my name. For two days it was fun being called Green, but now the name has a vulgar squealing sound, as if I'd forgotten to close my mouth. How beautiful sounds Greenberg; a long and a short, and the sound of the "erg" lingers like the name of some hero or great man.

You see, my father is known in Cleveland as being connected with a neckwear manufacturer who sells to the jobbers here who are in competition with me now, and if they knew he were me they'd no longer buy from him, etc. When it comes to business my father has a brave imagination. The business of wearing a false name shocked me at first but he went at it as if

it were a story he was telling about J.P. Morgan. When I received $50 to go to Cleveland with, I took it and went, and my false name went before me.

It seems I made a success of the St. Louis store—for the time being anyhow. And it's under my belt. Think of me as more chameleon than ever. You see, I had a factotum, and with a factotum you can do wonders. I had time in the mornings to finish my cigarette and, sitting in the restaurant, to dream.

I'm stuck here till the middle of the summer, and after that the feathers point to Los Angeles. But don't visit me here. I'll be hateful and you'll be messed up. The Lage isn't right.

St. Louis was much more of a place than Cleveland. Nothing has salt here. In St. Louis at least I could make up plausible poems about myself. This is like N.Y. with the secrets left out.

At the hotel there are a lot of effeminate washed-out Gentiles, unwholesome squirrels. And 1 or 2 very obvious fags and a whore who dresses all in white. She's perfect and wonderful and she drives a black roadster. There are also a lot of Bohemians, Slovaks, Poles, etc. here. I went out to the shrine of our Lady of Lourdes with a lot of their women and kids last Sunday. They smelled bad inside the trolley. One woman behind me said, "brejenk grashistz." And a negro boy in the shoe-shine parlor said, "Clyde has such a smooth clear attitude towards women." That's exactly what he said, so help me God.

About the ties, you probably didn't yank them right. It's an infallible test, I know.

> "Faded are the wares of commerce
> The shutters are all up, the goods covered."

Wohlan!
——*Clem*

Dear Harold,

You're in a hell of a fix. I've tried to think what you could do. Your loneliness is worse than mine, which is only concrete loneliness. I'm aghast sometimes when I think of your kind. Coming to Cleveland might make you glad to return to Syracuse but I'm selfish enough to fear the scattered feeling I'd have.

I had my picture taken: when the peddling photographer took it out of the can of fluid I was struck by the dégagé quality, the epoch, my time of

life. I was ready to turn around and be—not a Jew—but concrete, precise, to the point, to fill the circumstances. That's what I always do and didn't know till then. But not personally—understand that then it's the extreme opposite—generally, as one among others. Then, I'm what you've always told me, a faker and afraid of what'll happen to me if I'm otherwise.

There are 150,000 Jews in Cleveland, and the people who aren't Jews look like them. But there are more high-class Jews than in St. Louis, only they're too ubiquitous and always protesting about Hitler. Now that Maxie Baer has beaten Schmeling there's no standing them. There are a lot of Syrians too with faces like the Fayum portraits; but they're a scurvy lot, as bad as the wops, of which there are also swarms here.

I have to deal with the shit of the earth, worse people than in St. Louis for they're all Jews, and I wonder about myself to see myself taking them for granted and my loathing dulled.

I'm still reading Perse and finding him a little better. The "Eloges" were written in 1911 and prophesy Proust in the memory business—only with him it's the subject and not the process that's made unambiguous—exactly the other way around from Proust.

———*wiedermalig,*
Clem

JUNE 22, 1933

Dear Harold,

I got your letter in the morning just before leaving the hotel and began reading it as I walked up 13th St. to Euclid in the early sunlight, matutinally torpid and with that funny empty weak feeling between my nipples and my penis that I have every morning now for 4 months; and I thought of the difference: how in Syracuse my head was glazed in the morning and treasured sleep inside of it like a black hole, and how I was irritable. I didn't finish your letter but stuck it into my pocket when I boarded the streetcar and sat by the window looking out and wishing that I had 100 blocks to ride instead of 5 because while on the streetcar I do nothing in the morning but suck nourishment from my utter apathy, my legs and arms all loose and my eyes cherishing every detail, etc. So I finished your letter in the afternoon and realized then that I had changed and so had you—a little bit.

St. Louis is making a lot of money now, for which they're crowning my head with laurels. My father's letters are so tender with fulfilled hope that I've begun to love and cherish him with comfort, which wipes off the last

item on the list of my attachments and makes me finally free to hurt, abuse and disregard him. And for me that means I'm now inviolate by the world.

Money: if within a year this thing goes through I'll be making a lot of it; but I'll have to keep on making it. And what I do to make it is a sort of trance. In the evening after reading a book for two hours, when I put it down and suddenly realize where I am and what I've been doing and thinking about all day I feel absurd and, really, weird. I can't explain it, as you wd say.

I go swimming every night at 10:30 in the hotel pool, and after I spend 1/2 hour in the steam room sweating and when I've taken a cold shower, I feel so clean that it lasts till tomorrow.

Sunday I saw the "June Show" of modern art at the Fine Arts Museum. Zorach's "Spirit of the Dance" is there and it's a very good statue. Also another great picture by Brook, a reclining nude. I saw it across the room and not knowing who'd done it I thought I'd discovered something.

Also concerts—lousy pop concerts, they call them promenade concerts here—promoted by the enemies of music.

I found out I'm going home the second week in July.

Danny Fuchs has taken a summer cottage at Wood's Hole, Mass., wherever that is, and he's invited me up. It sounds good, but I won't have time.

Are the roses in Thornden withered yet?

Oh shit!

——Clem

JULY 2, 1933

Dear Harold,

I feel very lousy because business is bad here and people owe me money. Business is like this—you can't draw a breath without misgivings.

When I said concrete loneliness, I meant concrete: nobody to speak to. It's the less awful kind that eats your feet off first. In St. Louis it stuffed and clogged me; here it rushes through me. And here I go to women which makes my loneliness pathetic for days thereafter.

If you'll have me I'd like to stop in Syracuse for a day. I know I'm supposed to act happy and I try to, and it's all because you're sentimental about it and expect an adequacy for the situation and I can never be formally and intelligibly adequate to any situation. If I were to meet you on the moon

you'd expect me to <u>act</u> surprised. Anyhow it's trivial: the handshake with the extra squeeze and a smile that folds your face up into wide wrinkles. And then you say something to establish your effect as taking up what you've left off, something about the color of my suit, and I affably being affable, am affable.

Meanwhile the wind from Lake Erie (which is a poor lake) is whistling so hard up here that once in a while it actually strikes a note. I never heard it that way before. Cold weather has just come and the lake is shivery blue blue-gray and flecked with white-caps, even inside the breakwater. Tomorrow I'll wear an undershirt.

I just found out that the Allerton is supposed to have a reputation for being haunted by fairies. That explains something. Still there are also plenty of hustlers around. Not as many as in St. Louis though, and they don't have cars.

In St. Louis a music store was advertising a new song and on the sign it said, "Easy to play but blue." It's my latest Schlagwort.

Maybe you know how miserable I am.

As ever,
Clem

JULY 13, 1933

Dear Harold,

I'm taking the boat to Buffalo Sunday night and then the bus to Syracuse, which will probably get me to you Monday evening. I can't stay more than overnight; I haven't the peace enough and I want so to get back to the lonely house in Bklyn and live no more among strangers.

Wretchedness is soaking away. The panacea for every trouble is woman, thank God for that and their convenience. So every other night, having a dime to take them to the movies with, I see woman. The main thing is a platitudinous thing—oblivion, and, it comes so sweetly when you feel their thick thighs and smell their necks. And in the morning the memory stews and it's 2 o'clock before I wake up.

I'll come trusting that it'll rain in Syracuse.

I'll look at your books and feel bad, wondering what it was that I forgot to do.

I'll embrace your aura and kiss it.

You'll see that I weigh 155 3/4 lbs. and have lost more hair.

I'll smell the kitchen of your mother.
Now I'll fall asleep

———*in Traume*
Clem

Clem returns to the Allerton Hotel.

Dear Harold,
 Why I haven't written you in so long is because I'm all in a knot, (in choppy water) and thinking to myself about nothing. When I left you I had the feeling that I left something that was put—settled. After a while I see that I was wrong.
 But it's mostly myself.
 N.Y. was terrible. I didn't go to Wood's Hole. I stayed in Bklyn and lost patience. I felt and still feel—I can't explain—nowhere.
 I have chronic gastric indigestion now—the pre-ulcer stage—and I've put myself on a milk diet. That's something.
 It's funny that I say this; but I don't know what to think of myself. I've lost all yearning, all hunger, all compulsion.
 "Externally" I chase after women. Every night, and my stomach rises in my throat with loathing every night. But they save me.

Clem

AUGUST 23, 1933

Dear Harold,
 Yours was a good letter, and it helped me to feel better. I feel better anyhow, having done away with many things close to myself, casting them away utterly, as for instance: purpose, brooding on the future of my reputation, conscience of money, etc.—for time being.
 Your passage from this to that, holding your penis hands high above your head as if you were offering something up to your opinion of yourself (which you did) was swell reading, but I was left without the personal touch. To lose your virginity, Harold, is to involve and spend yourself, or else be seduced, but it's not paying $2 and sticking your prick into a slimy

pocket of skin. You're still a virgin of whatever you were virgin of, only maybe your curiosity—very much to the point—is satisfied; which is important, but in another way. To screw a whore is a loftier style of masturbation, and you don't have that swell dizziness, either, when you come. So stick around a while. When you lose your virginity you screw fervently and there are complications. But not that business of saving all for the end and fucking just for a fuck. Hell no. Maybe you don't even know what I mean? (Or you wouldn't have said my taking on a woman every night is like going to the movies. I don't pay for it, but I spend. That's the point.)

The woman has to be involved, see? It's a sentimental truth, see?

That you walked in smoking a cigarette, or rather that you had to say you walked in smoking a cigarette gives something away. I laugh around you with fondness and care. I feel motherly.

Look: you meet a woman and take her out 7 or 8 times. There's a various history of phone-calls, places visited, accidents, and qualifying avowals in all different situations. Then you find out a moment when you're both twisted and twined in each other's mind like winter snakes—to wake up next between solid chunky thighs, revealed, all flattened out like oil on water, remembering how you felt up to the moment and trying to realize how much you now own every inch of her and so on. Your penis is just "property," furniture—she's the precious and indispensable item.

Two days later you invent a sense of humor to cover the situation.

But even after you know that you have been in a state of concupiscence—you haven't just simply and neatly lost your virginity.

Look—I'm explaining things to you!

Slinking summer is coming to its end. Cagey August is here and looking out on the lake I feel sad.

—————*Clem*

Clem's father now sends him to manage an outlet in San Francisco. On the way, Clem stops in Ogden, Utah. He writes from the New Healy Hotel.

SEPT. 6, '33

Harold—

Imagine to yourself me and where I'm at. Consider! I've been riding 36 hours on end, and I've stopped here for 12 hours to catch my breath in this

place where everything is red and green and the delectable Mts gloom around and around.

The train won't be here for another 3 hours so I sit in the window and write to you.

Above the town you can always see the 3 mountain peaks, and now the moon and clouds are tangled up with one of them and I can only look at it so much, having seen the sun rise on the desert this morning and, setting, turn the same mountain into a vermilion something, splashing the sky at the same time with pink and russet taffy so that I say that the books are right and you mustn't admire these things too much but turn your back and read about them. Otherwise there is a very banal inadequacy on your part.

When you take the trolley up to the foot of the middle mountain you can look back and see it (the valley) circled all around by other ranges and in the middle the flat sheet of Salt Lake receiving the sun.

The sun here is the hottest I've ever felt it anywhere but the shade is almost cold enough to make you shiver. I almost caught a cold going from one to the other. The foliage on the trees is loose and the ends of the branches hang down. On the edge of the town you can see real chaparral and mesquite.

The town is modern with all the fixings but there are a lot of cowboys around too wearing slouches and high-heeled shoes. Little girls ride ponies bareback in the streets toward the outskirts and everybody suddenly owns police-dogs. But always you have the three sullen mountains over everything.

I stopped over so I could get a tourist sleeping car into S. Francisco; a difference of $20 and, besides, 12 hours in Ogden are worth money too.

My father was thinking ever since June of sending me to California, but he decided definitely 1 1/2 weeks ago and then came out to Cleveland by car and took me to Chicago and, for 2 hrs., the World's Fair. The first I don't like and the second was real spectacular and lousy withal, looking very very cheap in the daylight and like a swell soda fountain at night.

The ride from Chicago to Ogden cost me $7 but I had to sit up in a chair car for 2 nights. Anyhow I woke up this morning to see a mixture of the Rocky Mts and the Colorado, Wyoming and Utah desert, many colored in the sun, enough to make me talk to a big Swede cattle-rancher in the smoker.

It's intended that I stay in Frisco for 3 months and then go to Los Angeles for the rest of the year's exile. I'm not so excited about it and regret Cleveland which I left with a lock of mahogany colored hair and a green

comb. And when I smelled the hair for the first time on the train I smelled the girl so vividly that I became weak from believing with all of me except my head that she was standing next to me—and for each moment that I'd take a fresh smell <u>believing it</u>. It is one of the greatest things that ever happened to me. More than anything that Proust ever aimed at or literature or you and I have ever dreamt of. Please have it happen to you.

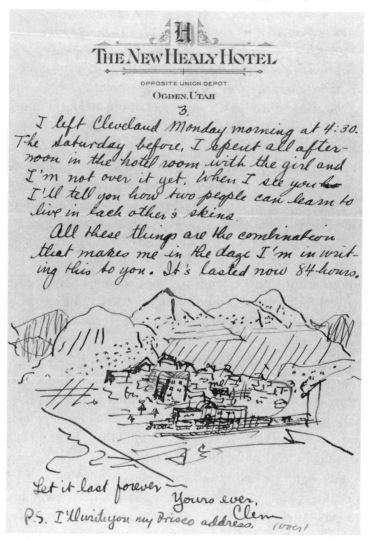

I left Cleveland Monday morning at 4:30. The Saturday before, I spent all afternoon in the hotel room with the girl and I'm not over it yet. When I see you I'll tell you how two people can learn to live in each other's skins.

All these things are the combination that makes me in the daze I'm in writing this to you. It's lasted now 84 hours.

Let it last forever——

<div align="right">

Yours ever,
Clem

</div>

SAN FRANCISCO

> *"The air is so empty, wide, and far. And loneliness*
> *goes through me like the wind and picks me clean."*

Clem stays at the Pickwick Hotel on 5th Street near Market.

<div align="right">

SEPT. 8, 1933

</div>

Dear Harold,

I'm in Frisco gradually. It's cold as the devil and everybody's wearing top coats and dark colors and summer is over.

I'm heartsick and indifferent to the miles I've travelled and the places been to and seen. It was too much in one dose. After Ogden the delirium just faded, and flickered only once more when passing over the Sierra Nevadas and going down towards Sacramento, seeing the new kinds of trees and foliage on the Pacific slope. Going over Salt Lake and through the frightening Nevada desert I was torpid and slept on a pillow jammed against the back of my seat. The sights seen—the naked ferocious mountains of raw brown earth in Nevada and the scrub, scrub, scrub, the real Doughty desert, no other, with the mighty soft mountain-folds always against the indifferent sky—I saw them like something I'd know more of by reading about and imagining than by seeing. (Geography and all, the earth, wherever she is, insists on being taken for granted, etc.)

Yet the mountains were the same "Jebels" Doughty made me so scared of and the Mormons of Utah as strange and animous as his Arabs, I walking among them in Ogden at night and letting them stare in my face—who are unmammalian and farther away than a horse or cow. Lord save me, how familiar and frightening the whole mess was! How I shrivelled down to my idea and threw my essence away!

Thank God for thee, Harold, whom I can talk to so that writing this letter makes me feel better even now, and whom I kiss on the cheek for-

ever after by sealed will and all documents needed to keep me from changing my mind so that I'll always know what on earth is good for me and always keep it.

Mostly I'm in love and parting was more than I needed of hell. But this place turns me away like an unwelcome stink turns you away. And yet Frisco is better than St. Louis; it's like its legend; after dark it begins to rip and roar; lights close to the curb, plunging crowds and colonial baroque decorations all reminding me of N.Y. before the war, gummy with whores, travellers and rackets, beer, gambling and the exhalations of big distance, a black mountain standing over the end of Market St. and an island mountain at the end of Mission St. in the Bay, (no one had ever told me of these things), hundreds of hotels with glass lobbies, the empty faces therein falling out on to the sidewalks like mist in the morning.

I'm in a very small modern hotel in the thickest downtown. I have a big room with French windows and bath. The furniture in the lobby is "mission," in my room it's lousy but endurable, a little Chinese being thrown in for intensive local color.

Meanwhile I miss Cleveland. I got to love its handsomeness. I found out that untrammelled spic and spanness is just to my taste. That's why I like to be clean: no local color, nothing but surfaces. I furnish the rest and want God to make heaven like the Bonwit-Teller building on Fifth Ave.—clean, nothing but surfaces.

Meanwhile again: give me just one woman I love to sleep with, who when she's hot wants me to say dirty words and have private nastinesses in common with.

The whole set up was rotten though. Being so much in love I should have been allowed to go home and dispose of it sleeping late mornings. Instead they rushed me off to Chicago at 4:30 in the morning after one hour's sleep, it being frightfully hot and Chicago the center circle of Malebolge. Then they stood me up in the North-western Station on Madison St. and I had to crowd into the train with swarming yokels, whose being where they were irritated me because they were not casual yokels but yokels who were in Chicago because it was Labor Day and the World's Fair.

Then half-asleep and remembering the night before how I spent it under the full moon sitting over a river outside of Cleveland in a little restaurant with an open porch and that I'd probably never do the same thing again—aw shit! Why don't you know the same kind of thing? I reproach you—or do you really understand my spilth?

Anyhow when I woke up looking on the discouraging fields of Iowa I thought: Sylvia, how graceful for a change this ending is, lock of hair, picture and all; how lousy thou must feel, Sylvia, to have waked Monday morning and realized that the going was to me, who have. (She sat up in bed, pushed her hair back from her ears and stretched her arms before her. Then she drew her knees up under the covers and folded her arms on them and rested her chin. She stared into the empty morning for half an hour, then lay back on the pillow again. She felt like crying, but couldn't, she never could. She would cry maybe tonight. Meanwhile here was all of an empty holiday ahead of her. She turned over sighing to feel upon herself all those places I had liked best. But there was no satisfaction in that, she discovered, and decided that after breakfast she'd talk to her sister about me, which would serve her unacknowledged purpose much better because her sister, also talking about me, would still some sort of hunger that she felt.)

I can remark curiously on that. But you do it—remark about it.

As ever,
Clem

SEPT. 20, 1933

Dear Harold,

See—it's 11 forenoon and I sit in my room writing. Five minutes ago the fog cleared up and the sun stepped over Mt. Tamalpais already Oriental. Only here am I content to sit in a hotel-room at this time of the day and write letters. Outside the sun always shines through a cross-hatched sky—always. There's a fuzz on the air and sitting inside I don't feel outside as I would in Bklyn at this time of the day.

You write stories and I write poems. There's swell poetry in being 4 hours later than the East.

Once a day I think about when I shall see everybody I once knew again. Thinking about it as a point of fact gets nowhere. I let myself go, and something answers "never"—because I have a never feeling. The strange thing is the delicious feeling that's in the never feeling.

But what can I tell you about the land? That Frisco is more cosmopolitan than N.Y. That the earth here is half a desert. That the mountains of the Golden Gate disqualify any remarks about scenery, being not scenery but events. (I threw all the stories away when from Presidio cliff I saw across the bay, 200 ft. down, black fog chewing itself to bits on the

grimmest mountains in the world—who stand out into the ocean inde-
scribably.) That the weather has always a monotonous abstract chilliness
lacking the slightest, tiniest hint of Fall, at which I complain like hell. You
have no idea how grievous it is to miss Fall. And reading about its sadness
in Goethe I think in a strange removal: how strangely lucky to have it at
all. Here there are no dead leaves, no smells of their burning, nothing. I've
come to think about it in a strange way that I won't ever be able to ex-
plain—as something rare, something too many people shouldn't have,
something—— Another strangeness is looking at Frisco from a hill and
seeing instead of a blackness and grayness and redness, a cubismus of
white, cream, yellow and pink flat-topped houses jiggling up and down
over the 5 or 6 ridges that run through the town. And the weird lack of
trees and grass making a nakedness of every view.

Otherwise Frisco has damn good restaurants, a lot of bookstores, for-
eign movies, perpetual art shows, perpetual concerts, narrow slanting streets
and an old-time leisure class for which all these things are. And, as I said, it's
more cosmopolitan than N.Y. In fact, it's the only Place I've been in outside
of the South.

As to writing like Defoe, I told you 2 years ago that he fools you. You
want to write like him, of course, but it's better to write like you remember
him, or like you read him.

But tell me about Babel. I want to hear his praise all over from every-
body.

And love sort of gets between my legs. Everywhere I trip over it, and it
changes the color of my eyes in the morning.

And having a "stupid"—there's no such thing—girl love you is, I sup-
pose, exactly what you imagine it to be. Anyhow it's better than having
a—what? girl love you. There's more of a cradle motion in the rises and
falls. Most of all when she opens her thighs it's <u>complete,</u> there's nothing
to be tacked on, it's a whole thing—and that, Harold, is what you and I
need very much.

——Clem

OCT. 10, 1933

Dear Harold,

The weather is perpetually cloudy here and I'm out of love.

I live in the worst part of S.F. and every Sunday I take the trolley out to
the ocean where I go walking through Golden Gate park which is a puzzle I

can't solve. Some day I'll tell you about it and how I pulled a clump of wild-smelling hair out of a buffalo's head.

There is no civilization here I've found out all by myself. You'd be surprised. Refinements, sure, but not civilization. The barbarism is appalling. I shudder often and wonder how Jews can stand it. So savage—but not wild.

And all of California is a desert except where they sprinkled water out of cans and made unwilling grass to grow and planted trees raised in other countries. I rode down to Palo Alto south of here to see a football game and saw the earth all around withered to the bone. And the air is so empty, wide, and far. And loneliness goes through me like the wind and picks me clean.

I live in the presence of earthquakes and possible volcanoes but nobody esteems them. It irritates me and I'd like to see the place blotted out in lava. Mt. Tamalpais which I can see to the north even downtown, on the other side of the Golden Gate, looks like a possible volcano and I always hope that the clouds on top of it are steam.

I waste myself away on that.

If business were better I'd feel better on top.

If I met good women I'd feel better too.

———Clem

P.S. If you want something good read the German translation of "Gilgamesch." Enkidu, his comrade, is a medieval hero if ever there was one.

———

Days later. I somehow couldn't let the letter go like that. I'm sick of telling about the places I'm in because it's all so anti-climatic. How much so it is to tell you that today there was the most perfect weather I've seen in my whole life. That in the park balm fell from the air and that the palm tree fronds cast shadows on each other that are like no other shadows. And how the hills stretch out to meet each other.

Here I'll just say how lousy I still feel. Business was wonderful and lousy I still feel.

I saw a swell Yiddish play, "Chasea di Yessoime (orphan)" about how everybody ill-treats an orphan girl and she kills herself. It was so rich that you could almost see it spilling over the footlights and soaking our laps.

But anyhow I'm out of love.

———Clem

Dear Harold,

Yours was a brilliant letter: nude eel, sworded spoon, evoe, evoe. And you leave the ivory tower, trailing your robe behind you. You too, my fren!

The air is dark and corrosive. Everything is corrosive. The place is rude, harsh and secretly violent. I picked up a Cleveland paper in the library and saw how gentle and mild—really—the breezes are that puff on the other side of the Mississippi. It's good to know it. The place is enemy, a foe.

Last night on Howard St., bum's alley, I saw a man hit another man 5 times on the jaw, each time banging his head back against a wall, the whacks being so loud I could hear them across the street. I stood on the curb and argued whether to stop it but the night was too dark and I got scared.

I go to Communist mass-meetings often to cheer myself up. I do. There's a savage strike going on in the San Joaquin (Wahkeen) valley, and the cotton pickers come up and tell us about it; and it's exciting as hell and eloquent too. "Me and Jose Hernandez was standing dere and de Cossack come up and say: git de hell out, 'n all de workers, dey say no to de servant of de capitalistic classes." Then the crowd cheers and whistles and raises its fists. A Jewish girl with fuzzy bobbed hair and dull cheek bones goes over and hugs the little Mexican. The crowd explodes and tears come into my eyes. I go home all jagged up.

Other nights I sit and write long letters to Cleveland telling her how much I still love her. I told her I couldn't marry her and you should have seen the letters I got about crushing her heart (heart, mind you) into the depths and destroying all that was once, in her, inviolate. For a while I was out of love. But then she wrote that she should have known better and everything was O.K. again. So now I'm back in love.

———————

OCTOBER 28

I just heard from Danny Fuchs telling me that 6,000 words of a novel he wrote this summer will be in December's "Story."

I do like Sally Rand a lot and without the reservations I usually make in such cases, I think her thighs and legs are magnificent.

About the State of the World: of course, there won't be any war. What's happening in Europe is the "reassertion of its normal alignment of powers." You see, since the war there's been an abnormal and for, at least, in the first half of the 20th century, unnatural, international grouping. It's absurd to have had England on Germany's side against France and for France to have been

the chief opposition to Russia. Now these things are getting back to their true balance: the Entente Alliance, a ring around Germany. Without Germany Western Europe would be pretty much of a reconciled unit, but Germany is bursting with her un-fulfilled destiny and persists, to none of her own benefit, in charging all comers. Someday when she goes Communist she'll communize the rest of W. Europe at one stroke, not with Russia's help, but in spite of Russia. And then everybody will find out that they don't like Germany's kind of Communism—Russia'll like it least of all—and then all of a sudden we'll have the real Untergang, and maybe the final one.

As far as a Pacific War is concerned, if Japan starts one, mark my words, it'll be in early spring. Japan always starts her wars in early spring because the late spring and summer give her a chance to conduct an uninterrupted campaign. Once the Japs have to interrupt anything they lose it. (That's because they're over-professional like the Germans; they haven't the amateur

Erwache Deutschland !

spirit.) So whether it's in 1934, '35 or ever fear the Japs in March. That is, provided they start war on land against Russia. In the Pacific it doesn't matter when a naval war is started. The Japs are liable, if they looked in our direction, to start a war at any time as long as it's a matter for ships.

But there won't be any war. For the time being we're incapable of that much excitement. Can't you see that?

This afternoon I went to a football game over in Berkeley where the University of California is. You take a ferry across the bay and then you take a train. It was just like Long Island only more barren. The mile after mile of houses gave me the feeling that somehow the place didn't belong where it was. Nothing like it should have been possible so far west of N.Y. and in a land of earthquakes. But that's the Anglo-Saxon for you.

They tell me that you can go for miles down any of the great inland valleys without seeing a white man, only Japanese and some few Mexi-

cans tampering with the earth all day. And that if white people live there they hate it.

I send you a picture of something marvelous. Anyhow, this (French wooden Christ, 1460) and some wooden group carvings by a Mexican are two perfect things. The Mexican, especially, is something nobody ever warned us of. I wish I could show you. The names are Celso Gallegos (The "Blue Four" is the circle he belongs to) and José Dolores López. I'd also like to show you the

ECCLESIAST

ART TREASURE IDENTI- FIED Three views of a figure of Christ now on exhibition at the M. H. de Young Memorial Museum. The figure, carved in wood and very nearly life size, was covered with a thick coat of paint until a recent date. When this was removed the fine quality of the original carving was revealed and Dr. Heil, director of the museum, believes it to be French workmanship of about 1460. The statue was the gift of M. H. de Young, founder of the museum. The three pictures are excellent examples of art photography by Johan Hagemeyer

The ropes are curious. I can't understand them.

shrunken body and withered legs that are underneath this head of Christ. The effect might remind you of the restored Aristogiton & Harmodius, but the very fact that it doesn't is significant. Really—it's the best piece of medieval art I've ever seen.

I also heard Mischa Elman play the violin(t!) and except for Mozart made warm I was cold. (Mozart should be made warm. The music is precise enough to stand it anyhow.)

The rainy season has started but they tell me it won't last. In the park the drizzle sounds like summer rain and the grass has become new green all of a sudden.

I go to Los Angeles after Christmas which they tell me is the New Babylon of the Western World. I expect a lot.

My hand across the mountains, the prairies, the deserts and the Mississippi River.

As ever, maybe,
Clem

NOVEMBER 9, 1933

Dear Harold,

I read your letter over breakfast and enjoyed it as I've enjoyed all your letters lately. (Maybe it's because of where I am or rather because you take it easier when you approach me.) How good thou art, Horus, I'll

Paene Sirmio ocelle insularum.

Horus I'll call you. falcon-headed

call you, falcon-headed. Haji, Hosea! Hrafn, Hortus, a garden, Harold of the Twisted Neck!

Buddha says that every word breathed or written on earth has a separate echo in each of the planes of existence and in each realm of heaven. In China they buy a batch of prayers and throw them about when there's a high wind. And a Name is a Holy Thing. I name your neck.

I see you hanging over the sink. Your pajamas (green) hang loose from the lost points of your shoulders. Your mother says "Harold!" and the sun shines through a single window. Meanwhile in the streets the Workers are starving and shivering.

You were hypercritical about that "Christ." Don't you see the crown of thorns and the cicatrices? And, for God's sake, don't you think anybody can tell offhand a medieval Christ when he sees one? Of all things! The wood is now an olive yellow with a very hard surface. It was once polychrome and you can see the flesh-color traces underneath the arms. As far as "thickness" goes, what can I tell you? Dope! it's solid wood, dope. Ask me how thick is a picture. Fond dope.

I've read both the books you recommended in St. Louis and agree with you, except about Moore, the English sculptor, who's stuff is very facticiously "moderne."

I see by the "Hound & Horn" that Mathew Brady, my favorite photographer, is beginning to be recognized. Do you remember the "Photographic History of the Civil War" I used to look at for hours in the History room? It's him.

I've met a girl with her own roadster and 3 dogs. She has lots of money and is sympathetic. She has unknown amounts of money, I hear. She even has shares on the market that go by her father's name. Meanwhile she likes me and calls me Clement, instead of Clem.

Yours,
Clem

Dear Harold,

It's as warm now as the air in a bathroom when the tub is filled with hot water. When you take the cable car up to Nob Hill the city lies underneath perfect in detail in the just hot enough sunshine. And you wonder at the permanence of the perpetually blue sky. And when you go down again into the city its grand urbanity is magic, and I say, this is a city. I rescind my harsh words concerning San Francisco. It's City and Place in essentia.

On Kearny St. below Chinatown and near the Latin Quarter there are dirty Xmas postcards in the window of a novelty store. Pacific St., that was

once the Barbary Coast, now has three new-fangled bar-and-nightclubs. A month ago it was the most forlorn st. in Frisco, with the old, old gaudy honky-tonk fronts with their white and gilt paint and curlicues on the Coney Island style which comes originally from Germany and fauns and nymphs all boarded up, chipped, cracked and desolate. It was sad to see. You have no idea of how exact a clue they are to places for which we no longer have a generic name. But now the street's humming again and the crowds are better even than in St. Louis. Between Kearny and Montgomery the whole street's in a reddish glow. Inside they sing dirty songs and the entertainers make dirty cracks when they see you leaving too soon.

North of the Slot (Market St.) I found a swanky, people call it "bar-lounge"—that's new—a bar and one enormous room where you sit and Chinese water-boys serve you while you watch casual entertainment. There are no tables, all you have are little tabarets and everything's speed-line modernistic, concealed lights and big blocks of color—really a swell place and I was very much impressed, the drinks withal only being 25 cents a throw.

I also finally saw Sally Rand dance and was disappointed. Frisco being broad-minded, she was stark naked and very careless about it, not bothering to hide herself with the fans. There was no tease and the dance lost its purpose. Anyhow her details are too heroic for such a short height and that made her nakedness too lubric for words, I getting all hot when I shouldn't of. She'd go swell as the Great Earth Mother. Still, her legs and thighs, especially from the back, were magnificent—I hand her that.

Business is still lousy.

Last Sunday I rode the ferry over to the North side of the Golden Gate. I found a peaceful valley 5 miles north between the mts and the bay where the air was clear as white wine and with the balsam smell of redwood firs. The trees were much taller than any I'd ever seen. I started to walk up Mt. Tamalpais and, a car coming, I waved and got a hitch. The fellow driving was from Syracuse! He had nothing to do, and so I bought some gasoline and we went travelling up the mt and then down again through the peaceful paradisical valley that was grown thick with eucalyptus, sequoia, gardens and white isolated houses. It was unspeakably beautiful. And then the strangeness of having the sun set so early in a summer-seeming place, green and warm. I can't get over that.

And going up the mt: on the one side the road fell away in a sheer drop of several 100 feet into thickly wooded canyons, on the other the steep mt. and banging around the curves made me almost shit in my pants. And I could see the ocean & the bay at the same time.

Ah well, even in Golus there was a river to weep by.

My Sylvia writes that next week is Thanksgiving and that "scarcely anything makes a girl happier than to be with the man she loves on a holiday." Sweet soul, she's becoming a side line now, although mornings in bed I tease myself with her image still.

Schreib schnell,

———*Clem*

Dear Harold,

Send the enclosed back. It's the only copy I have. Two days after the lynching down in San Jose, 50 miles south of here, they were peddling these postcards all over town. And they're still selling back-views from a stand on

Market St., a dime for 3 of them. But what's a back-view? This stuff haunts me like no newspaper crimes ever did.

The lynching is a very good paradigm for California. Consider it and feel informed about where I'm at. I'm anxious to see Texas, I hear there are even worse possibilities down there.

Out here when you say "thank you," instead of "welcome," the answer is "you bet." Everybody says it. If you tell them you're from the East and you're going back eventually, they say—every one of them in the same way—with quiet, confident assurance: "You'll be back."

The basement of the Museum of the Legion of Honor is filled with pieces of heroic sculpture of the style popular between 1848 and 1914, charging horses, fierce Theseuses, terrible Angels of Death, etc. They once bought as much of it as they could lay their hands on, wanting to have the best collection of sculpture in the world because sculpture is the noblest graphic art. Now all they have upstairs is a lone portrait head by Epstein of someone who used to live in San Francisco. Well, well.

Consider what I do in 5 days: hear José Iturbi play, see "Thunder Over Mexico," listened to V. F. Calverton lecture, hear Langston Hughes talk, see "Sailor Beware" and "Potemkin." Lord, I look at myself—for the first time—aghast and feel horror to see the emptiness of my time. "Thunder Over Mexico" was good in spots but had no drive, no accumulation—Rus-

The peons are watching the sun rise.

Thunder Over Mexico.

This is one of the shots from Eisenstein's picture

—Clem

sian pictures usually do have that. "Potemkin" was great but somewhat mutilated. I shall never forget the Steps of Odessa, never, never. "Sailor Beware" was, of course, bilge, but the worst kind.

Langston Hughes was swell though his poetry is mostly rotten.

Iturbi let me down. Literally dry, dry as old wood chips. And he missed notes: even I could tell.

The weather now is the unpleasantest I've known. A continual raw foggy chill, not cold enough for frost, just a bitter uncertain chill all of the time.

I don't make any poetry.

"How shall we sing the Lord's song in a foreign land?"

It's Saturday afternoon and it's yuling outside. This morning I had a dream of fair Buttocks and lay abed till 10 thinking on them, but jumped out of the covers and took a cold spongebath to get down to the store by 11. My rutting time of the year draws near: January–April. At the store I found 3 Xmas cards for me and they didn't stimm. In N.Y. a Xmas card was swell.

Yours ever,
Clem

1934
Clem writes on stationery of Century Neckwear, 508-510 Mission Street.

JAN. 26, 1934

Dear Harold,

Thanks, thanks, thanks for the Beowulf. I done already learned the stuff I got so excited. (And it's not half as tough as you make out.) Danc!

I think I feel a little better too. I've attached a womb man to myself, and Lord! that's all that was needed to make the Calif. sun rise. I think I feel laughably better. My days and nights are beginning to get full and I keep my fingers crossed for fear of breaking the spell.

The sun is warm enough this week to make my fair hair feel hot to the touch. I stand in the doorway with my face raised to it and take in little grains of warmth all over the top of my face. And the golden air falls down like tulle, draped over Twin Peaks and Mt. Tamalpais, and—OH GOSH!

Lord, I say to myself, must I be hysterical too? Excuse me—OH GOSH!

I met a German-Jew Communist leader at a New Year's Eve party, who'd escaped from Munich over the Alps on skiis a while ago. He knew Bert Brecht well, had met him in exile in Vienna and told me he was now in Denmark. Also told me that Stefan George had died 2 months ago, half-insane and all Nazi.

Saw Katharine Cornell in "Romeo and Juliet" in which the acting was lousy, the directing good and there were 3 perfect scenes where Cornell grew up and recited verse as I dreamed it should have been. It was really swell.

Heard Ruth Slencyzinski, the 8 yr old prodigy play Beethoven's Piano Concerto in G major, no 1., with more wit than Iturbi had played the Waldstein Sonata—and with a swell cadenza she'd composed herself. Then the pot-bellied kid went on to play 8 encores in a row without getting up from the bench, at which Molinari, the conductor, put on his hat, coat and white muffler and started to leave, swearing in Italian—which the kid said later was dirty names. Then the kid's father, a bald headed little Jew, came out on the platform and yanked her away amid the cooing laughter of all the women in the audience. I didn't know what to think. Really, I didn't.

Went to the Chinese Theatre and went crazy over it. Oh Harold if you were only here. It's better than something. The comedy that I could recognize always came before some one was to have his head chopped off, i.e. one victim showed his mandarin cap, piteously mugging; another victim, a servant-maid, was saucy to the executioner. I think of Hamlet.

Write soon.
——Clem

Dear Harold,

I'm so utterly in love that I begrudge myself the effort spent in rising from a chair.

Lord, what can I write you? except that I hope you are not as you were, and my fundament, in the eternal end, is ever to you—and not an Elizabethan "fundament." And that when I crawl out of this you shall be there as ever perching birdlike on this fence I forever run along.

But I'll tell you how I love. You know the tune—maybe it's different this time. This one wept suddenly while I was kissing her and said it was because I'd someday break her heart. I was shallow, she said, and I acknowledged it with a smirk, and then I kissed her and then she cried.

After, she sent me a letter and on it she'd stamped 3 dates: Feb. 12, 19 and 26, which were to be the Mondays, each, after the weekends I usually spend with her. And underneath she'd put a poem saying that they,

> "Seeming to be intrusive prophets
> of a future time,
> Are really testaments that time
> Stands still."

At which I pinched myself. And then 3 cards: on the first one she wrote "Inferno" and quoted this from Dante:

> "E che diro nell' Inferno a malnati:
> Io vidi la speranza de' beati."

and on the next, "Purgatory," whereon she wrote something about bachelors, and on the last, "Paradise": "Ah to be a chameleon myself. To reduce the pupil of my soul to a pinpoint like the pupils in your eyes—so in that manner am I in paradise, an objective one—in which one has cold-blooded control of one's sentiment, calculates about one's sensations and thereby purchases the world."

I felt the reproach so sharply that I lay awake that night with a pain in my stomach. Anyhow I want, for the second time in my life, to kneel before a woman and salute in her a Universal. But it'll all wash off in the end.

She's a gentile, her name is Toady Ewing and she's a divorcee, 3 years now, and she's 26 yrs old. So. If I had enough money I'd probably marry her to spare her the breaking of her heart.

Lord, I don't even feel devilish, the way I usually do, nor proud, secretly, of my prowess and smug. Lord, Harold, I'm lost.

<div align="right">

Yours,
Clem

</div>

<div align="right">

Feb. 22, 1934

</div>

Dear Harold,

When I said I hoped you were not as you were I meant nothing at all about "being to <u>me</u>." Among the signs of my coming of age is to forget that. To forget it here and not seeing you, only writing to you.

All signs make me say that you are about to become a genius—even though you still have no feel for this language. I wish you did have. I'd enjoy your letters more.

I can't help it if I sound inordinately smug now. I can't help it. But I'm not. It's that I spent last night with Toady, and going home at 7:30 in the gray cowpiss California morning—all passion spent and reeling with unrealized bliss—and going straight to work, I was this morning—when I got your letter—as encased in formaldehyde, and all the liquor had I gotten drunk on coagulated and made a thick slime to coat my insides. Then reading your letter I forgot all about this and where and when, and finishing your letter, I realized of the sudden my unmatchable bliss now remembered. And thus you have me. I still smell the smell, the acrid smell, of such bliss.

I can't tell Toady to write to you. She'd be greedy for it, but that sort of thing would tangle my heels when I make my eventual escape—shame on me for that, believe me, so vile—it would be giving her a hostage. Please, you don't know how in this case I hate myself. Please, you don't know how I've lost everything I once had on the ball.

The winter rains are on now, and it rains every day. Every 2 hours the sun comes out, but it still keeps on raining. The monotony of the strained and drained air coarsens your senses.

Write as before and thanks for it, thanks ever so much.

<div align="right">

——*Clem*

</div>

6

MARRIED

"I am so perfect and self-contained and complete as something uncreated."

Dear Harold,

Forgive the type, but I get pleasure out if it now. I go so fast.

When you read this I shall be married. This Friday it's going to be. A simple ceremony, a few intimate friends, etc. only not even a ceremony and there are no friends. The bride will be as it were, the groom as he would. "But, really, fellows, she's a wonderful girl. Wait till you meet her." After the ceremony the bridal couple will make a short two day trip to the North woods. "It's so good having you all to myself at last. It seems such a long time that I've waited." But so help me God if I'm kidding.

I'm sort of fell in. Lord, I didn't want to get married but as time went I couldn't help myself. Toady did an amazing job of it, anyhow. The timing and the deftness were miraculous. I was trussed up to my very bald pate and handed over as compact and unpliable as a salted herring. I can't even regard my belly button. But hell how I'm happy!

Now I'll tell you about Toady. She's 26 without looking it, has reddish brown hair, her eyes are mottled blue and she's 5'2" tall. Very delicately pretty, not a feature awry. Short upgoing nose, hardly any eyebrows and small always red mouth. (Oh Christ, listen to me.) Sort of well filled out. Good legs. Has a couple of moles on her forehead.

However the question is the soul. Toady says she doesn't know how on earth she could ever have been so lucky as to find me—a sense of humor, she says, that refutes the world and makes it as nothing, tall and handsome in a thorough, imperfect manner, will pat horses and then smell their necks, an aristocrat, a blue-blood because living as in a vacuum.

But Toady is very feminine, gossips like a chicken, swears hysterically, wants to know what people think and makes cooing noises in her throat when she loves me. Has to go to the toilet every 5 minutes. Reads slowly and talks in a monologue, so that I can listen whenever I want to. She's English on one side and Mostly Scotch and a little bit Irish on the other. Was brought up a Presbyterian. Has relatives on the Social Register, a grandfather who was a judge, a cousin who's a colonel and an ex-husband, who it seems was a tall, handsome shit, but had a lot of money that he really didn't have. Got out of Stanford where she was one of the snappy, high-toned Kappa Alpha Theta girls. All this I know by heart, and some of them give me visions that break my heart.

Anyhow write and ask me how I feel, and you feel different too but not hysterical like me.

In 2 or 3 months we go to New York, then you come and see us and act in such a manner that my wife will see what a wonderful husband she's got. And she'll cook you breakfast and listen entranced while we talk in our pajamas; at night, that is.

But don't send me a wedding present. Write an epithalamium.

Tell your mother and then tell me what she says.

———*Clem*

I'll be living in her place now, 1644 Taylor St. There are no relatives except a widowed mother who's going down to Carmel to live. Light housekeeping, maybe, it'll be.

APRIL 5, 1934

Dear Harold,

Thanks for the Epithalamium, the solitary legendary note. Being married was otherwise something I did in my spare time. And otherwise one of the steps of a development that has steps. Anyhow how remote and far-off faint doth thy voice sound.

I can't tell you much. The emotion has to be recollected in tranquillity. I walk in the street and feel that on me and with me goes a business of ramifications, of having connections, of standing for something, of filling more space than my body actually occupies. It's not a good feeling.

Also the sense of completeness: actually nothing lacks, nothing. I am as perfect and self-contained and complete as something uncreated.

Fat and ardent I walk about my wife in circles, circling ardently. My wife stands her shoulders bent forward slightly and smiles up at me without showing her teeth. Her eyes water with happiness and with loving me so much. I smile too, reassuringly, large, protective, curious, impersonal and self-possessed. I know what she's thinking about but she doesn't know what I'm thinking about. She continually asks me and I have to invent things to tell her.

Meanwhile we made a 3 day honeymoon. We started out Friday afternoon and stopped for the night at Merced, 125 miles west and south. Saturday we got to the Yosemite, which is a flat valley filled with fir trees and streams and surrounded by great rock escarpments that lean over narrowly on the narrow valley. Waterfalls pour down from all directions—we saw them in the moonlight—and antelopes come up and feed from your hand. We left that place Sunday afternoon and went like hell to get through the mountains before dark. That was in her mother's car. And so we got back and settled down. It was very nice.

My father is all in an uproar, suspecting the worst and inditing cutting remarks, but he's 3,000 miles away.

The night was made for love.

The comfort is what kills, the too too utter comfort. I've not been so much at home since my stepmother came into my life. Toady hangs up my pants, turns off the alarm-clock, makes my breakfast and rubs my back, which she says is supposed to be a pleasure.

The son of the president of the Southern Pacific R.R., which impressed me no end, and his wife gave a "cocktail party" in our honor at which I met some few choice shitheels and many pricks. Every day now I'm meeting some of the best people. It's not Toady's fault; she can't help it if everybody likes her and everybody knows her and wants to make her feel good. The anointed, although chosen for angels, are always surrounded by the damned and the wicked, too.

The Epithalamium was somewhat wasted on Toady as the only poetry she understands is her own. Anyhow what she understands and what she doesn't signifies very little to the case.

We'll have to leave San Francisco after the first of May as the place here is being given up. I don't know what's going to happen to us.

Write and tell me.

——Clem

Dear Harold,

I was disappointed in what your mother said about my marriage. I was disappointed in what you said. I was disappointed in what I myself said.

Everybody tells me how happy they are—you too—and I can't understand. Why happy? I wouldn't be happy for somebody else's marrying, not even—but yes I would—for yours. But why happy anyhow?

Besides it's something that you all take so seriously. I get frightened, standing up and looking all your seriousness in the eye.

All those things you wrote about my becoming this and that (family man, as others, etc.) are true. It's plain to see. Greenberg enters and now we all can behold him—at last. Sure. You even had to warn me about the "young married set" business. Except for that, I could have written what you did write beforehand for you and saved the trouble. But that married set business, 'twas an unkind cut, my friend.

My wife, whom I let read your letter (we sit down and keep no secrets from each other, since we're so congenial and this is going to be like it should be, all cards dealt and showing, even to the blackheads on my buttocks) is already jealous of you, assevering that you love me dearly. We went on an orgy of letter reading, I reading the letters her boyfriends sent her, and she the letters my girlfriends sent me, and each girlfriend, she said, loved me, even the intellectual and the casual ones, more than I knew.

I guess Toady is <u>something</u>; though hardly, I suppose, what you think. This much, maybe signifies: that her sense of humor has been turned inside out several times, yes. But otherwise, palpably ignorant, unwarned, and without whimsy, inordinately well-bred, and with that Gentile passion for knowing a lot about a little bit. But what keeps me astonished always is to live so much for the heart, to be so pretty and to fall into tears so quickly when I tease her with saying I won't be true to her forever. Then as usual I fall to my knees and kiss her feet.

Her real name is Edwina, since you asked for it, which naturally I can't call her. Toady, I like.

I ain't as tough as I used to be, am I?

And to be so perfect, too—well fed, well rested and well fucked all the time. Every line in my face is substituted, every curve in my body replaced. Oh well.

I've reread this Saroyan. Yeah, I'd like to meet other people too.
Read Stephen Spender. I bought his book, "Poems." Real good.

——*Clem*

P.S. Forgive me a lot of things.

Dear Harold,

Coming down to the store at 12:30, found and read your sincere letter. It was god damn nice of you to make the business so serious—which I can't do myself. There would have to have been a sharp cutting off, and then a sharp beginning. But it wasn't that way at all, so that outside of the first few spasms after the judge had hitched us, I felt back again all my loose ankles, joints, etc. and my leisure and my private nastinesses and all the rest; only the poetry was different.

I'll say that the amazing, miraculous, confuting thing is that marriage doesn't at all have to be what it's always, without exception—for me—been made into. I can't understand why I'm the first not to say: honey, dear, sweetheart, and to cozen.

As for the too-much happiness, that I don't know. It's not the happiness, anyhow, it's the perfection and completion inhabited with.

Toady says, upon seeing her, you've got to like her eminently. I say so too.

See: Toady unfurling her hands about her like you.

See: Toady defining the right thing in the right place; even as yours, her hands writhe to show intangible contours, and her mouth strains to show colors.

See: Toady drinking innumerable straight whiskies, while I go blurredly drunk on two sniffs of gin so that her face takes on a halo.

See: Toady ascending to heaven in the simple regal magnificence of the pure and simple saints.

See: Toady as the Heart of the World speaking kind words to a beggar.

See: Toady, disgusted with me, turning her smooth white naked back.

See: Toady chattering full-heartedly in a circle of women, and looking towards me with kind impersonal eyes.

See: Toady understanding everything, catching the most and the least. That's the real wonder.

We drove into the Yosemite valley in our open Ford and she turned her back coldly on the overpowering scenery.

I can't get [Sir Thomas] Wyatt for you here as they don't even know the name in this place. I'd looked high and low for your present and only found Brehon mouldering in a close out lot. Otherwise the place has nothing— dozens of good bookstores with no books in them. The library is worse.

Sol writes that my father, the king that was before me, now takes kindly to my marriage, having seen a picture of the girl and being convinced that she's "very good–looking," good–looking enough to be his daughter-in-law, the cynical law-giver. The padre, however, is in a fuck of an uproar about my "plans."

——Clem

APRIL 24, 1934

Dear Harold,

Your long letter was very beautiful, especially about my father, who was never reported so well and perceived so thoroughly. It will stand as his definitive text. You really have talent, Harold. No kidding, it was damn good.

After Los Angeles Toady doesn't want to go back East on the train and neither do I, so we have an idea that maybe we'll go back through Mexico with the purpose of getting stuck there and having to have money sent us and not having to have to leave. The only thing I lack is intrepidity, but Toady has enough for both of us. We think we'll find a tramp steamer out of L.A. to Mazatlan on the west coast of Mex., and from there there's a railway line into the interior that ends up at Mexico City where, however, we do not want to go. Dearly dreaming. My wife is scatter-brained and I haven't the slightest faith in her intention, only she loves me a lot and wants to make me happy.

Oh my plans. There is no sense in a book of poetry, no matter what you say. I shall tell my father that Toady will write the book. She writes very

good diaries in the Anglo-Saxon style and writes well anyhow, putting down nothing but facts and what the hatter said to the hare.

Thanks for telling me about my brothers. I'm curious about them, not so much about Nanny, whose integrity I haven't suspected. Marty I'd like to enter for the boy beautiful long ago, fatness notwithstanding, and Solly for the reaping of the sowing. I know about his Communism and it pains me because it's too typical of where I come from. I'm very nasty to him about it because the being one disgusts me.

As to using influence to get you a job at N.Y.U., foolish boy! Do you think because the son of etc. gave my wife a cocktail party she has influence? or that the son of etc. has influence? or that I have the influence to influe? Such naive Jewish faith. My wife herself was needing influence herself when I first did meet her. Besides and for your sake I'm hurt that I have to kid you about it this way, your trust in the great ones of the earth.

I've heard about [Giuseppe] Ungaretti too, but I shouldn't have any interest in modern Italian poetry. It's a hunch.

Meanwhile I'm reading "Martin Chuzzlewit." Look at me doing it and you see how I am now.

Be happy.

<div align="right">*Clem*</div>

Clem and Toady are in Los Angeles at the Hotel Ritz, Eighth at Flower Street, "popular prices, absolutely fire-proof and earthquake-proof."

<div align="right">MAY 17, 1934</div>

Dear Harold,

We were supposed to come down by water on a little wooden steam freight schooner, but after spending one night on board, being delayed by the stevedores' strike, the sailors and mates also struck and we couldn't get out of harbor: so we came down in the day time by train, which was a grievous disappointment and the scenery was lousy.

This place is what you expect it to be, only more and less so here and there. There's no rest and of course everything is hectic and en route, etc.

We waited 2 days for the boat to leave and said goodbye 4 times, which made an effect on me that I've never before known. As if I spread my legs too far apart.

Los Angeles sheds its glory afar. I was excited more and more as I approached it. Well, it is that sort of a place truly. I've already seen one movie star, but I don't [know] who it was; a blonde young lady ensconced in the back of a Rolls-Royce like some precious jewel, as inanimate and as much to be gazed at. I was thrilled.

But think kindly of me.

As ever,
Clem

Clem writes on stationery from National Neckwear, 766 South Los Angeles Street.

MAY 25, 1934

Dear Harold,

It's very hard right now to write a letter telling all. I don't know what's going to happen to us after next week and I haven't the heart for minutiae. We're living at this moment as in a desert, sleeping late, and during the day I'm all preoccupied and discomforted writing poems in my head. I don't feel good at all.

As for the "alone and together" business, I knew that in San Francisco and on the honeymoon. But please don't ask me things like that.

Day before yesterday I went to the R.K.O. studios with a letter of introduction, trying to get a job. I saw some mope with a book in his hand and one of those ubiquitous sport suits on who sat and moped and told me nothing doing. Introducing him to Toady he gave her the once-over in the French manner and looked rapingly hot daggers all over. Toady told me that was the Hollywood style. Then we saw a picture being made. Something else about Villa and a Mexican girl sang "Cucuracha" and Don Alvarado looked very handsome in skintight pants. Anyhow the movies are nothing but a Jewish business and that's all you need to know to know what they're like. Inside the studios look like big bath-houses and there are a lot of sporty looking little Jews and fairy scenario writers and high-school girls.

Los Angeles is, like Frisco, without particular qualities. Only not as cruel and without the hollow gustiness and ammonia in the head feeling. The ecstatic architecture is strangely toned down somehow by the place and the climate. Anywhere else it would be a hot poker in the asshole and hysterics but here it's nothing but houses. Over all is nothing but cheapness literally—not cheap taste but cheap cheap shit, cheap goods and

cheap cheapness. A nickel buys a dime if you have the nickel and you can piss on the sidewalk.

At dusk the sky turns into a beauteous undiscovered blue. The general foliage is a much darker, blacker green than anything I've seen before. Behind it the reddish-yellow earth is always struggling through in perpendicular strips. The trees can't show for goodness against your beloved northern ones. They're very poor and the shabby palms are even worse, seeming not to prosper in any of California. Nothing grows on the mts. in back of L.A. except black scrub, and half of the time not even that. But they are grand mts., very much of the quality of mts. showing swell through this vacuous air. Meanwhile civilization sprawls over a great plain 30 m. by 20, that ruffles into hills here and there and cracks into dry water-courses, most of it covered with yellow brown grass. And dingy bungalows.

MAY 28, 1934

Saturday we went to the Pasadena Playhouse and saw the "Playboy of the Western World," which was swell and given pretty good. Saw Marlene Dietrich there and when her escort, a little German, asked me for a match, I almost fainted. Also saw Theda Bara. Saw the Huntington Library and Museum in the morning and some swell pictures by Joshua Reynolds and Sebastiano Mainardi and the best tapestries I ever saw by Boucher.

Did swim in the ocean Saturday before, which down here is saltier than the Atlantic but at S.F. is the same.

Much driving and seeing and yelling goes on in scattered slung out snatches but at the bottom this place is much slower than Frisco, smothered hysteria and all.

I'm reading "Two Years Before the Mast" and going down to San Pedro to pick out the spots.

Don't pass up Auden, the English poet, in spite of fancied resemblances to Stein. He's really a much better poet than Spender. Read "The Orators" which counts as much as "The Wasteland." Honest.

In a week my salary stops.

Write to the Henry E. Huntington Library, Mr. I.M. Iiams, assistant to the Librarian and ask for a job with the foreign language collections. The address is San Marino, Calif.

Clem

Dear Harold,

You're very right in not trusting my judgment about poetry. I don't ask a hell of a lot of it. Still your hunch about Auden is wrong. Read his prose in "The Orators" and then his ode to his prep-school Rugby team. There's no question about it, my fren'.

Since Toady read Marianne Moore aloud to me and I discovered how nothing she really was I've given up and gone in for my faults. I sent a poem in to the Van der Lubbe Contest the "New Republic" is having, after seeing in it Stephen Spender's lousy poem about that same. I wrote it in the same swing me up again, John, quatrains, ending as follows:

> The prey is dead and we see it moulder.
> But these who have not eyes
> Must leap and tear again the flesh, colder
> than all their rage can warm, beyond their prize.

It was fun writing on a set subject and besides, I really don't like the Nazis.

I wrote an account lately of how John Colter escaped from the Blackfeet. He was a Lewis and Clark guide.

I'm now writing a guide book to California. It's become easy lately (knock on wood!) for me to do whatever I want with prose. Rhetoric doesn't haunt me so much. And it's easy too to sit home and write while Toady is behind me in bed, reading "2 Years Before the Mast."

There are also some very interesting things that come up between us, making me think that at last I've come to real grips with life and that you might be able to write a book about it if I told you which I don't know whether I will.

I feel wretched every other day but it's all right and you can worry.

In a week we might go up to Carmel where Toady's mother is now living with a sprained back.

My father, the sly dog, breathes not a word about our going East, and I don't know whether I want to yet so I don't ask him.

When you write to the Huntington Library, say that you know very thoroughly Anglo-Saxon, middle English and its orthography—you know, with facts. The collection specializes in early English business I found out.

Come to California. You won't like it but it'll do you good. You'll be miserable but it'll still do you good.

My guide book is doing me good.

Toady sends her regards.

——*Clem*

She thinks it was swell of you to invite us and will come if I come. Toady is like that, so you know, huh?

Clem and Toady are now living in Carmel-by-the-Sea.

JULY 24, 1934

Dear Harold,

The silence was desperate silence. I couldn't have written to you for the sake of heaven.

Crisises that stay: I never had one before—that stayed.

The business went out of business, my salary stopped and we came to Carmel where Toady's mother lives. I haven't a cent and we're living on the mother which is a damnation I couldn't have dreamed more exquisitely. Papa takes it for granted, which isn't so bad; maybe if he took it any other way I'd be in worse, out of perversity.

Anyhow we've been here since June 10th, about. It's a cottage bungalow with 3 rooms we live in on a street bordering the wilderness. Carmel is where Robinson Jeffers, Lincoln Steffens, etc. live: California Bohemia, dirt streets in the middle of a pine forest on a rocky coast, romantic scenery, old Spain, the John Reed Club, little theatres, "Homer Winslow" water colorists, etc. It could be a lot worst, and it isn't awfully bad. The smooth mountains are good, the rocks in the ocean; and the color of the water is the real miracle here, something to live for and hope.

Meanwhile I write short stories, send them out and get them back, and suffer from a lot of things, about which some day I'll tell you.

I don't know what's going to happen to me or Toady. Maybe I'll come and visit you.

For a week I had a job on a newspaper in Monterey (look at a map) but didn't have enough experience to last, maybe. Anyhow I interviewed Charles Laughton and my name was signed to the article. Charles, himself, was a dud and carried a wife with him to prove he wasn't a fairy—and asked me right off if there were many "perverts" around here. But otherwise commonplace.

I'm too young to be married. If I could be a great man it would be different.

And Harold, I thank God I have you. Honest, I'll tell you. You're Jesus almost.

Summer here is like anything else. The hillsides are burnt brown and the days are longer—that's all. It's disheartening.

I'm still, I think, in the daze out of which I didn't write to you. It should be a daze, I shouldn't be fully conscious, I should be able to hear my hair walking and see the color of the air I breathe.

Clem

Dear Harold,

Thanks for your good letter. Just before it came I was in the last extremity, devising ways to run off to China, make money or kill myself. It's not that I'm still not doing these things, but it's with more hope now.

Anyhow I'll be leaving here soon, like a skunk maybe or maybe just like Ishmael. My father wrote and very sympathetically offered anything he could do except money—or only the money to come home; he offered that.

I wish I had the patience to explain. Toady's going to have a baby which can't be stopped. I feel as unconcerned about my seed as if I'd used it to water the burnt grass here, and no love for it or tenderness or metaphysics, not even an expedition of the mind into fruitfulness and conception and the duplication of myself or all the other things that might, typically for me, be aborning. She wants to stay here to have the baby, with the doctor who once operated on her. I won't stay.

Anyhow don't tell anybody until it's born. I'm ashamed of being a father and I'm too young to be one, as somebody said.

On my way to N.Y., if and when, I want to stop with you.

As for your being a Communist, I'm glad to hear the saying so, but it doesn't make much difference, you know that I know. We'll talk about it so we can both laugh at the right moments.

Harold Jonas and wife stopped to see me last week. They shipped their brand new 1934 5-seater green Buick to Los Angeles on the boat with them and drove up. The man is fat and awful, the woman is nasty. Toady couldn't stand them, I'll say for her. Harold is spending lots of money and they have a maid now. I said to Florence, "with all that dough," and she shook her head slowly in awe and said, "isn't it though," looking at me for awe.

Your pictures were good for you. But you're really much handsomer. Really.

Here is a picture of Toady. See?

Meanwhile, when my head clears all I can think of is the shapes of the hills. They drive me crazy here and I write poetry about them. It's California's revelation.

First I used to get mad at the ones across the Golden Gate and then when I saw more and more of them I got more mad until it stopped. They are the only thing here.

——Clem

Dear Harold,

I should have written sooner, but I was in that state where I got up every morning to move thickly, pawing the air, and ready only for inspiring tales about the remotest things on earth.

I wrote my fadir to send me bus-fare, having chosen and decided. It's a fuck of a situation, as someday you may hear.

As to fears of fatherhood: I once told you how my penis was very impersonal to me, how I felt it belonged more to the well-ordered, established and duly constituted world than to me, & how I, personally, had little to do with it. If it weren't so, then I'd have fears of fathering a monster, but as it is I'm only the vessel of the seed of my forefathers. I'm just handing it on. I haven't even touched it. My father will see to it that there is no monster. The baby will weigh 7 1/2 lbs at birth and for 5 years look like Marty.

But I can't talk much. It sounds so bad to my ears.

I expect to start for the East within the next two weeks and go by bus to see the scenery. I've been reading Washington Irving and I want to see all the places. Besides, on my way here the train went through the best part of the Rockies at night.

I've a lot that I have to tell you, that I can't write you: epic, dramatic, comic, tragic, obscene, swelling, etc.

About fatherhood again, read that about it in the library episode of "Ulysses": the father never conscious of his fatherhood. It's the last word on it.

Write me more and sooner. My state is on me again. All lyrical and vague and important. You know.

——*Clem*

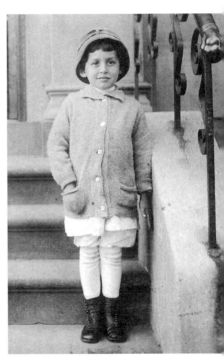

Left: The family, 1926: Martin, Clem, Sol, and Joseph (seated). "My father says I'm a lazy son of a bitch and a disgrace to my heredity, but I don't care because I like him too much."

Below: Clem in Norfolk, 1914

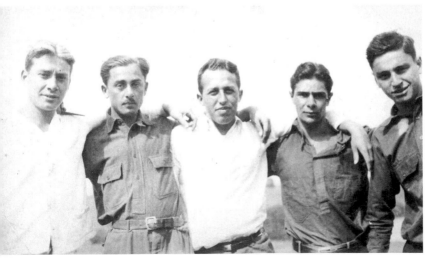

Left: Camp High Lake, 1928. Clem (center) with fellow counselors Bob Bostaman,(?), Willy Wallace, and Danny Fuchs.

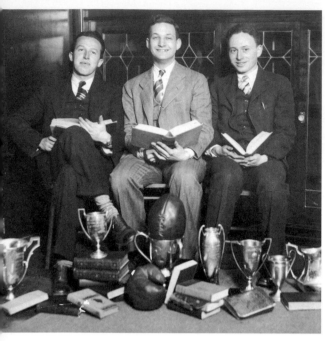

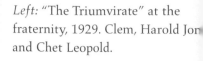

Left: "The Triumvirate" at the fraternity, 1929. Clem, Harold Jon and Chet Leopold.

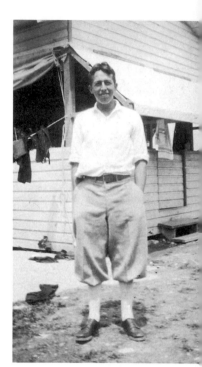

Right: "Mothering snotty brats with names like Seymour."

Below: ETA Chapter, Sigma Mu fraternity, Syracuse University, 1928. Clem, 2nd row, far right.

Right: Cleveland's Sylvia: "More than anything that Proust ever aimed at, or literature or you and I have ever dreamt of. Please let it happen to you."

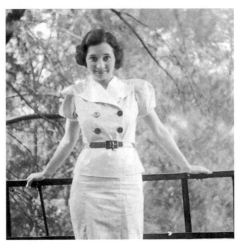

Left: Nanny, 1932. "I share her routine: lamb chop, mashed carrots and a nap. It's like a magazine story by a Jewish old maid."

Below: Visiting Marty (far right) at camp, 1932. With cousins, Irving Greenberg and Irvin Galin.

Right: With Harold Jonas, "the idle heir of millions."

Below: Toady, 1934. "I'm so utterly in love I begrudge myself the effort spent rising from a chair."

Below: Toady and friend Perky: "Toady is very feminine, gossips like a chicken, swears hysterically...one of the snappy, high-toned Kappa Alpha Theta Stanford girls."

Natalie and Pa's new Buick, 1936. "I want to drive it and ride horses, tie all my cares to a wild mustang and gallop over the plains. I want out."

This is the first part of a **TWO-DAY STORY** *worth reading*

Jalisco Mutiny

by ROBERT HERMAN TORRES

THERE we were, the twenty of us, lying on our stomachs in a ditch in the middle of Mexico, the sun shining down, and all around us the flat scrub and the black and yellow mountains we were eating our hearts out at.

And a machine gun up in front was filling the scrub with bullets that hummed in the little bushes like bees looking for flowers that weren't there.

The ditch was shallow, so we had to lie flat and keep our faces in the dirt, the sun burning through our shirts and making the rifle barrels red hot; and we had been there since dawn. We had lain there sweating and cursing at everything, and we had come up in the night and the sun had come up while we were still moving around, and then all of a sudden a machine gun had started firing at us from somewhere up in front, and before we could duck into the ditch three of us were dead.

★

SO there we were. We threw the bodies up on the edge of the ditch to make a parapet, and lay down and waited for something to happen. The walls were of sand clay and we lay in the soft sand in the bottom, and it b...

were still thirsty and that the mountains of Jalisco aggravated us as much as before, and we ate our hearts out at them and waited for night to come.

McGowan woke up and told us we would all be executed for mutiny. He asked us for his gun and we gave it back to him, and then he sat rubbing his head and cursing, and wanting to threaten us, but doubtful of us, and contenting himself with swearing at the warm air. Then as the afternoon wore on and nothing happened and we lay half asleep and not caring what came next, he began to tell us how we would be tried in front of Villa, and every one of us put against a wall and shot. Felipe tried to argue with him, but the rest of us did not believe him, and what he said we only fancied to ourselves idly, wanting otherwise only to be rid of this war and out of the ditch.

Meanwhile the sun fell down in the sky and the foreheads of the mountains lowered and threw long shadows across the valley. The north wind came up, and we buttoned our shirts, feeling refreshed as if we had just taken a bath after a long afternoon nap.

★

FOR no reason we were full of hope, and when the machine gun started shooting again we minded it no longer, thinking how we had almost captured it and how in the dark it would not be able to find us out escaping.

Then we noticed a stripe of pale dust on a mountain slope far down the right-hand side of the plain, beyond where the machine gun was. The dust moved and came down into the shadows on the level and suddenly we heard far-off shooting. We peeped over the top of the ditch, and then when the machine gun did not seem to notice us, we half stood up and looked towards it and saw it in a little nest of sandbags a hundred yards or so away from us in a faint depression in the plain, and we made out men

Clem's *Esquire* story, 1935.

Harold, 1935.
"The distance
between your
eyes will
impress many
people."

Danny: "An
inheritor of Jews,
a scion of Saxons;
one who stands
up for what is
right and farts in
low company."
With his grand-
mother, Annie
Ewing, 1935.

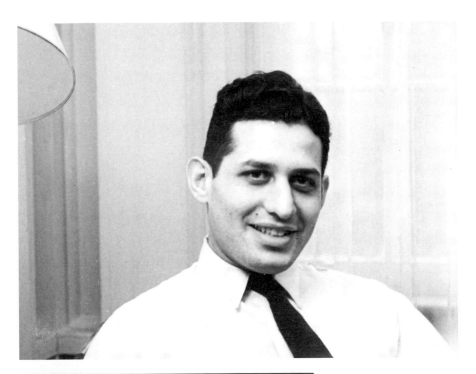

"Solly, the good
brother," 1938.

"It's hell to have a
kid and not see a sin-
gle piece of
yourself in him."

Left: Danny, at three. "A joyous rowdy look. Oh my son. He's going to grow up such a stranger, such a California athlete."

Right: Danny and step-father, Buddy Offut, Washington, D.C. "Poor Offut, reduced to an appendage to a biography."

Below: Angien le Bain, 1939. Clem with his paternal aunt, Sonia Steinberg (next to him), and her family.

Top: *Partisan Review* editors photographed for *Time* in 1940. Seated: Fred Dupee, William Phillips. Standing: George L. K. Morris, Philip Rahv, Dwight Macdonald. "Probably unwisely," Clem becomes an editor a few months later.

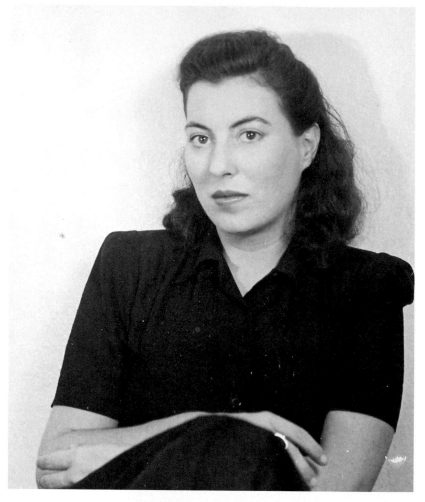

Top: Jeanie Connolly, 1940: "My international glamour girl."

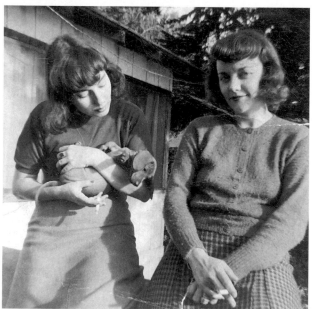

Right: With sister Annie Bakewell.

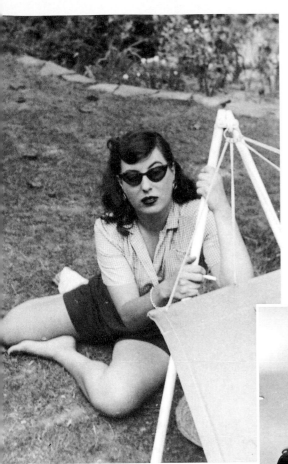

Left: "Utterly personal, utterly sensual, utterly unboring...she is wonderful, but what an underside."

Below: Jeanie, Gertrude and Sydney Phillips, Margaret Marshall, and Annie.

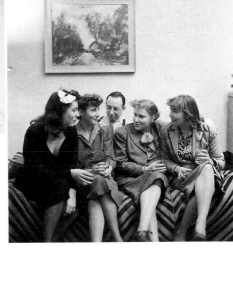

Left: "The Vita Nuova, that hazy dazy era. I hope it will last forever."

Danny, Marty, and Toady, Washington Square Park, 1940.

Left: "A very faithful portrait of Jeanie," painted by Clem in 1942.

Top: "Langouring in the sun, talking to no purpose" in Amenia, N.Y., 1941.

Left: "Marty is a product of what the Hebrews have enjoyed." Army, 1941.

Army Air Corps, Flight E,
Tishomingo, OK, 1943.
Clem, 1st row, 6th from left.

"I'll never look like a
soldier."

Clerical trainees. Clem, far left.

Flat from Clem's stage set. Bunkmate, Joe Gormley, at right.

After the war. "I still want some madder wind and gayer music."

7

CUT & RUN

"I wish it was next year and I was in Jerusalem."

In mid-September Clem returns to Brooklyn by bus. On the way, he spends a few days with Harold in Syracuse.

<div align="right">Sept. 29, 1934</div>

Dear Harold,

It was good for me that you wrote. Don't you know that experience doesn't teach, no matter what it learns? Where was *your* wisdom?

Anyhow since San Francisco and still, it's a nightmare.

I didn't tell you anything.

Oh shit!

<div align="right">———Clem</div>

P.S. I thought you'd saved, but after a mile you hadn't. Not you—me.

During October, Harold visits Clem for a week.

<div align="right">Nov. 2, 1934</div>

Dear Harold,

I finally got a letter from you. I hadn't expected you to write one immediately after you got home, but it was a long time. Nothing still happens here and something had to happen for me to write first.

Or maybe something did happen. A week ago today the mail-man met me outside of our door and handed me a long envelope that had "Esquire" printed on it. In it was a check for $50 and a little letter saying the editor had found

my ms. "Mutiny in Jalisco" "available" for "Esquire" and "can pay" me $50 for it. Thank God, I'd had the presence of mind to fasten a pseudonym to it: "R.H. Torres," a swell pseudonym, too. The letter also asked me for a paragraph of "biographical data." I gave it to them, averring my full name was Robert Herman T. and I lived in Carmel and knew 7 languages. So there was much celebration in the family and my father now wants to register my Trade name. He gets me up in the morning saying, get to work, the typewriter is out.

I don't know when the story will appear.

Thanks for sending out my poems. They'll come back. I took your suggestion and sent "The Indian Who Danced" to "Story," after changing the beginning according to your negative instructions.

That $50 has aborted and miscarried half that used to be in me. If you did the same, everything would be all right. Oh Thales. Write a violence about Arabs or Indians.

As ever
Clem

NOVEMBER 17, 1934

Dear Harold,

It makes me despairing to think of you still where you are. It makes me disgusted—but you'll take this personally, I'm afraid, until you know what I mean. Shit, you know what I mean.

Next Friday I go to St. Louis for 6 weeks to wind up the store there. I'm

going by bus, and the prospect of St. Louis at the end of a bus ride is the worst conceivable. Then I don't know whether I'll come back to Bklyn or go to California for good.

I read a short novel by [Italo] Svevo in Italian, "Il Buon Vecchio e la Bella Fanciulla" and didn't like it much.

I'm reading Malraux's "Les Conquérants" now and "Inferno" over again.

Everything is still just the way it was when you left. It must be very lousy on earth everywhere.

I'm writing another story and I'm trying to finish it before I leave. Send me your desert story.

What magazine did you send my poems to? Under my name? I hope not, honest.

I've lost a lot of poems, I discover. I've hardly any of the ones I like left. My grandfather stowed my stuff down in the cellar while I was gone and it was scattered about. [For a few years, Clem's paternal grandfather, David, lives in the Brooklyn house, taking over Clem's old room.]

Danny Fuchs' book [*Somewhere in Williamsburg*] came out 2 weeks ago and got hardly any reviews, over which he is much cut up. There'll be a review of it, however, in the "Times" tomorrow.

The dentist pulled a tooth out this morning and that side of my jaw is aching now, especially around the cheekbone.

My mark for the Exam [Civil Service] came yesterday morning; 95.75 out of 96 in the intelligence test and 95.50 in the other part. Now there's hope in the family for a job in Washington. What did you get? I'm dreaming that you got 100 and we both go to Wash. which is altogether a satiety.

The baby is due Feb. 1st and with that I can't finish this letter. I don't know whether I'll head for California or not after Christmas. I want to. I feel so low and cheap. I yearn so much. It's not even a question of right and wrong. It's whether the baby has blond hair and a Jewish expression.

I can't write. But you write. You can.

<div align="right">

As ever
Clem

</div>

Clem writes from the Continental Neckwear Company in St. Louis.

<div align="right">

DECEMBER 8, 1934

</div>

Dear Harold,

I couldn't write until now because of what coming here did to me, and because writing a letter to Toady every day puts me in that state of thought only fit for her. Of course, it's mostly St. Louis.

You know what it's like. Only I must remark this: dreadful loneliness recommends itself to me now and would be all right except that when I'm

restless here I can only get rid of it by impersonal means. But when I'm restless I want to go to somebody who says, "You are . . ." and so and so.

I went to a wrestling match Thursday night and had a wonderful time. If there are any in Syracuse go to see one. Be sure to notice the colors of their trunks. They match them to the shades of their skins.

The Indian story came back from "Story," and I told Solly to send it to the "Mercury."

But I can't write this letter.

It's snowed here for the last 2 days.

I live at the Y.M.C.A. It's cheap, private enough and I can send 2 bucks to Toady every week. All that's bad is having to shave at a common trough. The idea of the Y. is bad enough though.

I wish it was next year and I was in Jerusalem.

I can't write any more.

Clem

DECEMBER 19, 1934

Dear Harold,

I'm writing this immediately I got your letter. I rose late this morning, found 3 letters at the store, no business and no future; it snowed all last night and is now gluey slush, and I'm in a quiet placid frantic catalepsis. Mostly because I can't sell any ties. First a letter from Toady, then Danny Fuchs, and then yours, and letters disturb me. First Toady's, an incoherent business of how she feels about me and Christmas (the good gentile nordic of qualms within a qualm; if you and I could know it we'd write great literature. As it is, all we have is Schwarmerei and prophecy, the drug on the market). Then Danny's with despondency over his lousy book to make me feel sorry. And then yours telling me to write direct and clear. You don't know what you're asking. I can't fuck around with words like death and I don't want to make myself shameful, which I'm not. Oh Lord, I've taught you & myself to be serious about the wrong things.

I don't like to talk about Toady to anyone. I'm sorry I told you what I did. Well, it was you anyhow.

At the Y. I go swimming every evening before supper and then take a hot and cold shower. It's good for me to prance around naked for half an hour, and I've become very healthy and supple and smooth, and the coldness of the weather is never cold enough. Then I eat supper on a well-bal-

anced basis, go to the library and read about what happened to the Chero-
kees when they were dispossessed and German travel books. On my way
home from the library every night a whore taps hysterically on the window
as I pass. One night I stopped and asked her how much she wanted, saying
it'd probably be too much anyhow, and she became insulted and sullenly
told me to beat it.

I'm rereading "Anabase." Perse needs plenty, plenty. His song is one I
know. As suspect as any poet's poet. "The girls hold aside their robes to uri-
nate on the shining trench of the day." To feel that having finished up with
that, there's nothing more than that to say. If only you could!!

It's begun to snow again. Nieve.

I won't send you Stein until I succeed in reading at least 2 pages. I've
tried five times. "The Making of Americans" was different.

"Esquire" hasn't published the story yet. If they do, it should get the O.
Henry prize.

The museum here just bought a Chardin. I don't like it. There's a pic-
ture of a little girl in a pink dress by Alexander Brook that's one of the
greatest things I've ever seen. A lot of very bad Italian primitives. There is
some Duccio stuff—like Cimabue—that does stink.

I shall probably leave here the 26th or 27th. I don't know where to.

Noticing down at the pool that the average penis is at least twice as long
as mine, I've begun to question myself. Now at the pool in Syracuse it was-
n't so decidedly that way, and I don't know what to decide about myself. On
statues, I've noticed, the size is mine, a minor detail, but nowhere else. So
what? What do you think?

It's snowing faster now.

Armpit of the West. Perse says something about a lizard licking at the
armpit and leaving a stain.

Clement

1935
Clem has returned to Brooklyn.

JANUARY 27, 1935

Dear Harold,
 Your letter was forwarded to me by Toady from Carmel. She said that it's
being addressed to Carmel was touching. It was. I wondered and knew why

you hadn't written. But my business of going to California was only bluffing.

I left St. Louis 2 days after Christmas and went to Washington, where I found out I was ninth on the list in "English." They wouldn't tell me your standing, but I gave them your name and address and they said they'd send it to you. I also visited a cousin of Toady's, who's married to a general, and they told me all about how gas would win the next war. The general is chief of the Chemical Warfare Corps.

Home I found an air-mail letter from "Esquire" wanting my photo to run in their March number with my story. (It comes out Feb. 15th.) So I went downtown with Marty, who was home for Christmas [he is a fresh-man at the University of Michigan], and had a quick picture taken. I was awfully dissatisfied with it but sent it on anyhow after mutilating it.

Since then nothing's happened, and I haven't made any money. Toady wrote about a week ago that the baby's so close to changing from futuran-dum to esse that its nose scrapes whenever she sits down. At first I got all excited but now its become indifferent again. It will be born with blond hair and green eyes, greener than mine, and have a squashed nose.

Two days ago I started helping 2 school-teachers write a textbook on business methods and they are so satisfied I may have a steady job for the next month and a half, for which I'll charge $150. The publishers have ad-vanced them $1000 so far anyhow, and they're helpless bastards.

I do want to go back to California but thinking of Mrs. Ewing stops me. But then everything except going back to California is beside the point.

It snowed plenty last week, and all of it's still on the ground. I wear the raccoon occasionally. In cold weather N.Y. feels like N.Y.

I've been reading Communist pamphlets and Henry James. I finished another story about Pancho Villa.

My father will go back into the compact business in the spring.

And how'st with you? Oh tell me.

You're fine.

——*Clem*

FEBRUARY 19, 1935

Dear Harold,

The baby is born—on the 1st. A boy weighing 9 lbs and Toady had a tough job getting rid of him. He's nineteen days old and still hasn't a name. Mrs. Ewing calls him Buster and so he's Buster for a while. He's supposed to

be beautiful with a chest like a barrel, wide shoulders, pale blue eyes and light brown hair. Healthy and perfect. By the last letter he's just been circumcised. Toady's back from the hospital but he's still there until Toady's strong enough to take care of him.

I'm still working on the text book and getting paid off and on, so I'll have money, some money. The text book is all right. It goes: "John Clark is a clerk in the firm of Doe & Doe. He is faced with the problem of mailing a letter. What is his first step? He picks up a stamp and affixes it to upper right hand corner of the envelope." It's all right.

My story came out in "Esquire" with a drawing of me. The story is absurd, the drawing is absurd, the biographical note is gratuitously fun, and everything is absurd. The little fly illustrations are very bad. "Esquire" is anyhow a shameful magazine. My Pa thinks the story is very good. Marty writes from Ann Arbor that the dialogue is bad. I think, as Danny says, it's a very competent story in its class.

Of course I want to go back to Carmel. I had what I wanted there. I mean, I could wear a sweater and go walking in the woods. That's the sense of it.

I forget most of the time that I'm a father. At first it was awfully bad. But now I love my son and am dying to see him. Toady says that the nurses say he's very indolent and erratic, viz. when he's sleepy he won't take his bottle and he has no regular schedule for being sleepy and hungry. He's also very calm and collected and grabs whatever's shown him. Oh Joseph, oh my son. He weighed exactly 8 lbs. and 13 oz. when he was born.

Did you read T.S. Eliot's "Rock"? There's some good poetry in it.

——*Clem*

MARCH 8, 1935

Dear Harold,

Just got Toady's letter telling me of the silver spoon. It was a good idea. Thanks from me too.

Naturally I'm still in suspension. Half of what my life is is trying to happen. I was never more scattered than I am now.

Thanks for taking the story as seriously as I wanted it to be taken. Sure it was sloppy. Two excuses: I composed it on the typewriter and sent in the 1st draft (ask Toady). It was so dirty and mussed up I still can't believe "Es-

quire" took it with deliberateness. Second excuse is that I falsely thought I was manufacturing a kettle. I'd sat down with the mind to write something made to order for "Esquire," right up their alley. Half way through I realized I was having a good time.

I've finished another Villa story now for which I had the plot 2 years ago. The plot of the other one I got from a newspaper about a mutiny in France during the war. The rest was all my own. Especially the cards, machete, head, etc.

I received pictures of Daniel—that's his name now—a few days ago. A pushed up nose and wide face. Sort of receding chin. Thick and sturdy with a good head. I'll send you them if you'll send them back. He looks disap-

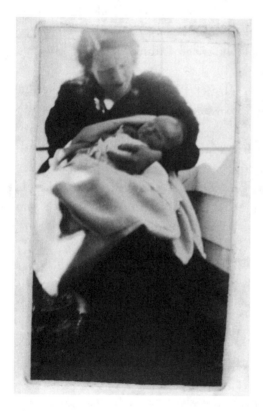

pointingly Nordic. His attitude, I mean: slightly forward inclined forehead and Anglo-Saxon-steady eyes, according to a profile picture. I understand he doesn't cry much but he fills his diapers plenty often. Eats a lot and always hungry. Hair is light brown with red copper tints. Very fair skin, I feel that my Pa is a closer relation than he is, although he is half me, and I'm only half of Pa who's somebody else, whereas the half of me that's Daniel is myself.

I can't write poetry, although I made a popular song for somebody in my story to sing.

Did you like the Minnesingers book? There's a new book out by the Insel with Altdeutsch poetry in it: original and parallel modern. Some wonderful poetry, Mariengesangen and the Annolied. Like med. Latin verse a lot.

Yours as ever,
Clem

Dear Harold,

Buster (when it's your own child you don't care about nicknames) had a birthmark and was taken to S.F. to have radium put on it. It's on his stomach and bright red. It had me worried—not the birthmark, but going to S.F.

I met Burt Hoffman [fraternity brother] (do you remember him?) in the subway 2 weeks ago. He works for the Press of the Pioneers who published "Americana": true tales of the Wild West, the Far South etc. He took me up to meet his boss and that one gave me a manuscript to "put into shape," "The Life of Chief Joseph," the great Nez Percé Indian. He wants to give me only $50 and I want more as it's a tough job. Chief Joseph anyhow was a great man.

Meanwhile I'm still working on the textbook.

As a result of the "Esquire" story I got letters from 2 publishers wanting a long book—maybe. Reynal & Hitchcock and Doubleday, Doran. I went up to see the first and met Barry Benefield, the short story writer, and Hitchcock. They poured oozing honey over me. The style, the style—something absolutely new—full of lusty gusto, swing, rhythm, color. It was especially the "little unexpected turns of phrase" that led them to hope things of me. They want to see anything I've got. I told them I had nothing.

Doubleday wrote they'd read my meise with "interest and pleasure" and wanted to see something of "greater length."

I can't imagine what you're doing. Share all this here glory anyhow with me.

Write a book on Indian warfare around N.Y. State and I promise I'll get it published for you. Honest. And it's something worthy too. The Press of the P. has to put out 36 books a year and it takes everything.

As ever,
Clem

Dear Harold,

"Esquire" took the second story for $75. No note of acceptance. Just a check. I'm specially glad this time, because it means that hunting song will be published, imbedded in the story.

I sent $50 to Toady, and she sent me back her first letter in two weeks. There's nothing like money. She's still peeved because I haven't announced Danny.

I've finished "Chief Joseph" and am now trying to get the right pictures and maps.

I've found out what makes an Indian look different from a white man: big nostrils. It had me puzzled for a week.

It's been a cold spring and I have no time to long. Sol's gone off to camp for 2 weeks, and I'm enjoying the lonely bedroom. But it's an awful cold spring.

I'm reading Golding's "Metamorphoses" on Ezra Pound's recommendation and find it good. Good telling.

As ever,
Clem

JULY 4, 1935

Dear Harold,

Viking Press has had one copy of your Tristan since the first day you sent me it. The other copy went to Macmillan. They returned it with the enclosed letter, and I took it down to Knopf's and left your name and address for the return. I think I'll go to Viking and see what they've done with it.

Toady wants me to come to Carmel, and I may go some time this month. Danny's ears, she tells me, are beginning to stick out and his head is flat in back, which she says makes him altogether "not so hot." If a mother says that about her child, what does it mean?

I hope Boas has given you more work. How do you find it? Can you make it literal? While you're at it translate some more of Brecht and also Rilke.

Don't expect to make much money if the Tristan is published. Nobody's ever made money on that kind of book.

I got an offer from the "Daily Express" of the Beaverbrook chain in England (the equivalent of Hearst's) to syndicate "Mutiny in Jalisco" throughout the British Empire and to translate it for foreign distribution. I'm to get 50% of whatever it's sold for.

The Carmel situation is vague. Pa promises me $25 a month if I write short stories faithfully. Press of the Pioneers has give me 2 more books to do, but so far I've only collected $25 for Chief Joseph, and I'm having a tough time getting the other $25. So don't bank much on that.

——Clem

The following two letters, among the few typewritten, initiate the occasional dropping of apostrophes, a habit which continues—hit or miss—even as Clem returns to writing by hand.

AUGUST 18, 1935

Dear Harold

I expected a letter, but you probably think I've already started for the West. And so I shall by the end of next week. Mrs. Ewing sent me a screaming letter to stay away, and that accounts for a little of my hesitation, but I'm going anyhow.

I received a letter from Viking saying they'd given Tristan "careful consideration" and finally decided they couldnt include it in their "small list." It's almost hopeless to sell poetry. Write a novel out of it like Joyce did with the Odyssey. It's legitimate to imitate him. I'm serious. It'll save you from everything.

Your suggestion of short novels is right and good. But to make steady money you have to write magazine stuff. I wrote a story about a bridegroom melancholy at the wedding feast.

This is a new typewriter I'm writing on, a Royal portable with a streamlined top. It's a present from Pa. It goes like a Cadillac.

Mrs. Ewing sent me 6 pictures of Danny. He's very fat and has an enormous head with a flat back. He looks neither like me nor Jewish. As gentile as an Anglo-Saxon with Irish in his blood. But he has got a joyous rowdy look, full of interest and a sense of himself that's very unbabyish. Oh my son. He's going to grow up such a stranger, such an unheeding guy, such a California athlete. I have altogether no hopes of him and will be satisfied if he keeps his nose clean and an honorable name and doesnt pull my beard and shout Yiddle.

He's very unlike the Greenberg push of babies. We were none of us fat and never were good. Oh, he looks as if he wants to swallow everything, do everything, be a man of action, an oppressor of others, an esteemer of himself, a saluter of salutes, a receiver of cheers and a sayer of "horseshit!" to his poppa, a jewel to his mother and a prize winner for his grandmother. An inheritor of Jews, a scion of Saxons; one who stands up for what is right and farts in low company. Oh what a bully.

I'm already resigned to having no influence on him.

Clem

Dear Harold,

That is a very good picture. It shows how far apart your eyes are, and there is oval Oriental beauty in the hair line and chin or jaws which oval lines are lines and yet not lines. The distance between the eyes will impress many people.

I feel more hopeful for you than I have in years or ever. A notebook! Youll do it. Dont pay too much attention to style. Please, no rhythms, no unfurlings. Being sensitive and aware as no one but you and I are aware, and as Doughty was, style will take care of itself. Have foreground; dont make Kafka's mistake and write poems manqué. There's no sense in writing fiction otherwise. Kafka didn't write poetical rhythm, but too much poetical conditioning to the point where he excluded ways of life, like lyrical poetry does. A good novel starts being universal where it begins to end, where poetry begins. Read this with care.

But you know everything I'm telling you, only you have to hear someone else saying it. Incidentally, read E.M. Forster's "Passage to India." It's a great English novel. The man is so wise, so truly full of that kind of wisdom you and I thirst for. He's a poet, poetry's transitions that you like. And he can write. No kidding, if Forster only had a sense of illustrative grand form, the form that takes care of 1000 pages and becomes a symbol, he'd be a great novelist. But he's not. He couldnt keep his plot in line and eased the tension 100 pages too soon. But that's beside the point. Read him. He's been no fake Discovery for me. Read also his "Longest Journey."

Danny, I hear, is grown a lot and uses a regular water closet now and on schedule. His hair is no longer red but light brown. He babbles a lot and eats half-solid food. Is very suspicious of strangers like Nanny used to be. Marty was that way too.

When you write your novel you wont have much trouble getting it published. Viking, Simon & Schuster, Knopf will take it. At least those are the ones willing to take a chance, a mild chance. And it will be a mild chance.

Clem

Clem stops over in Chicago on his way to San Francisco. Midland Club Hotel. 172 West Adams Street—"In the Heart of the Loop."

Dear Harold,

I've been here since late last night. Left N.Y. Wednesday morning. I answered an ad and got an auto ride with a big German ice & coal trucker (he owned the car) and a Y.M.C.A. athletic instructor. It was a lousy car so the ride took 2 whole days.

It's 3:00 and tonight at 10:30 I take the Great Northern train travelling West via Minneapolis, N. Dakota, Montana, Idaho, Spokane and Portland, thence south to Frisco. The tourist fare is the same as by the direct route through Omaha and you see all the Northern Rockies, etc., passing 2 miles from the place where Chief Joseph surrendered. It hardly comes to more than bus fare as I'd have to include stop over hotel expenses. This way I sleep every night in a tourist Pullman. Now I'm very hot with anticipation.

We reached Chicago thru Pittsburgh and Fort Wayne. The 2 dopes werent bad company. We all used very filthy language and it was swell. I felt so comfortable and fluent. We whistled and waved at every woman we saw. Now I wont be able to use such language again for another 2 years. Oh it was a delight: every other word was fucking. I never knew before that one of the reasons I was uncomfortable with people was because I couldnt swear with them.

I've mixed very mixed feelings about approaching Carmel. I dont and I do know.

I got up at 10 this morning and rode around seeing Chicago. Anyhow it hits hard, but not quite as hard as N.Y. But in another way harder.

I sent my books and part of clothes in a wooden packing [case] by boat to S. Francisco, so I'm only carrying a suitcase and the typewriter. I feel light and ready almost for anything.

——*Clem*

P.S. I got up at 3:30 A.M. to leave Bklyn. Pa took me in the car thru the dark night to the subway station and I rode up to 125th and Broadway where I met the Dutchman and the car. During the same afternoon I had the queerest feeling that Pa had seen me off 2 weeks ago instead of that same morning. It was an infinitely pathetic feeling. He felt so bad and worried when he said goodbye.

Postcard: "Crossing the Flathead River, Montana"
AUG. 31, '35
Dear Harold,

Am in flat flat N. Dakota. Good ride so far, but lousy scenery. Pass near where Chief Joseph surrendered at 7 A.M. tomorrow. Follow me on map. No poetry here. How is Tristan? ——*Clem*

Postcard: "Statue of John F. Stevens discoverer"
SEPT. 2, '35
Dear Harold,

The greatest mts I've ever seen. All rock, really Rocky mts. Just passed the Continental Divide and noticed a little trickle of a stream flowing westwards that has become the Flathead R. and in the pools is the most perfect translucent green you ever saw. I'm committed to the Coast now I've crossed the Divide. ——*Clem*

Home once again in Brooklyn.

DECEMBER 14, 1935

Dear Harold,

You'll have to forgive my not writing. I've been in awful dumps for 3 months.

It's all off with Toady. I went out there. Her mother raised hell—I left— Toady was sort of indifferent. I was only in Carmel 6 days. Came back by bus.

Danny though was wonderful. As big and healthy as all the cherubs ever painted. He smiled the first time he saw me. He's blond, blue-eyed, rosy-skinned. Very obliging, raises his eyebrows and tries to understand what you're at. Never cried once. I couldnt understand that. When he's not satisfied makes a loud querulous sound, that's all. You put him to bed and he goes to sleep without any ado.

It's torture not seeing him. Real torture. Bad.

I'm trying to get Toady to divorce me. It's a dirty question of money.

Got $125 for translating half a German book about the Nazis [*The Brown Network*] for Burt Hoffman, who's gone into publishing on his own.

Wrote 2 good stories but couldnt sell them.

What are you doing? I die to know, but couldnt write a letter to any-body. Havent written to Toady for 3 months. The worst thing is not seeing Danny. I think of him every minute. It was [a] terrible 3 months. Still is—except I'm making money.

This stinks. But you write. I'm coming out of it.

As ever,
Clem

DECEMBER 25, 1935

Dear Harold,

It was mean of you not to write first. I was in the tougher hole.

It's rough that you have to take those courses [teacher's education], but then it's not bad. Something might as well be done.

You should write the novel instead of the play. Don't waste your time. It's your only hope. Haven't you pride?

As for Toady: I fell out of love just as the bus came in sight of Salt Lake. I miss her though, because something else than falling in love and out was involved. It's a habit and way of life to be married and feel that you're two. Therefore it still hurts.

Danny hurts most of all. He's interested in animals, bugs, patterns on cloth and the barking of dogs far off. He raises his head then and listens with a queer look in his eyes. His neck was still somewhat weak when I saw him, and his head was always bobbing and it gave him a tentative transient sort of look. He'll be a Gentile all right, an Anglo-Saxon one, more interested in things than in himself or people. As I said, he'll be a shouter when he's drunk, a crower when he's happy and a blubberer when he's sad. He'll try to seat himself on the bald head of the world; he'll be a bully boy.

Haven't heard anything from Esquire. They probably turned sour on the story. It often happens that way.

I cant write poetry any more. But I've made some swell translations of German translations of Edda poems.

I want to write a book about some great man. A true book.

Please save yourself for my own satisfaction. Work. Work. I mean that exactly. Write a book, please. It'll be published.

Clem

Dear Harold,

That business about your eyes is not in your eyes but because of the way you've been living. New scenery and people to talk to, walking in strange places is the only thing. Write lots. Write even when you think it's lousy. Write automatically. Not at a desk, but on your lap. As long as you write a lot, something is bound to happen. Your eyes will get better.

For my own comfort, I'm afraid to think of where you are. Christ, it could be so different, if you were only a little stupider. Be stupid. Dont read so much.

As for my writing—I'm trying so hard. You read what Hemingway sd. in the middle of African book? About the writer he's looking for who will make prose great; Kipling's talent, Flaubert's this, etc. He was thinking about what you & I want, and I'm glad to see someone else aware of it. Well, I want to be that, but havent found the theme or terms yet. It's got to be something as wide as Montana, tawny, active, illogical—like the part near the end of the story "Esquire" still hasnt printed. It must have some Perse in it. I try to write it and find myself dropping off into personalities—which is absolutely ver-boten—it must be about a lot of people all taken together.

Anyhow, talking about it helps.

Please leave the play alone.

A letter from Toady. She & her mother are getting poorer. Full of vul-gar Gentile notions about "safeguarding Danny's future." Wants me to have life insurance, so forth. Therefore I want to make money—not for life insurance—but for money. If I die, Pa'll be so overcome with regret he'll cherish Danny as a souvenir of me so there's nothing to worry about on that score. Just as he cherishes the 3 of us as mementos of my mother. But I want to have money so I can go to Calif. and play with the little bastard. And divorce Toady, which we both want.

Skip the birthday present this year—I mean, just to me. If you make some money keep it. If you insist on present, make it Oxford Shakespeare and I'll buy it here cheaper. You can send card & I'll paste it in book.

Read a book in German called "Der Weg durch den Februar" by Anna Seghers, emigré German novelist, about Socialist uprising in Austria. It's more sincere than Malraux's "Man's Fate" and in some ways better. I was all cut up by it. It was submitted to Hoffman by a literary agent, but I ad-

vised him not to publish it, as he cdnt sell it. It shd be published though. The same agent is trying hard to find an American publisher for Brecht's "Dreigroschenroman."

The anti-Nazi book was journalism—but my stuff stands. I'll send you a copy. I translated last 200 pages.

———*Clem*

8

CIVIL SERVANTS

"As Gods might be we should be, Harold."

FEBRUARY 3, 1936

Dear Harold,

The government gave me a temporary job in the civil service commission at $30 a week. It will last for 2 months. I started working Saturday: copying addresses and stamping dates—at the Federal Building downtown. I wish you could have gotten it too. But those jobs dont pop up in Syracuse. Two months in N.Y. at $30 a week wd. be a life-saver for you, too. Two other chaps were taken on with me, one of them was 11th on the list; I don't know what the other's standing was. It's a goddamn shame.

Nobody has exact information about the English exams. At the Board of Examiners they said the requirements were in a "fluid" state, etc. The fact remains that you have to have teaching experience for a regular English license. Your courses are O.K. I dont know how much a teacher-in-training makes. Probably about $30 a week, which is what a sub in the grade schools gets. To get a regular license in a grade school you have to wait your turn. Danny Fuchs has had his sub's license for 5 years, and his turn for a regular license still hasnt come.

It looks pretty lousy. There are thousands waiting for school jobs. And the high school exams arent strictly on the level either. You can get 100 in the written exam and then be failed in the oral and personality test because you dont pronounce fftt correctly or because your appearance is not Nordic enough.

My opinion is that it's not worth messing with.

I am about [to] translate a junky novel on Goya's life [*Goya: A Portrait of the Artist as a Man*] from the German, for $200 down and royalties—maybe. It's for Burt Hoffman. "The Brown Network," the other book, is coming out in March. It's very bad and I'm ashamed of my stuff. The Goya

may be better. I shd. offer you the Goya book but I'm too selfish, and in addition Burt wants only me to do it; that is, he thinks I'm good. And I have to feed the copy to him as I go along. Besides I need $125 for a divorce from Toady and other money to keep sending things to Daniel. But honest I'll get something for you. (No patronizing, I mean I feel bad about your lacking dough, honest.)

I'll have to work nights on the Goya, which reminds me of things I've never known. The day & evening work, I mean. I come home all limp and then have to tighten up to translate. It's particularly gloomy here because there's been no snow for 12 days, and the steady cold has a bad effect on all the Jews and out-of-towners living here; they become hopeless and trample on each other in frantic hurries-flurries.

As Gods might be we should be, Harold.

And thanks for the Ralegh [*Poems of Sir Walter Ralegh*] which is a real book to own, even though I don't like the cover and Ralegh himself didn't write enough poetry.

Please write a book.

<div align="right">*Clem*</div>

<div align="right">MARCH 3, 1936</div>

Dear Harold,

I seem to make lots of money, but $100 is going for the divorce, which Toady will file in a few days. She says she doesnt write to you because she doesnt feel right: true enough. Danny has 6 teeth now, is 31 in. long and weighs 24 lbs. Toady is typical and exasperating in not sending pictures.

The gov. work is not hard, but it makes me tired and is an awful waste of time. That's the worst thing about these jobs.

The translation, of course, I'll be ashamed of, but I found out that you have to be ashamed of translations. Otherwise you're not faithful, but writing your own book which doesnt pay. I saw the Goya show and seeing the portraits were the best there are, I was disgusted with the book. I couldnt believe the portraits were so good. I went out of the room & looked at a Bronzino, and it was true. But the bullfighting and landscape were terrible—terrible for a bad painter—and the drawings were only so so—except that you found out through them what a great man Goya was, in an original way for his time.

But I cant write to you properly now. I'm fluttery. I cant think of how you are. Please depend on yourself and take joy that way. Forget what you want.

——*Clem*

Dear Harold,

I was glad to hear about the wire from Washington. You deserved it.

After finding out your willingness to accept a job, the Commission waits at least a week while you're being "certified." Today I started on another job at the Veterans Bureau at $1620 a year, for which I also had to wait a week after being "certified." The work is ordinary red-tape routine. Very easy, but boring, yet human. You know.

I've been so drowned by having to translate the Goya book evenings that I cdnt write and havent seen a movie in 2 weeks. The book was split up among 3 translators. I did the 1st part. It'll be published in May. Strange, I'm not ashamed of the translation. It's as good as the text allows.

I'm still far away from myself. It's a real menace, this putting all your eggs in one basket. To sacrifice my withdrawal, which I dont want to do until I'm 30.

The divorce is toddling along like Danny. First Toady wanted $10 a mo. alimony & 15 for the kid. I kicked like hell. Then she said $1 a mo. alimony "to keep it open" so she cd. grab me when I came into millions. No! I said again. Now I haven't heard from her in a month, nor from the lawyer who's supposed to represent me out there. I think he's two-timing me.

I don't even want to have to pay anything for D. by law. She & her mother will otherwise pull my pants off some day. It's as tragic & necessary as rain in the spring. If I remember to think about it I worry.

There's a mean Gentile quality down at the bottom. So cold, so just, so cruel, so sensible. They'd just as soon draw & quarter me if the law said that was to be done to divorced husbands. It explains capitalism.

You're all wrong about 31 in. not being tall for a 13 months old baby. It's enormous. He should only be about 28 1/2 in. long. I'm dying for the little stinker.

——*Clem*

Harold gets the job at the Civil Service Commission and moves to Washington, where Clem writes him at 3829 Cathedral Avenue.

<div align="right">APRIL 7, 1936</div>

Dear Harold,

It's good you wrote so soon. I was more curious to hear what was happening to you than for years. Going into strange cities to take up abode there and work is something that belongs to me and is very personal.

That Angst, I know it. It comes when you approach a strange place, never before seen, where you are going to live all alone for months. Some part of yourself threatens the rest of you. Menaces you for changing, for changing permanently, and is very scared of something and takes it out on yourself.

But it'll wear off—first with excitement as you get to see places & people never seen before, as you feel free, so free, and time looks so ready to be filled up with events—then it changes to weariness and boredom, and finally turns back into Angst—this time because you're scared by the fact you have no one to say anything to. Which is the worst of all, and is implicit in the first Angst moreover. The first Angst knows <u>that's</u> coming. The first Angst knows there is no one in the whole wide world to depend on.

I think you're paying too much for your room. It's more important than anything else. Still, remember you're really making only $27 a week, and the carfare, etc. is high. But $75 is plenty of money to spread over a month—I know—as long as you don't want to save. Don't go to expensive movies, and watch the nickles and dimes, and you'll be able to live almost rich. The little nickles & dimes can eat you up.

"American" or not is meaningless for the place. What you'll find out is the South. Otherwise Washington has no guts, is like well-bred American capitalists, is too too Gentile, as you say.

I want to drive you around in the car and talk. But I take the job here so seriously that I'd have to have leave. Because I'd have to have 2 days at least. Really, I take my job too seriously. The seriousness wears me out. I don't even read on the subway anymore.

Your eyes—enough sleep is the only answer. And no hurry in working. Hurry is the worst. Slow walking is good and washing the face often.

I now go horseback riding a lot. [There's a stable two blocks away on Ocean Parkway.] It makes me feel good. I bought a pair of black boots and rusty riding pants. It's all I do.

Rest your eyes by writing. Please write a book.

<div align="right">——*Clem*</div>

APRIL 14, 1936

Dear Harold,

Your letter sounded cheerful. At least the lay-out could be a lot worse. You might be working in dreariness and going home at night in shabby purlieus. Washington, whatever it is, is not depressing just in itself. Like St. Louis, for instance, which dampened all kinds of joy. St. Louis was one of those indefatigable places I hope you'll never find. Washington, being white, being wide, being sanitary, is cheerful like an up-to-date bathroom. Cleveland was like that, only it had much more in addition. Washington may turn out to act on the lonely stranger like Frisco, which began to oppress me because I felt an awful lot was going on that I was being left out of, that people paid no attention to me, that for the specific place I was very unimportant.

I'm glad you moved. The $25 saved will be the most cheerful thing in your surroundings. Whether you save it or not.

You'll find out all about the government style. The stiffest used ever by any government anywhere. You'll get to use it yourself on rejection slips: "applicant has failed to establish identity within regulations and rulings governing such cases as formulated by etc."

Didn't I tell you I'd seen the Odets "Paradise Lost"? It was altogether a lousy play with swell lines, wonderful Dostoyevskian possibilities and the lousiest poetry and rhetoric I've ever heard—absolutely the lousiest, really furiously lousy. Odets is a genius. The 1st and half of 2nd act were good— opening possibilities. The 3rd act made everything impossible. Oh it was lousy! I read the [Kenneth] Burke business ["Paradise Lost" review, *The New Republic*]. He's talking through his underdrawers. Pure nonsense, copied from latest style of analyzing Shakespeare's plays and also from the notes to "Wasteland." Burke is a jackass half the time.

But Odets is really a Jewish genius. He knows what words as literature are supposed to do—only his knowledge is debauched or something or other. When he gets real serious I never heard such pure shit. The time's agin him.

The time's also agin your finding anyone to like with a good heart. Besides, everybody's too old. You'll have to wait for a Vita Nuova. Me too.

Continue to talk a lot & be witty. Only don't let loneliness demoralize you into talking too much. That's the road to ruin. You become a moral wreck. I became one in San Francisco from talking too much out of loneliness.

I go horseback riding almost every other evening. Ride through the park and think of nothing but the horse and myself. Ride in the dusk. Then gallop home down Ocean Parkway through the dark. The purest joy I've ever tasted. Riding always was that way with me. I go in search of green bowers and singing birds. Or sometimes I think of the prairies in the West and the silhouettes of the mts. above them. It's enough to perish.

Write soon with details.

——*Clem*

APRIL 20, 1936

Dear Harold,

It's a joy to receive your letters—maybe that's why I think they're cheerful. They're like they used to be a couple of years ago. What makes them most joyful is that they remind of better worlds—you and once in a while a poem being the only things that do. But lately from Syracuse they were stewed, too fermented, nothing but ingrowth. Washington's made you new again, miserable or not.

I think you <u>are</u> miserable. But you'll feel better. And please God they put you on "correspondence," recognizing that you are the only person in the service who can combine the proper firmness with the necessary politeness in manner and style. Your latest letter was so right. Everything was right. The "communal cheerfulness" at knock-off hour. You should see us pour for the door when the bell rings! Everybody's hysterical and relaxed, there's a twittering, a shoving, a pushing, an edging forward & backward, a lifting and a falling. The feeling of that moment, not its circumstances, should be immortalized.

About your play: to write a good play you have to have a simple & passionate conviction. Please send me some of it. (Hire a typewriter. It'll be worth it. Sitting alone in your room before a typewriter, you'll write reams. Like I did in Monterey last September while going through my last passion.) Meanwhile, I dont want to think of your play. Either you'll make a new genre or the thing will just be amusing. Show it me.

You're wrong about Odets. He has poetry. Even tho you were right about young Jews. But the Jewish "Schwarmerei" is made too much of. Jews, you're right, are laie and flat. But think, my friend, of their moral earnestness. In a hole I'd rather have Shylock to call for help to than Shakespeare. Oh, Harold, please know how noble Jews are, how they can afford to be shameless and vain. And nothing else is worth a shit than goodness. It's so. And the sure and almost only symptom of goodness is impatience. And

the great Jews are either the outright impatient ones, as in the Bible, or those who, forced to live in Western Europe, were good enough to cover their impatience with a large philosophy, like Maimonides, Spinoza and Marx and Trotsky. Impatience, what a quality!

Down here they hum Wagner while they work, or Bach. And the examiners—mostly smart City College yiddles—discuss T. S. Eliot and French etymology and Communism. And a fellow from Columbia called me a parlor pink. All of which makes the place very dreary. Isn't there any originality on earth anymore? You're original, I'm even more so. Why should we be exceptions?

The fellow from Columbia, he's a big tall Gentile, blond and massy, almost became original. He had dirt in him and was very sentimental about music and thought "Anthony Adverse" the first classical piece of literature turned out by this country. He made chucking sounds with his lips whenever a woman passed. But then he slithered into nothing but selfishness and ordinary Gentility. He couldn't stand the gaff. There's a fellow named Bloom—he's half-Jew, half-Irish!—who's the jewiest you ever saw. He has eyes the exact color of mine.

Of course, I wrote Toady that I'd take care of Buster, etc. under any etc. That's the only way the sentence cd. have been finished, and besides, I meant it. The tendons of my wrists yearn for my son in the West. Euphorion! Figliuolo mio! Der Sonnenjüngling!

The horse-back riding is something to look forward to while working, mostly. As for animals: Rilke never had anything to do with a horse. The company of a horse is more unsatisfying than the company of a bird. Dogs are therefore miraculous.

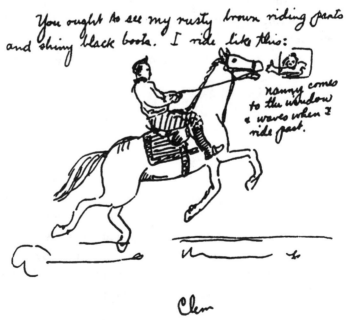

You ought to see my rusty brown riding pants and shiny black boots. I ride like this:

nanny comes to the window & waves when I ride past.

Clem

MAY 2, 1936

Dear Harold,

Dont try for transfer to N.Y. and discourage anybody who does. They aim to start discharging here on June 15, and it looks bad. They're a bunch of bastards down here and fire people right and left, every day. And I might be fired as quickly as anybody else.

Spring's come on hot, bringing out all the smells. And when you talk about the air knocking the color, feel and smell out of everything—you should see Los Angeles! In Los Angeles everything was uh.

I'm glad you know people like Tierney and that people wait for you at knock-off time. Down here they don't do that, they're afraid and clumsy. Or they're veterans and have chips on their shoulders. Everybody's afraid the people they're talking to aren't important enough.

I was looking over my "novel" [Sweet] and found it awfully bad in spots, and hated to think I could have ever written the asininities I did. It's my sense of humor that gets in the way. It feels so good to let it go full blast, which I can do in writing, but can not do in living—then it becomes terribly overdone. And really lousy humor. But humor's the only thing a possibility nowadays.

I'm very weary and worldly cynical. Tired and disgusted with everybody I know, like I was 8 years ago. Without moral grounds either. Animal pleasures and simple women is what I want. I guess it's the women more than anything else.

Take care of yourself. Get soft jobs. Sleep a lot. Don't aggravate yourself. Wash your face in cold water.

Produce something. I'm going to myself. It will be easy.

Clem

MAY 11, 1936

Dear Harold,

Sure, I'm worried about a job, but I'm surprised you take it so seriously. I want to make enough money to <u>have</u>—that's all, the "necessary thing" not being to get out. Please, do I have to explain a lot of things you already know? What's bad in this, in being where you and I are, is bad everywhere. And as long as you're talking about JOBS, those in the gov't are very respectable. Think of how much of yourself you can save up, which you couldn't were you working for something that had to show profit.

It's easy to examine 300 applications in a day. Try it if it's easier on your eyes. I do 400 without much effort, and I'm slow. Dont be afraid.

I had a swell job supervising girls. Time passed quick, and I got away with murder. But now the apps. are giving out and the girls were shifted to other work, so I'm back at the examining grind—special cases which is a little more interesting.

Please tell me what you do when you're not working.

"Esquire" finally came out with my story ["The Brothers Jiminez"]— the June number. It's crap, worse than the first one, except for a little poetry here & there. I was afraid to take the thing seriously, but there was no need for fear. Oh I might have done swell. I shall be serious forever from now on. And then, it should have been a 200 page book, not a short story.

I've seen the Greco picture. It's too good, it makes me have reservations. I can't approve of that sort of thing. Greco is not true. If he wanted to paint that way he should have been born a 100 years earlier. Or he should have done this: The distorted flesh separate from the draperies and no horrible mystic eyes. El Greco's not my Kultur.

The "Goya" is coming out May 19th with some good line cuts. One of these days I'll call up & find out what's happened to Chief Joseph, whom I still love most of all.

I read an article in a German Communist magaz. that called Brecht the greatest master of the German language since Goethe. On the basis of the prose in "Dreigroschenroman" I agree. But I dont know enough German to agree. All the same I smelled it in the novel, bad as it is otherwise. Maybe B. does to German prose what Swift did to English. A master of language, that's seldom: only Joyce, Milton, Chaucer, Petrarch, who else? Leopardi? So now they say "die Sprache Brechts steht neben der Sprache Luthers, Kleists, Büchners." I'm glad to be told.

I envy you getting up at 11 in the middle of the spring morning. Don't you feel good? Then, at that moment? I remember, in Norfolk, how affec-

tionate the distances were. And do you ever hear the crows cawing? In California I missed that, where the ravens didn't caw. They went around in black & blue gangs and covered the cornfields with ink when the farmers weren't looking. But in the South they go around only in twos or threes and make more noise. Go out and hear them when the wind doesn't blow.

Clem

Dear Harold,

For God's sake, please depend on my coming on Memorial Day.

My eyes smart & burn in the morning, and after movies they won't stay open. On the subway in the morning they try to climb up in back of

Is that you?

my forehead. Coming home in the evening I lie in a torpor, and people stare at me, I'm so sprawled about.

Tell me some more about what you do every day. Drink the juice of 2 oranges instead of one. It has a wonderful effect in the morning. It makes you feel as tho' you could afford anything. And if you can afford that you really can afford anything.

Sinus trouble is really a cold. I know. Take aspirin.

I still go riding 3 X a week, and it keeps me alive, otherwise here at home I wd. turn inside out with exasperation at the rest of the family, including Natalie, who is turning out as alien as her mother. I canter thru the park and sing "A Melody from the Sky" from the "Trail of the Lonesome Pine." I always go a little too fast, and when I get back the riding master bawls me out for sweating the horse. It takes me a night's sleep to calm down. But somehow or other it doesn't seem good for my eyes.

It seems years since I heard from Toady. Today I realized with a start that Danny has by now probably a lot of blond hair on his head, walks, talks and feels good and bad and knows which—is sentient, a person. It's tough

that he's such a stranger when I love him so, and I know that he's turning out all right, which makes it worse. I know he's frank & affable and dislikes old women. I know he's interested in dogs and wd. appreciate my interest in him. And I'll bet he's so beautiful that he makes a radiance like the sun.

The reason nobody knows about the crows is because they haven't lived in the country or else they just didn't notice. I know whereof I speak. And I cd. tell you about the vultures too.

That Sweet novel, I'll never finish. It hasn't got it in itself.

As for foreign bookstores, Wash. is not half so metropolitan as it looks. Even S.F. had a place that had a foreign book section, where I chiselled a Goethe from 40 cents to 35 cents. But Wash. is a fooler. It's fastest speed is the March of Time.

I also am too tired in the eyes to write more.

The hot weather gives me visions of luxury with milk-skinned women with russet fuzz between their thighs. I sit over the "schedule books," writing things in them and look out at the swart waters of the Hudson. I think of heroic destinies and stormy love. The price never falls. Love continues to hold its gains, and its tone has never been anything but steady. And the joy of the fruit thereof is brighter than exploding planets—Danny I mean. Oh Lord, he is something which has a meaning.

———A DAY LATER———

I will leave Friday night at 5:30 Standard Time which will bring me to Wash. before 11:15.

I've just been horse riding and as usual it gave me a high jag. I cant settle down, can't sit down. I want things ripe, dangerous and rich—but being Clement, not too ripe or dangerous or rich.

I'm a mess to let a spirited horse do this to me. And right now I hear hoofs rattling outside on the Parkway.

Now I'm sleepy and will go to bed—until I see you.

Clem

JUNE 6, 1936

Dear Harold,

The trip home was hot and unpleasant, with the lousiest set of people aboard, and the travelling from one place to another was meaningless. As usual after leaving you, I couldn't get down to writing till now.

This afternoon I bought Daniel my son a brush and comb, silver with initials engraved, and an expensive white polo shirt from England and a dark blue sweater. Toady still doesn't write.

I've taken to fooling around with the girls at the office. I need it. One is good-looking but of no character and somewhat oldish. The other I just fooled around with a tiny bit the last couple of days, and then she got appointed to Washington. So I gave her your address and told her to look you up which I think she will. Her name is Anne Ehrlich, she's 21, very damn nice looking and of much sweetness with black hair and green eyes. She doesnt know I'm married so dont tell her—not that it means anything, but still I'd rather not. I think you'll like her. She has intellectual pretensions, for she speaks with an intellectual Jewish accent and comes from East New York where poor Jews live. She'll probably call you up. If she doesn't, ask for her at the Internal Revenue Department. A nice girl who I could go for.

The weather's been fine here, and in the morning I'm filled with longings. In a few weeks Pa says he'll get a new car. Maybe we'll take a trip, though nothing less than California will be enough. Any path that doesn't lead to the glorious beauty that Danny must have is no path. I want to see him in his polo shirt. And I wonder what color his hair is now.

When I left you you looked good and content, and now that makes me have high hopes of you. The more you get of self-sufficiency the greater you'll write, and sooner. Anyhow your play was a revelation, and I mean the word. You can build your microcosms and in fiction that's what counts most. And I never thought you'd have that désinvolture in dialogue. When I think of you it's with quietness and faith for myself in you. It's a new age. Now write the novel and forget the play.

I hate to think of how hot Washington will get soon.

The strike in France has me all stirred up. It's a peculiar strike because it is almost completely a political strike, and still more peculiar, a political strike initiated by the rank & file against the leaders. And for that it needed an amount of cynicism and disillusionment I thought no workers on earth possessed. There are funny things on the fire. I have a theory that the French proletariat are beginning to realize they have been intellectually disinherited, that France's culture never had anything [in] it for them. The German proletariat is at the other pole; their folk songs and ballads, Goethe's Röslein auf der Heiden are still for them. Toynbee almost says that. But maybe I'm talking nonsense.

——*Clem*

Dear Harold,

The hot weather or the rainy gloomy weather or the indifferent weather scatters me into demoralization. I take my job too seriously and smoke too much.

Today I was at the window answering veterans who wanted to know why they hadn't received their bonds. There were six or seven incompetents, and I had to tell them the cryptic words, "See Mr. Clark upstairs." All the incompetents tremble and shake if they're Nordic; if they're Polacks or Wops they curse. And they're so pitiful, just like Danny, my son; anxious to please, but they want something. And the women whose husbands have disappeared, and want their bonuses. "My husband went out of sight in Cincinatti." And the big shots from the American Legion: everybody from the office crowds around to tell them to go to hell.

Did that girl, Anne, call you up yet?

But shit, this is going to be a lousy letter. I'm too sleepy. I dont know what I want. I'm tired of smoking Lucky Strikes. I'm tired of drinking ice water. I'm tired of looking at women.

You're right about my being afraid to open up on myself. Solly says the same thing.

Pa bought a sleek shiny green Buick. It's a honey. That's what I want to do. I want to drive it and ride horses. I want to find out a lot about Chief Joseph. I want to tie all my cares to a wild mustang and gallop all over the plains. I want out.

Marty came home [from college], and he's wonderful. I want you to see him.

———*Clem*

Dear Harold,

Thanks, thanks for the pictures and Toady's letter. I was disappointed in both. Danny is a pretty usual sort of beautiful child with no salt in him—at least from the pictures. But I got a big kick out of him, he's so fat and looks so much like Toady, and even more like the pictures of her father. But maybe he acts like me.

Toady is not really as bad as her letter. She's always terrible when she's being warm to a stranger. That's why she has so many good friends. But she

is still weak shit. And as you say, literature: especially the mother-domina-tion. She is the sort that would sell out Christ's kingdom to the devil. I es-teem her less than her old virago mother.

She could have told me why she was hanging fire on the divorce. I'd have sent her cigarettes and money. She didn't have to let me seem such a skunk. She'll be able to say I deserted her altogether. And that's just what her mother wants her to be able to say. Her mother would like to have me boil her in oil so she could say I did it. Her mother is literature too: one of those villainesses in the silken cord plays they used to have 7 or 8 yrs. ago. But such cheap literature.

But what got me is the natural way Toady said the baby is her mother's property. "Property"—was appalled.

Here we are at home, pretty ripe in richness. We eat steak, lamb chops, drink Portuguese sherry, and go to see "Idiot's Delight" at $2.75 a seat. We buy $2.50 shirts, $8 shoes, slacks and jackets, silky pajamas, and fancy dresses for Natalie. We contemplate expensive weekends. We even ride taxis.

But I wont send Toady a cent until after the divorce. She can starve first.

She didnt tell you I send Danny something every two weeks. I send him the Best. Expensive pajamas. This week it will be a collapsible tricy-cle, a frilled shirt and velvet pants like William Astor's son wears. He'll have the Best.

Did Anne Ehrlich call you up again? I didn't expect she'd say anything you didn't expect, but she can be nice and impudent when she likes you. She liked me.

——*Clem*

Dear Harold,

I've just this minute come back from camp where I had a good time, and now feel so light and airy. I went up to swim and play tennis and be in the woods, and that's all I did and was, besides sailing a boat, dancing with 15 yr old girls and going swimming naked with girl counselors, which was—at night—an event. So what else was it I went to camp for? Saw Natalie. She's very whole hearted about it. She takes it so intensely that she's wearing herself out. Her poor legs have gotten so skinny, alas.

Your efficiency rating is the best you can get. All I got was "very good." I'm glad you'll be "permanent."

The business in Spain has me all upset. I'll die if the rebels win. It's all I can think of in the morning.

BORN FOR BOMBS (By Associated Press)

Death stalks the streets above ground, and these Madrid children have taken refuge in the subway to escape the hail of air bombs that Franco's fliers are showering on the city. Now look right.

Read Forster's "Abingdon Harvest." He's the nicest fellow writing the English language.

It's fairly definite—knock on wood—that I'm to get the car for a week in Montreal. Allowing me to pay for all gas and oil, it would cost you about $2.50 a day or a little more for food, bed and amusement. Why cant

you afford it? Now I wont deny I'd enjoy the trip all by myself—it would be the swellest sort of anarchy—but I'd enjoy it with you too. If you want to come, O.K. Your talk about geography is vieux jeux, and the moving silences are an illusion. I want to see Quebec plain & simple, because in Quebec there's a different culture. You, my dear friend, are full of shit. I'm exasperated.

I'm being canned Sept. 30th. There's no more work left, the place is cleaned out. In October I may come to Washington to look for a job if I dont find one here. What will you do if you're fired October 2nd?

Write quick.

——*Clem*

Clem, without Harold, drives to Canada in his father's new Buick.

SEPT. 20, 1936

Dear Harold,

I had a swell time in Quebec, which is a good deal what it's famed to be. I'd imagined that what I saw would make me contemplate and consider, but instead I regarded only naively & lived from hour to hour.

I left at 6:30 A.M. Saturday and travelled up thru Conn., Mass. and Vermont until I cut back into N.Y. and spent the night at Ticonderoga in a tourist place. Sunday I went straight up along Lake Champlain, crossing the border at Rouse's Point.

The first thing was the sick sweet smell of fertilizer in the fields. Later all the Frenchmen in Montreal smelled that way until I got used to it. I came into Montreal at six, finding French & English signs all along the way and the place modern but with signs of English & Catholic grandeur. I put up at the Ford Hotel, full of tourists, went down to the French section on Ste. Catherine St. and saw a French vaudeville show. Monday I drove around the city, gawked at the halles, watched women climb the stairs of St. Joseph's Oratoire on their knees with prayers, looked at the abandoned crutches & glass eyes around the shrine, looked at the amber glass the pilgrims kiss, offending one of them, saw Lachine rapids, etc., had a good dinner, saw a good French movie "Mayerling," then went to the dives on St. Laurent-Main where I drank good beer, saw dirty floor shows, was approached by whores, talked to English sailors until 2 A.M. and went to bed.

Tuesday I left for Quebec. It rained, spattering the car from head to foot with mud. The country got nice about 25 m. from Quebec, rising high from the river on both sides, the houses painted now in 3 or 4 different colors. Before, half of the houses were unpainted. I got into Quebec at 7 and found my way into a rooming house run by two pretty young filles in the absence of their mother. The place is 97% French and in the Basse-Ville nobody knows English. The Haute-Ville, up on the Plains of Abraham, is where the tourists & English are dumped. Went to a French movie where the cashier complimented me on my French. Had a swell dinner with dandy sauterne wine before that.

Wednesday it kept on raining. In the morning I saw the town, went through Sous le Cap in the Basse-Ville, where the street is so narrow the houses are bridged overhead, and little brats asked me for "penne, penne." In the afternoon I picked up a French lad named Pageau who guided me to Ste. Anne de Beaupre 20 m. north, a shrine even holier than St. Joseph's. Pageau could hardly speak English so we had to do it in French, and I got fluenter & fluenter. Argued about the church & communism. The church stinks, I had to decide. They sold charms against baldness and flat tires. I bought souvenirs for Anne, our maid.

On the road from Ste. Anne's to Quebec children sit with big dogs hitched to carts & let you take your picture with them for 25 cents. Also saw oxen drawing wagons for first time. In Quebec had another good dinner, then sat in the living room and got acquainted with Genevieve and Clotilde Lanouette, 20 & 17 yrs old, dark and blond. Stayed up till 2, drinking beer.

Next day woke the girls at 11 and drove around L'Île d'Orléans in the middle of the St. Lawrence. We stopped and talked to school kids and gave them hitches. One little boy said "fuck you"; it was all the English he had. Took the girls to dinner, then got drunk and stayed up till 3, making love to Clotilde in French and exchanging soul kisses. Up next morning at 11, woke Clotilde, necked her in her pajamas, had breakfast with her and departed. By that time all I could speak was French. At Customs I answered "Ah oui," that's what the Canadians always say. Drove thru the Maine woods, all scarlet, cherry, orange & yellow and spent the night in a cabin on Lake Wyman where I had a log fire, kerosene lamps, and a wonderful sunset.

Next day drove 500 to get home at 10:30 P.M. Went 60 m.p.h. for 12 hrs. straight and was tired as hell and sorry to get home, with Pa surly & grousing.

It was a vacation from the inside of myself, and now I feel lonely & pathetic.

—Clem

Dear Harold,

I'm as stricken Stumm as you are. I cant even make rudimentary sounds like in a zoo. I'm as dumb as a giraffe or a fish.

The automatic joy, the expected and natural joy, of the vacation has worn off and now I remember painfully the exception and surprise of spending a week the way I did. I was alone, I had the car, and nothing was necessary, required or fated. I'd sit in a roadside place, eating breakfast, sixty bucks in my pocket, and look out at the car waiting there so neat and compact and stream-line, ready to take me places I'd never been before. Like Hannibal's horses, I bathed in old wine: everybody said how good I looked when I came back.

The 2 weeks since then should be crossed out of my life. That's what bothers me every time I go some place. I begin to worry about how bad I'll feel when I come back. At Danbury, the sun peeking thru the clouds, I said to myself it's going to be terrible in a week, I wont be able to stand driving thru here on the way back. And that spoiled the whole trip down from Quebec thru Maine. (But even so, Maine wasnt so hot. The West has it licked in all directions.)

At the Civil Service Comm. here they've practically promised me a job by the 15th—at $1440.

What you say about Social Security sounds good, but they tell me here that the NY office is still in a nebulous state and that with all the applications in, the best thing to do is wait and watch. The ass't civil service dist mgr also told me to not go to Wash. looking for a job, as Wash. was full of people like me fired by the V.A. also looking for jobs.

But the weather is getting good. It's very nice in the morning, and you smell dangerous winter in the air, with threats & promises. It's very hard to see winter come. I mean summer never has fear.

—Clem

Dear Harold,

And I want to write you but can't. Working for a living means not living.

Nothing has happened. I'm still at the Civil Ser. Commission, where they're so easy on you that I wish they were tougher. It could very possibly happen that I shd stay here the rest of my life. I even long for the V.A.

What's your future?

I havent had a letter from Toady in 2 months. Her last said that because Danny's legs were bowed they were afraid he might have a touch of rickets. Which got me all worried, and now she's heartless enough not to have written.

This evening, however, I got a big de luxe picture of the kid, showing him with a high smooth short-clipped blond head, square cheeks and the effort of smile that opened his lips—like Toady he smiles with his mouth shut—and let me see his teeth that have spaces between them, especially the 2 front ones. Altogether he looks shining healthy—and even a little Jewish around the mouth, although his lips are not thick like mine. His eyes are as Nordic, alas, as Wotan's. I mean, I can't see Israel anywhere in them, the picture even shows their blue color. It's hell to have a kid and not see a single piece of yourself in him.

I saw, in case you're interested, Leslie Howard's "Hamlet" which wasn't half as bad as the papers said. Howard was awfully inadequate to the big moments, but he carried on conversation better than Gielgud, and there's plenty of conversation. Meanwhile all I'm interested in outside myself is that the Loyalists win the Spanish war and that Trotsky gets safely into Mexico and that Mrs. Simpson gets the syph and that govt employees are put on a 5 day week and that it comes on to snow.

I've had gastritis for a week with belly-aches and lots of belching. I'm getting sick & tired of it.

<div align="right">——Clem</div>

P.S. Enclosed is $3.50, a compromise. I gave the other 50 cents to the Spaniards, for you. It will help furnish forth a guerrilla band in the Tagus Valley.

1937

<div align="right">JAN. 19, 1937</div>

Dear Harold,

I've just been 4 days sick with the grippe—3 of them in bed—so I feel like writing a letter. Saturday, my birthday, I had fever & a headache; I didn't go to

work, I went to bed & stayed there until today. As Pa, Fan & Natalie went to Florida Saturday morning for a month, Sollie had to feed me, then my Aunt Beckie. Sunday I had the doctor in and as soon as he came I commenced getting well. It did me good to be sick in bed. It sort of marked a period, and now I start all over again, thin, resigned, gentle & contemplative.

But that isn't all there is to my bodily ills. A month ago I started having stomach trouble. It got so I couldn't eat. Finally I went to my cousin who told me I had hyperacidity of the "pre-ulcer stage" and that I should go on a "bland" diet, which I've been trying to do ever since. There is now an infinity of things I can't eat. Anyhow the stomach trouble has stopped, and the business of a diet begins to give my life a certain form & measure it lacked before.

An 18 page letter from Toady describing the scenery on Monterey Peninsula sounds I dont know what. I sent her $50 on her plea. I get a letter back saying Danny is very nervous, had hysterics once and is over-timid, being at the same time a difficult child to handle, etc. Which upset me for a week & I sent a harsh letter to Mrs. Ewing, telling her to go easy on my son. She is wacky & I know damn well she's been spoiling & babying the kid to the edge of insanity. She can do that sort of thing very efficiently: pamper & cozen him until even at the age of 2 yrs. he begins to have delusions about himself. Mrs. Ewing is almost like a Jewess when it comes to overdoing something easily, but is nothing like a Jewess in that she'll keep going & overdo it dangerously. I'm awfully afraid Danny might grow up to sadden instead of gladden me. I want joy from my children.

How much longer do you think you'll be with the V.A.? It looks as though they'll never let you go.

I saw the best performance of an Elizabethan play I'd ever seen in the WPA—"Dr. Faustus" with Orson Welles, the 22 yrs old fellow who helped write and directed "Horse Eats Hat," playing the leading part & also doing the directing. He delivered verse like I've always dreamed it should be. He knew all about the transitions from declamatory to conversational. There were parts when it was like listening to music, the sensation was so perfect & unmixed; some of the lines he made sound better than they really are by timing them for special meaning. There was no scenery or "sets," just lighting. The costumes were theatrical, not authentic, and all the comedy was burlesqued, laid on. The main thing, that is, is that there was no attempt at realism. Of course, it isnt as easy as that with a Shakespeare play, and besides "Dr. Faustus" is more like "Murder in the Cathedral" than an Elizabethan play because the drama works out inside a single man's mind, but all the same the same

sort of thing cd. be done with Hamlet. However, Marlowe's verse comes much easier to the modern tongue than Shakespeare's; it's easier to speak.

I also saw "Othello," which was lousy, Brian Aherne being the lousiest Shakespearean actor I ever saw. He chewed & mumbled his lines worse than a high school kid. [Walter] Huston was out of place in his part, but he got better towards the end and in the "Othello's lost his vocation," and in the death speech he was really O.K. The play was directed so bad that I fell asleep during one scene. For that matter, I don't like the 1st half of "Othello" anyhow.

But that Orson Welles' "Faustus"—wow!

——Clem

MAR. 16, 1937

Dear Harold,

The sudden stoppage of work—I'm surprised it didn't come sooner. Are you worried? I've a hunch it won't be you they'll let go. Go & translate troublelessly. In Washington you can read Rilke better than I can here.

Danny & Susie Fuchs and Bob Brosterman & myself are taking a 3 or 4 day trip in the general direction of Washington where we may stop one night. It's an anomalous business: we're going to a race track maybe. Anyhow don't expect too much of me. It means nothing. If I get to Washington I will call. I had to invite them along on the trip as the idea's been proposed by them years ago and I had to come through. It's not exactly the way I want to visit you in Washington.

The business of not writing something until you're able to write your best is horseshit of the utterest kind. You'll never write your best until you've already written less than that.

I feel very tired & lousy. Please Harold do something to give me hope.

——Clem

MAY 13, 1937

Dear Harold,

It's about time I wrote. The reason I hadn't so far was that I was a little ashamed of myself and somewhat mad at you. I'm such a shitheel and you're such an ass—at your special times, such an ass. But you're generally an ass out of goodness.

The trip was not so hot. The Shenandoah was only good in spots. Anyhow the Fuchs being together are not such hot company either. Danny without his wife is much better. I must apologize for him. He thought that I didn't want you to come along and feeling he had taken the initiative in inviting you, had to take the initiative in retracting. Which moves the apology on to me.

You're on my conscience. What conscience I have.

Write and forgive me. Consider how I complement your good-weakness by my shittiness.

Forgive me.

Clem

JUNE 28, 1937

Dear Harold,

So far no results as to a job. NY is deader than hell in that respect. Everybody's waiting for the budget. The indifference of the management to the fate of their ex-employees is appalling. It's a lesson.

Here, being on leave that's no leave, it's terrible. I shd be riding horses and swimming, but I haven't the spirit for it. Added to all that, the fate of poor Spain depresses me every morning. If the Loyalists were winning I'd really be happy in a personal way.

The house is overcrowded, now that the 3 of us are home together. We get up simultaneously at 12 every day, and being the sort of fellows we are, have nothing to do until night time. It's an eye-sore to see 3 hulks lying piled in the living room during the bright noonday.

Tomorrow I go downtown to finish off the last shreds of working time I owe.

Toady wrote me, asking for $11,000 to invest in a "wonderful piece of real estate" that wd guarantee Danny's upkeep forever. I don't know just how to evaluate a person that Quixotic—or dumb. Tell me how. Is it true what the psychologists say about people whose minds dont correspond to reality?

——*Clem*

The divorce was finalized June 26 on grounds of desertion, child support set at $5 a month. Toady has now moved to Washington, D.C., leaving Danny with his grandmother in Carmel.

Dear Harold,

How did you find the shock? and what do you think of the cracked ice that is my ex-wifekin? I saved for you the fine full first force of the surprise, not even dulling it by a wire, as she did me.

It will be something perfect to fill your tediums, and hasnt it already been so? Tell me honest. Tell me what you find her. She's a dear at times, isnt she? Nice to take into a place and buy a beer for, isn't she? I envy you that.

Give me a good cold size-up. As you can. But make it plain.

Please dont tell Toady what I say in any of my letters. That's a permanent rule, just to be on the safe side.

You should see these pictures before I return them to Calif. He's hard to make out, and I need help. His head is shaped like a tropical fruit.

That being held on at the Vets while the rest are being fired, that's swell, because it makes your record look good. Did you get your new pay check yet? You have a future maybe.

<div align="right">

Clem

</div>

Dear Harold,

Your valuable letter was much appreciated. Toady you've got to a T. Some things I realized for the 1st time in your telling them: the way she hates the impersonal and how dumb she is once out of a certain orbit.

In her letter she said nothing at all about her job, which is what I am now more curious about. That is, will she be in Washington forever?

Here I've found no job yet. In the high places there is an amount of stupidity that thinks I'm of "too high caliber" for certain jobs whose pay I like. Sometimes I worry and sometimes I dont.

From Friday to Tuesday I was at the folks' cottage at Camp Tamiment [Pennsylvania], getting healthy. It's like a good night's sleep in which there are and arent dreams. All day I'm bored, playing tennis, sleeping, swimming, changing my pants on an open porch. At night I tag after a revolutionary dancer named Malvena Fried, originally from Mobile, Ala., now from Moscow and Sodom & Gomorrah. She likes me but likes the brightness of her own shining more. But she has something on the ball, makes her own dances, etc. She's something out of a modern novel, like Toady, only more so.

I sent my Wash. poem to Horace Gregory who's making a book of "New Directions" for W.W. Norton Co. I got a reply, saying they were holding it for consideration until September. I dont know at all what that means. I had an experience at camp. I was walking with my cousin through the center of the bungalow colony, not looking at the ground but talking and thinking and looking at women. Suddenly I heard a hissing little rattle, looked down and saw a beautiful green diamond-back snake, fat and about 4 ft long, stretched right across my path. It was a rattle snake, waving his tail and moving very very slowly. It was the mating season, he was full of sperm (so a doctor said) and on his way from the hills to the coupling grounds. I threw rocks at his head, finally caught him in the crotch of a bush where I stunned him a little with a stone, then dropped a big rock slab square on him, breaking his back and splitting his hide. Finally some one came along with an oar and a knife and cut off his head. It was some snake, very beautiful and somehow cute and cunning, nothing fearful about him except his name & history.

And then one night I also saw a small bear scampering thru the brush. The country is very wild, being part of a game preserve, and has deer and wildcats as well as bears and more rattlers than any other section of the Eastern US.

——*Clem*

AUG. 6, 1937

Dear Harold,

I finally got a job at the Appraiser's Office of the Customs Service at $1700 p.a. with $100 mandatory raise at end of each year, until it reaches $2100. Some luck! I'll be a clerk in the liquor and foodstuffs import section.

The job won't start for 2 weeks. Until then I'm happy. It's a trip I want to the Adirondacks for 4 or 5 days.

Please, please, wheedle or steal Danny's new pictures from Toady to show to me. I give my word of honor to return them.

——*Clem*

Dear Harold,

Your letter and the nice things you say about my poetry finally stir me from apathy and make this letter. But 1 of the reasons I didn't write is that I just can't separate myself from $4 which I owe you. Besides I owe $2 to Spain which 2 different people gave me to give to Spain.

The job is somewhat difficult for a fellow like me—so much detail—but the day passes like lightning, which is the highest good in a govt job. I'm the "routine clerk" attached to the liquor examiner. All we handle is liquor. I have a whole office to myself and no supervisor. There is desk work half the day & the rest of the time I run around in the warehouse room checking cases of liquor and measuring the contents of wine bottles. The liquor itself is fascinating: the cases are so well made and neat, and when the laborers open them and lay out the sample bottles in their expensive packages or without them, it's beautiful. And before lunch the smell of the opened wine drives me nuts. Handling French, German, Italian, Portuguese, Greek and Spanish invoices is also fun.

My fellow employees in the office are all farts, nice farts, old farts, but still farts. The laborers are regular, though, real nice proletariats. There's a funny sort of apathy around and everybody's frantic about not being frantic. A real govt. Stube. And young or old, everybody's been here at least 10 yrs.

I've been writing poetry lately. It nags me, teases, gnaws, annoys. I smooth poems out and smooth them out until I've smoothed out whatever is good in them. If only some part of the world wd say one of my poems is good, then I'd be all sureness and audacity and I wd. write wonderful stuff. That you read my poetry to a girl amazes me & gives me strange joy. But her "holy hush" was good manners; she wanted to do the appropriate, believe me; I can't believe otherwise.

I've had lots of 1st hand letters from Spain shown me lately. And the stuff in the New Masses. I've never read worse. I blame it on Stalin. His darkness infects the minds more thoroughly than syphilis infects the blood. Often now I go into a froth about the Stalinists, especially when an intelli-

gent Marxist—I met one—lays it into them. His example sets me on fire and I go wild. But then I'm very easily influenced. Especially lately, about politics and literature.

Incidentally, read Spender's "The Destructive Element." And I think I'll buy Laura Riding's book [*A Trojan Ending*]. She needs the royalties and the loyalties.

Incidentally, the business of being easily influenced: I've gotten the feeling lately that there are people on earth who are thinking ahead of me, that I'm falling behind, no longer the intellectual bonanza I used to be. Me, who used to be able to think toe to toe with any man alive. It's because I no longer read books carefully. I also waste too much time, neglect to think a thing through.

I'm sending you a poem I wrote to a girl at camp. The girl was even more inadequate than the poem.

Of course, I suppose, Toady's boring, but you're not supposed to regard her on the plane of boring. She's something else, and I'm afraid sometimes that it's very lousy, what she is.

——*Clem*

Dear Harold,

About my son. I can't write to Toady unless she writes to me. If she brings the kid East I'll contribute at least $15 a month and most likely more. But I don't take her seriously, and she doesn't take herself seriously, otherwise she wouldn't excuse herself through me. I'm planning anyhow to send the old lady some dough, which is hard to accumulate because I'm not yet willing to deprive myself of much. I have no friends or women, so all I have is money, the Spanish war and Stalin-Trotsky. Of which money covers all.

I've written a piece about Anna Seghers, a short story and a monologue, also a few poems. And have discovered a marvellous dichter, Joachim Ringelnatz, about whom you may have heard faintly. He's not anywhere near as serious or important as Brecht but he does things Brecht can't touch. Wait'll you see.

Some time after New Year's I think I'll move out of the house and take a room in NY. I'm getting sick of travelling 2 hours a day; besides I'm paying $35 a month to Pa. $35 + chasing the trolley every morning isn't worth it.

And Solly who comes to bed and wakes me up exactly when I'm about to get the right amount of self-confidence to fall asleep. These things wear me out.

I joined the C.I.O. and have been made secretary-treasurer, which is half a nuisance.

——*Clem*

1938

Clem writes on stationery from the Treasury Department, Office of Appraiser of Merchandise, 201 Varick Street.

FEB. 8, 1938

Dear Harold,

Exactly the way you said, the news of Toady's fiançailles made me squirm inside my skin. [Toady has met and become engaged to Buddy Offut.] It's no light thing to have given a piece of your life to somebody. You can't get it back so easy. The worst thing is when they take that piece and thoughtless, throw, toss, drop it as they're walking in the street and forget immediately all about it. Toady lives like an animal without qualms or afterthoughts. But she has the superb cleverness of a scheming child. She estimates and handles her tools like Michelangelo. In her line she's perfect. But real Goyische Dreck. The lard-eating, uncircumcised kind.

That piece of my life made me feel bad. Not Danny. He's already out of her scope. Tell her that I'd rather have Mrs. Ewing take care of him than a 2nd degree Mason. But my vanity's terribly hurt. To think that I produced no effect. It's a real novel, a real lousy one.

I'm sending you your birthday present tomorrow, as it's already bought: the complete Plato. And keep the [Wallace] Stevens "Blue Guitar" as I've bought another copy for myself. But send back his "Ideas of Order."

Myself, I'm trying to work up more stories.

Who did Miss Perkins marry? Things happen so quickly. Maybe it's because we're living in the epoch of wars and revolutions. Forces are expanding, pressing at their bonds.

I think I must move out of the house. I think I must make some more money, so I can support Danny. How he'll need me soon! I mean somebody in my category.

Somehow I feel very definite and sure of myself lately. No hesitations. But I don't think I'm half so hot as I used to be.

If Toady were to marry a right guy I'd feel very flattered. Hence, the opposite is an insult. Oh my poor esteem. I'm squirming and squirming. I had no idea a thing could be flesh fleshly and yet as important.

——*Clem*

THE VILLAGE

"I could give myself emotions."

Clem moves to New York—48 West 17th Street.

MARCH 11, 1938

Dear Harold,

I've finally moved to W. 17th St. between 5th and 6th Ave. One room—fair, with a "semi private" bath. A fair room. The location's wonderful. I can get up at 8:30. There's no daily crisis with the trolley car, no more tense moments in the morning. And in the evening I don't have to make my way home, I can just drift there. What a relaxation of life: the antithesis of big city living. Only from the suburbs can you discover the agonies of the metropolis. It's almost socialism, except that the room gets a little too cold, but I'm willing to stand it. Thirty bucks a month.

Not a single passion. Only the Moscow trials to bring me alive, and social intrigue in Greenwich Village as between the Stalinists and the Trotskyites. I may write something.

What's new with Toady? That business of living in an apartment. Imagine, 6 months in Washton. and already being kept. R-r-r-agh!!

——*Clem*

MAY 16, 1938

Dear Harold,

I'm glad to hear the operation went so well. I don't like operations on the nose. I never trusted them. But you sound all right. When will you be coming to NY? Try to make it on a Saturday, to stay over.

I am writing stuff.

Do you want to see the "Sea Gull"? Let me know when & I'll get tickets. When you're convalescent I feel so solicitous.

I have become acquainted with artists, abstract artists. They're delirious about Picasso, naturally, but also Eluard, altho they don't know any French. So I have given viva voce translations in public. I have enjoyed myself. I could give myself emotions.

——Clem

JUNE 2, 1938

Dear Harold,

You haven't fallen sick again, have you? Your nose is OK, isn't it? Not hearing from you, I began to have fears—but which I'm sure are baseless.

Since you left I haven't had a chance really to sit down and think. N.Y. is different from Bklyn. In NY you never can actually meditate, you can't sit back & become passive. It's probably the worst thing possible for culture. I am at odds & ends again. My life has no meaning.

I'm writing poetry copiously. A scene ["Progress of Poetry"] on the style of Apollinaire's "Larron" about the Ascete Poet, the Professors, a Baptizer and the Women. The Ascete-Poet is an Orpheus, but he is also Paphnutius, Socrates & the ghost of the absolute, craving itself only and admonishing women for their flesh. They want to tear him to pieces for it—and will.

Rosenberg [Harold, a new friend of Clem's, has just moved to Washington and a job with the Advertising Council. Through him, Clem meets "the Partisan Review crowd."] finally wrote to me and I'll write him telling him to look you up. His wife [May] is now with him, a nasty customer. Watch out for her. I'm always afraid for you. You have to make conversation.

Igor [Pantuhuff and his girlfriend, Lee Krasner, are among the "downtown" painters Clem has also started to meet] has asked about you, wondering how it is you work for the Vet. Admin. He says we don't know how to exploit ourselves properly. I go to sketch class at a WPA studio with him every Tuesday now and have fun. Drawing from life is such anguish. I have no conception of creation, I can't control myself; all I want to do is get the model down on my paper the way I see her instead of the way I think her, which is utterly bad. To draw what you see is pure passivity.

I'm reading philosophy. A fellow by name of Kierkegaard. Also Kafka's best novel "Amerika." Much better than the "Castle," less abstract. Cuter, funnier.

I am so goddamn frivolous lately.

My perceptions and comments scatter like a girl's.

I'm sending you a drawing enclosed. Good, I think. I'm beginning to loosen up. Drawing from a model does that. That is, that's the after effect of drawing from a model. You come home and your imagination seems released from a prison.

<div align="right">Clem</div>

JULY 23, 1938

Dear Harold.

The reason I didn't write for such a long time was a case of trench mouth, which I still have a bit of. For 2 weeks I was miserable. Slight fever, heaviness all over, aching teeth and smarting and bleeding gums. Life was not worth while.

I had a little squabble with my favorite girl friend, whom I'd been playing so so carefully, and now I'm coming more & more to believe that I'm unprepossessing, that I smell bad, that I dull myself, that I'm a fat man. Meanwhile the girl who's been a nuisance "has given me up as a bad job," at which I'm both relieved and troubled.

All this—the fact that I write about it—is a symptom. I'm no longer prick-proud. I yearn to discuss my private life, which is an amazing sign.

I'm in a shitty state. I'm allergic to reality.

Life class is over for the summer and I miss it.

Did you find out yet about my son? Did you search Toady? Or is Buddy permanently sore at you? I have a hunch he is. Not because he's that kind, but because Toady has that effect. He's reduced to an appendage to a biography. She's a marvellous thing. The dazzling inane.

Have you seen the Rosenbergs again? Listen to Harold, he's a good antidote for our kind, for us spinnakers that are more sensitive to the wind.

All it does here is rain. The city's in a state about it, really. A metropolitan psychosis. But I'm pleased.

<div align="right">——Clem</div>

AUGUST 4, 1938

Dear Harold.

Your aperçus of Rosenberg burst with justice and accuracy. One thing you left out: the childishness is also associated with that desire always to be right, correct, and this is why these guys, brilliant, don't amount to anything in the end. With more error and less childishness, Rosenberg wd be a forest-fire success.

I'm glad you get along together. You need him, you need exposure to him. You need more of that logic which is a confession of the inability to know anything immediately and directly. That is, when you read a book you should be able to explain its message.

Heigh ho, heigh ho!

Is it hot!

I need love. I mean love has to be released in me. I can't stand hot weather without love. Even history palls. Will I ever find la Vita Nuova?

And think how indifferent, relatively, everybody is to the Russo Japanese fracas. Time was—before the Spanish war—when a thing like that would leave me quivering with interest all day.

My drawing was entirely original. Your hypothesis hurt me. Von meinen kleinen Leiden mach ich grosse Bilder.

How is Toady going to California? Alone? By train? Is she definitely bringing the kid back with her? When she gets married forward my congratulations. Not to be funny, but because I really mean them. But don't congratulate Buddy.

——*Clem*

AUGUST 23, 1938

Dear Harold.

Yr letter with description of nuptials came at the inevitable moment, when having gotten up late and shaved I was rushing to board cab for work; it was inevitable because I was as blousy as Toady's dress, after a 3 day weekend at Saratoga with the Fuchses, in the course of which I had my pocket picked for $22 and won $125, both at the races. Add to that a flat tire, a long distance phone call to Danny from Marc Connelly, a blow-out at an expensive roadhouse, swimming in the lake and a ride home to NY last night from 6 to 11. And now at work with the trench mouth still with me. For 3 days, for the 1st time in my life, I spent money like water. We lived on the best—and I still have $73. I can't understand it.

And now yr letter. The blousy bride. Couldn't she look pretty? And why in a church? The white trash.

I'm glad H. Rosenberg is nice. He is, as a rule, considerate—when all it will cost him is social effort, but otherwise he has it in him to be greedy like a child; to grab without waiting to decide whether he wants what he's grabbing.

I'm seeking desperately thru the pages of the NY Times for a place to live in. I'm looking for home, really. Home, a home.

AUG. 25

Yesterday my stomach went on the bum: gas, nausea. I was so weak I couldnt stand. Today I am well, after 10 hrs sleep. All my holidays have this aftermath. How I pay for pleasure.

Refiguring my winnings, I discover that they were closer to $140 than to $120. So all I do is think about horses, which frightens me, as they are nothing to think about. The trick was in getting long shots. Night Alarm is the name of the horse who won us $200. I'm going to write him a poem. Royal Sortie is the horse who won us $170. I rolled on the grass with joy.

Now it behooves me to sit down and become a great writer. I'm oh so lazy. The birds wont fly. I swim in marble.

My poem, however, about the poet, the air and the women is trying to move. Will it? It swims in wool.

——*Clem*

Clem writes from Burtt's Houseboat & Cabins, Alton Bay, New Hampshire.

SEPT. 17, 1938

Dear Harold.

I was about to start on my vacation when yr letter got to me. So I went anyhow—troubled in mind.

All I can do is write Toady a letter, which I will. As to the adoption procedure itself, I don't think it's quite so simple. Whether or not the child is in her custody, it has to be shown that I have utterly cast it off before the court goes about making him some one else's son.

Sure I'm to blame. I wanted Mrs. Ewing to bear the burden. I didn't want

to sacrifice for the kid's support, feeling that why should my life suddenly have a property judgment on it as a result of Toady's and Mrs. Ewing's aberrations. Of course, I'm wrong. Yet I know that I'll be shelling out plenty; that Toady & her man are sooner or later going to run into money troubles; that I'll be coming through. Now while they're full of their juice and pride they say—or Buddy says—never, we'll die before we have to come to that. But they'll come to it.

Meanwhile I'm on my vacation, alone. That's the way I feel. Utterly selfish.

Forgive me——

——*Clem*

Clem moves to 9 Minetta Street.

OCTOBER 7, 1938

Dear Harold,

I'm afraid to hear from you. I didnt write to Toady. I just worried. Half way thru my proposed letter I had a revulsion. My own arguments were revolting.

Have you seen him yet?

For the last month I've been living in suspension. My vacation was not a rest. Coming back, I didn't move into my final quarters until a few days ago: a furnished one room apt—not so hot—in Greenwich Village at $36.00 a month.

A child cannot be adopted without the consent of both parents, if they're living. You say that Offut's willingness to adopt the kid is understandable. Like hell it is. Aside from the false relationship, the embarrassment of names & identity will be enough to plague the kid his lifetime. Don't the damn fools realize this? Aw shit!

Have you seen the Rosenbergs? They were in NY the end of August, and Harold annoyed me to death. I can't stand any longer the mockery of himself.

——*Clem*

NOV. 1, 1938

Dear Harold,

I didn't write out of shyness. I was very much abashed by the idea of

Danny in Washington, only 250 miles away, and myself, dying to see him, but somewhat afraid.

Your words about him are so many pearls, but you don't describe him physically enough.

I may and may not be down Armistice weekend. But what's this about Offut not letting me see the kid? Is there liable to be any outrage? I'll shoot the bastards, both of them.

Has he got any friends? Does he ever play with kids? How's the climate affect him? When's Mrs. Ewing coming East? Does he need anything? What does he think of Toady?

My one room apartment is OK. I live only 2 or 3 short blocks away from work, so I have eliminated a lot of the day's stress & strain. I have written very little lately—no poetry at all, but I'm doing a good deal more drawing.

I'm reading German philosophy without profit. I'm looking for conclusions, and all I get is methods. But there's nothing else to read, absolutely nothing else left. Not only literature, but even politics are dull, dull in discourse. History, of course, remains interesting, but only what it says about what is happening. What I need is new conclusions.

But I mustn't exaggerate. Neville Chamberlain, for instance, has caught my imagination with his big brown eyes, dewlap and his shamelessness, well-meant. The effrontery of his intellectual violence, which is violence because it is very calm, very cool and very un-intellectual. He and his kind are oppressors of the reason.

That radio broadcast by Orson Welles also affected me. I heard the last half of it, and therefore was able to feel the humor of the thing better than otherwise. But the panic, with its cause, is fast food for fancy. I mean it, serious fancy. The combination was so perfect. It is something not to be passed over quickly. We live in momentous times, when the gap between reality and the dream is once more closing, when the things we hope and fear actually happen.

I could explain myself better, but I'm satisfied to agree with everybody else that we live in momentous times.

——*Clem*

NOVEMBER 9, 1938

Dear Harold,

I won't come to Wash. until I'm sure I'll be able to see Danny. If I come

and go without seeing him it'll be more than my sense of myself can stand. I'm bitter sore, not at Offut—who is apparently a very nice guy—but at Toady who's made a black villain out of me. You, of course, can't take it upon yourself to argue it out with Offut, but for God's sake don't write as though the situation is something to be taken for granted.

What aggravates me more than anything else is Toady's slatternly laziness in letting Offut take complete care of the kid. What a slug she's turned out to be.

And I'm to be de-paternalized because I didn't come through with money. Does Offut know that the only reason I didn't send dough to Calif. in the last 2 years was because I wanted old lady Ewing to bear the brunt herself for a while? And that I'm willing to take the kid any time? And it's lousy to have to take a stranger like Offut into consideration and worry about his getting the true version of my private affairs.

Anyhow, you can tell them that while I'm me they haven't a chance in hell of adopting the kid. And also that I will come to Wash. and get a court order forcing them to let me see the kid. Which reminds me that I want you to do me that favor right now. Get a lawyer, ask him how it's done & engage him for me. Have him get the order out immediately, let me know how much money is needed and what else. Please.

And you—for God's sake don't be so pusillanimous. Offut's OK, but in so far as he thinks I shouldn't see the kid he's a stupid fuck. And if I come to Wash. and can't see Danny I'll kick the shit out of him. So help me I will. And I'll also kick Toady in the ass.

Meanwhile you haven't told me whether Danny plays with kids, what color his hair is and whether he cries much and is timid.

Excuse the tone of this letter. Forces of evil are abroad. My conscience is not clear, but my logic is.

You're a true friend.

——*Clem*

1939

JAN. 13, 1939

Dear Harold,

Instead of Doughty, which although I want to own, I don't want to read right now, I'm taking for my birthday the new double number of the "Cahiers d'Arts" which has almost all of Picasso's latest work in it. This is the present I <u>want</u>. The idea of having it fills me with joy. It's $4, and I'm

buying it tomorrow afternoon. Being very thick, it has all the dimension necessary to a present.

The Brecht volumes will be on their way to you by the time this letter is. I told the bookstore to send them to you direct and me the bill. So that's that.

Does Buster really draw well on his blackboard? Find out for yourself. I really don't believe in heredity. Get him to draw something on paper and send it to me. Tell Toady to have him begin copying pictures with simple, easy to distinguish forms, and at the same time to draw pots, cups, books, etc. That is, if he shows anything. If she gets him to struggle with drawing, he'll probably quiet down some.

I saw a lousy play, Irwin Shaw's "The Gentle People" and heard Ernst Toller read an even worse one, his own latest ["Pastor Hall"], in beautiful Deutsch. The demoralization of the left, especially the one-time German, is even deeper than I had thought. Toller handled himself in a sacerdotal manner, but his play showed that the manner was sincere, not simply a literary attitude. Similarly Brecht's latest play "Señora Carrara's Rifles" is full of, not religiosity, but pietistic morality from the side of the People's Front.

Lionel [Abel] says he was sorry he didn't have a chance to speak to you more at length, but "the circumstances were difficult." It seems that Rosenberg has sent in to Partisan Review a revised copy of his piece [on Thomas Mann], which is being printed willy nilly. Every minute more the fuss about Mann irks me more. The intellectuals—like Swift's true critics—have excrescencies to nibble on. But only because Mann deals with important questions explicitly. Let them try their teeth on Joyce, the unfashionable now, who deals with these same things better, only implicitly, so that their elucidation by a critic will prove to be a real accomplishment of criticism, not a pretext for writing importantly.

One thing however I am grateful for: true critics are never Philistines, in spite of what Swift says. You won't understand me—it's a personal matter I haven't time to explain.

——*Clem*

10

INTELLECTUALS

"Dante should've provided a special circle for them some-
where on the <u>periphery</u> of Hell."

Dear Harold,

As usual I don't feel my birthday, but nevertheless I'm very sad to be thirty. Villon and the usual. And truly, I feel I've drunk all my shames. Plenty, plenty.

You didn't make the adoption business clear enough to Offut. Is desertion sufficient grounds for adoption? And can they pull a fast one on me by pretending I've deserted? Meanwhile I must thank you—on my birthday I must thank you.

I do want to see the kid before I go to Europe.

About Brecht—you'll disagree with my review [for *Partisan Review*]. I read the book [*Dreigroschenroman*] in German 4 years ago and just skipped lightly over the English. I think it an utter failure as a novel, because there are some things a novel has to be, just as a poem has to be, and this is not them, in spite of the fact that everything you say about it is true, except that it's good. That's very good what you say about everything being second-class. I wish that was in my review. Yes, everything is 2nd class, second hand, inferior quality, knocked down at a discount, closed out, adulterated and not up to specifications, even the forts of society. But the book is also boring. It lives not with the life of a story.

As to my other piece, the article—it's about Brecht's poetry, not about himself. Of course my consideration of his poems is inadequate, but I don't agree that it's ineffectual. But how can any good poetry be introduced adequately? Shall I, like you, give an impressionistic description of it? No. I must explain its public significance. As for Rahv's [Philip, an editor of *Par-*

tisan Review] remark, in rewriting the piece I shall have to follow more or less the same directives I started with: popular poetry, Stalinist politics.

To show how good Brecht's poems are and what they really are I would have to write poems of my own about Brecht that would be as good as his.

Saturday afternoon I ran into Lionel Abel on his way to Washington. He's really a savage, the way children are savages. Rosenberg, I realize, is preferable. At least he's somewhat sensitive. If I were a gentile, both of them would make me a Catholic anti-Semite. Judische Intellektuellen—I see what so many stupid people rage against. These fellows snort and feed and wet their chops, and they don't get fat on it; all they do is oppress the air and whoever happens to be in it. Dante should've provided a special circle for them somewhere on the <u>periphery</u> of Hell.

I see where Wyndham Lewis gets his spleen against the Israelites from. But it's not to be blamed on the Hebrews. Rosenberg and Abel are the product of what Hebrews have suffered. My brother Marty on the other hand is a product of what the Hebrews have enjoyed.

The Picasso Cahier d'Arts is the nuts.

The last several nights I've been reading Pope and Dryden. The former I enjoy. He's a Master of English like very few good English poets have been the masters of their language.

Marty sends his regards——

<div align="right">*Clem*</div>

<div align="right">JAN. 24, 1939</div>

Dear Harold,

That's swell about yr raise: $180 a year at a clip! Now you're making as much money as me, which is fitting.

My review has been pared a bit, but not grievously (I saw the proofs) except for the omission of a last paragraph in which I called attention to Brecht as a great talent in spite of his novel's failure. Macdonald [Dwight, an editor of *Partisan Review*] should not have cut it out—he told me he was going to consult me about cutting, and then he didn't. Well—it was such a tightly knit review that there was hardly anything else to cut, and he had to fit it into a single page, I suppose.

About Lionel Abel—that's wonderful what you say about his being a poolroom shark. I say that he's the first person ever to approach literature and the things of the spirit like a sports fan approaches baseball. Exactly—

and as a matter of fact, he's passionate about football and heavyweight championship fights, unreservedly, without poetry, without humor. Like Rosenberg, he's what Hitler thinks Jewish intellectuals are and what Catholics think irreligious people are: because they both—as you say—remain unaffected, untouched, unpermeated by the things they occupy themselves with. To like poetry, much less to write it, to read philosophy, much less to use it, should, in a healthy subject, infuse poetry and philosophy into veins, add a subtlety, an inflection, a space, a humor that percolates into every chamber of the head. Danny Fuchs, who is a Philistine and rejects everything, has more, much more of this, than either Lionel or Harold.

But you are too harsh with Abel. He has certain virtues, even if he is a savage: he is what he is wherever he is, he gives himself entirely in whatever he does and has no sense of relation to the world—which is an admirable trait and is why he begins to read poetry to strangers and talks at the top of his voice about the anti-Christ in church. He has no politics, no long-term motives. At the same time he knows nothing whatsoever about anyone, has no perceptions for other existences and for this I could damn anyone, and yet at the next moment forgive. He does know something about poetry, too. Often he has remarkably sharp insights and wonderfully ingenious ideas or constructions; being that it's Abel who has them, they're worthless eventually, but they're also entertaining and exciting for a while, and I'm stimulated also. Why do I see him? In order to talk about the "spirit." In other words, I commit the sin of using him as a means not as an end—which is what I also do with another of Rosenberg's friends: Igor Pantuhuff. Who the hell else have I to talk to? Do you think I see him because I like him? Especially when I see all my own weaknesses—especially my puerility—magnified and intensified in him 1000 times. But I must have Geschwätz.

Well, I sound fatuous, don't I? But you understand the shading which is absent. With you I don't even have to imply. We have to do here with the purified dregs which are the last products of capitalism, as Rosenberg should say, if he weren't himself. And precisely because Rosenberg wants to make fun of me proves to me that I can pass through this outer circle of Inferno without being burned or soiled, where another would have to keep a distance.

A word from my father can still annihilate this world.

Picasso's pen & ink drawings are tremendous.

——*Clem*

Dear Harold,

I haven't written to Offut yet; somehow I can't get the words se-lected—but I'll have an Einfall sooner or later. I miss Buster. And when you mention more and more often his freakishness, his vagaries, his in-corrigible brattiness, I know him for my own son. (Tell me some details, though.) That's the way I was at his age: wild, timid and unaccountable. My father still reminds me of it, how it pained to see how full of weak-nesses I was. And I was: brutal and fearful, full of disordinate impulses: once, for no reason at all, I axed a goose—I was six. I didn't know how to act, how to handle my existence, and that still remains. All these things take a long war to overcome.

How did you like my review? ["The Beggar's Opera—After Marx: Review of *A Penny for the Poor* by Bertolt Brecht," *Partisan Review*] Did you read Macdonald's piece yet? I smelled something familiar about it, something that came from my piece on Brecht's poetry, and sure enough it turns out that the other editors of the magazine objected to Macdonald that he had taken my ideas. He himself told this to Sol. Well anyhow, be-fore I'd heard this, I sent him a long letter pointing out certain things I disagreed with in his article and my own ideas on the subject—nothing at all to do with his having taken them, for I'm still not sure that he has, or if he has, he's garbled them beyond recognition. So he answered by say-ing that he thought my letter was wonderful and that he wants to publish it as an article in the next Partisan Review. This irks me because I want ei-ther to re-submit the Brecht piece or send in a poem. A poem, most of all. And there is the danger that if once they get the idea into their heads that I'm a critic, they'll decide—they're like that—that I'm not a poet no mat-ter how good my poetry may be. (Incidentally, say nothing of this to Rosenberg—he's liable to write Macdonald that I'm accusing him of swip-ing my ideas.)

I liked Rosenberg's article on Mann ["Myth and History," *Partisan Re-view*] very much—you can tell him that—not so much as a necessary im-plication of his political ideas (I think he misfired there by a spark or two) but as an exposition of Mann's method. Brilliant, in fact. Tell him I think he ought to tackle Malraux next. Also tell Rosenberg to consider why the only possible subject for a good novel on the Spanish war by a writer with Mal-raux's previous political awareness is the Barcelona uprising of May, 1937. We've come to a place where politics must enter any conceivable aperçu, and Barcelona sums up the whole political content of the war.

I'm trying to contain an excitement. Last night I painted my first picture. I'd borrowed paints from a girl and was saving them for the right moment. But last night, distracted, I started painting anyhow, on one of the wooden cabinet doors in my room. Just haphazard at first, tremulous and afraid to see whether or not it needed the same skill to handle the brush as it did to draw with a pencil—because it's the only skill I have. Could I actually do it, or would I have to learn painfully like piano lessons? When lo & behold a picture took form! I discovering that, save for a little clumsiness, I could do the same things in the way of volume and contour as with a pencil, and with the same personality, that it was easy and that it was 100 times more sensuous pleasure. In an hour and a half I painted what I think is a wonderful picture. The colors, the colors came just right, flowed smooth from my conceiving eye. Damn, how I wish you could see it! Well, I got so excited I couldn't sleep all night. I was full of commotion and still am, like when I meet a girl I think will be wonderful. It must be because—without any pretentiousness, just observing the way I act when I'm off guard—the instinct to draw is as deep inside me as the instinct to fuck. When I believe that, I believe I'm important and I look at myself in the mirror with respect. Whereas with poetry—there's no instinct involved. Poetry, the activity, is as external to me as my taste in clothes. It's all ambition and the need to create something detached and objective. Poetry is public. Drawing and fucking are private.

How is $1800 a year? Any ease, any room? Learn to drive and buy a car.

I saw Abel the other night. He said he didn't think you were serious. I told him you had many many things he couldn't dream of—which did not get him sore, but puzzled him. For he thinks all he lacks is a sense of practical reality. Now I judge a person by what he wants, not what he lacks, and accordingly when I find that all Abel wants is human vessels into which to pour his ingenious ideas or constructions, what can I think? We should really weep for him, not call him savage, rude and impossible. Let not our tear ducts fail for such. But I'm smug.

——*Clem*

<div style="text-align: right">March 3, 1939</div>

Dear Harold,

Greetings on this, your thirtieth birthday. I wish to hell you'd write a book. And I wish we could have a party. I'd recite you a poem and paint your

picture—painting, incidentally, begins to be difficult, chiefly because there's no one to teach me how to mix colors and handle the tricks of brush work. I have to find out everything by myself.

April 20th—almost definitely—I leave for Europe on the Île de France, to return by June 7th. My leave has just been approved.

Sure, I'm willing to chip in for Buster, but I must, as you foresaw, be allowed to see him. Let not Toady be so stupid as to be stubborn. Anyhow I won't be ready to contribute until I get back from Europe. And you can tell her that.

About my review. Under socialism I could write it the way you want, which now hardly anyone would understand. You have no idea of how you, in spite of your reluctance to think in concepts, are an expert and savant in shades and inflections compared to the leading intellectuals of this country, whom I am now meeting. (An American section of the FIARI—Diego Rivera-André Breton manifesto in Fall 1938 Partisan Review—is being formed which I am invited to join. At first meeting I met poets, painters, etc.) These people, except—I think—the poet John Wheelwright who acts like a crackpot—live and have their being on a level far below that on which they practice their poetry and their painting. Wheelwright, who's a fanatic New Englander, is the only one who's all one. And that I like.

Did I tell you that Rosenberg came into town 2 weekends ago and awoke me from the pleasantest sleep of the week at 2 A.M. in hopes of finding a bed? I concealed my anger. What an oaf he is. But he's still all right. He's weak like me.

I was in the demonstration at the Nazi meeting 2 Mondays ago and was almost trampled by a horse, but was not afraid for some reason. Solly traded punches with a cop. I honestly would have done the same had it not been for various investments in established society and my pledges to fortune.

I'm in a smug mood, having slept well last night, and I find myself insufferable. As Nietzsche says, "der Mensch ist etwas das überwinden werden müss." I most of all must be overcome. I'm filled with the worst, the vilest impulses. There is something in me that must be rotted out. You know. And think, society is in the same plight.

Tell me more about Buster. Can't he draw? Don't forget that a 4 yr old kid shows ability by simply drawing firm lines, not by drawing good. So look him over. Have any pictures of him been taken lately?

——Clem

Dear Harold,

Yr criticism was the best it was possible for me to obtain in this world. However you have the shortcoming of complete understanding, you derive what I mean in a way not even posterity will. Poetry, the best, must make concessions to the public.

I've just been reading Auden's latest and while I admire his skill and his pleasure-giving retreat to English tradition, I have had to admit to myself that my latest poems are better than his, on a higher level. I at least have no mannerisms of emotion. A shadow of "intellectual disgrace" begins to "stare" also from his "face." (He writes how "intell. disgr. stares from every face.") I'm afraid he's finished—and why? Perhaps his Stalinist politics explains it, perhaps not. Perhaps nowadays in order to keep on writing good poetry it is necessary to remain half-unrecognized all yr life, like Wallace Stevens, who is down at bottom even so a numskull with paltry ideas. Anyhow it's shame that Auden is not developing; he had so many germs in him. He will not even go as far as TS Eliot.

I'm definitely leaving for Europe on April 20th and will be back June 6th. That mess in Madrid. Maybe I'll go into Spain, but I'm afraid I won't be able to stand the sight of their newly won "order." If it's placid it will dishearten me. Yo voy gritando guerra guerra guerra!

It's the shank of the afternoon. In a minute I'll have to go out & take the floor [at the Customs House], while I think of high poetical issues. But it's a salvation. If I didn't have the cases of liquor to bore and repel I would not half so steadfastly think of poetry. This is a terrible connection, but a romantic like me can only act by reaction.

I'm drawing a good deal, but not so good.

—Clem

Dear Harold,

Thursday I had my first shot against typhoid fever; I'm to have 2 more at intervals of a week. Friday I was a little dopey and my left arm was swollen and sore, but underneath it there was a general euphoria as all the anti-bodies came into birth and action and went to work on my trench mouth germs and sundry others. I've already received my passport with a

woebegone self-picture that isn't however a bad likeness. I send you a copy. All that seems to stand between me and Europe now is the political situa-

tion and the tricks of fate. As to the first, I pray that France makes a deal with il Duce; as to the second I do nothing, but the boss is likely to come in some day, and finding me reading "Thus Spake Zarathustra," suspend me. I have no control in that respect. Time hangs heavy, and Zarathustra makes every inch of life seem important.

A couple of days ago spring came lukish into the air, and now I'm starting to go wild and have all sorts of lust. For the time I'll be travelling is in the spring, when I die to travel.

I did not send my Poet poem to the PR, instead gave Macdonald 3 shorter ones all of which you've read: The revol. one about "Tomorrow news will come," the one about the brain Alexander, and one that begins "Drear dribbled." The revol. one I know is good, and if they turn it down I'll protest. I never before felt so right about a poem, so right that even if every line had a fault it would still be a good poem. But you can't tell about editors; these ones, they're well-meaning all and intelligent and sensitive but they're not original, and being unoriginal, they're unsure and timid and influenced by extraneous considerations. Macdonald sums them all up.

I'm writing a piece ["Avant-Garde and Kitsch"] on the basis of my letter to Macdonald. It cracks my teeth, and I'm afraid of my own flights of spun theory. I should have it finished by the end of this week.

Phil Rahv has been over to see me and he seized the first opportunity to jump on Abel & Rosenberg. I joined in with a lot of relish. We went to town. Rahv is intelligent but not wise; but he is sensitive and full of interior awkwardness like me. He did them up brown. To a turn, to a crisp. Clowns, innocent mountebanks, frivolous egomaniacs, Philistines of humility, hypocrites of boastfulness, is what we called them. They are all that. As a matter of fact, even Macdonald seized the first loophole when I saw him to attack Rosenberg. That was surprising, even tho I know Macdonald is nobody's fool, least of all Rosenberg's. But what was surprising was that he resents Harold, as I do, for both teaching him so much and for having at the same time taken him in. Of course, you won't breathe a word of this.

As usual, I miss Buster. Natalie is growing tall and to me beautiful, and when I see her I miss him. Marty & I talk for hours; he's the only one besides you to whom I can talk freely. But when I talk that much my throat begins to hurt. In that I foresee my speechless doom. I need a woman, only a woman can save me from loneliness without talking.

Rahv lent me the 1st vol. of Kafka's collected works which contains the "Metamorphosis" and a lot of short things I never saw before and which I like much better than the "Castle." You'd like them even more than I. Real search, real discovery.

——*Clem*

Dear Harold,

Day after tomorrow I leave. The boat sails at 11 A.M. It's shame you won't be there. But, as I myself know, seeing a boat off is not altogether a pleasant experience. Standing on the pier, you're left with the bag in your hands and the future seems unutterably empty.

Of course the European situation is personal to me. So personal. I've never followed it with such intense attention, feeling that everybody is aiming at me, that that's why Hitler's birthday happens to be on the date I sail.

I've submitted the longish piece ["Avant-Garde and Kitsch"] to the PR. I think it's good, but not ample enough. They'll probably turn it down, and my oeuvres inédites will mount. I've also written 3 or 4 new poems, 2 on Pindar's style.

There's a magnificent poem by Yeats in the spring book number of the "Nation." Read it.

The three poems which I submitted to the PR 3 weeks ago, Dupee [Fred, editor at *Partisan Review*] told me at the time he did not think were very good, but they've not been returned yet. Maybe they're being held out of courtesy. Anyhow I was angered by his opinion; I knowing one poem was as good if not better than anything the PR has printed.

Your last letter had swell writing about Buster. I saw him with the sharpness and ambiguity with which you perceive by means of good writing. Write something ambitious about Buster in the same tone as yr letter. Memorialize 4 yr old malehood. Do. Please. "A Day in the History of our Race."

I'm going to keep a diary on the trip. I'm also going to sketch here and there. I'm landing at Plymouth and going directly to a place on the Welsh

border, Pontypool, where stays a corresponding girl friend of a girl I met in the WPA life class. Megan John's her name and she has a car, is 26 yrs old and extremely blond. After, I go to Stratford, Oxford, then London, whence to Paris, then down France past the Riviera into Italy—Florence, Rome. That's the rough itinerary. Maybe it'll have to be changed. I'll have 5 weeks to do it in. I'll also try to get a bit of Switzerland in, preferably Zurich.

I was just interrupted by a phone call. Macdonald wanted to tell me that he thought the piece was very good, but that it had to be re-cast in form. I'd rather almost he turned it down, for the question of organization is always the most difficult problem of all in presenting ideas—for me at any rate. Macdonald and his wife [Nancy] are coming over tonight to talk the thing over.

The avid interest with which Harold came up to NY, interest in the FIARI, was disgusting. "Just his meat." It's hard to explain what I mean, but he should be more interested in his ideas than in gregarious combinations. Anyhow he's washed himself up with me. Abel's even worse I now perceive.

Abel is actually boring. He came over one night and hammered the kettle until I was almost hysterical. He has read absolutely nothing outside of ha-cha modernism. Rimbaud, Rimbaud, Rimbaud. An eagle's eyrie for weak pigeons. You saw through him quicker than I, and I greet you for it.

Dupee also came over one night. A nice guy even if he didn't like my poetry. But lacks intellectual vigor, altho not sensitivity. Has an insecure grasp of his own opinions. The exact opposite of Rahv, who has no vibrations.

There's a piece in the March "Nouvelle Revue Française" by Kierkegaard on the subjective thinker which accounts marvelously for what's lacking in brilliant abstract thinkers like Harold. Really, a remarkable thing. Please read him. The connection between a man's ideas and himself. The lack of connection, and the consequent lack of "existential" intelligence in a supposedly brilliant person.

The whole family and sundry others are seeing me off. Then I shall be left to the quiet of the ship.

German battleships are cruising the coasts. If war breaks, I'll be a prospective prize. Concentrated in Weimar for duration of war.

———*Clem*

À BORD, LE VINGT-TROISIÈME AVRIL, 1939

Dear Harold,

An ocean voyage is something like what they say it is. And also quite a lot like a summer hotel. They're very few people on board and things are probably in state of suspension on account of Hitler.

The sea is smooth & the boat doesn't rock, although I did feel a little queasy my first day out. Now that's all past. But I do hope we run into a storm.

———————

VINGT-SIXIÈME AVRIL

Looking for whales

Tomorrow we reach Plymouth where I disembark by tender. I'm half sorry the crossing is over, it's been such an interlude, such a suspension. It's absolutely impossible to think on board; all I can do is play deck tennis and ping pong, drink and chatter and sleep in the sun. Ah me, ah me.

Today the sea's kicking it up and the boat's rolling like a woman's buttock, mais c'est bon.

Sherry Mangan [Paris correspondent for *Time* magazine], the avant gardist of the old days who now lives in Paris, is on the boat and we see a good deal of each other.

My French works over time, is horrible, but effective. One night all the talk's in English, the other night in French. It's true what the French

Line ads say: when you step aboard our ships you immediately enter a foreign country.

I'm not half as much on edge to see Europe as I should be. Reality rubs the sharpness off everything. In addition, it's difficult to write when the boat's rolling. Your wrist hasn't enough joints.

————*Clem*

Postcard of Tintern Abbey
4–29–39
Dear Harold,

Wordsworth is justified. Only I can't get a chance to re-read the poem as nobody has it here. England is England, but not quite as different as I expected. I saw and I saw and I shall see. —*Clem*

Postcard of Porte Saint Martin, Paris
5–11–39
Dear Harold,

Paris is yes—but there is also a no therein. J'ai rencontré Arp, Eluard, Hugnet, Man Ray, Virgil Thomson, etc. —*Clem*

Postcard of Avignon, le Pont Saint-Benezet
5–15–39

A paradise—actually. And not for its historic aroma, nor Petrarch, but for the way it is right now. Calif. full of angels instead of Californians. —*Clem*

Postcard of Genova, Piazza della Nunziata
GENOA, 5–18–39

Sous in Italia! I genti parano molte come gl'American. My Italian is helpless. —*Clem*

Postcard of Città del Vaticano
"Raffaella–Il Parnaso, Camere di Raffaello"
5–22–30

This is marvellous, really. No let down here. But the rest is suffocation. —*Clem*

Clem returns to 9 Minetta Street.

Dear Harold,

Right now I can't take Buster. It would mean moving to different quarters, buying furniture and getting a maid—for all of which I have no money, as I'm bust after the trip. I suggest that Toady hold on to him the while, and I'll try to send enough to make it possible for her to get a maid and live in 2 rooms.

Thanks for your haste. I'm still a bit dazed, what with everything coming at once. Washington I can't make this weekend—the importance can't be that burning—but I shall be down next Saturday afternoon.

Poor little bugger. Who doesn't fail him?

What the devil did happen between Toady and her man? I am ashamed to tell my father that she's getting divorced again.

——*Clem*

JUNE 27, 1939

Dear Harold,

The barrage of telegrams, telephone calls and letters from Washton has finally slackened and I can take time to get a word through to you. There are moments when Toady becomes monstrous: $100 asked for so unassumingly. I saw red and proceeded to reason like my father, with good results, for it seems the worst was averted and life now appears endurable to Toady, which was after all the most difficult & important of the aims involved in this mess. As a side note Mrs. Ewing now threatens to become if not a corpse, a serious invalid. Without being sentimental, my heart bleeds for her, because she wants to see Buster before anything else happens. Affairs therefore are still in a state of suspension, but my mind is more at ease.

I'm trying to get down to serious work, but my foos won't moos. Women whom I don't particularly care for are complicating my life.

This morning I received Eluard's latest book of prose, "Donner à Voir," inscribed to me by himself "fraternellement." It's a dull book, however, full of the usual surrealist song and dance.

(A bee has just flown into the office and I'm perturbed.)

Dwight Macdonald called up to tell me he's very dissatisfied with my piece ["Avant-Garde and Kitsch"] because of its unsupported & large generalizations. I became furious. These people with the best intentions do as much to smother American culture as the Roman church. Habits, habits. Macdonald has a journalistic notion of perfection; his only notion of perfection.

I'm working on my Orpheus poem ["Progress of Poetry"], of which I send you the latest draft. Tell me what immediately. I'm so full of self-confidence at the instant moment that I can only endure Yeats after reading it.

(The bee, exhausted, is stretched out on the window sill, panting. Where did he ever come from?)

New York is a miserable country. My heart longs for England more than for France. It's curious: there were in France things too resistant, too inexplicable, diet, logic, lighting, which in England were not so. Therefore, while England is much drearier and emptier, its sense is more my own and I'm more comfortable. Cheltenham would give me less trouble than Avignon. And what I found resistant in France was 1000 more so in Italy, Fascist or not. Florence, for instance, takes your breath away, but at nightfall you're left empty and uncomfortable. It's like putting a good novel away. So what?

I think, I think—I'll still take Idaho. It has more flavor. But damn, damn New York. C'est horr-i-b-le, like Laforgue's Hamlet says. Only Rome is worse.

Cast an eye on Toady every once in a while to see what new messes she'll be getting herself into. But don't treat her as a responsibility. Just see, please.

——Clem

In the beginning of July, Clem goes to Washington to see Danny. Harold is vacationing with a friend in New Orleans, and Clem stays in his apartment.

JULY 11, 1939

Dear Harold,

I'm glad you had such a pleasant trip. Who did you go with, or rather why do you make such a mystery about who you went with?

I have a hankering myself now to see what the far South looks like—as far south as New Orleans. It's where I've never been.

I'm amazed that what Toady told you about my stay in Wash'ton made you feel very good. I don't understand—or all I understand is that Toady can fabricate fabrications to no purpose. It's time I enjoyed Buster, but not completely. And for the rest Toady bored me stiff without, however, wearying me, and seeing Buddy was not very pleasant, and the weather was too muggy. No, I did not have a good time. Toady's presence, the presence of her helpless laziness, demoralizes me. The presence of her

husband decays me; the presence of the absence of her mother makes me despair. I wished all the time that you were there to save and redeem. Toady is so mortal. Buddy is really too decent, but somewhat if not exactly a liar. That Toady should have married him was insane and for him too tragic for us to permit ourselves to realize. That touch of a higher sphere will ruin him—oh I'm so sure of it, alack alack.

Anyhow I have the utterest contempt for her now—only don't tell her. The way she treats Buddy, first, and second, her white-trash, imbecile hope of marrying me again and all that goes with that hope: arch letters, "what we mean to each other." I've written and told her that we're all through, and it does no good. She is positively the most selfish and heartless woman I've a clear conception of. The lack of a sense of responsibility and reciprocity to her fellow mortals, the easy motives for her acts—the fact that she requires so little motive to justify her cruelty. All she can do is tell the truth.

You—you—have no business worrying about all this. If it doesn't make me sick, it shouldn't make you either. So don't go getting upset about his drinking, etc. That is, don't take Toady on her own terms. I know I did the first time in Washton, but that was because I hadn't met Buddy yet and so had the vision of something horrible in my mind. But it's not Buddy that's bothering Toady; it's the debts and the lack of money. She's let her disappointment over his income turn into a disillusion with his personality. She's talented at those quick & subtle transferences. And now to feel so self-righteously that he is a knave for her, a scoundrel, a blackguard, a villain, a pestilence, an impossibility. Oh I'll never forgive her that.

Buddy wrote me a 2nd letter in which he warned me about Toady's intentions towards me and presented, so to speak, a bill for Buster's transportation East and time & trouble taken on his account. I referred him to Mrs. Ewing, who writes me she's coming East in August as the result of my persuasions. The kingdom of corpuscles will then be complete.

But enough of that.

I will get yr shirts at Wembly's but would advise against buying tab collars, especially in hot weather. They're too neat, and ever since I've seen the casual sloppiness of the English I've taken a violent distaste for American neatness and a look of a certain line that's being toed, which above all should be avoided. In England only the proletariat in the provinces wear them now. However, despite all that I shall get you them—altho Wembley's has no sale just now. Incidentally, you will have the right to return those you don't like.

——*Clem*

P.S. I borrowed Perse's "Eloges." And yr mother's cookies are as good as ever.

Dear Harold,

Sorry for the delay. I've been living vacuously for the past month, never getting enough sleep and never getting anything done. I'm trying to get rid of a woman who doesn't deserve it except that she bothers me to death and I'm taking treatments for my hair, and between the two I haven't a spot in my soul I can call my own. I'd rather think about Buster.

I wish you would come up. There's been a fire home and the house is pretty much a mess, without water & electricity, but Marty & Solly still manage to sleep there. You can choose between that and a hotel. October, when I move, I'm going to furnish a place and have a spare cot. I'm sick to death of strangers' furniture and last year's dust.

I'm relieved that Mrs. Ewing has come. I urged her. Toady's incompetence comes out of fiction, it's so extraordinary. As for the old lady's influence on the kid—it just has to be. There could be worse things. Toady is just as bad for him. But he'll digest them. The trouble is he won't digest himself.

I wrote Eluard a letter full of blandishment in which I asked him for some poems for the Partisan. Macdonald insists that I finish my piece ["Avant-Garde and Kitsch"] in time for the next issue, to run along with my [Ignazio] Silone interview [conducted while in Rome], which has come thru in its revised form greatly expanded and detailed, to the delight of the celebrity-worshipping editors.

The climate is terrible, and human beings have no longer the capacity to please. The office is lousy, and customs service people are positively the dregs of bourgeois society—pos-it-ive-ly. I ask for a war, a holocaust, to come and destroy them, brimstone to purge them.

Europe is very far away. And now that I know what it looks like, even further. I can't believe that at one time I didn't know what it looks like, that I ever thought Dickens' London was the marvellous place it is not. Walking up Borough High Street in the direction of London Bridge, what a disappointment.

I have no more wanderlust, but I am looking for a high-class paradise.

Tell Toady she'll get a check Monday or Tuesday.

Clem

Penny postcard
7–17–39
Harold,

Wembly has put aside 6 shirts for you, awaiting more specific instructions as to sleeve length: there's no such length as 20 1/2. Do you mean 30 1/2 inches? Let me know immediately. You measure from wrist to wrist across the shoulders. But why the hell do you want French cuffs, they're so damned uncomfortable? The total is $14.50. I'm sending you 2 copies of "Finnegans Wake," for you and Rosenberg.

——*Clem*

AUGUST 23, 1939

Dear Harold,

Yesterday I received a vicious letter from Mrs. Ewing in answer to one I'd sent her. My letter was a bit querulous; I told her not to bicker with Toady, and I criticized Buster's diet. Grimalkin's answer was one of her typical documents, full of stale American shit. But more vicious, not towards me—towards you! She accused you of being a spy. (That's how I "found out" about Buster's diet!) Of course, it's nothing that should bother you, but it's necessary to have it in mind whenever you go over to see the unfortunate family. And I should warn you that nothing she says is to be taken personally. Annie Ewing's attitudes are all expressions of mortified inferiority. She can never forgive the world for having let her be what she is. About Danny, I myself am not as bothered as I should be. I should be worried to death.

New York has been too hot for too long. It's affected me.

The Rosenbergs passed a couple of days around here before moving on to Provincetown, and I found him unbearable: the sublime presumption with which he told me how I should have travelled to Europe, and what was wrong with me. As Phil Rahv says, all this is carried on for such very low stakes.

The Russian-German pact kept me up all of night before last, thinking of how much sooner we over here would now go to war. In spite of the fact that I've been allowing its possibility ever since 1937, I now have an unreal feeling about the world. The trouble is we have the habit of the unsurprising. It's necessary now to live according to surprises. I find it difficult. I'm getting old and I'm settling at the heels.

I've been reading a lot of Yeats. Read "Sailing to Byzantium" aloud, and the sonnets close after it. You'll like them.

Macdonald seems to like the revised version of my piece, but it means nothing yet.

I re-read "La Vita Nuova" yesterday, and it's very poor—as you've always said—including most of the poetry. Dante was such a typical literary person.

I'm coming to Wash'ton this Friday evening.

——Clem

SEPT. 15, 1939

Dear Harold,

I hope you're working hard on the Brecht translation. The Partisan wants very much to publish him, and will if it remains in existence, and can get his permission.

The visit to Washington was, and wasn't, disappointing. Buster seems such a stranger. Toady was pleasant on the trip up and left me alone in N.Y., except to have dinner with me one night and help me look for a room. I like her, Lord help me, but it won't help her, who thinks she's madly in love with me, and prates like the Queen of Hearts.

May Rosenberg came into town and immediately knocked on my door. She claims she's worried about you and to prove it made remarks of carping commiseration in her ineffable, impossible way. What people! What suffering! How is mankind humbled and degraded in her anguished person.

Today I'm sending off the "Progress of Poetry" to the Southern Review. For the first time it's without trepidation. That is, I would be very happy if it were accepted, yet, on the other hand, it wouldn't bother me very much should it be rejected. May all decisions be taken under the same auspices.

This is the Rosh Hashana time of the year, which fills me with sadness. Yom Kippur and all the tawdry new clothes in Borough Park. Under Socialism all holidays will be like weekdays. Or holidays will come in shifts.

——Clem

SEPT. 26, 1939

Dear Harold,

I may not be able to be at the station to meet you Saturday. It all de-

pends on what day I'm able to move. Although I haven't a hell of a lot of junk to shift, there's still enough to perturb.

I've bought furniture, which is being delivered to the new place: vulgar maple, self-effacing enough not to bother me. That I'm to have my own furniture has awakened a domestic spirit in myself I never knew to exist. The stainlessness of it is what I like. If there are to be any stains they'll be my own.

The new place is a single room about 2 1/2 times the size of the old one, and much newer and better kept. The only objection is that it's up 4 flights of stairs. But that means less dust and noise. There's also a tremendous closet and a modern bathroom. The rent's $37.

You're too hard on Toady. You look at her from the point of view of another woman. That's the realest view, but not the truest. The inflection of sex is a constituent part of anyone. I'm under no illusions about her, but neither am I under the illusion that perfect reality is possible. That's what you've always wanted.

What bothers me is the way she's carrying on about being in love with me. She thinks she's found a new future for herself. The proximity of Mrs. Ewing is liable to make that a cause for new wars.

But Buster at least has the consolation of having a mother who loves his father and a father who's more charitably inclined towards his mother than she deserves. Such a situation will make him pustulent soon.

———*Clem*

SUCCESS AND THE VITA NUOVA

"Honors pile. But I want dissipation, indiscretions, glitter, dash, sparkle, sin. . . . Feeling is all. The end of all is to feel deeply."

Clem writes from his new address at 6 Jones Street.

NOV. 29, 1939

Dear Harold,

I was waiting for your letter and intending at the same time to write myself. But I am all tight. It's one those periods when I live at a second remove from myself. In spite of being alone, I seem always to be involved in distracting business.

I'm glad you're keeping at the Brecht, for Macdonald has written to his agent in London for permission to reprint him.

My piece ["Avant-Garde and Kitsch"] has been a "success," according to the editors of Partisan Review. Everybody "likes" it. James Burnham says it's one of the best articles they've published. Van Wyck Brooks wrote a note to say he thought it very fine. Louise Bogan likes it. Delmore Schwartz thinks it's a "wonderful piece of work" and should be printed in italics, and so forth. I'm not surprised that it's good but I am surprised that people "like" it. In fact, many people say they "enjoyed" it. Now, the PR wants me to write more articles for them, and I feel very warm and gratified.

Kenyon Review returned the "Progress of Poetry" with the remark: "Shows promise, but far from being mature." This of course irritated me, in view of the Audenesque stuff they print.

As you probably know, Toady has surrendered all hopes in me. In about a month or two she'll get herself involved with some dope. Watch out only for Buster, please.

I am supposed to translate some of [Rosa] Luxemburg for Rosenberg's imminent article on her in the PR. Incidentally, he told Macdonald he liked

my piece, with reservations, but won't say a word about it in the postcards he sends me. What an egoism that can't afford to give me the little salve of a compliment.

Read the sonnets in Auden & Isherwood's "Journey to a War"; they're the best poetry being written right now, even if they don't have the molten originality Auden's earlier stuff has. Read them. So neat, so good.

I need a good woman. A good woman needs me.

Clem

DECEMBER 12, 1939

Dear Harold,

Dwight Macdonald tells me that no article printed in the P.R. ever stirred up so much comment as mine and received such universal praise, etc. The only dissent came from Meyer Schapiro, who says in addition that I borrowed some of his ideas. The praise warms me, but I'm afraid I lack a critical audience; the piece is full of loopholes which no one seems to have noticed.

Anyhow, the PR wants me to write more stuff for them along the same lines. They are more impressed by other people's opinion than by their own.

The Southern Review has kept 3 poems I sent them over 7 weeks, leading to false hopes. Maybe they got lost in the mail.

Thanks for thinking of me as a poet. I think of myself that way not yet.

Clem

1940

MAR. 2, 1940

Dear Harold,

I finally get a little breath and take time to write to you on the eve of your birthday. What between my article and the shabby social life I lead, I have nothing to live for or in.

A week ago I sent you Handel's "Water Music" which I hope you received in good shape. I had them play it for me, and it was good, very good.

I miss Danny like the devil. Mrs. Ewing sent me some drawings, one of swans flying, and another of a rhino and one of a cow or something, which were all good, especially the swan composition with a swell abstract shape on the left. He seems to be going ahead a mile a minute. Pa and I will probably drive to Wash. sometime this month to see and be seen by him.

He could replace women for me in my life, you know.

In Auden's latest book [*Another Time*] there is such a strong influence by Rilke—and by Brecht—that it's almost shameless. Especially the Brecht.

There will be an article on Brecht in the Kenyon Review—damn it—by somebody called Laurence Brown. And the Partisan is gnashing its teeth at having been beaten to the draw. But will go ahead nevertheless with Mahagonny [Harold's translation] if only Brecht sends permission. I feel a little gypped. I should have introduced Brecht. I found him first.

I received a card from Silone telling me he had my article ["Avant-Garde and Kitsch"] translated for a little Swiss magazine. The third number of Horizon, the English magazine, announces me among its future contributors. That damn article is becoming something I have to live up to. It's twice as hard to write on account of it.

Nicolas Calas ("Revolutionary Sadism") arrived from Portugal, a tall, handsome Greek with an Oxford accent, and is coming over to see me Friday. He too thinks my article is a wow.

With all that, I wish somebody would print one of my poems.

I'm worrying about how to fill out my income tax. The idea of giving money away purely & simply is excruciating. If I only had some more dependents.

But it's my job really that has me down. It's such an interference, so unwarranted.

Let there be a great cataclysm. Let everything crash & tremble. Let the customs barriers splinter, let living flow, let money go, let sex and digestion rumble, rumble.

Clem

MARCH 20, 1940

Dear Harold,

I shall be in Washington with my father the Friday after this. Pa will go on to Portsmouth by boat Saturday night, leaving me with the car to go back Monday or Tuesday.

That Mrs. Ewing & Danny are about to go to Calif, in spite of my being for it, is causing me real anguish. It seems an unendurable arrangement. He shouldn't be so far away from Toady and me. He shouldn't. But what's to be done about it? By no means can I see him going through another Wash. summer.

I've just about finished the first installment of my next piece ["Towards a Newer Laocoon"] which will come out, if O.K., in the next PR. I've also written a little poetry. I'm trying to do it within very narrow limits.

Calas is 6 ft.3, thin and very, very handsome. The surrealist fairies here have gone into a tremendous dither over him, which will make him difficult and more irresponsible than ever. I went to a cocktail party given in his honor at which I saw the eeriest fairies I've ever laid eyes upon. All rich & cultivated—so to speak.

My social life is full, but not rich. I need a good woman, not intellectual conversation. I need 7 hrs a day to read in; and a chance to paint. Incidentally, I'm working with ink wash now, and it's miraculous to see the effects I get. I think I have something on the ball. But I don't know.

I'm glad you like the records. I'm afraid, however, that the music will wear thin in the course of time. I'm crazy about Bach now and can savor everything in him—almost. So clear, so clear. And also strong like Dante and everything else that's strong. It's remarkable. After 30 yrs you just begin. It's not fair. I had so little help from my elders, so little. Ach, how you and I had to shift for ourselves. We're self made, we made our own way in the world of the spirit—we did. And I see the young squirts taking for granted what we hungered for in such isolation.

You have to become something, have a Fach, a line. Study Byzantine architecture or negro music or something. Read Kant. It's necessary to have credentials. And there's no inner life; that goes without saying. No one is impressed by an inner life. They're, as far as being impressed, in the mass all like Phil Rahv. I am too. I am not impressed by anyone's inner life, except my father's, maybe.

It's sad all the same. What insensitivity.

Oh please make something of your own sensitivity. Please. Write on life. Reveal.

Clem

4–5–40

Dear Harold,

I got home 7:30 Thursday evening dog-tired. I still am. But I had a very good time, as I now realize. I miss Danny the way I'd miss some girl I was in love with.

T.S. Eliot sent in a long 9 page poem ["East Coker"] to the PR, and it's going to be run with my piece, when and if the latter is accepted. It's the greatest triumph the PR has yet achieved.

Louise Bogan in an article on lit. in the Nation will quote my last piece. Honors pile.

How is Toady behaving? Don't let her stop you from seeing Danny. Mrs. Ewing says she'll end up with a horrible disease, but I say that the worst that will happen to her is to live with a man who'll beat her.

Clem

JUNE 24, 1940

Dear Harold,

I'll send you a couple of poems to send to Marshall [Margaret, literary editor of *The Nation*], but I'm sort of loth. I'm almost resigned to not being a poet—until posthumously.

The PR is running my article in the next number. They forced me to cut it outrageously. Now I'm meditating another article, not about art, but about Nazi ideology.

I hear from Calif. that the menage is settled. I miss the little bastard so much.

Are you taking any of those exams recently announced? I may take the translators one, although there's no sense in it: if God preserves the equilibrium, I'll be making $2000 by September; besides, where would I be with nautical Spanish? But you ought to take a shot at it. And one of those curator ones, too. I'm sorry I didn't study to be an art philologist; it now looks to be the least taxing of the academic ruts.

I got a letter from Silone who wants to come to America but can't get out of Switzerland. Surrounded on all sides by enemies.

Are you writing anything about Mexico?

The editors of the Partisan Review, however, make me sick. Preserve culture from Jews. Hitler's almost right.

I've reached a turning point in my life. If I don't find a suitable woman, I shall never be the same. Read Forster's "Where Angels Fear to Tread." There's a woman named Lilia in it who's Toady to the T. The book is one of Forster's misses, but it's good. You—you—write a novel like it. Please. Don't waste your time so much.

I'm wondering what Danny will have to draw now that he has no zoo.

I've become, simply through thinking about it, extraordinarily sensitive to painting. It's wonderful to have sureness of taste—relative sureness—in such a fluid element. All pictures being good. I'm able now to discover such a painter as Vlaminck, whose latest production is extraordinarily good. And for the life of me, it shouldn't be.

Does the war distract you? I can hardly read a poem, so loud does history in movement rumble. I should hate to be too young to witness it, or too unaware to appreciate it. But I still don't know enough to sense the forms of history revealing themselves. I can't conceive the basis on which Hitler will unify Europe. My past doesn't flow into his future.

Clem

I just had a glass of Frascati Amabile Spumante—being at the office—and I feel good.

JULY 22, 1940

Dear Harold,

I hope your failure to write means that you're having a good time. You deserve it. Mrs. Ewing writes that she believes Toady is having a "grand time." I hope you're not involved in that.

What happened with Marshall? I should like to make some money doing book-reviews.

Do you miss Danny? I do. I could consume him with love. I tell every one who's going to Calif. to pay a call on him. If they do Mrs. Ewing will be amazed by the Hebraic and other diversity.

I'm in—or maybe was in—the throes of a slightly strange affair. The wife of Cyril Connolly, the editor of Horizon, being an American originally from Baltimore, has returned to this country and at her husband's suggestion looked me up. She turned out to be a big handsome dark girl of about 28, raised by money and cosmopolitanized and Anglicized by 15 years of Europe. After about a week we took to sleeping together furiously. I believe I was seduced. She is surrounded by swarms of fairies, mostly expatriate Americans returned from the war; her husband who's still in England is Τρίοργος, like a good many fairies, and it is all very decadent and, omitting sex, dull. An any rate, it's a taste of a different and very heady, ammoniac world. She knows all the English writers, not to speak of lords & ladies, high ministers of state and so forth—from all of which I receive a thrill. Yet it is dull. I've met & seen a lot of Louis Macniece. And he's dull. Drunk, he swore to me he wasn't a fairy.

Last week Jean—that's her name—and I went off together to the country for two days, at the end of which, most thoroughly fucked-out and emptied—she takes her sex like a man or like an Aldous Huxley villainess—I deposited her at the place in Massachusetts where Auden and his innamorato are staying, both of whom I met. The great poet turned out to be patronizing and almost repulsive: the most sensual blond mouth I have ever seen, depending loosely and fluttering over a mouthful of long, black, faulted horse-teeth, the eccentricity of a genius who is accepted for no other reason; the sulphurous atmosphere of his great lust & loneliness. His sweetheart, Chester Kallman, to whom he dedicated his last book, was on the other hand Jewishly blond, really charming and shamefaced in my beholding. I think I've seen him before somewhere. Auden was blissful with love; Chester had, it was obvious, the upper hand; and one of them was enjoying it very much. Auden made me uncomfortable and after an hour or so—despite his attempts, which I suspected, to make me go swimming before I left—I fled with a gay, honestly, heart, glad for an unknown reason to be clear and alone and driving the car at 65 miles an hour.

Nevertheless, after 4 days, I've begun to miss Mrs. Connolly and am afraid I shall fall in love with her when I see her again—against my better judgment, for she's too greedy, pleasure-loving and uncomplicated and has lived too much in sin. If her husband gets over here, which is likely, it will give murder unless she gets rid of me first. For I shall hang on to her. She's too wonderful in bed and flatters me with saying that I am the best stallion she's ever come across. Which is true. I'm really good now, as I've been given to know from other quarters. Allow me to boast about that.

It's easy to write a letter when a confession's to be made.

When will the Vita Nuova come?

—Clem

AUGUST 7, 1940

Dear Harold,

Why the devil don't you write? I'm getting worried. Either something strong has happened to you or you're angry.

I've been living in a translated state. Two weeks of honeymoon on Jones St. with my glamorous girl. Now she's gone off to California & I'm left exhausted.

Success and the Vita Nuova 217

I've taken to writing a second article in continuation of the one that's in the present number of Partisan Review ["Towards a Newer Laocoon"]. I hate writing.

The future is uncertain. I believe I'm in love. I'm extremely fortunate.

Have you seen Toady? I hope she's happy. I hope she's been going out to dinner with the Chilean ambassador or that some rich man is sufficiently taken by her personal poetry to keep her.

Write, blast you—as I've come to say since all England has lived with me in my room.

As ever,
Clem

AUGUST 13, 1940

Dear Harold,

Last night I dreamt I received a letter from you, saying you were angry & wished to have nothing more to do with me. This morning there was yr letter in the mail box. What symmetries are working through me? Who played the prank? Who's having fun? What's the joke? Why was the dream so coquettish?

That you're in a dead center is explicable by 2 things: the let-down after Mexico, which must be as abysmal as mine, or more, after Europe, and the heat. Then write, write, write. The Partisan Review is well nigh exhausted. They haven't anything to print. Let yrself go or drive yrself & write. It'll get in.

I have just spent a horrible week missing Jean Connolly. The world was never so empty, and there were 2 moments, one on Sat'day & one on Sunday when it was so unendurable that I almost thought of committing suicide. Really. Not for love of her, but because of ten-fold loneliness. But I sat down & forced myself to start work on my next article—about the future of painting—and it worked like a success book maxim: I became engrossed, the future lit up with glory and I was cured.

Jean came down 3 Sundays ago, intending to stay with me 3 or 4 days and then go on to Florida where she was to meet the fairy adventurer [Denham "Denny" Fouts, American expatriate and her traveling companion to New York] who was to take her to Calif. in his car. She stayed 10 days and left to catch up with him in Dallas. Ten days vacation from myself and from the customary ordeals of life. Ten days of power. Ten days to exterminate the horrors of sex: I gave her more pleasure than any man had ever given

her before. We did inconceivable things. What pushing & pulling, what flip-ping & flamming, what jumbling & tumbling, rummying & tummying, fricking & fracking, whipping & whacking. I got rid forever of something that Toady's sexual inadequacy had thrown off on me, & for which <u>now</u> I'll never forgive her, the misshapen instrument of confusion.

And it was wonderful to see Jean turn into a beautiful woman, leave off her English make-up & clothes and become something else that I made by my fucking & my advice. Oh power! Everybody took to looking at her on the street. Allow me to gush.

Like Toady she's pleasure-greedy and somewhat childish. But at least the facts, which are close to $400 a month, permit her to be so. We're not very sentimental—or at least she's not. It's simply that she loves fucking more than anything else and that I make her hotter & give it to her better than anyone else. At the same time I fascinate her. For me the best thing, better than the copulation, is the fact that I can talk to her about anything, anything whatsoever, in any terms. She's read enough of the books, has cir-culated among the most sensitive and intelligent people that speak English, and has chosen to be frivolous nevertheless. At the same time she reads French poetry with an honest interest and has inevitable taste in literature & in pictures, especially in pictures.

Of course, the sin makes it all the more attractive. She's been to bed with almost as many men as I have women, and she's liable to do so with somebody else before I see her again, from which there comes a pleasant horror. Meanwhile the air-mail letters are flying back & forth.

According to her present plans—which may or may not become fact; I'm dubious—she's to come back to NY near the end of September, take an apartment and settle down for a while, with me filling the role of mistress, letting myself in by the back door after all the guests have gone home. That's too good to come true.

Meanwhile I must become a great man. A great man will find other Jean Connollys around, a succession of them. A great man can be lonely with impunity, and not become so dependent upon an attractive woman who consents to spend 10 days with him. A great man will also be able to go to Calif. when he feels like it, to see his son. A great man can dazzle instead of being dazzled.

This summer in the city is become unbearable. My room gives me the willies. Greenwich Village seems to have sunk below sea-level. I'm sick to death of my job. I want to be rich & elegant & mobile; I want to circulate among beautiful, graceful, idle people & go to bed as late as I like. I don't

want to be bored. I don't want to return to Flatbush. I suppose it's because I'm in love with an international glamor girl.

It's ironical that on the eve of my seduction I received a letter from Cyril Connolly inviting me to write something for Horizon on politics. He would "print anything I wrote." And accordingly I sent him 1500 words along with a letter in which I thanked him for telling his wife to look me up and that I found her nice & that I felt almost that I knew him too personally by now. Poor Connolly, he was under the impression that his wife only went for play-boys and thought that I must be the safest & most owlish-eyed of intellectuals, not knowing that the serious solitary, slightly hard-boiled, slightly virginal, poor but hard-working citizen was just the type that appeals to her most.

Please enjoy being my confidant.

Mrs. Ewing writes that Buster is fine & that Toady is miserable.

———Clem

AUG. 24, 1940

Dear Harold,

I'm abysmally in adulterous love, and so is the object, which writes me long letters & longs to return, which seems too good to be true. Meanwhile she's circulating frivolously among a horde of rich English fairies, conscription-dodgers and what not—among them Christopher Isherwood—and having her addled brains scrambled.

News: Horizon seems to have accepted the short piece of mine on politics ["An American View"]. I have been invited to write for a new mag. starting at the Univ. of Wisconsin, and a very flattering invitation it was. Partisan Review—and please don't breathe a word of this, not even—and especially—to the Rosenbergs—may fold after the next number. Dwight, who controls the Maecenas—[George L. K.] Morris—is disgusted with the rest of the editors & blames them for the characterlessness of the mag. He wants either to push Rahv, Dupee & Phillips out & replace them with me & 1 or 2 other people, or to expand the board by adding me & ditto, or, failing that, to kill the PR & start all over again with himself & me as the guiding spirits and as <u>writing</u> editors. I'm flattered of course, but wonder whether I'll have time & energy enough. I hate reading ms. & I hate reading stuff simply in order to find material. Anyhow, it may all come to nothing. Dwight is titivating himself with qualms as to whether the historical mo-

ment is right for a new magazine. But the fact remains that he's disgusted with Rahv, Dup. & Phil'ps, and the occasion for his final surfeit has been my present piece ["Towards a Newer Laocoon"], which they were all strongly opposed to, & which now seems to be a success. That, together with the fact that they've all ceased writing & are demoralized, has nailed the coffin.

As you see, I'm busy with my career—but I'm not enjoying myself. I want to be a big shot in order to stand up to Mrs. Connolly, and in case she walks out, being a big shot will be some solace. And she's very liable to walk out, being subject to glittering temptations & herself having no principles whatsoever or hardly any. Nevertheless, it's wonderful, and my life becomes very rich. However, there's one strange thing: Toady could always excite me sexually more than Jean can. It's something to do with the color of the pubic hair, I suppose, and the way necks slope into breasts. I can't penetrate any further. Something in Toady was powerfully attractive to my "Es," and I suppose, as the German sexologists wd. say, it was Danny wanting to be conceived and born. I don't think I could ever get Mrs. Connolly pregnant. The mixture wouldn't jell.

Yes, my career. You know me. But my personal life. Do you think you cd. explain me that? I wish you would. Try.

——*Clem*

AUG. 28, 1940

Dear Harold,

I need yr words. Keep telling me.

La Connolly is still very much on my mind. No fear that I shall inflate her—you've got Toady in mind, whom I didn't inflate, I tell you. The more I have to do with other women the more I realize what she had that was valuable, and which she's lost utterly now, as I found out the last time she was in NY. But she had it once: she had it, the way she cd take yr head in her hands & kiss you. Sometimes a very good actress can do it that way, but otherwise I've never seen it.

La Connolly was frantically in love with me—and I hope still is—and if she comes back still in love she might—I don't exactly know; perhaps I'm all wrong—want to divorce her Cyril & marry me. I'll be in a fix then, for I shall have a hard time resisting. And then on the other hand she might, or has, discarded me. In either case the humiliation is mine. Anyhow I underrate her. She has more intelligence than you might conceive, and a dreadful fear of suffering.

Margaret Marshall is a false alarm, I think. I hate intellectual women; they ruin it all.

You're right, I suppose, about mine article. But criticism is the only really living genre left. The readers of Partisan Review, for example, read the articles much more avidly and with more pleasure than the poems & stories. And I can in an article say more of what I really want to say. At the same time I'd, of course, rather write poetry.

La Connolly makes the same objection to my language. But when you're serious & actually are pursuing a truth that's involved in reality you find it very difficult to choose words. Certain ones are forced upon you, you become victim to the drawbacks of the age, because you're after truth. I know my style is too much like Thorstein Veblen & John Dewey, but I'll be damned if I can deliver the birth otherwise. It's practice I need.

I suppose one reason you don't write is because you don't know the right people. Not that I do, but then something else makes me go. You should gaze at sin personally. You shd smell the world I've just been smelling, where buggery, beggary, cunt-sucking, blackmail, lechery, money, frivolity, poetry & fistulas are all mixed in one glorious knäuel. Oh these fortunate Anglo-Saxons who live face to face with the ultimates at all times. And how sex does make the world spin.

The Rosenbergs are of course pustulent. For their malice & envy they should at least have grace & beauty. They should make some demand on one's capacity to enjoy & for the enjoyment, to forgive their sins. But they're altogether braun. I'm becoming a snob. I want beautiful people & grace. Just think how Harold wd carry on if he knew about my affair! I've already invented all the things he wd. say & have written them to Jean. How he wd. say that the editor of Horizon liked my article so much that he not only sent me 10 guineas, but also his wife to sleep with me. And that I'm her prat-boy & probably eat it and so forth. Which, perhaps, is all true—except the sending of the wife, which was a mistake on Connolly's part. But he'll probably never find out anyhow.

——Clem

SEPT. 16, 1940

Dear Harold,

I'm the one who needs solace now. I'm in the lowest mood possible. The only thing I can remember similar to it is when I was left alone in St. Louis

7 years ago. So utterly abandoned, & the future stretching out ahead of me so utterly empty.

It's mostly La Connolly. I fell out of love with her 2 weeks ago—she'd stopped writing; had found a bi-sexual prize fighter to copulate with, as I cd gather. Being out of love was knowing the horror of sex, but it was endurable. But Friday I went to a literary party at Macdonald's, and was it fearful! Five women, all except one, extremely unprepossessing (not including Nancy Macd.) and twenty or so male literary busybodies of all sorts of boring varieties. I got drunk immediately & talked to the one attractive woman, Walker Evans' girl, all evening, hopelessly, for she's faithful to her man. And then, and then—the drunkenness made me miss La Connolly so excruciatingly that I wanted to cry. Since then I've been in pain, not wanting specifically her so much as some possible woman to hold close. I'm sick of being alone, sick, sick of it.

Curse the Macdonalds & the people like them who have no personal lives & fail to recognize them in others. What with that, there's a fuss about my next article on painting. My last article, Dwight has discovered, was rather a failure, because only painters & aesthetes liked it. Some more grief. I am to write only what the readers are sure to like.

What makes La Connolly hang on is that she's the most diametrical opposite one cd. find to my literary friends. Utterly personal, utterly sensual, if not gracious, utterly unboring by virtue of what she has to recount of her own surprising life, and always promising a sin together, a deed of darkness with undefinable emotions. I've written 5 sonnets on my feeling already.

With all that—and here's the horror & the fascination—a very slut, a superficial creature, a self-indulgent, selfish, unsure creature, without poise & without assurance, anxious to please, yet calm & bovine. Awkward & untrim, as Marty pronounced, having met her once. Yet with perfect taste in her clothes & the instinct by which a woman breathes, eats, shits & pisses immaculately.

If you met her you wd. think her horrible & still you'd acknowledge the reasons for which I fell in love.

I met Margaret Marshall at Macd's party & did not like her. Too snotty & too unattractive. However, as she was leaving she asked me to call. I told Rahv I wdn't kiss her ass for a book-review, yet I will call her up. Hay must be made. If I don't pursue my career it won't pursue me, and my genius is not enough. Originality turns you into a crackpot in America.

My piece on politics came out in Horizon ["An American View"] of which I'll send you a copy, & I found it good. Connolly answered it in his editorial with the common sense that precedes catastrophes. I'd answer him except that I'm ashamed to carry on controversy in public with one I've cuckolded, & about whom I know so much. And he's probably a nice fellow at that, even if he is a snob.

Saturday afternoon I moved a floor higher to a rear apt, which is quieter & lighter. Moving always depresses me, & it added to my gloom. Last year my new apt. was spoiled by my poetess becoming pregnant. And then it seemed as tho, if she wd only menstruate, life wd become exceedingly rich, much richer than ever. This year I'm poorer than the poorest.

It's horrible to be a close-mouthed person & at the same time one who needs confession so much.

The Partisan Review crisis has been settled, & it will go on as before, except with an office. I backed out & refused to become an editor if it meant pushing one of the present editors out. I didn't want any personal unpleasantness. And besides it wd have meant too much work. I was flattered & that was enough.

Write, give me advice & tell me what you think. And if you can spare a day come up to NY. I need yr wisdom, you're the only one who has the kind I need. If only you yrself wd make yrself brave by it. Please offend people by not exerting yrself.

Clem

SEPT. 19, 1940

Dear Harold,

I found solace. Monday life was almost unendurable, not so much because I missed specifically Connolly but because her body, passing through, had left a void that wasn't there before. I wondered how I was able to live from one moment to the next. It was horrible, excruciating. I needed to confide in some one, to externalize it, and there was no one, absolutely no one. And then I remembered Perky, Toady's friend, whom I'd liked more on short notice than anyone I'd ever met. Luckily, I remembered her address, dashed over & found her home with her husband. No sooner did I enter their apt. than I felt relieved. I was in the presence of personal lives. And her husband had to go to some meeting, and we were left alone, & I immediately unburdened myself. Confession is almost as good as fucking. Perky

understood just what it was all about, understood perfectly. Even better was the sense that if Connolly were to enter the same room as Perky I'd immediately recognize her for the infantile slut she is. But mind you, Perky was the only woman I knew who cd put her in that light. So I realized that it was the deficiencies of my friends that make me victim of snobism.

Tuesday I had a relapse for a few hrs. I called on my cousins & knew immediately I'd made a mistake. Everything they lacked Connolly has—and I began to miss her like sin, but got over it by reading a novel—I hadn't read one in 6 months & they're wonderful as a poultice; I don't do enough vicarious living. Anyhow I realize now that there are certain people I must avoid like sin, except for necessary business. One of the chief reasons Connolly got me was that I saw her in the company of the Macks [Macdonalds] three times & each time was convinced how infinitely desirable they made her seem.

But she herself is an animal, & there's no vice she hasn't indulged herself in. She's been buggered, she's practiced mutual masturbation with girl friends, she's been unfaithful while in love, etc., etc. With all that, as innocent as a child. And as unsure and as anxious to make people like her and as desirous of affection. Infantile from top to bottom. That she has good taste & is very intelligent is only incidental. That I fell in love with her was a function of my loneliness, and also that I knew I cd always extricate myself easily.

Anyhow I'm glad for it. It was worth going through. To find out some more about myself. And to get some cogent evidence on the horror of sex. I've written 7 poems in the last week, 5 sonnets & 2 others, none of them bad. All of them new—for me. I'll let them cook a while & send you them.

How we all need personal lives, how we do.

I've gotten thinner, have no sex & am extremely spiritual-looking. Certain delicatenesses have come out on my face.

I miss Danny & miss him.

Do you think he'll save me from the draft?

——*Clem*

Dear Harold,

Everything seems to be as it was. Perhaps. I'm in my new place; the same people come around; the weather is abstract; Greenwich Village loses its purpose daily.

My glamor girl has come back. A long letter saying that her wonder as to why I hadn't written was finally resolved by finding her last letter to me unposted in the pocket of one of her fairy friend's jacket. She still counts on me, has found no one to replace me & is returning with her 2 duennas as soon as she gets enough money together. The whole episode now becomes prosaic. Nothing is settled & I still want a girl like the one that married dear old dad.

The Partisan Review is in the throes of turning down my second article on painting [never published]: well-written but "unsound." Maybe they're right. In about a week I shall go into a dudgeon about it. My vanity remains intact, however. No progress is possible. You only want what you have. America, America.

Kiss Toady goodbye for me. [Toady is moving back to California.] I feel sad for her & hope she gets a good man.

I'm writing a new article on Brecht's poetry from scratch. I've found my central idea. It's much easier to write about writing than about not-writing, like painting. And I have learned so much about painting, too. What a shame to waste it. But everyone dislikes technical criticism of painting; and there's no other decent kind. What's wanted is horseshit. And the horseshit is so easy to write brilliantly, but I shan't.

The reason I took La Connolly so hard was, I realize, the hope that she was opening up a new personal future for myself. I'm so disgusted with intellectuals, with impersonal, inorganic people like Dwight Macd. & Rosenberg (to some extent). I loathe them, I'm sick of them.

Yes, the honors pile. But I want gossip, sexual intrigue, back-biting and hair undoing. I want women, confidences, confessions & broken hearts. Dissipation, indiscretions, glitter, dash, sparkle, sin. La Connolly has a lot of all that & something else besides. A personal & particular interest in all forms of sexual sin, a careful attention to the physiology of life, a taste for personal qualities & whatever can't be said adequately in words. I adore it. Yes, I adore it. Feeling is all. The end of all is to feel deeply.

But you know all this anyhow.

I mean that I require the female principle.

Read a book by Elizabeth Bowen called "A House in Paris." Not a good novel by far, but with things in it. Bowen is a close friend of La Connolly's. They both know what they want.

——*Clem*

Dear Harold,

I've trundled along rather equably the last 2 weeks. Finished the Brecht piece ["Bertholt Brecht's Poetry"] in 5 evenings & have already had it accepted. It's good & almost adequate. Not quite. But it does as an introduction to Brecht as poet. I'd send it to Horizon too, but am ashamed to face Connolly. Something like that has always to interfere with my career.

La Connolly & I continue our correspondence, but rather tepidly. She's lying and has already wriggled with one, if not more, men since me. I think the pause in her letters marked a binge of 2 weeks, during which she probably performed as Messalina, only to come out of it with disappointment to decide there was no one like me. But I have a feeling I'll never have her back—not the way I want her, as a handy & appetizing piece of tail. She's planning to return "either in 2 weeks or in Nov."

What did you think of my "American View"?

Didn't I already tell you that the hitch is getting Brecht's permission—which now seems beyond all hope, as report is he's fled to one of the Baltic states under Soviet protection. The PR might print your "Mahagonny" without permission—I don't know. And in any case I don't think yr labor wasted. It'll see print some day or other.

I called up Marshall, but this & that prevents our meeting. She doesn't seem over-enthusiastic. It's her turn to call me.

I'm in the throes of an awful case of hives, worse than the one I had on that trip. It's combined with a cold. Luckily, I had a dinner date last night with a beautiful neurotic girl name Adeline. At the table my face started to puff, & by dessert I looked so hideous it was indescribable. She, sweet creature, took me home, put me to bed & applied boric acid compresses to my face & stayed talking to me until I fell asleep. She was marvelous for such a good-looking person. Anyhow I stayed home today & feel better but not much. I met her last Sunday. She's very pretty, 5'10" tall & slightly too masculine, but delightfully fearful & inadequate. An art expert. I hope something comes of her.

Yours of Toady was magnificent. There's no one else on earth could write such a letter. You're such a passive bastard! Write a novel made up of letters or of diary entries or of telephone conversations or of notes to the milkman. WRITE, WRITE. Harold, you'd be a wow. I know what I'm talking about. I do. Just precipitate yr wisdom.

——*Clem*

P.S. Imagine the novel was a letter to me. Your private talk. And just let go. Write 10 times as much as you need to. At the office, in trolleys. Haphazard, slapdash. That letter about Toady awoke me to the fact that yr sensibility is worth all the intelligences of Rosenberg, Greenberg, etc., etc., put together. You can show us up. Do.

OCT. 22, 1940

Dear Harold,

I had a drink with Marshall last Tuesday before dinner, got a little high on an empty stomach & told her the Nation stunk, to forget about my poetry and that it was difficult for me to talk to strangers. She offered me a review in the vaguest terms: when I see a book I'm interested in; and admitted she hadn't read any of my stuff. She's a very nice person, but to think that what's in her hands is what it is—oh! I'd like to do reviews, but not if I have to chase. And that's what she wants, nice as she is. And so practical, mm, mm, mm.

Anyhow I had a date for dinner with a girl I was falling in love with, so felt I could afford to accept & reject on my own terms. In an hour I wd. have what I wanted more than anything else, so why not?

This time I got love the way I prefer it. The name is Adeline Tintner. She's a rabbi's daughter, a high-school teacher, an art-expert in a fashion, a girl who's been around, is 28 yrs old, Titian-haired & a knock-out. All the glamor you want, and as unsymmetrical as Jews like you & I. You have to meet her.

Connolly softened me up. I went looking for it, & found it. And found it just right. I love people who don't know how to live, who are sloppy & passionate. We go to bed together in a room in Tudor City piled high with clothes, notes for a doctor's thesis that was never written, cigarette ashes, suit-cases & blankets. We never have enough sleep & are always sparring. She has a deep voice, suspects herself of homosexual tendencies & has practically no breasts. You'd go wild about her for her sense. La Connolly has faded away into the West.

I'm typing the final draft of the Brecht piece. You'll like it in spots, but will feel that I haven't exposed the kernel, you'll be right. But if I exposed the kernel it might be dull reading for people who've never read Brecht. Everything is accommodation in the writing-about line.

I saw the World's Fair art show Friday & it was a swell surprise: a wonderful little "Battle" by Rubens, a Renoir landscape, the best jungle Rousseau I've seen, a wonderful "Arabs Hunting" by Delacroix, a good Tintoretto, a heap of Goya goods, the best both Hobbema & Ruysdael & a curious Poussin & so forth. Adeline, in her spare time, is one of the girls who

guide, & having no illusions about her guise, was embarrassed having me around, & I had to skip from room to room to avoid her. But when it was over it was wonderful exuding upon someone who not only understood but was also beautiful & with whom I was shortly going to bed.

Excuse the gush, but why bother not to gush? The end of living is to make these wonderful mistakes. To be in a position to be caught with yr pants down.

<div style="text-align: right">Clem</div>

<div style="text-align: right">Nov. 25th, 1940</div>

Dear Harold,

Yr draft number sounds bad at first, but you yrself sound better. They won't take you, you're too old, & they're not such fools they won't realize it's a waste of money & time to make a soldier of you. I wdn't worry, what with yr eyes & your sini.

Thanks for Danny's drawings. Mrs. Ewing also sent me some. He still pays too little attention to the shape of his page, & he's too intent on reporting what he sees. Well, that's the first instinct of a born draughtsman and of a masculine nature.

My love affair with the spectacular, Titian-haired one has gone aground. She reminds me so much of you, in a coarsened way, that I scream & scatter. Anyhow she's taken my time & my soliloquies for almost 2 months, & it's come now to the point of scratching & raping. It wd be much easier if she weren't so tall & so beautiful. Really, she's beautiful the way you don't expect reality to be. And dissolute & unsatisfied—so much like Toady—by sex. Anyhow, it's too wearing.

La Connolly threatens to be back at any moment which would be a comfort. Maybe.

This business of finding a woman & one who's glamorous enough to keep you excited, & the business of watching one's own chemistry say "love" & "not love"—am I really alive now? Anyhow, it's the point of living. To feel is all.

I'm trying to write a piece on Klee. But I don't know. An artist remains an artist. And paper & words always miss the point, as everybody says. And yet it's not so. Klee, at least, & Picasso too, need a little deflating. Miró needs to be praised. But the way I write about art nobody listens.

I'm in a bad way, as you say. I don't need silence. I need what Dorothy Dix calls emotional security. Loneliness is killing me. Oh shit!

Have you ever heard Beethoven's piano Concerto No. 4 in G Minor played by Schnabel & the London Philharmonic? Hear it by all means. I've never listened to anything as good. Also get hold of a Columbia record of a song by Handel called "O Ruddier than the Cherry." Mozart, except the operas, is wearing thin.

My Titian takes, or took, me to see collections I never heard of, & so I'm learning about art. Not from her, but to & through her. I've found out that a genius is really a genius, i.e. when you've heard of the artist's name he is almost always sure to be good. And my eyes are become as delicate & fastidious as my ear, which is a great accomplishment. I'm smitten now with Delacroix's Arab scenes, Hobbema, Guardi, Courbet, when he's good. I can tell a Rembrandt from a Rembrandt. Going to see pictures with Addy is like going with you. Everybody is in such a hurry to show how sensitive they are. But since I think & she doesn't, I generally come out the amused one.

Oh it takes me so long to grow up.

——Clem

DEC. 31, 1940

Dear Harold,

My times have been full & most personal. My tall love affair got more & more difficult, it being with someone a little mad, but not in the good sense of mad. And then my glamor girl came back, having been astoundingly faithful, and I chose her immediately, & the tall one went off, & meanwhile I'm turning in bed with Jeanie, & I like it to death. Last night I had 3 hrs sleep & I just finished fornicating 1 1/2 hrs ago, which is why this letter is rather cute.

I've become an editor of Partisan Review; probably unwisely, because it takes too much of my time, & reading & revising mss. defeats my own impulses. Besides, I have a guilty conscience because of the missed opportunities to really act as an editor & force good writing forth, which I am too lazy or preoccupied to take. Besides the Brecht piece there will be a review by me of six new little mags. ["The Renaissance of the Little Mag"] which was quite some fun writing.

I wish it wd. get freezing cold. New York wears itself like a shabby refuge for pleasure-seekers fleeing war.

I'm 2/3s through with a piece on Klee. As for Rouault, I'm a prig. Most of his stuff displeases me because it's too squarely centered & therefore too much at rest in spite of the in and out movement of the color: which is exactly

how stained glass works. The best Rouaults I've seen are his 1940 ones in the latest Verve, as also a wonderful rooster by Miró. My real passion at present is Vlaminck. There's a whole story of modern art involved—but not here.

But when I talk about art I feel as though I were spouting horseshit, & then I have to read Baudelaire's Salons to reassure myself. Oh it's so difficult.

But shit, I don't like the sound of myself anyhow. I'm turning into a snob & prig. Come up & take it out of me.

——Clem

P.S. The draft will probably get Marty by April, alas. But you will certainly flunk the physical exam. Don't worry.

1941

JAN. 6, '41

Dear Harold,

When you come will you bring Mrs. Ewing's letter with you? She never tells me her troubles. I have to imagine them & that's not very good; I keep forgetting that Danny is the most exhausting person I've ever met. (Addie, my previous, told me that I was that for her. It's really greed, voracity & some ringworm of the soul that makes me want to live in multiplied state.) At the same time I think she needs Danny. My idea is to have her come East with him in the summer at some expense to me instead of going West myself. My brothers miss him a surprising amount, and it'll do him more good.

Art & writing about art: nobody has discovered the history of art yet, honest to God. And I insist on what I say about Rouault: it's simply a question of determining why he doesn't satisfy my eyes enough, not of foisting upon him what I require of painting. You seem to think the last. Otherwise you're right, articles, schmarticles, particles.

Rosenberg's piece ["On the Fall of Paris," *Partisan Review*] was badly & dishonestly written & yet was good. Good in spite of the things that made me grit my teeth, in spite of the rotten pretentiousness that came through and of the utter lack of feeling for the language. Dupee & others agree with you about it, incidentally, but it's a narrowness on his & your part not to see that Harold's imagination did nevertheless provide some good & exciting reading matter & that thank God he failed in spite of himself to take writing too seriously. Good Lord, I wish you did.

Rosenberg was down New Year's Day, rang my doorbell to find me out, put up at Macdonald's, saw Rahv, & learning for the 1st time that I'd

become an editor, denounced me far & wide in violent, slanderous terms. Friday morning he called me up at the office, wanting to see me, & I was embarrassed. I really don't know what to say to an enemy. And he's so stupid & unscrupulous. Well, I broke two appointments to see him. The second was for Sunday morning at 10. He rang the bell at 11:15 when I was not only in no mood or strength to see him, but was in bed with La Connolly. And so I didn't answer. I think the inflamed state in which he returned to Wash. will lead him to get in touch with you in order to proclaim my perfidy. He'll do it, & how.

What I want out of the "personal life" is not the good for me, but the good. That is, I want to enjoy myself, be excited, etc. Why not? Why not women? Why not personal relations? The interior life is always there. And I'm sure to relapse into loneliness again, it's as certain as my survival; and then the interior will have a chance to improve itself. In agony. My loneliness becomes agony more & more. The point is that I'm interested in the ends as well as the means, and the principal end is to roll in bed with some one you love, & to feel. Can't you see?

I suppose it wd be better if you stayed at a hotel when you came up & let me share the expense, the way you did with Mrs. Criswell [Harold's landlady]. La Connolly stays with me certain nights, & it would be distressing to us both to skip them.

I miss you & want to see you. Come up in trusting mood. We'll be easy on each other.

Everybody says I'm difficult, that there's something funny or puzzling about me, that I'm a snob or a stinker, or that I could be "so wonderful" if I only let myself go. A fairy said the last. I'm convinced that the only thing I cd become other than what I am is an ass.

Wholeness! I'll become whole like my father or Marty—harder, really, than flint.

Clem

FEB. 15, 1941

Dear Harold,

Yr rejection in the physical exam was exactly what I had expected. It couldn't have been otherwise. But it's a relief to have it over.

Parker Tyler's sent a nasty letter to Partisan Review protesting against my review of View, and involving me in all his fairy tales. It's very embarrassing.

I saw Margaret last night. She's hard to talk to, and like me has social emptiness. But we read Dante and I gave vent to my depression, with which she sympathized adequately. I've already received the proofs of my review of that art book. It's just an ordinary book review ["The Structure of Science" by Carl Thurston, *The Nation*]. Margaret says she likes it, however. I told her 2 weeks ago you wanted Winchell's book. I'm still on the Goethe piece [unpublished]. It turns troublesome towards the end.

My time is so taken up. I have something on for almost every night for a week ahead. And none of it very attractive. Oh life, life.

I revisited the Vlaminck show twice, the last time with La Connolly & ran into Addie. It was quite dramatic. Jeanie didn't like it, since she was made one of two, and I the One. Later it came out deviously. Addie tried to be cutting, but Jeanie was more so, by being indifferent. I felt so focal.

I have still to type the final draft of my Klee article. I must let it simmer a while. I hope it's as good as you think it is.

I got a letter from Danny, printed very well, with no misspellings. It was really quite surprising.

Sidney Phillips [managing editor of Dial Press, now owned by Burt Hoffman, is to become Clem's closest life-long friend] was sorry to have missed you. He says he was unusually well impressed by you when he met you a year ago. From Sidney that's no small praise. Well impressed is not the right phrase. Poor Sidney, he wants what he shouldn't want. He wants glamor and can't stand it. Don't we all?

———*Clem*

FEB. 25, 1941

Dear Harold,

When you write don't stop to criticize yrself. And of course, it seems lousy. It always will. But after a while you get used to it. You discount & take into consideration the state of the world. Above all else, write what comes easiest. That's the way to be sincere. And if writing is good today it's first of all sincere. I've found that out as an editor.

Margaret is so timid & circumscribed she's almost impossible. Jeanie & I had dinner with her last Tuesday to consume the Alsatian wine. It was a damn well-cooked dinner, but talk was so difficult. So we read Dante, & Jeanie got into a pet because she was left out of it & didn't like my Italian accent. Which was followed by an excess of fondness, & so we went home &

fornicated all night. My glamor girl does so want to be loved. Well, affection really is 75% of sex after the age of 25. And I like to hand it out, when I can have sex along with it.

Apparently, you find Jeanie wonderful. She is. But what an underside, what an underside. Some day I'll initiate you.

Who ever takes Parker Tyler's poetry seriously? Even if he does write a good, relatively, poem once in a while. As for dishonesty, there isn't enough there to be dishonest. It's irrelevant. As is shame.

I'm impatient with my job, but it's still the best possible. I want more time for idleness, pure.

You don't miss very much in New York. Everything is quatsch. Social life sends me farther & farther back into myself. Find one's own garden & hoe it. Warm one's own little gift. And how, how. How glad I am that Goethe waits home for me.

Margaret has invited Jeanie & me to an evening with the Edmund Wilsons & Auden. After much hesitation we have decided to go. The presence of Auden may pain me. He's kingpin, & he demands the privileges of kingpin. Last week at Jeanie's for dinner he was a little obnoxious. I'm as much as he, as much much. And Wilson is cagey, suspicious & luke warm. But I like his wife [Mary McCarthy]. And anyhow anything for a change from the editors of Partisan Review & the fairies.

———Clem

MAR. 18, 1941

Dear Harold,

I'm trying to screw something out of the world which will be as good a birthday present for you as the dictionary was for me. I should like it to be a mixture of apophthegms & concrete love, something like Paracelsus; but there's no such book published. But I'll find something. Truth to tell, I forgot about yr birthday because I was thinking too much about myself & how rotten I felt for a week or so. That left room only for Jeanie & sex. In some ways she's bad for me—and forgetting yr birthday & supplying her constant constant desire—yes, desire—are some of those ways. I need my seed sometimes. But she's a darling in her way.

You're right in a sense about my Brecht piece. But I gave up being essential about a writer whom my putative readers haven't read. If I could assume that, I'd really try to go to the carpet with him. As for "subject matter," you're off on a flight. It's not the right term. But yes, the piece could be

better written. I'm not enough experienced to avoid all the stances one falls into when introducing a writer. I hate some of my sentences. Wooden, wooden, wooden. (Auden denied to me being importantly influenced by Brecht in particular.)

The thing is being liked, but I'm suspicious. The editors like it extravagantly. Don't blame me, by the way, for the issue's poetry. The only poem I opted for was the [Milton] Kaplan one. The others were accepted before my time or over my objection—particularly [Harvey] Breit's & [Rayner] Heppenstall's. Yes, everybody says the number's a good one.

Phil Rahv married his girl [Nathalie] 2 weeks ago & went to live in Chicago where she's got a job. He resigned from the board, as has Fred. So we look for a new editor, not that I think a new one particularly essential, but Dwight wants new blood, the tenacious optimist.

Margaret had Jeanie & me over to meet the Wilsons, John Peale Bishop & Haggin [Bernard H., music reviewer at *The Nation*] two weeks ago. The Wilsons, whom I already knew, confirmed my impression of them. "Bunny" [Edmund] is a bunny. Mary is a "Mary." Bishop is a damp but neatly pressed handkerchief. Haggin is a bristle. I'm reviewing current art shows for the Nation this week or two.

Partisan Review is sending out questionnaires to its readers. Of the 10 received back so far, two dislike my stuff violently for its "obscurity," "verbiage," etc. & none like me. Everybody likes Rahv, & almost everybody likes Macdonald. Also [James T.] Farrell. That's what's wrong with America. At the same time Dwight tells me I'm the "white haired boy" of the magazine. More quatsch.

The folks are back from Florida & Cuba, Pa full of travel stories & the excitement of the exotic. Places affect him so. He sounds so much like me.

——*Clem*

12

BEARING DOWN

"I'm up to my neck in love; now I want to be serious."

Dear Harold,

I stand on my apologies for the Brecht piece. I'm satisfied but not pleased. Yesterday I re-read my complete works & decided to continue as I am, only more so, which means to change conservatively. I've digested the rebuffs. It's really not to the point. But I have the notion that it's up to me to reform American culture.

And I must write poetry. I haven't for some months, & I feel it. There's something that doesn't get done otherwise. This sounds pretentious, I suppose. It is.

Saturday night the Morrisses took me to see & hear Götterdämmerung. Really, it's awful, with wonderful things in it. The music is better, much better than you suppose from radio or concert. But what things are on the stage, & how everything goes on. We sat in a box; I had claustrophobia, & interludes of deadliest boredom. There were also musical people along, and the atmosphere of emotion without intelligence that filled the box pretty near suffocated me.

I finished my art review for the Nation and since I had only 4 pages to roam in confined it to Miró, Léger & Kandinsky. It's full of my habitual obsession, & not well-written either. I have a feeling of distaste about it. The sin of having to fit space & so say what should not be said without much qualification & explanation. And to reckon with my audience. To have simultaneously to explore & investigate the thing written about & to educate those who read what you conclude. Nothing will ever get done.

Marty was inducted into the army this morning. His reconciliation to his fate was a process as horrible as the fate. He sensed that; and his state was something I appreciated only because I remembered one or two bad dreams.

Yes, write. And please don't stop to look at what you've written & say how bad it is. Write, write yourself out like a roll of toilet paper. Issue, issue. And afterwards you can cut & discard & improve. Only one thing: have yr. eye on what you write rather than how.

And then send me some. Do that.

—Clem

4–17–41

Dear Harold,

Your review was swell ["*What Makes Sammy Run*" by Budd Schulberg, *The Nation*], really, without friendship or anything. The sentences in the 1st para. or so may have been involved & a little difficult to work out casually, but it didn't matter. It was so full of wisdom, not only about life but about writing too. Frankly, I was surprised. You're much more a natural writer than I am. And how you packed acute observation & cunning terms & perceptions in. Really, a revelation. To think you did it in a hurry.

You have no idea how pleased I am. I read it with bated breath, fear & trembling, as though you were Danny. And seeing that you were successful, I exulted, my fear being so great.

Our visit to Wash. was unsuccessful, I think. You didn't have time to come out of your hunger for intimacy. We all have it, but you're tactless about it; you presume, you ask too much. You should be manly about it. Anyhow Jeanie was annoyed with you for yr nagging about the Brecht piece. She understood you, but felt you should have recognized the presence of a third. She's right. She predicted your ceasing to be sentimental about her after seeing her with me en route en hotel en boudoir. But never mind. You shouldn't have been sentimental about her in the first place. You should only have been transfixed with concupiscence & curiosity. Her heart, not her feet, is of clay. She subsists like a very natural fish. But you deserve my criticism. You have no control & get provincial about social face to face intercourse. I could spank you at times for coming all apart with warm feelings about yr friends.

Did I tell you that the next number of Partisan Review will have a new long poem ["The Dry Salvages"] by T.S. Eliot? I haven't read it yet. Also my piece on Klee.

Marty's address is Private Martin etc., 65th Infantry Training Battalion, Camp Wolters, Texas. The news from him is non-committal, but I can see he doesn't like it. His letters are calculated to cheer up my father who's bemoaning his Benjamin.

Jeanie's gone off to Baltimore for 3 days. I miss her, but a vacation was needed. We've been living like Siamese twins for a month, mostly in bed, & I could see nothing but a blur when I looked at her. I think I've made her pregnant, but won't be sure until the end of the week. If so, there'll be quite a dither. What mothers I get for my children!

I think I'll write something on politics which is urging to be written about.

I see almost nobody, & who I see is too much. The magazine is giving a cocktail party at Geo. Morris' next Tuesday, to which only "influential" literary figures are invited. The process of finding out what we meant by "influential" was nasty, & I almost had a fight with Dwight. He has no friends, so it was quite easy for him to be practical about it. I wanted to invite certain people I liked. I won, but for the wrong reasons. It was filthy.

———Clem

MAY 20, 1941

Dear Harold,

I'm sorry my delay in writing has worried you. Jeanie has moved down to Greenwich Village, so that I spend almost all my time with her: breakfast, lunch, dinner, bed, Satday, Sunday. The flame's white hot. But I'm still perturbed. She imposes her habits on me too much. Not that I don't impose my own on her. But I have less time & space in which to compromise.

At any rate I've done nothing in the last several months except write a review of Oscar Williams' anthology of 1940 poetry ["Poetry Continues," *The Nation*]. Now I'm doing an editorial on politics with Dwight & then I must get on with my Goethe piece.

You should have been at my party. The Morrisses, Dwight, Dupee, Eleanor Clark & Margaret were there besides Jeanie. And then some other literary people came uninvited: Carson McCullers, Bessie Breuer, Nigel Dennis (lit. editor of New Republic), a German poet & a pair (invited) named the Sterns [Tanya & James], friends of Jeanie. It was all very drunken. Mrs. McCullers accused Jeanie & me of insulting her, which was very amusing. And it all stunk too, being so literary & international.

Marty hates the army. He doesn't say so in his letters home, but he says so to me & his friends. He's been made a corporal & has an office job, which helps. His last letter says he's bored. I'm thinking of publishing one of his letters in Partisan Review. It's a document of cold observation by a cold

blooded person of a situation warm with misery. Marty is a cold fish. He never asks for love.

Jeanie says I have a capacity for being cold too. But I say it's because terrific heat feels almost like terrific cold.

The mag. has received a longish poem from Auden called "At the Grave of Henry James." Margaret was peeved when I told her, as she was also peeved about our getting Eliot's poems. She says we don't pay enough to deserve Auden, & are too politically at odds with Eliot to deserve him.

All is so literary.

We need rain.

I'm a little harassed. I don't know why.

———*Clem*

JUNE 10, 1941

Dear Harold,

Yr [Josephine] Herbst review ["Satan's Sergeants," *The Nation*] is damn good. You're doing the best reviews of novels in this country—& I'm aware of what I say. In some respects I liked yr first one better, but there was nothing in the first one so perfect, so just in tone as the last paragraph of this one. You tickle me like Danny's turning out really to be able to draw.

I came down with the grippe last week & was in bed 4 days with cough & slight fever. Jeanie took care of me marvellously; cooked, cleaned and administered—so that I was rather comfortable and had a rest, all in all.

I'm writing a political editorial in collaboration with Dwight—which is hard going ["10 Propositions on the War"]. I really hate the idea, but the mag. must take a stand, and nobody else is willing to go on record.

In the next issue we're printing excerpts from 2 letters Marty wrote from camp to friends ["Letters from an Army Camp"]. They're very good, I think.

My father paid me an unexpected visit while I was sick, & found Jeanie giving me lunch. His emotions were something, coming out all over his face. So were Jeanie's, but better controlled. She found him full of charm & "sexy"—like me. I suppose she's right. Meanwhile Pa's full of curiosity & trying to get me home to pump me & find out all. I don't relish the curiosity, & feel a little ashamed.

———*Clem*

Dear Harold,

I'll be away this weekend too [Amenia, N.Y].

Thank God I missed Rosenberg. He embarrasses me. Such a lack of shame. I'm also thankful I missed [Kenneth] Patchen. PR isn't running his ad because he hasn't paid us yet, & we're afraid we'll never get the money unless we get it in advance.

I had a pleasant time & I hope you had the same. We walked in the wilderness & found lakes in which I went swimming naked. The inn was unpretentious & comfortable; we lived as intimately as at home, sleeping till noon & languoring in the sun, talking to no purpose, not reading, not wondering, not desiring.

Jeanie's friends who live about 2 1/2 miles away drove in for us every day & were present enough to break the monotony. James Stern they are and his wife [Tanya]. He's half Irish, half Jew, Eton, Oxford, international Bohemian, ex-queer, louche, wistful, charming, malicious, jealous of me for Jeanie (whom he yearns for darkly), a snob in his way & not very intelligent, but nice, nice enough. His wife is a German Pole, same age (37 circa), good-looking, short, muscular, an ex-lesbian, a physical training instructor (a special method akin to Yoga), supports the menage by her work, and is nicer. Her brother is Alfred Kurella, a famous German communist now in Russia. Stern writes short stories & has been in O'Brien's collection 5 or 6 times. I tell you all this because the details let you know where I am.

Jeanie came back with me Sunday & hasn't succeeded in leaving until today when she rides back with Auden & his sweetie, who're going to put up at the inn for a week. Jeanie is going to stay there until August. I expect to go up every weekend, money lasting; although it's not very expensive. This weekend I don't look forward to so much; Auden's a petty dictator & offends easily when crossed. I cross him whenever I meet him, & don't mind him. But now there'll be a solid little England from which to exclude me—I'm an interloper anyhow—notwithstanding Auden's sweetie who comes from the same Bklyn Jewry as I, only more so. I mean these people build fronts, scratch and bite, and stick their fingers in yr eyes. There'll be such tension, such strain, such loops & curls of conversation. Oh well. Jeanie'll be no good to me in the circumstances, because she belongs to the same louche world by nature and by past; she belongs to me only by love & the flesh, neither of which count. Oh dear. I want to sweep with an iron broom, I want to bring down fire & the sword, I want to cleanse with lava &

blood, I want to Blitzkrieg the cities of the plain.

How are yr mother & father & Dorothea. Give them all my regards.

Syracuse in 1941 I cannot imagine. Still green, still mouldy?

If you get back before me Sunday go to the Brevoort. I'll ring there as soon as I get in.

You must know how I am. It's not good altogether, is it?

———Clem

Dear Harold,

I was disappointed that you didn't come down on yr way back. We haven't had a proper chance at each other for a year. I suppose you're a trifle piqued at my neglect, so to speak. That's always the way when you're in love. Jeanie asked me whether I confided in you, & I said yes. She said, I'll bet he's not too interested. Are you?

My weekend was all right & tiring. I wasn't left alone with Jeanie enough, & coping with Auden was a task. He takes full advantage of the fact he's a great poet. In content he was dull—so was I—but objectives quite interesting. It made me realize how much poetry is self-expression.

His boy doesn't really like him physically & is tugging at the leash. This keeps Auden on the go & makes him happy: he's happy to be loved by some one who doesn't love him. Or rather, happy to <u>have</u> someone who doesn't love him. Queens have to be vicious, try as they may, and they have to <u>have</u> people. There was a great to do & talk all the time about whether so and so was attractive or not; & in back of everything was a general shadiness. Vistas of sin. You—and only you—would be greatly amused. I was a little too much involved. I'm not yet, like Jeanie & the others, prepared to contemplate every possibility but I soon will be.

This week I shall have to do some work in earnest. I've done practically nothing for 3 or 4 weeks & it's bothering me.

I want to write some poetry, & then—I want the profound. I want the bottom, final explanations. Or to prophesy the future, the worthiest task for those who, like me, think there's no outlet adequate to their opinion of themselves. I'm up to my neck in love; now I want to be serious.

Auden is not serious—he supposes himself to be, but he really isn't, nor does he really want to be. Most of what he writes that's not poetry is presumption & rashness. But he's good because he makes me realize how important it is to be serious, what a lack is present.

Margaret shd be drawn & quartered for printing Sandburg's poem. She makes herself an object of despair—and of contempt too. With all her timidity. Bawl her out.

I suggest that you do a short, crisp piece on [Henry de] Montherlant, either for the Nation or for us. And then one—for us—on E. M. Forster. Knowing that you have, say, only 3500 words, explain what makes him go.

Another shameful letter from Mrs. Ewing, bewailing Danny's difficulties, filled with such nonsense, such nonsense—as: there's anti-Semitism at work against him, he can't get along with people, etc., etc.—to end by wishing a bomb fell on him, and saying that she doesn't tell Toady this for fear of breaking her heart. My heart, I suppose, is strong enough to stand it. What a wretch, what a fool the old woman can be. It's all a form of pleasure. She wants so much to have a fuss made over her. I've offered to take Danny myself in a letter I sent off this morning. I'll do it somehow or other.

——*Clem*

I don't sleep enough. I desire too much & I'm too conscious of my body, especially my penis—maybe it's an overdose of sex. How can you tell?

Yr Oxford dict. is on the way.

AUGUST 25, 1941

Dear Harold,

The lease on my apt. is up Sept. 30th & I'm trying to decide on my future mode of life. As it now is it's unsatisfactory with Jeanie & me living together in 2 separate establishments, but as you can imagine there are embarrassments. Jeanie's mother will be in town for a few months this fall, for instance—and then there's the matter of her openly confessing to a serious affair with me, etc. But the way it now is is insupportable—costing too much money—too much inconvenience.

Meanwhile my job is getting more & more irksome: what I have to do, but mostly the way it ties me down to one place. I'm sick of Greenwich Village, & I'd like to leave NY for 6 months. I'd like to see too what I'd do if I had all day to write in.

I did a short review of John Wheelwright's poems for Margaret & a review of a life of Rosa Luxemburg [by Paul Frolich] for the Partisan. My Goethe piece is stubborn.

I took Kenneth Burke's latest book [*The Philosophy of Literary Form*] up to write an attack on it for Partisan but after 100 pgs I found myself applauding—except that his prose is so wretched. You ought to read it—carefully.

Mrs. Ewing writes rather cheerfully that Toady is in Carmel, where she's looking for a job much closer to home. The cheerfulness is not explained. Danny seems to be all right. For a while, anyhow.

It shd have been obvious to you that the [William Carlos] Williams poem ["An Exultation"] wasn't printed for the sake of poetry, but as a document from himself. I can't understand how one can be so obtuse as to think otherwise. I'm angry at you. Williams writes a good poem only once in 5 years. But this was outside the category of verse. It was interesting because perverse.

Tonight Margaret's coming over to Jeanie's for dinner. What shall we talk about? I'm offering her a batch of [W. R.] Rodgers' poems for the Nation. He sent us 20; we took 3, & are trying to get the rest published elsewhere. Some of them are wonderful, and we didn't take the best one of all.

Harold descended on me Friday afternoon just as I was taking a shower after getting home. Fortunately I had to be somewhere at 5, so shook him, saying & half-meaning to call him the next day, which I didn't do because I realized suddenly how much an effort it is to be with him lately. He's been offended now, I suppose, for the last time. Before we separated he told me he heard from Abel that I had become very sensitive lately: i.e. I had told Abel, hoping he wd. pass it on to Rosenberg, that Harold's insults heard at 2nd hand made me unwilling to see him. I answered that he was sensitive too & dropped the subject because it embarrassed me.

Write soon.

———*Clem*

P.S. When last over at Margaret's, she showed me yr letter about Shih Hu. Partisan Review will take anything you write about Chinese. The whole business is something new to me, and extremely important. Later, Dwight came over, argued loudly & with the help of drink we all became warm towards each other. We had a good time.

SEPT. 10, 1941

Dear Harold,

Marty is home on furlough, thinner—almost scrawny—and softened in disposition. The army has taken a fall out of him. Like living in the West & marrying Toady took a fall out of me.

I hardly manage to do any writing. The Goethe piece won't move; when it does it insists on being crabbed, piddling, and too detailed. Perhaps that's all right, but to reflect my private-most preoccupations is embarrassing. What am I talking about?

Partisan Review takes too much of my time. All the other editors have been out of town all summer & everything descended on me. The view of American literary life I get via the office correspondence is depressing. The provinces are full of original characters, an echt Amerikanische tradition. It all annoys.

In spite of all this I can't get the editors to publish the kind of poetry I want. It comes in at times too. But they're all stinkers anyhow. No daring, no faith either, & no ideals. The mag. will degenerate into a grab bag of opportunism, you'll see. I can do little about it.

Meanwhile Jeanie & I are prosecuting our love affair. We're changing each other's lives & are both misfitting. I drink a little too much, she sits home waiting for me too much. We have all the disadvantages of married life with none of its advantages. I can't obtain composure, what with the business of running back & forth between our two domiciles. And oh I do so need composure.

Home, Natalie is growing up to be a big girl with breasts, hips & tawny hair. I don't think she'll be good-looking, but she won't be boring. Hardly at all. My father works too hard. Sol is well & fair enough at his job [a wartime job as a welder].

Washington must be hell. I abhor the very thought. The New Deal at war, summer, expansion, uniforms, govt. clerks, automobiles, the South, shit. New York is shitty too. The lower middle-classes are still where they were, on 42nd St. & Bway, at Radio City, at the beach.

I'm suffocating.

———Clem

<div align="right">Sept. 20, 1941</div>

Dear Harold,

I'm moving some time next week to a smaller but newer & cleaner place, for which I will pay about the same rent. It's at 50 Greenwich Ave, not far from where I am now. Jeanie found it for me. The business of moving harrows me. Jeanie will help.

Marty is going back to camp tonight after a 3 weeks' furlough. He is not at all happy about it. But I don't think he's any worse off than I was at his age.

Jeanie is thinner, and likes me a lot. I am inadequate, I believe.

Last week I met Christopher Isherwood, who's charming, physically prepossessing, and unassuming as Auden is the opposite. Yoga gives him a certain detachment, however, and there's a feeling—which Jeanie feels—that it is impossible to get in touch with him any more. He's quit his movie job because he's finally made enough money to assure his half-wit brother of security for the rest of his life.

I'm doing too little work, and getting caught in a futile round of reviews. That's bad.

I feel a curious absence of inner life. Love turns me inside out, and the Partisan Review and the literary life pull me apart as if by horses.

——*Clem*

Clem moves to 50 Greenwich Avenue.

OCT. 2, 1941

Dear Harold,

Your review is wonderful [*Historical Foundation of a Democratic China* by Shih Hu]. Do something like that for Partisan, will you? What book do you want? Jeanie, whose opinion on literature, and art too, I respect immensely, thinks it's "frightfully good," "brilliant"—it makes her want to read more of Harold. All this, from both parts, is sincere.

Mrs. Ewing writes that Danny's in a nervous state: Toady's antics and too many fairy tales. She's going to Palo Alto to try to live with a lady who understands children. I'm somewhat upset. I can imagine what it's like from my own childhood, but I don't know whether Danny has the same resources. Anyhow, living alone with Mrs. Ewing is bad for him, and she admits that. I'm trying to persuade her to come East with him.

Why not come up for Columbus Day weekend? You could stay at my new place, & I would put up nights with Jeanie, from whom I'm now only 2 long blocks away. We're practically living together: she's fixing up the new place according to her own tastes, cooking dinner, having the mattress restuffed, buying a straw carpet, book-cases, household utensils, etc. (at her own expense), and in addition cooking dinners & breakfasts. Domestic, but I'm a little fearful: too many hostages to fortune, but then I can always return them to Jeanie—she says. Anyhow I'm snug & smug—but I shouldn't enjoy myself so much. And I should write more.

I've got four poetry books to do for Margaret: Marianne Moore, George Barker, Harry Brown, a chap named George Zabriskie; there was some other shit, which I threw out. I'm sore at her for not putting your name on the cover.

Jeanie sends her love to brilliant you.

<div align="right">Clem</div>

Harold moves to 1928 Belmont Road, N.W., in Washington.

<div align="right">Nov. 25, '41</div>

Dear Harold,

There is a kind of silliness in you that irritates me without disturbing. Sometimes you can be such an ass—I can be fatuous, but you can be an ass. For instance, the high horse your manner mounted in respect to doing the [F. Scott] Fitzgerald review of "The Last Tycoon," only on the basis of your 3 Nation reviews. I know—as no one else on earth can—how little the high horse had to do with you, and yet you were an ass for even conjuring him up. And now on the Delmore Schwartz thing [to review Schwartz's verse play *Shenandoah*]. Your prissiness is inexcusable. "I can't be bothered." The point is that nobody in the literary world outside of the Wilsons, you & myself think Schwartz bad for the true reasons. Wilson himself doesn't like to attack people; I would embarrass the mag. if I did so, thus it's up to you as a moral and public duty—if only to puncture even if ever so unspectacularly this balloon that's been let loose to corrupt American writing with its gas. You could have done it in 500 words. That's all we want—500 words. I ask you again, will you do it? Schwartz's badness has to be analyzed. It's more the personality of the poet than the quality of the work; it's one of those rare instances where the evidence has to be sought in the subject. For God's sake don't swoon so much. And you know you wouldn't take the same attitude if Margaret were to have asked you to do Schwartz. That's what makes me angry.

I got my Moore/Barker review [*The Nation*] off last Tuesday. I'm not altogether satisfied, but I do think it's respectable, it's an effort.

That your room is nice is good. Thank God you have a bathroom. It's almost a basis.

We didn't go to Philadelphia after all. At the last moment I got into a temper with Jeanie and her friends, told my father I didn't want the car, stomped around, sprawled on my back with my hat over my eyes, and at-

tained my purpose, which was to upset Jeanie and let Tony [Bower, an American art critic] & Johnny [Farrelly, his lover] know I was tired of them. I was sincerely in the blackest rage, and sick to the gorge. It cleared the air, disposed of the 2 queens temporarily and reminded me of myself.

I'm afraid both you & Jeanie were too hard on each other. But it was mostly your fault—you with your demands on human intercourse. Poor girl, she just wants to enjoy life.

Marty has just written to say he's coming home shortly on furlough to get married, which shocks & amuses & excites my father. Nobody dares object.

Anyway, the boys at Partisan Review don't want to have Fitzgerald reviewed, saying he gets enough attention elsewhere. I didn't feel very strongly about it. Rahv has however written, asking to do a short review of the book. He won't get it.

Oscar Williams called around last night, and was the most peculiar & ignorant person.

I'm sick of reviews & don't want to do any more—especially of poetry—for months. I told Margaret in a note that after the Robinson Jeffers et al. omnibus I resign from poetry. Reviewing makes me sick of writing—it's probably because I don't let myself write them properly.

<div style="text-align: right">Clem</div>

<div style="text-align: right">DEC. 10, 1941</div>

Dear Harold,

Margaret's had a nervous breakdown & went to the hospital over the weekend. She's back home now, but still piano. If you could come up under your own volition it would do her good.

I'm worried about Palo Alto's worrying and am writing Mrs. Ewing to come East, hang it all. Not that I think there's much actual danger yet, but there is the presence of the possibility of danger. Calif. is only too well capable of hysteria of its own accord; but with the Japs after us the mood there is unimaginable.

Jeanie had an outbreak of tears Monday evening. The war and a nervous crise. Life is so untidy for her. She wept for an hour. If Margaret can have a nervous breakdown, she says, why can't she?

As for your social manners, they're impossible. Intercourse is such a challenge to you. I know, I know, but you should be spanked nevertheless, because you task your friends, who want you to appear in the same light they see you. Why don't you let other people assert themselves and create society?

I don't think you're snubbing Partisan Review. The Schwartz book has gone elsewhere. But I'll find you something else.

The war seems to be about to dissolve a good deal more than I expected. The incapacity of its leaders will shake—literally—this country to its foundations. In the end they'll find a group of dogged blood-spillers like Gen. Grant to pound out an agonizing victory. But this country is nevertheless a rotten shell—empty inside and dry, a swarm of coolies. Myself, I'm afraid for my own skin. You on the other hand have nothing to fear. They won't touch you.

Marty came home on special furlough & got married to his girl [Paula Lerner] in one of the most depressing ceremonies ever witnessed. It cast me down for 2 days. It's dreadful to think how bovine most of the world's inhabitants are.

Mrs. Ewing sent me some unique pictures of Danny. He has such pathos. But Calif. takes some of the delicacy from his face. You can see the beginnings of flavorlessness. I must get him East somehow.

I'm finishing up another review for the Nation [*The Mind's Geography* by George Zabriskie & *The Poem of Bunker Hill* by Harry Brown]. After that I'm through with contemporary poetry. But through. I hate the writing about it. Nothing later than Oscar Wilde from now on. It's such an ungrateful task.

———Clem

P.S. Mrs. Ewing's address is c/o Cobb, 1715 Waverley Street, Palo Alto. [Toady is now in Gulfport, Mississippi, working in a hospital.]

1942

1/5/42

Dear Harold,

Why haven't you written? Are you going to do the books I sent you? Margaret told me she returned your Lin Yutang review for rewriting. Did that upset you? It shouldn't. She does write the most tactlessly worded notes. I've seen Margaret twice since she's been sick, and she seems to be getting along all right. The trouble is she's so god-awful lonely. There doesn't seem to be anyone around near enough to be consoling & warm.

I met Judy [Margaret's daughter] who turned out to be the awfullest brat ever. It was all I could do to keep Jeanie from slapping her. But really, Judy is fearful, horrible. And some of it is Margaret in her. For example, Jeanie's Tony has gone over big with both of them. Such taste.

I hate Jeanie's friends, but still love her. In the month or so since you were here I've been at work whipping her into shape, which I hope holds. The point is to convince her I'm boss. I do that by walking out on her every time I'm annoyed; and then she's forced to come around or telephone in contrition. It sounds awful, I know, but it's best for both concerned. Her queens are to be treated lightly—for her own sake as well as mine—but I'm to be taken as the most important thing of all.

I met George Barker by his request at Margaret's, and he was the nicest English poet yet, full of charm, impulse, insincerity, pose and good spirits. He confessed he was utterly stupid on the way home. And not a queen, thank god—or if one, only to be agreeable. Also, very acute in the way you are.

Mrs. Ewing writes letters full of lamentation over "air raids" in Cal. I'm thinking of settling her & Danny in Bklyn near the family. It'll cost me lots of money probably.

WRITE

——Clem

P.S. I've just got a letter from Mrs. Ewing, saying she's put Danny into a military academy at half-tuition. The Commander, a Kelly, is "interested in children of divorced parents." I'm upset, as you can imagine, just having written her that I couldn't bear to have Danny in a military school. Anyhow I am going to do something somehow. I can imagine nothing more awful than a Californian military academy—nothing. And assuming that the kid is anything like me, he must be utterly miserable. Will you write too, saying without any digressions the same thing? She must be shamed out of the business. And if she throws up her hands, I'll take the kid.

Jeanie, incidentally, feels even worse about it than I, and has been on my neck all day to bring him East. The idea of a Palo Alto military academy has such horror in it. She wants to help me with him, but I don't know how she can. Anyhow I'm trying to persuade the old lady to come & live with me or else to send Danny to an Eastern school, my father helping financially.

Thanks for what you said about my review [*What Are Years?* by Marianne Moore and *Selected Poems* by George Barker, *The Nation*]. But you were unduly silly and irresponsible about the underground tradition. It certainly is there, and its poets were certainly plebeians. Or do you take plebeian in any but its literal sense? And as for late Anglo–Saxon verse, I mean the dreams, visions & gnomic sayings. What I didn't like about your short-handedness was its flavor of the Kenyon Review & lively academicism. You know what I meant, & you should be ashamed.

Dear Harold,

Your Lin Yutang review was wonderful; some of the things you say have never been said before. But it was 2 paragraphs too long, and in them you repeated yourself and used too many phrases in apposition. Not that it was all such a blemish, not by any means—but it was a tone you didn't want, but couldn't recognize in yourself. It's finality one wants, and one misses it by writing one sentence too much.

We're all happy about your new glasses. Jeanie is quietly proud of herself.

I'm overloaded with work, finishing the Kafka translation [*Josephine, the Songstress: Or, the Mice Nation,* for *Partisan Review*], reviewing three art books for Partisan [*Vlaminck* by Klaus G. Perls; *Paul Klee* edited by Karl Nierendorf; *They Taught Themselves* by Sidney Janis], and now with the latest "New Directions," 700 pages strong, to review for the New Republic.

I haven't heard from Palo Alto in 2 weeks. Mrs. Ewing is having her bluff called and is, I am sure, in a quandary.

There's a rain and wind storm outside, but it doesn't make any difference. Jeanie was awakened by it during the night and frightened. She wanted me to get up, she said, but it simply made me sleep better. Jeanie thinks it's "bogus" romantic to enjoy storms.

The war is getting more awful momently. A curious sort of oppressiveness has settled down. One night a week it bothers me. My faith in the revolution does no good, since it depends strangely on my faith in myself.

I bought a Dryden & a Pope with your birthday money. Pope is more fun than I expect; having read enough of him heretofore, he gets better & better. I just like language used well, and he raises the good use of language per se to poetry.

I'm surrounded by literary people, mostly poets. They ring my bell every night. All except Oscar Williams are careerists.

——*Clem*

Jeanie is well, but a little fat. I'm well, but tired.

Dear Harold,

Please don't think me presumptuous in suggesting these large cuts and small changes. I like the review very much [*The Real Life of Sebastian*

Knight by Vladimir Nabokov, *The Wisdom of the Heart* by Henry Miller, *The Wife of Martin Guerre* by Janet Lewis, *Partisan Review*], it being full of the truths I value, but you proliferate too much in the actual writing. It comes of finishing it late at night & sending it off without another look. Your pace is like a continual expulsion of breath, which comes of not letting the prose cook a while.

Please, Harold, do agree. The only criticism I have, aside from proliferation, is it adheres too much to effects in the critic rather than causes in the book. You know what I mean.

Mrs. Ewing writes that she can't make up her mind to come East. In other words, no. The arrangement with Danny in school is too comfortable. I don't blame her, really. And I expected this when it came to a show-down.

Marty wants to know if you'll lend him your pamphlet of German idioms. His address is now 14th Training Regiment, Camp Robinson, Arkansas.

I told Margaret how much I liked your review. Don't tell her I asked you to cut it, just as a matter of sagacity. I spoke straight out on the Lin Yutang review. I wasn't too easy. I'd expect you not to be to me, so why should I be to you?

I've been feeling rather well lately, have finished the Jeffers for the Nation [*Be Angry at the Sun and Other Poems*] and persuaded Margaret to let me do a paragraph on art shows every other week. A short paragraph, but something—which is just the way I want to do it.

The Partisan and reading other people's manuscripts still takes up too much of my time. I have actually come to shudder at the look of a type-written page.

Jeanie is trying to do without alcohol, which is very difficult. She sends her love.

The Customs office is driving me neurotic. I have no energy left.

I'm reading the Goncourts' journal with lots of pleasure.

And I'm thinking seriously of doing a book or books on landscape in our art & poetry. It would require a tremendous amount of research.

——*Clem*

3–2–42

Dear Harold,

I'm sorry that the affair of the review has gone sour for you, but not indulgent. Why shouldn't any piece of earnest writing go through a sourness? Shall I tell you of my experiences with Partisan?

As to making the review easy to read. That's where all the evil commences. This business of making easy. Isn't most of the stuff around easy to read? Aren't the Nation & New Republic easy to read? Where are these tight little pieces? I'm grateful for them, because they justify their space. Oh, it's this awful easiness that ruins everything. I wish you were here, so that I could explain to you how the "easiness" of your review was excess, not ease, but proliferation and no easier to read. Over-writing, I would say to be more precise. Anyhow I could almost be angry with you. But enough.

Mrs. Ewing is in a state of lamentable indecision. She's now returning to Carmel because her tenant is leaving—and she's taking Danny with her, not for his own good, as she says, but because she'll miss him. So I will try to persuade her harder than ever to come here.

Doing art reviews for the Nation gives me more satisfaction than any amount of previous reviewing. I've already written three, on André Masson, Darrel Austin and [unpublished] Walter Quirt. Margaret thinks they're very good, surprisingly.

You—if you're not a critic, why the hell don't you write something else then? How long do I have to plead with you? Don't you realize how much fun it would be for your friends if you turned out something that was exactly what you wanted to do, whether perfect or not? Some direct expression of yourself, I mean, such as is impossible in criticism. I'm tired.

Jeanie & I had dinner at Margaret's last night. Then we went to the movies and afterwards sat in a bar until 1:30, having a very good time. Margaret's more cheerful. We talked and bit people's backs, especially Mary McCarthy's, whom Margaret dislikes more actively than anyone else on earth, I suppose.

Jeanie's going on a fruit juice & soup diet for 3 days, to much clamor and groans. All N.Y. is going to shake with it. I should go on a diet myself, as I'm getting fatter. It's this delightful business of having meals at home. Yesterday—Sunday—we got up at one; Jeanie cooked a big breakfast, and I didn't bathe or dress until 5. It's ruinous.

Tony has gone back into the army, very miserably, and Johnny is leaving for Calif. Wednesday, to clear the atmosphere. Tony was in an objective way getting me down. Now there's another of Jeanie's pansies here: Dwight Ripley, a millionaire and rather masculine. He goes for heterosexual middle-aged men and thinks I'm the most attractive thing on earth. He's always pinching or patting my ass. Anyhow he takes us out and pays for everything, and he's not a bore, and his pal, Rupert Barnaby, a gentle blond-haired queen, is the nicest and most sensitive yet of Jeanie's flower garden.

They are both botanists and English, and Dwight is in addition a philologist, expert in the Latin languages and Russian. Something new. Especially with so much money.

It's 5 o'clock. Write soon. Jeanie sends her love.

———Clem

4–23–42

Dear Harold—

Forgive, and I wasn't fit to write, having forgotten your birthday until a week after, and since then being undecided as to what yr present shd be. But mostly, it's that the world is too much with me. Jeanie & I hardly ever have a moment alone, people come over every night. And all I do is write book & art reviews, because of which I am disquieted. I should be sinking myself into some purpose separate from myself.

Tuesday I was interviewed by a special Customs agent anent my trip to Europe & my writing. It is feared I'm an agent of the Comintern. But I'm hardly worried, even though I do feel that they're actually out to get me.

I've made what for me is a tremendous Discovery—that the good in art & literature is the result of virtue somewhere in the creator. The Rousseau show awoke me to that. The good effect, that is, is the function of a moral quality, compounded of desire, worthy ambition and insatiability. Insatiability also characterizes the greatest sins. Everybody is insatiable, only in different places. The trouble with H. Rosenberg, for instance, is misplaced insatiability.

Incidentally, he sent Partisan a poison-pen missive attacking me, which we are printing with a reply from myself. He accuses me of referring to myself 10 times in my art-book review, and therefore being a greater egotist than the egotistic poetry I denounced in my poetry piece. My answer is that Rosenberg seems to read my stuff rather closely. Faugh, he's disgusting.

Jeanie has practically moved in with me now, and cooks dinner most evenings, but I eat too much.

Danny writes floods of letters. He has a crush on correspondence for the moment.

The draft hasn't come near me yet. I don't think it will until some provision is made for supporting dependents.

I think you're wrong about Oscar Williams' poetry. That second one ["The Mirage"] I think more & more is a wonderful poem. It's strange though how so many people take an antipathy to his stuff—violent antipa-

thy. Just consider again. Find the subject in each poem, for there is one; &
Williams writes, despite appearances to the contrary, towards a subject, his
eye always on it.

George Barker has handed us a long poem, which my fellow editors
don't really like & don't want to print because of its soft spots and length.
Re-reading it several times, it gets better & better and the soft spots harden.
Now I shall have to fight like hell for it. Barker himself is a cockney rascal,
utterly selfish & full of disingenuous charm & the last thing from a bore.
He's fun to talk to. He was over last night and wd have stayed until dawn if
I hadn't chased him out much against my will by emphatic hints. Get hold
of Calamiterror & read it—it's a book he put out 5 years ago.

If I lose my job, I don't really know what I'll do. Reviewing for the Na-
tion & New Republic certainly won't support me. What I might be able to
do is get an advance from a publisher on a book. And I do want to write a
book on landscape in painting, poetry & everywhere else.

I've read the New Testament and St. Augustine's Confessions lately
with a lot of edification. The New Testament is an eye-opener. And read "La
Princesse de Clèves" [Mme. de La Fayette, 1678]. It's remarkable.

What do you want particularly for your birthday? If you don't know
I'll get you a picture, I think.

Clem

8–10–42

Dear Harold,

Of course you can do a piece on [Constance Mayfield] Rourke. The book
[*The Roots of American Culture*] is being sent you.

I was disappointed that you didn't call me on your way back to Wash.,
but I could guess why. It's true, I'm getting sourer & more crustacean—but
you yourself are being confirmed in all your mannerisms.

A terrible blow—nothing else: Mrs. Ewing had written me she was
going to live with Toady in Gulfport, and I finally persuaded her to stop in
NY on her way. She was vague as to just when she would leave, having
been sick, and I assumed it would not be for at least 2 weeks. Last Friday I
went off to Jeanie's place in the country [Snedens Landing] for a week's
vacation. Getting back last night, I found a letter from Mrs. Ewing saying
she had wired me that she would arrive in NY on the 10th—today—but
that the telegram had been returned to her because I was away on vaca-

tion. Without doing anything further she changed her plans, and went straight on to Gulfport. It's a little object lesson as to how Mrs. Ewing raised & spoiled Toady. The old woman is so profoundly stupid in places. She could so easily have telegraphed my father, who knew where I was, which was only 15 miles from NY.

I enjoyed my vacation, but not as much as I ought to have. Jeanie's got this big country house, full of expected & unexpected charms, and 2 ex-lesbians and her very attractive & pleasant younger sister [Annie Bakewell] are staying with her. That was all to the good, but there were too many people about too long a time, and I couldn't stay in bed as long as I wanted to, and I couldn't do any work. But I did paint 2 landscapes, which aren't bad, and a very faithful portrait of Jeanie.

The draft is getting closer to me. I got my second questionnaire 2 weeks ago. All I could say was that Danny is dependent upon me.

Partisan Review stinks slightly, so do I.

The war is turning sour. Three years of it, and so little to have happened. The deepest boredom, which we all feel.

My job is becoming intolerable, more so than ever.

All this doesn't mean I'm unhappy, but I might just as well be. It's the feeling that I'm at the mercy of the army, the Customs Service and my own resigning body. And also of Mrs. Ewing. (Taking Danny back to his mother is the worst thing short of sickness that could happen to him.)

I agree with what you say about Spender. Consider him a little bit in his historical—poetic, politic & social—context. Like Shelley, he's one who in a more settled period would have been an out & out aesthete. Also, like Shelley, he treats his lovers, men & women, very well and very badly.

Clem

8–31–42

Dear Harold,

You are so right about Mrs. Ewing. Arriving at Gulfport, she found Toady as bad as ever, and was on the point of coming to N.Y. when she thought suddenly that since I might be drafted within the next 6 months, that was no use either—not at all realizing that if she & Danny came to live with me it wd. probably save me from the draft another 6 months. How she clings to her misery & error. What worries me is that it's liable to have the same effect on Danny as it had on Toady.

Because I've been feeling so poorly the last year or so, I went to a specialist, who examined me and said there was nothing wrong aside from the

fact that I'm nervous, harassed and dissatisfied. He recommended changing my job or taking a month's rest. Although I can do neither, I felt better for the advice. It's flattering to be told you are overworked.

Two weeks ago, at Jeanie's country place, in front of Margaret & other people, Jeanie & I had a slap, scratch and wrench fight. We were both slightly drunk, but I stayed angry for a week. It was an interesting interlude. And for someone like Jeanie who lives so utterly in the present a quarrel is a good thing occasionally. It makes them review & - anticipate.

One of the great evils of American culture and of intellectual life in general in this country is that no one has a conception of the human being. Rosenberg & Abel are excessive cases of a general malady. They look for the complicated in the wrong direction. Oh God, I'm sick of their kind, sick of Partisan Review, sick of propositions, sick of the impersonal masculine, sick of careers. It's the impersonal that kills me.

How are you making out about that job with the WPA art survey?

———*Clem*

Penny postcard
10–13–42
Dear Harold,

Being in no mood to write anything but a perfunctory letter, I haven't written. But, literally, my thoughts are with you. I had the grippe 3 weeks ago, & the doctor said I also had a gall-bladder condition. Since that is as due to nerves as to anything else, I decided to quit my job, with as yet no prospects beyond a part time job with Dial Press, which is tolerable now that Burt Hoffman's in the army. But in a way I don't give a damn. I was too fed up, utterly, utterly, at the Appraisers'. I'm glad you liked my art piece. ——*Clem*

10–27–42

Dear Harold,

I hope the hell you do quit the V.A. The situation here is still a bit unclarified. The girls [Jeanie and her sister, Annie] have just gotten their

new apartment and will go to Baltimore next week to get Annie's furniture out of storage.

I still haven't found a job, but am managing to make some money through Dial. And of course, there's always the Nation & Partisan to come through with a few bits, though for the amount of work one does Dial pays ten times as much.

Jeanie, I now realize, always says "my dear." You shouldn't mind so. It's part of the Vita Nuova, her and Annie's hazy dazy era, which I hope will last forever.

I'm glad you liked the Seghers' piece [*The Seventh Cross, The Nation*]. What was wrong with the last paragraph?

I'm reading Spender's poems with more interest and emotion than ever I expected in the case of someone I've never laid eyes on. I may have objected to things in your review, but I laughed at nothing. Don't be silly.

———Clem

Clem writes on *Partisan Review* stationery: 45 Astor Place.

11–17–42

Dear Harold,

Your new job at the WPA sounds like the best thing that's ever happened to you. It cheers me, personally, up, and makes me more optimistic about the world in general.

I'm making money too, in a fairly pleasant way, but not as much as you, and it's quite uncertain. And I do need a little more money for Danny.

I'm glad you liked the art pieces. A line was chopped from the Tchelitchew brief [reviews of Pavel Tchelitchew, John Flannagan, and Peggy Bacon, *The Nation*] but it didn't much matter.

Margaret just called me up about your Spender review, in which she says some of the writing is a "little involved." So I'm to consult with her. If any changes are made, believe me that your best interests will be kept in front.

The girls have just moved into their new ap't. which lacks furniture, but is, from the outside, the most beautiful little house in N.Y.

Listen, do you remember that translation of Brecht's "Apfelböck" you once made? Can you find it? And can you get your "Mahagonny" in shape

to be seen? Klaus Mann is publishing an anthology of European literature between 1918 and 39, in which he's using my [Kafka's] "Josephine," and he also wants to use, specifically, "Apfelböck" and "Legende vom toten Soldaten," which last I'd already half translated two years ago. I've mentioned your translations to him, and he wants to see. Please don't let me down, but do it. That is, find the translations.

I heard your voice over the phone, but didn't say anything for fear you'd be charged.

I don't know of any French material on the desert, but why don't you look under "French colonies"? Also the German Burckhardt who explored Arabia; also Wilfrid Scawen Blunt, I think, and Gertrude Bell. And there is, besides, the German traveller in Arabia, Barthold Niebuhr.

Come to N.Y. You can stay at my place.

——*Clem*

DECEMBER 16, 1942

Dear Harold,

Sorry not to have written. I'm in 1A now, having received a physical examination 2 weeks ago, which disclosed that I have a severely deviated septum and a throat inflammation, but neither of the nature to definitely keep me out of the army. Somehow or other I'm not worrying about it very much—yet. Of course I'm afraid of active service, but it seems, for paucity of my imagination, very remote.

Mrs. Ewing writes that Danny gets A+ in everything at school except arithmetic in which he only receives C+. In his drawings he works under a compulsion to fill every blank sheet of paper, just like I used to do. She writes sillily that she'd just about given me up for lost, simply because she hadn't heard from me for 3 weeks. She doesn't trust my love of Danny. I do.

Margaret is well, but still nowhere near happy. Jeanie is harassed and busy furnishing her new place—much too busy. Sol is finally 4-J and will never see service. [Sol had polio as a child which impaired the use of his right arm.] Marty is still where he was & seems permanent.

I'm making little money in driblets. But the draft business keeps me too suspended to worry about that. How's your job now?

I want to start a book but never get around to it. My life is altogether too unsettled even without the threat of the army. Eventually, I must get out of Greenwich Village, and live in the same house I eat in.

What did you think of my Spender piece on "Ruins and Visions" [*Partisan Review*]? A little too superficial, no? It couldn't be helped.

Write soon. Keep healthy.

———Clem

P.S. I'm not worrying too much about the draft. They may find I have chronic trench mouth. If you hear of any sort of job that carries a deferment with it let me know.

1943

JANUARY 7, 1943

Dear Harold,

Naturally, one owes it to oneself to worry, but there isnt a chance that the army will take you. They're simply going through with the routine of giving the army doctors a glance at everyone with four limbs, not-blind eyes and without TB who was turned down by the draft board people. I know someone with coronary thrombosis sticking out all over him who was sent up for induction only to be turned down with hoots and pity. You have your sinus, your nose, your weight and your nerves—don't try to make the psychiatrist think you're normal; here in NY they're leery of intellectuals on principle. I only have my 100% deviated septum and chronic inflammation of the left side of my throat, all of which was noted on my papers, lord knows to what end. Anyhow he was concerned by my not being able to breathe through either nostril, and the only others whose papers were noted were hernia cases. The septum lets me out of the navy and air corps, but does it make me an actuarial risk in general? That's what they really seem to be worrying about.

The government wants people who can read German, Italian and Portuguese and translate them into good English. It's required only that you be draft-deferred and not in essential war work. Fill out the enclosed and mail it with a letter saying you passed a translator's exam to the US Civil Service Commission. It begins at $1800, and is in NY. I went over and found out everything. You wont be given an exam, and they'll probably be ready to hire you by the time the army has definitely said you are 4F. It's a New York job, do you understand?

Jeanie and I are thinking of going to Pass Christian some time next week. If so, we'll stop in Wash. probably on the way back. I figure it will take us about 2 weeks. The draft board gave me a month's deferment just for that, after turning down my appeal against my classification.

Margaret says your Spender piece is OK now and will shortly appear. I'm getting a little stale on my art pieces, and people are beginning to like them more, naturally. Oh America! But I did what I think is a good piece on a book of William Steig's drawings.

I'm very hard-up for money and being partly supported by Jeanie. Dial Press is a poop-out. I'm not fit for the commercial world, and cant stand awful people. And what a state I'm in not knowing whether I'll be in the army or not next month and feeling that I most likely will be, and having so many things on my mind anent writing which are all to be made so ir-relevant.

Jeanie and Annie send their love. Margaret had the jitters yesterday but is all right today.

<div align="right">

Clem

</div>

13

DRAFTED

*"Under all is the solicitude that I come out of this historical
period at least alive and capable of suffering and enjoying
the next episode."*

Clem is in the Army Air Force. His return address reads: Pvt. C.G., 1131 T.S.S., B.T.C.
9, Flight 515, Miami Beach, Florida. Harold has quit his job with the WPA and re-
turned to his family in Syracuse.

<div align="right">2–22–43</div>

Dear Harold,

Your letter was an encouragement. I don't want to hear anything about
myself. My personal bad luck depresses me too much.

I'm taking the army as well as most do, as much as my spirit rears and
bucks. One can come to a kind of agreement with it, chiefly by allowing
yourself to be changed inside & out. I am, amazingly so; tougher coarser,
more callous, more indifferent, insensitive & casual. Of course it's awful.
Words cannot say the miseries of the first week. But then you adjust, liter-
ally that. The conventions change, & you learn to be as happy & sad within
them, that is, in the same proportions if not with the same quality as before.
There are usually two or three moments a week when you feel you can't go
on another second, but you do. After all nothing is required of you, no chal-
lenge is made—just submit & do what the others do & try to get away with
as much but not more than possible.

I'm living in a hotel room with 5 other people. I have one drawer & my
barracks bags for my belongings. The others are tolerable, nice enough, but no
more than that. I would prefer a barracks. A bathroom shared by 6 is much
more inconvenient than a latrine shared by 100. Miami itself is just what you
expect it to be, only more so. Modernistic glamor-kitsch. White cakes of ho-

tels, in one of which I live, along the beach front. Tousled sky lines of palms, etc. It's what Calif. tries to be. The people almost as flavorless, but not quite. There's a remnant of some century-old tropical American tradition. White wooden houses one & two stories high in the middle of flat palm groves.

I see some of the family friends here, which I find a relief & a bore, but for which the other soldiers envy me. I miss Jeanie enormously. She is wonderful. I discovered that after about 5 months' acquaintance. Some people discover it in 2 weeks. She wrote that she got a letter from you which she doesn't know how to answer. I hope you weren't clever.

I get up at 4:45, have breakfast at 5, come back to clean & shave & dust & sweep until 7, then drill & exercise strenuously, after a 1 1/2 mile march to a park, until 11:30, lunch at 11:45, then at 1:30 back to drilling, exercising, etc. until 5:30, then dinner & freedom—unless we are restricted to quarters, as we are once or twice a week. Lights go out at 9, & we have to be in by 10 on weekdays and 11 on Saturday. I endure it, I think or hope. We're crowding 13 weeks of basic training into 3. I qualified for the administrative & technical school—both of which are near Denver—and may be shipped out before my 3 weeks are up. Meanwhile I'm trying to get Jeanie to come down & stay here a while with Annie.

The Air Corps goes in for singing in formation, & the songs are one [of] the chief afflictions. The refrain of the Air Corps song is:

"We live in fame, go down in flame,
Nothing can stop the Army Air Corps!"

It was cool when I arrived on Saturday, the 13th, but summery cool. Now it's hot & almost sweltering. I sweat gallons on the drill field.

The army is more leery of mental cases than of anything else, & if you give them a history of a nervous breakdown, that coupled with your general appearance of fragility, would be enough to dissuade them, I think. Get in touch with some doctor who you could persuade to corroborate your story. Or go to a psychiatrist in N.Y. & tell him how unfitted you are for the army & ask him to confirm a psychosis for you. How about Margaret's psychoanalyst?

My languages have made no impression as yet upon the personnel authorities, and I really never expected them to be impressed. They're not efficient enough for that. It's all luck. They tried to qualify me for duty in the air, because I have—in their opinion—perfect eyesight and acceptable teeth, but I foxed them by inventing a bad medical past, so I was thrown out of the physical examination. Such are the dangers you get exposed to. They'll put

anyone under 36 and 180 lbs in an airplane if he has no obvious physical defects or maladies. Apparently not enough people volunteer.

Most of the fellows in my flight are between 18 and 26. I'm the second oldest. The oldest is a genial person named Pat Murphy, who served 6 years in Elmira for holding somebody up. Most of the boys are Italian & Jews from the East Side.

As I was in the train waiting to leave Fort Dix I saw Selden Rodman, Nancy Macdonald's brother, get off another train with newly inducted men. What was remarkable about that was that after 3 days at Dix I couldn't conceive of any but proletariat being drafted, & it was quite a shock.

Marty is applying to the Japanese language school at Ann Arbor, to which only Phi Betas or people with 6 months of Japanese are eligible. They are also starting Russian & Chinese language schools, I hear, both of which I'd prefer to Japanese.

Meanwhile I'm always physically tired, sleep well and dream a lot, which I haven't done for years. The food also is quite good & better cooked than at the homes of some of the people I've been visiting. Only we have to eat it in mess kits. And we have to clean them—as well as polish our shoes, identification tags, buckles & what not. The hair cut I got last week has finally revealed the true state of baldness I'm in.

Under all is the solicitude that I come out of this historical period at least alive and capable of suffering and enjoying the next episode.

Write, with lots of news.

———*Clem*

P.S. I just got your letter mailed on the 18th. My advice is much too behind hand. By this time you know your fate. I still don't think they'll take you. Or if they do they'll send you home after 2 weeks, as run-down & asthmatic. Though you might surprise yourself by thriving & surviving.

I've decided not to let Jeanie come down here until I know more definitely what's going to happen to me. If I get sent to a school I'll want her to join me there.

3–10–43

Dear Harold,

I've been in the hospital for 2 days with an attack of aspirin allergy. I had reported sick with a sore throat & told the doctor I was allergic to aspirin—which is the army's panacea—and he had prescribed APC capsules,

either because he thought I was lying or because he didn't know that they are very similar to aspirin. Anyhow I had the worst attack I've ever had. They took me to the hospital in an ambulance. My face was 3 times its normal size, I could hardly breathe & I itched and burnt all over. To my surprise, people laying eyes on me for the first time, assumed that my appearance was normal, but they happened to be very stupid people. Here in the hospital I'm quite comfortable & being treated well. I've been in since yesterday at 3, & shall probably be released tomorrow, although the medical captain may have me stay longer.

I'm to be shipped to a school some time within the next 6 or 7 days, just when and where I don't know.

I expected you to beat the draft but am nevertheless very happy about it. All your qualms about your conduct therein are so much self-indulgence. One is justified in going to greater lengths to escape the army than to escape death. You're like Auden, who as soon as he was rejected proceeded to dramatize himself in a self-flagellatory manner as a homosexual parasite, incapable of propagating himself, and so ordained to be offered up in war, yet profiting by the injustice & inequity of the fact that homosexuality is not accepted by the army.

Of course, after 2 weeks of the army most people end up by thinking they like it, simply because they've found it endurable & because the first 2 weeks are over. You suddenly find in yourself a capacity to make so much of small pleasures that life after 5:30 P.M. becomes a little carnival. Walking the street, buying a newspaper, loitering, drinking, eating off a plate become pure delights.

I seem to be bearing up well but you never can tell. I may break down all of a sudden. I hope I do. A rather simple, handsome kid of 21, as normal as one can be, working with me on K.P., said, when I warned him about the possibility of a crate dropping on his foot, "I wish to hell it would." That's the way we are. He's been in the army 4 months. Sometimes, crossing the street, I half hope an auto would run me down.

—Clem

3–25–43

Dear Harold,

I can't tell you what army life is like, beyond that it is a puerility and that one relapses to adolescence, animality and indignity, without suffering much from it.

All sorts of things have been about to happen. I asked to be reclassi-fied, and the lieutenant in charge assigned me to a language job here in Miami, only to have that turned down by a major on the ground that there were already too many men here doing that sort of work. Tuesday I was forwarded a wire from home asking me if I was available for a $3800 job as civilian editor with the Signal Corps, the sort of thing that would have saved me from the draft had it only come 6 weeks ago. I wired back asking them to request my transfer to the Signal Corps, and am now waiting to hear.

Meanwhile, I discovered, I had been due to be shipped to a clerical school at Fort Collins in Greeley, Colorado, 70 miles north of Denver, the day after I went to the hospital. My name, through some error, was not scratched from the list, and all my records were sent there. It will take months to get them back, and in the interim I can not get paid and shall have to stay here, drilling and pushing brooms.

Without losing weight I've become thinner & harder. I surprise myself in the mirror.

Sure, I want the shower slippers. Thanks.

Jeanie is coming down within a week, I hope.

I envy you your "Syracuse 1929," and the leisure you have to enjoy it in.

I've finished my basic training, been inspected by the colonel comman-der for my appearance, and had my name posted on the bulletin board, all of which means absolutely nothing.

Oops—I've just got word through secret channels that I'm being placed on shipment tomorrow, which does not mean necessarily that I'll be sent out the same day, but that I will go within 2 or 3. I'm sure it has nothing to do with the Signal Corps business, but that I'm on my way to Colorado. As little as I like Miami I still don't want to be rushed off in the middle of my uncertainty, and complicate the possibility of getting shifted to the Signal Corps.

Have I told you what Miami is like? The colors of the sky & foliage are more like a postcard than a postcard is. Miami Beach as distinct from Miami is a man-made sandspit, and everything about it is unreal and marvellous.

Regards to your family.

——Clem

Clem, now a PFC, has been sent to Section 6, Flight "E," Tishomingo, Oklahoma.

<div style="text-align: right;">4–4–43</div>

Dear Harold,

I'm in south central Oklahoma, at a swell junior (!) agricultural college 1/2 mi. from the 2000 town of Tishomingo. The remoteness is almost absolute, but the regime is worlds easier than at Miami. There are 400 of us here, all studying to be clerks, 1/2 from 6 to 2, 1/2 from 2 to 10, 8 hrs a day & 2 hrs of drill, calisthenics and obstacle-course & cross-country running. We're in [the] charge of two 1st lieuts, and a warrant officer, and because of the shortage of bosses are left pretty much to our own devices. We learn "engineering & operations" form-filling, military organization & correspondence and typing, for which I'm grateful. I'm on the early shift this month & like it. After 2 months we'll be sent to various air bases or overseas.

I live in a dormitory room with 2 other fellows, as compared to 6 in a hotel room at Miami. I'm now a private 1st class, which means only that I get $4 a month more.

This used to be Indian Territory, and Tishomingo was the capital of the Chickasaw nation and is named after a chief who died here. There are still plenty of Indians to be seen walking around.

The wire offering me the Signal Corps job stated that it was for "war service," which means a deferrable job. When I left the Customs I had my name put on the reinstatement list as an editor, for which my record qualified me, & I suppose that led to the offer. I had stated I wouldn't take less than $3000 a year. I doubt whether the Signal Corps will do anything about that now. As you say, it's too logical.

Now that I'm sedentary again I've managed to verknüpfen Beziehungen again, and have done some more on my Stefan George review. There's a small but fair library at the college, and the atmosphere suits me.

I want Margaret to send some easy books to review; George requires too much final summation, and that's hard work. I'd prefer some perfunctory non-fiction in my present plight.

I'm writing this stripped to the waist on a bare bluff above what I call Stink Creek. It's hotter here than at Miami but dryer & much windier. It's poor withered dusty country but somehow not unpleasant, and the town itself as small as it is is not provincial. You have a feeling of access to the rest of the world, something you never have in a small town in the east.

My fellow soldiers here are not as original or entertaining as the Wops & Polacks & Jews in my original flight. I'm fast friends now with an Englishman

out of Oxford and a 20 yr old pansy who doesn't seem to know he's one but is utterly effeminate, and a boring rich Rothschild from St. Louis. They are all quite boring and I'm not sure I've chosen well, but at least they appreciate me.

I don't write to Mrs. Ewing any more so have heard nothing of Danny. I wrote to Toady to ask & get his birth certificate, so that I can prove his filiality. She sent the certificate but did not write. I have a feeling of distaste for mother & daughter & am actually less concerned about Danny than I was. He doesn't need me & is much more well adjusted than the old lady ever gave me to understand. So now I'm a bad father. I want to see him & have him but no longer long for him to the extent that I gobble up everything I hear about him.

Write immediately. The shower slippers are not so important.

——Clem

Job hunting. Harold is temporarily staying at the Hotel Emerson. 166 W. 75th Street in New York.

4–15–42

Dear Harold,

The day before your letter came, that is, day before yesterday, I received $5 from you, I don't know why, but it came timely because I was down to 75 cents. I had asked Jeanie to send me 5 and I suppose she told you. I'll pay you back when the army pays me which will be on the 30th. I'll have been in the army 3 months by then and have only got $10 from them so far.

Meanwhile there's nothing to look forward to. Jeanie can't come out here because her mother's coming east, as you know, and she owes Annie $400. After I get through here I'll be sent either to an air base or to a staging grounds where they'll get me ready for overseas duty—and there's quite a chance of the last, there being such a shortage of clerks abroad. Everybody in the Air Forces, including the intellectuals, wants to become a mechanic.

———————

Later——

I just got your second letter. I've taken out $5000 worth of insurance, but I still don't think it would be wonderful if I got killed and could leave it to Danny. He'll inherit his grandmother's money. You know, Harold dar-

ling, your one, and it's practically your only major defect, is silliness. Fortunately you never actualize it in anything but words; it flows from the really amiable over-readiness of your feelings. All this leads up to a quotation from your last letter: "Just think how wonderful it would be if you were killed and could leave Danny $10,000." Of course you didn't mean what the syntax actually says, but it was in the syntax that your silliness seized a quick chance to give a little flourish of itself. Or "it looks pretty hopeless, etc." of course you're being somewhat facetious, but it is the result of silliness, like your baby talk, that the facetiousness finds the wrong context. As usual, you ask too much of language.

As it happens, I'm not miserable, simply dissatisfied and uncertain. I'm not in as great danger as the younger men of being sent overseas, but there is some danger. But even the eventuality of that is not as terrible to contemplate as it once was. After all I'll still be a clerk, unless a submarine gets me before I reach the scene of my clerkdom.

Don't worry about your classification. I have the impression that the army is not as indiscriminately avid as it was 2 or 3 months ago. There are too many breakdowns. The probable reason for the delay is the confusion in all draft boards at present. Your eyes and "slight neurosis" will never earn you more than 4F.

Thanks a lot for the slippers and the chess set, though I won't have much chance to use the last, having a neurosis about my spare time which leads me to read every possible moment. In any case I can always give it to Jeanie, who's passionate for chess but is always lo(o)sing her men. The slippers are exactly what I need and fit perfectly, although they are 8s and I wear 9 to 9 1/2 shoes. If you continue to feel giving you can send me a couple of cartons of Chesterfields, which cost 20 cents a package in this fucking state.

Jeanie writes that your letter was a great consolation to her. She had been just insulted at a party by one Christopher Lazare who's been trying for years to get Margaret to have him handle art reviews for her. He's a one-eyed, very witty and repulsive pansy. There was a brawl, one of Jeanie's girl friends slapped him, and a sailor knocked him down. I'm sure that on his part, as I've told Jeanie, it was rather impersonal. He was angry at the person who happened to be doing the art for the Nation. He called Jeanie a cunt, whore, etc., and Jeanie threatened to kick him in the balls if he didn't shut up. The next day he claimed that she actually had done so.

Jeanie's life is hectic now that I'm away. A month ago she had a rough and tumble fight with Allanah Harper in which she came out on top. But

they've become friends again. Jeanie's Art Notes I find disappointing, and I've intimated as much. They're too perfunctory. The Nation's literary section has been mediocre on the whole these past months, though I don't blame it so much on the Nation per se as the state of the times. Your review of the Monkey [by Wu Ch'eng-en], however, I liked a lot. You didn't press too hard.

You'll have to find the subject of your novel around you. You might take my affairs and some of me. Toady & Jeanie are both novelistic characters, and Toady's present lifelessness and utter boring emptiness inside are a challenge to your figurative ability. Have Danny in it too. But you ought to see him in his latest metamorphosis.

Jeanie will probably be in Snedens Landing when you get to NY. Call up Palisades, N.Y., and ask for Harold Guy's phone number. She'll invite you out.

School is boring, even though I'm slowly learning to touch type. I get over 90 in everything but that, and should get 100, but I always forget details. Oklahoma is full of wind, clear sun and extraordinarily vacant air. The trees are scant but not infrequent. They feather the land. I lead a healthy life.

Sam Mercer, the Anglo-American from Oxford, about 22, utterly English and out of the same class that populated Jeanie's world, had a nervous attack—trembles and weeping—and was taken to the hospital, from which he'll probably get a medical discharge. He hates it more than anyone I've met. Now I envy him. There's nobody left to talk to, although there are 2 people who are my fast friends & bore me to desperation. They're both 20. I find that between people my own age with tastes uncongenial and those younger but with congenial tastes I much prefer the former. I discover or rediscover that I find my natural self among masculine unintellectual people. It's not Hemingway sentimentality. It's a fact, as it was in the SAM house. But my most natural self is in bed with Jeanie and among women in general I know well enough not to have to be polite with.

I've just finished James's "The American," which is a curious book in relation to the times it was written in, aside from the fact that it contains everything James was ever to write about. But I think you've already told me that yourself. He is perfect reading for the army. I wish the college library had more of him. All the other stuff they have I've already read.

I must finish this, shine my shoes & go to bed. They wake us at ten to five, and it's all I can do to stay awake in class.

———Clem

Dear Harold,

Tishomingo is dreary and boring—chiefly, I've discovered, because it's in the Bible Belt and not so much because it's remote. The reason I'm so late in discovering this is that it's hard to find the cause of a vacuum.

My future is uncertain, very. Half of us are to go to an overseas replacement camp in Utah for 3 weeks of intensive conditioning before being sent abroad. Just which half will be determined by chance in the commanding officer's office. He actually draws lots to decide. Whether an exception will be made for those over and as close to 35 as I am, I don't know. The way I feel now in all my loneliness and ennui is that I'll be glad to go anywhere just to get out of here; but I hear the camp in Utah is even more abandoned, though I don't believe it. I know Utah and it's not piss-pious the way this part of Oklahoma is.

Please don't be telling Jeanie there's such a good chance of my being shipped abroad. You don't know any more than I do, and all I know is that there is some chance.

Tomorrow my section goes on the late shift, which means rising by 6:15 and going to classes from 2 until 10. I'll have much less time to myself, as there will be, for the first time, cleaning details and such. And instead of drilling & exercising after classes we'll have to do it four or five hours before.

Meanwhile I have an interior backache which has the doctor puzzled. Nothing to do with a muscle, it comes probably from some internal nerve. It doesn't worry but it does bother me.

I'm reading Anna Karenina with a great deal of pleasure. Tolstoy had every appetite one can have and with each one a qualm. High life really is high life when he writes about it, because it fascinates him by its supposed evil. I know just how he felt.

They've put 310 Germans captured on the N. African front into a prison camp a little over a mile up the road. They're all young, two are 15 and one 14, and most of them very well set up. I walked over last Sunday & watched them scampering around, playing at being nudists and seeming in general quite cheerful and at the same time somehow superior. There was nothing about them dejected or humble. They'd found a good spot and were biding their time until—as they said—the guards would hand their guns over to them. They're to be put to work cutting down the trees, the sites of which will be flooded by an artificial lake when a big dam is finished. When they get through with that they're going somewhere else.

I liked your review of [David] Greenhood's "The Hill" but thought the first sentence or two a little too rococo.

———*Clem*

Harold returns to Syracuse from New York.

5—14—43

Dear Harold,

You don't want a magazine job. You only think you do. You ought to know better.

Why is M in doubt as to whether she'll use my story ["Goose Step in Tishomingo," *The Nation*] which cost me 4 hours of effort?

I've gone to my last class. My section is putting on a show, for which I'm painting the mural sets, so I've been excused to do that. The classes themselves are pretty much a farce, which the officers realize. Only 2% of us are ever going to be Engineering & Operations clerks, and the training we now get in the classroom can be absorbed in much less time in an actual operations office. I leave here the 26th, where to I don't know.

I've not been to class since last Saturday. First it was to work on our "graduation" book, for which I did the Calendar of Events, finding in it a chance to vent myself on the army. Some of the stuff is actually in violation of the army regulations, but the Commanding Officer was too ashamed not to O.K. it, especially since I put in a dig at him. It gave me more satisfaction than anything I've done so far in the army.

Hearing that Melvin Lasky is still out of the army, I realize that I might still be out if only I could have done some fixing & squirming. But I didn't know how to go about it.

I've never been so bored in my life. The weeks I spent on the late shift— thank God that came last—were like living in Kafka's world. I hadn't time to defecate, really. And I was always so unutterably tired. Not that I'm less tired now, but at least I can lie down almost whenever I want to.

Meanwhile I'm trying to finish Anna Karenina and be by myself at least for 5 minutes during the day. My room is always thronged, either by the bon vivants or the intellectuals. I think a kind of nervous derangement can come of that. For the last two nights I've gone to bed slightly drunk.

I really am thinner, although I've gained weight since leaving Miami. But I'll never look like a soldier. When the Colonel commended me I had

been in a state of trance for over a month. Now I'm out of it.

I'm too sleepy to write any more. You write.

———Clem

Clem is now stationed at Kellogg Field, Battle Creek, Michigan.

6–19–43

Dear Harold,

I haven't written because my fate has been and still is so uncertain. On May 30th I was sent here with 24 others, at our own request, to what was presumably a permanent station at an air base. Arriving, we discovered that we were to be, and the 24 others were definitely, assigned to what are called "station complement squadrons," units of 109 men each, designed to operate enemy air fields upon their capture, and moving every few weeks to more recently taken ones. We were to be sent to a port of embarkation after only 30 days of training. Luckily—for the time being at least—I'd always been dissatisfied with my classification as a clerk and protested it as soon as I got here. The officers here seem to agree with me and say that they've sent a letter to headquarters on me and that I'm to be sent somewhere else on a more suitable assignment—which I'll only believe when I see it happen.

Meanwhile I'm unassigned and languish in what's called the Casual Detachment, where I live in exquisite discomfort, having had an infected heel, which is taking weeks to heal, and having lost one of my barracks bags. I limp around on one shoe & a slipper, and though my infected foot is well enough to be shod by now I have no shoe for it, all my shoes having been packed in the lost bag.

I sleep till 10 every morning and read novels from the camp library all day, being left strictly alone (1) because I'm a casual and (2) because I'm lame. The camp itself is new, and also neglected. Those who're competent to judge say it's the worst shithouse in the Air Forces, which I believe to be the truth. Discipline is lax, the training is aimless, the officers are raw & incompetent, and the men are a little frightened and very much dissatisfied because they're not to get furloughs before being shipped overseas.

There were days that I'll remember as the lowest in my existence. I wanted Jeanie to visit me but she's both too lazy and too harassed to. I'm

greatly disappointed in her. I should have expected that but her propinquity for 3 years had made her seem otherwise and I enjoyed believing otherwise. She's also short of money.

When & where I'm being shipped from here, I don't know and no one else seems to. The inefficiency and the ignorance are majestic and fantastic.

I agree with you about the George review [*Poems* by Stefan George, *The Nation*]. I revised it considerably in proof but, as also happened with the prison camp piece, the proof got back too late. "Rounded-ness" was exactly what I meant but not the right word.

Jeanie's Art Notes, I think, begin to be terrible. She has a sort of conceit about not trying hard with them.

Nobody I know has been drafted since I've been in the army. I begin to resent it.

——Clem

<div align="right">8–11–43</div>

Dear Harold,

A nervous breakdown's happened to me or something like it, which is why I haven't written in such a long time. I really haven't the strength to tell you about it but I think it was living in an enormous barracks for the first time that did me in. A week of the blackest depression, and then blooey, I shook and shouted & wanted to cry. So I got 5 days' special furlough and went to NY where instead of depression I had jitters. When I got back to base I had jitters & depression worse than ever so was sent to hospital for 6 days, from which I was discharged with diagnosis "maladjusted, slightly neurotic" and it was recommended that I be transferred immediately to some place where my qualifications could be properly used. So I came back to the base & shortly Jeanie came up on $100 borrowed from my Pa, and I kept on having jitters, and Jeanie couldn't stand Battle Creek & had no money left, so after 2 weeks she went back, suffering from nerves herself. I was put in a barracks all my myself and set to work writing the Air Base history, a seemingly difficult job which they think no one else can handle. I'm left to my own devices & can come & go as I please. But it's no good. I awake in the morning with nausea, having jitters at noon and only begin to feel normal towards evening. In between I have fits of despair & want to cry. I may go back to the hospital. I can't stand my fellow man in masses.

Anyhow I hate it all and see nothing within 200 miles worth going on living for. My solitude is some solace but it's by far from being enough. That's my mood. As for my nerves, I'm a mere spectator as far as they're concerned.

Clem

Dear Harold,

Anything said to a nervous case is beside the point. Change his life, like a revolution, that's the only thing.

Monday I was sent back to the hospital, where the chief psychiatrist told me contemptuously, more or less, that he was recommending my discharge, and sent me back to the air base. "You'll feel better out of the army," he said, as if he were telling me something utterly new. Now I'm waiting around, less despairing, but still as nervous. "You're not trying hard enough, Greenberg," the psychiatrist told me, his gimlet dead-brown eyes going through me as if I were made of isinglass. "Fuck you," I meant to say. "Try—for what?"

The reason I wasn't sent home immediately is that I'm not considered neuropathological, just "maladjusted." Nor am I neuropath, even though I shake like a leaf 2 hours a day. I'm simply the victim of moods, and though that's in the book of psychiatry the army pretends to ignore it, it's so rare and so easy to fake.

Actually, I was and am still the most unhappy creature at Kellogg Field, 700 strong. There's nothing within 200 miles that can induce me to go on living.

As to my discharge—I'm so skeptical about everything said to me in the army that I shan't believe it until I have it. They might—headquarters at Tampa might—shift me out of here before the discharge comes through & for all I know the Medical Corps may be helpless to do anything about it. You can imagine that all this doesn't make my state of mind any easier.

Meanwhile I'm holed up in a room all my own in the Casual Barracks still left utterly to myself—which is O.K. If only everything didn't revolt me so. I've gotten so I marvel how anyone can stand the army. I marvel that the authorities can't at one glance see that I can stand the army less than anyone. I marvel in spite of the fact that nothing about the army indicates that anyone in authority can see anything.

What is it? Sheer, sheer boredom, desolation, dreariness. Not the onerous duties but the onerous boredom, the lack of all rewards—for me. I don't like the movies any more, my fellow soldiers leave me indifferent when they don't actually offend me, Battle Creek is a hell hole of G.I. misery (there's Fort Custer, with 35,000 men, a mile away), whatever I look at insults my eyes, whatever I hear my ears: land mines going off, rifle & machine gun practice, airplane motors, radios. But I'd better stop before I throw myself into a mood.

Anyhow there's no reason, except the fact that I pretend to be a normal bourgeois, why I should stand all this. It was only a matter of time.

And you, you've been in Canada most of the summer? I'm disappointed that you don't seem to have written anything. You haven't got much time left, really.

——*Clem*

Harold is visiting a friend, Virginia Robison, in Pigeon Cove, Massachusetts.

AUG. 27, '43

Dear Harold,

Tuesday, the 24th, I went before a board of officers and on the recommendation of the chief psychiatrist was voted a discharge, which will take almost a month to effectuate. Meanwhile I live by myself in a staff room—which I'm sure I won't be allowed to enjoy much longer—and do nothing. It's a help but not enough of one. An utter emptiness stretches ahead of me and I have chronic anxiety. The diagnosis of my case is "adult maladjustment," a silly enough term which covers perhaps the private parts of my case only. There's something physical involved, I'm sure. I have low blood pressure but the army doctors don't bother to take it, and the psychiatrists deliver verdicts on the basis of 2-minute interviews. Anyhow my only cure seems to be removal from the army and, almost as much, the Middle West.

The Massachusetts coast sounds wonderful, and I long to see all the types I used to be so sick of. The horror of army life is told by among other things the swallowing up of even the types you find most repulsive. Everybody converges towards a single norm of behavior and from that norm proceeds to be a stinker or a nice guy. The impossible is done every day, alas.

I wonder whether I'll be able to write again. I've been trying to do a review for Margaret for months. My sentences are mushy.

Enclosed is a Danny drawing which I should have sent you weeks ago. It came, expressly for you, in the only letter I've received from Mrs. Ewing,

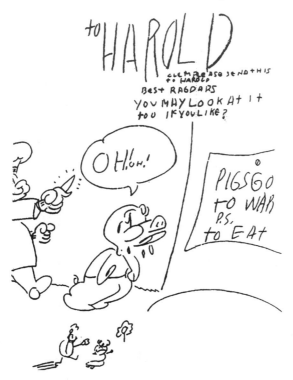

which she wrote to ask about Danny's allotments. I answered that I hadn't been paid for 3 months. Three weeks ago the Red Cross got in touch with me and showed me a letter from their Monterey office. Mrs. Ewing had gone to them and intimated I was trying to dodge my responsibilities. The Monterey letter had a paragraph about how wonderful Danny was and that if I could only see him I would be but too ready to assume responsibilities. Mrs. Ewing is beyond question a natural. She's vile as only aristocrats can be, with a vileness for which God doesn't forgive anyone. She belongs in the army. She expresses better than the army itself does the energetic, vigilant and solicitous stupidity that gets big things done in this country and that is the quintessence of army spirit. Above all, that absolute, absolute indifference to any need that can't be satisfied by a physical object.

Don't worry about me too much, but you can worry a little. I don't trust the army at all and won't believe in the discharge until I actually have it. Every turn I take I meet a monolithic, monumental inefficiency.

Jeanie is languishing in Gaylordsville, Connecticut, oppressed by the lesbian affair sweet Annie is having with monstrous Sybille [Bedford]. It's been going on now for 6 months. Jeanie, like Toady, can accept and put up with anything, being equally unfastidious, but this is getting at her subconscious a bit. (For God's sake be discreet and don't mention it to anyone.) It's almost impossible to interfere, for it's love. What makes it worse is that

Sybille is really awful, a caveat canem! to anybody who comes near, and a bully and an egomaniac and a lard-heap of selfishness. Strange to tell, Annie is being the masculine one of the couple. She gets on top.

But that's all trivial compared to my horrors. Kellogg Field, oh Kellogg Field—sandy, flat, treeless, uncult., unsociable, friable, utterly what it is, and there's nothing worse than an utter thing.

Write soon and lots of facts and events, no opinions or diagnosis. News of the other world in the most literal sense.

Regards to Virginia. I should like to see her naked some time. I'll bet she's wonderful.

——*Clem*

Dear Harold,

It's wonderful that such a wonderful place as Pigeon Cove has actually been found. How I do wish I were there. Out of the slip-stream of history. My God, that I should be part of history! So this is what the poets have been talking about.

I have weird luck. Still further efforts have been made to involve me in history. Today an order came from Air Force headquarters transferring me to the 79 something Military Police something at Anacostia in Washington, to report on the 6th, as Italian linguist. Required: the fluent speaking of Italian; object: overseas shipment in a trice. If this had come through 3 weeks ago I would not only be in the army for the duration but for what a duration, years of Italy, and with my luck it wouldn't be Rome or Florence but most likely Apulia. Aside from the fact that I don't at all speak Italian fluently. How persistently the army fucks me up. Anyhow the personnel officer here tried to persuade me to let my discharge go and take the transfer, to which I said nothing doing: in my present state I'm incapable of making a decision and besides I don't ever want to come as close again to suicide as I did in this particular army. No. Let me out. So he said, being only 24 and very sympathetic because I'm so cultured, that I could have it my way. He may be trustworthy but I don't trust him; I trust no one in the army. So I'm in a bit of suspense. He told me I should be discharged some time next week, which means I'm lucky if I'm out in a month, if I do get out at all.

I got a wire in the middle of the week from Jeanie saying she has infected sinuses and may go to the hospital. Since then I've heard nothing. Should I be worried?

About Sybille & Annie. You must understand that Annie doesn't rate herself as high as other people do and that like Jeanie she finds nothing about sex, normal or otherwise, distasteful per se. Both of them are equal to anything if they think it's going to be fun. Very experimental, you might say. They both lost their maidenheads at sixteen. Annie let herself in for Sybille because there were no counter attractions around, and Sybille is supposed—why, I know not—to have potent attractions for women even with the presence of suitable men. Jeanie minds the business, surprisingly, since she has no real position on lesbianism. I mean, if it's all right for your friends it ought to be all right for your sister. All I mind is that I find Sybille distasteful in the extreme both personally & physically and that it isn't making Annie happy and that she still shows symptoms of being sex-starved. Yes, wie viele Möglichkeiten haben die Leute.

I'm in a funny state, where I'm not sure that being out of the army, that anything, will make me any happier. So if I'm out of the army, so what? So I'll write reviews, so what? So I'll be able to get drunk whenever I please, so I'll have sex, maybe, so what? I want to stay in bed, forever, sleeping and dozing.

Incidentally, headquarters also tried to transfer me to the bomber group now at this field but the personnel office stopped that. I only discovered the presence of this latest hazard today. They might get me yet, the bastards. The insecurity is marvellous. The army would as soon kill me here as in action.

My one irrational sentiment, my only one, is indignation that they should propose to treat me as they do everyone else. The fact is too evident and vivid that I'm the only person in the base who's the only one of his kind. I'm less like my fellows than any one of them is like any one hundred of his fellows. The compensations which the army offers one for being in it are for me additional hazards. All I've gotten out of the army is touch-typing and bars of chocolate. Everything else that I like is a flight hazard. The rest, the regime, the company, the spirit, is a personal insult. That's about as concise as I can make it. How did they expect my spirit to assimilate so many bruises and offenses? Mass-armies, citizen armies, what wanton cruelty. I deserve to be out of the army because I've paid the price in the past for being unsuitable material for it. I renounced too many of the easy pleasures of society. I want my reward now.

I could go on in this for hours and pages.

Your letter was a treat. Write more of the same.

——*Clem*

Dear Harold,

My discharge came through approved Thursday but will not be effective until Monday the 13th because I've had to take a physical exam and the x-rays of my chest—merest formality—won't be ready until then; and there's a good chance they'll be botched because I trembled and that I'll have to take them over again, which would be the last straw.

Today and the next will be the most difficult. It's got cold and there's no heat in the casual barracks where I am. My fingers are numb as I write.

I don't know what I'll do when I get home. There's Jeanie's place in Connecticut but I suspect complications what with the fat Sybille and Annie's brats. To go off with Jeanie somewhere would be out of the question because there's no money.

A letter from Margaret telling me she's advised the Contemporary Jewish Record, a bi-monthly [to be merged into *Commentary* in 1945], to offer me its managing editorship. The salary is purportedly $100 a week. Of course it's not my sort of thing, but it's at least better than Time, Inc., and $100 is too tempting. Also of course I don't know how to be an editor but I found out on Partisan you can learn how in a week. The biggest obstacle would however be the contents, which I'm sure I should loathe.

You're right that there should be a transition from the army to NY that would be more than the train ride. As much as I yearn for NY I don't want to be plumped down into it suddenly. The family is moving to a 4-room apartment, 360 Central Park West at 96th St., on October 1, and I don't want to be around during the moving. At the same time I'm enormously glad I won't have to travel to Bklyn once a week any more. That journey used to take things out of me, and Bklyn would invariably depress me; in a way it depressed me more than the army does.

Thanks for what you said about my touch. I need it. These past 7 months have made me so impatient with most writing. I can hardly endure reading the Nation even, so patent do the standard stances of each writer become at a glance—discounting the usual things wrong with Nation writing.

My regards to Virginia. I'd still like to see her naked. Ask her if she'll let me some time.

—Clem

14

MOVING ON

"I now want to look and act and say and write what I am forever and ever."

Clem returns to his family in Brooklyn. Harold has returned to Syracuse from Pigeon Cove.

<div align="right">

SEPTEMBER 23, 1943
</div>

Dear Harold,

I've been out since last Monday, arrived in NY on Tuesday morning. You were right, I shouldn't have come to NY directly. As it was, I expected to go to Gaylordsville on Candlewood Lake and stay with Jeanie for 2 weeks, but Jeanie had started an affair with another man who is staying in the house next door, and although she was quite ready to have me come up and go on sleeping with me at the same time as the other one, it was more than I could stomach. The shock wasn't as great as it might have been, for since she'd left Battle Creek I'd been preparing to give her up but I wanted to name the time and place. As usual she beat me to the punch, always triumphant. Years ago I'd tried to break it up but she'd managed to stop me with tears. I knew then that it was a mistake. The new man is Laurence Vail, he's fifty odd years old, Kay Boyle's [and, before that, Peggy Guggenheim's] ex-husband, and has his charms. Nevertheless I realize it's all for the best.

The family is moving to NY next Thursday. Before then I have to find a room, and I'm in no state to do so. Bklyn is uncomfortable and horribly depressing. I long for my old apartment on Greenwich Avenue. I was equal to anything there, just now I'm not equal to the great gap in my NY life left by Jeanie. Strange to say, I don't miss her but I do miss her milieu.

Everyone has been greeting me with joy, etc., but everyone is slightly

flat. Margaret is nice but more defeated than ever, what she needs nothing on earth can supply. Religion perhaps. I need a place to be alone in; I still have nerves when too many people are around. Bklyn is absolutely the wrong thing there. Solitude can be such bliss. I'm longing for the return of those mystic states I had the first two nights I was alone in the army. I wish there were some technique by which they could be induced.

I've finished a review for Margaret at last ["The Jewish Dickens: *The World of Sholom Aleichem* by Maurice Samuel"] and written a short Art Note [Mondrian's "New York Boogie Woogie"]. I long to get back to work and as I tell everyone I want to write a book. But how with no money? [Upon discharge, Clem received $61.90.]

I expect you shortly.

Clem

SEPTEMBER 27, 1943

Dear Harold,

I can't find a hotel room for myself, and I have to get out of the family house because it depresses me and because they're moving anyhow to a smaller apt. Didn't you know that I sold my furniture when I went into the army? I very much want to live in a hotel now, and there's hardly a hotel room to be got in NY.

All this adds to my general quandary. Besides that I have a feeling of chronic loneliness; it comes from having practically lived in a married state for so long. As for Jeanie I told her we'd better not see each other any more, and she was quite willing, being so smitten with her "papa." It's a scandal to all her friends and under that all my original contempt for her is coming back. But my vanity is quite sore, nay, it positively aches. When I see you I will to you a tale of horror unfold.

As for Margaret she's in a bit of a state but won't let you down. I could wring her neck sometimes; she has a way of quitting on one in the spirit, as if it's my fault for not making her feel gay. But she is in a state, and depresses me to death.

About the job. It's ridiculous me being editor of anything Contemporary or Jewish. I'm now more afraid than anything else of being out of character again. The army has cured me of that for good. I now want to look and act and say and write what I am forever and ever.

NY is piffle before the wind. I'm definitely a manic depressive; depressed during the day, elated at night. I feel that my luck must turn. Sure,

I had luck in getting out of the army, but that was just to cancel out, and did not sufficiently do so, the bad luck I had to get in.

Tomorrow is another day. But where is a new girl to be got? I still want some madder wind and gayer music. I have cravings in me my fellow intellectuals don't seem to share.

That's all for the time being.

<div align="right">Clem</div>

[on envelope] I just found a place at the Murray Hill Hotel.

Clem writes from the Murray Hill Hotel. Harold has been in New York for six weeks and has now gone on to Washington for a short stay after receiving his draft notice.

<div align="right">11–16–43</div>

Dear Harold,

It makes me feel so awful. I don't know what to think. Maybe I felt worse when I was taken but not half so bitter. They're so fucking stupid.

You will of course get in touch with that colonel or major as soon as you get back here.

The worst thing about the army is the feeling that you're missing something. But after your stay in NY you shouldn't have that.

I was awful to you Saturday night. But think that maybe the army is the hand of providence for you too. And nothing as awful will happen to you as happened to me, since providence has other designs for you. Everything may come out solved. God help me, I'm beginning to believe such things literally.

Do not anticipate too much what's going to happen to you. Only remember that in the end—after basic training—you get taken on your own terms. Dont be scared either of basic training. That I myself could have taken for years.

One thing more. I swear this is true. After it's all over you'll be happier to have had it happen than not at all. That I'm sure of. That's because it won't really touch you too closely.

<div align="right">——*Clem*</div>

Now, in 1943, after fifteen years, the steady flow of letters stops. The following letters were included in the package Harold returned to Clem, and reflect a friendship

which becomes increasingly formal and distant. Their paths diverged, and, as well, it is clear from Clem's 1947 letters that he had been actively cutting off from Harold for some time (see Postscript). Despite this, the absence of *any* written communication from Clem between 1943 and 1946 seems unlikely and remains unexplained.

1946
Clem now lives at 248 West 11th Street in New York. Danny, age eleven, is living with Clem. Harold is at his family's address in Syracuse.

13 JULY 46

Dear Harold,

I should have written you long before this, but life seemed so provisional for such a long time.

Mrs. Ewing stole out at dawning on the day she left; I woke up to hear Danny calling "Granny, granny, granny" and getting no answer, then getting up and wailing when he found she was long gone, leaving only a note behind her. With her exact genius, she'd hit on just the cruelest possible way to leave him. He felt like an abandoned lover, missing her bitterly and at the same time angry at her for needing him so little as to be able to leave him— a complex of feeling he himself explained to me last night, comparing his relations to Mrs. Ewing with mine to Annie. He's always so preternaturally wise after the event. Now he no longer misses Mrs. Ewing so bitterly and is completely able to understand himself. But like a lot of penetrating people, he penetrates so far in others that he often goes a mile beyond the truth. In any case he still doesn't act on what he knows.

The maid, as I secretly expected, didn't show up, and Danny had to sit alone in the house until Annie finished getting Jeanie off to France and Sybille to Mexico. Then things picked up and all sorts of aids were found. Now I've got a housekeeper, an old-maid refugee, who's coming on the 23rd. Meanwhile Danny will go to Will and Edna's [Phillips] for a week, and then I may take him with me on vacation. I feel pretty sure about the housekeeper, she's one of those big, dark women I always find it easiest to understand. I painted the job in blackest colors, but she found Danny fascinating—as did another applicant, also a refugee, who refused to take the job only because she thought Annie would live with me as my mistress (she later turned up at a house Mary McC. [McCarthy] was staying in, which is how I found out her reasons; she told them to Mary).

Annie left for Baltimore on her way to Mexico the beginning of this week. We're through forever, even as friends. As usual, you're right: you

warned me once, "remember, she's Jeanie's sister." It would have been even correcter to say: she's her mother's daughter. The only thing I can explain her behavior by is lesbianism, and I suppose that is the explanation. I'm bitterly disappointed, but was never enough in love with her to miss her now. It's the most peculiar affair I've ever had. And when Annie left she was angry at me because I refused to take care of her cat while she was gone!

Meanwhile life remains socially hectic. Manny Farber or George Barker comes around almost every night. If not them, somebody else. And this keeps me from feeling sorry for myself, a bachelor with a son and no woman (but I already have another one—life is so repetitious). Saul Schwamm, my childhood friend, now millionaire, about whom Danny is crazy as about no one else, 1) because he's so immensely rich, and 2) because he is the only grown-up around who approves of Danny 100%.

George and Johnny Farrelly and I were reading poetry aloud the other [night] and I got drunk enough to haul my own verse out and read some of it to them. George didn't like it, saying it was too intellectual and too argumentative and used too many big words (is that true?) and Johnny didn't think much of it either, though he didn't say, but I was surprised at how good some of it was—though some was extremely bad—and how underived, how absolutely underived it was. Derived from modern literature, yes; but not, like so much verse we used to get at PR, from modern poetry. I think I'll polish some of it up and try to get it published. But I want your advice first.

I envy you the situation at Syracuse. I never get alone and aimless as I used to in my twenties any more—especially in summer. No more dawdling and reading and sweating and yearning and thinking about myself. And in many ways, as I see from my verse, I was a lot wiser then, and have forgotten a lot since. Strange, how I was totally incapable of acting upon anything I knew, though—strange, how little self-confidence I had and the conviction that the competition was invincible.

Come down for a week. Write again soon.

Clem

1947

Clem writes on stationery from *Commentary*, 425 Fourth Avenue. He is associate editor. Harold now teaches English literature at Temple University and lives at 2022 Park Avenue, Philadelphia.

Dear Harold,

Your letter affected me particularly, because the two weeks before this last I suffered from a very black session of depression like the one I had in the army, but in some respects worse. It was centered about sex, in the person of Annie, whose being in love with me affects me even worse than the same thing in Jeanie's case. I came out of the depression about 2 weeks ago, then to have a case of nerves, which almost tore me apart one awful Tuesday afternoon & which I got out of by the aid of sleeping pills & beer. It's a kind of turning point in my life and it turns around the ideal sex object, which is Annie, and as always the ideal sex object is what I don't want to marry & in some ways have contempt for—but it remains the ideal, perfect, irreplaceable sex object. And again, that ideal sex object, as before, makes a father image of me. I'll have to tear this problem apart with my teeth.

I didn't reject you, except in so far as you've been rejecting yourself for 15 years now, quitting on more & more of life—I mean literally life. As I get more desperate I ask more & more for pieces of life from other people, which I think is right & the way people should get in relation with each other. You give me no sustenance, that is. (For that matter, do I give you any?)

Since 24 I've been spending most of my psychic energy running away from my father. Sex was, I imagine, the thing he seemed to me to prohibit most, and so sex became the thing I ran most toward. Nevertheless, his tabu on sex made it always something of horror for me. Lately the attraction & horror have torn me apart. You're on the same ride as Pa, but even more so; I can't do with just Pa; I also want Ma.

Don't withdraw. Be, as you say, free to be fond of me. But for God's sake comprehend & be sympathetic about my infantile compulsion to assimilate sex.

Meanwhile Annie will destroy me or I'll defeat her—since she's destroyed already. I refuse to travel through the world of non-Pa on any terms but my own. Once I'm settled with a woman I'll be better—& in some ways worse—for my friends.

As always
Clem

Dear Harold,

Thank you for your nice letter. I think it was extreme, but that doesn't

matter really. What's been happening to me in the last ten years is extreme—and I truly think I needed it, and that you take too tragic a view. You have to go through everything in order to own it; and I now own Jeanie (you can't imagine how much I've enclosed and digested and immunized myself to that experience) and I also own Partisan Review and this year I've come to own art and what goes with it. All that goes to make life to depart from, as a point of departure, by the time one's almost forty. I had to have it, given Pa and Bklyn (and Pa, curiously, confessed to me the other day that the reason he hadnt a better education was that he had had to do and see and feel everything when he was young—what a revelation to me).

What's affecting me now is the anxiety of which I've always had such a store but which I used to be able to propitiate so well. Now that I can't apply it so well to job, money, independence, I apply it to sex and the question of marriage. In the last week or two, I discovered that the situation I was in with Annie was, emotionally, an exact duplicate of the one with Toady before I married her. Annie is burning to marry me and by an awful, woeful trick I played on myself consciously, and her inadvertently, in the last week she has fallen in love with me as never before (though she tries in her characteristic way to conceal it) and I with her—though what I feel about her is rather nympholepsy than love. At the same time, in the characteristic way of the Bakewells, she has brought another man into the situation, the longest of Peggy G.'s [Guggenheim's] latest lovers, a piece of loucherie incarnate. Annie professes not to take him seriously and certainly she puts him at a distance when I make any really earnest gestures toward her, but nevertheless he only serves to intensify my feelings about her.

JULY 19

Things are much calmer now. Out at William's [Phillips] in the country 2 weeks ago I slapped Annie soundly and haven't seen her since the night after that, which has done a lot of good. What I'm a bit sorry for however is that Annie's pattern is being duplicated: namely, to come out of every situation in defeat. Though it's her own fault that she's rejected as a wife, she's not a mean or vicious creature and not as wanton as Jeanie.

(Incidentally, Cyril [Connolly] has asked my permission to cite me as corespondent in his English divorce suit; he needs a London divorce in order to re-marry, which he now wants to do.)

Don't compare my state with Virginia's, at least not yet. I'm still not able to do much work but my anxiety seems to be disappearing, and the sadness I have is the normal one of renunciation. It's a necessary crisis; I have to surmount these things in order to grow up. I have a theory, which I'll tell you when I next see you, about why this crisis was associated with nerves—it has to do with the neuroses of the girl I was fooling around with three months ago, which was when I first began to get apprehensive stomach aches and when my bladder went slightly out of control for about 3 weeks. This girl would have solved the Annie business but she wouldn't have me, not at that time; and she had stomach aches too. Now her stomach aches are over, and I feel that, with patience, I'll have her this time. Then there was Delmore [Schwartz] in whose private life I got slightly mixed up and from whom I feel I also got infected. There must be such a thing as telepathy—Freud discusses it seriously himself. Anyhow everybody is in a state. The details are boring.

Don't worry about me too much. I think I'll know when I have to see a psychoanalyst. As a matter of fact, an analyst gave me a Rorschach test last week for his own edification—he'd been asking me to take it for months—and he's not of the opinion I need analysis seriously. (He happens to be the husband of a painter I know.)

I hope to go to Provincetown next week. Thank God Solly's wife [the painter, Leatrice Rose] is up there to get me a place. I may stay two weeks, it all depends. NY stinks in its special summer way.

Write again soon and tell me how you are. (To suffer every day of yr life because of sex demands that you do by now something drastic.)

Clem

PS: This is a real neurotic's letter, but by now I feel entitled.

26 AUGUST 47

Dear Harold,

I just got back this last Saturday from 4 weeks at Provincetown, where I too had a surprisingly good time, now feeling better than I have in 7 or 8 months. I began to feel elated the moment I got in the cab taking me to the train & by the time I reached P. I was in a state of calm so strange to me that it took trouble to recognize it as my normal one.

The incidents that took place after that I can't go into now. What mattered was the general, not the specific. N.Y. was the main problem it now

seems: Commentary, the place where I live, the people I know. It all happened to get concentrated, in a way dangerous to someone of my type, on Annie, who represents the irresponsible way out. Now, at this interval, she doesn't seem to matter at all. It's all the past, the past—a period that's dead & gone, along with Jeanie & all the people who came over during the war.

I have the feeling now that I'm at a turning point—toward what, I don't know. Write.

As ever,
Clem

[This is the last letter to Harold.]

POSTSCRIPT

Informal biographical notes on some of the participants in this story.

JOSEPH "PA" GREENBERG

In 1977 Clem's father died at ninety-six of old age. The high esteem and affection the younger Clem had originally felt for his father soured over the years. From the mid-fifties on, when Clem spoke of his father, as he often did, it was as if the wound were still raw; it was, raw with rage and betrayal. The idol had fallen. His love was a cold love.

Joe never acknowledged the achievements of his son—at least to Clem personally. One of the only times he allowed that he was impressed was when Clem published a piece in *The Saturday Evening Post*. On his part, Clem's admiration had dwindled to one thing, his father's longevity—an achievement he had dearly hoped to surpass.

Unlike Joe's other sons, Clem kept his distance, even though in 1960 when we moved to 88th and Central Park West we were only a few blocks away. In return, "Pa" never visited or called. As I recall, our visits to him numbered perhaps ten or so over the many years until his death.

SOL

Sol graduated from NYU with a degree in philosophy in 1935. For several years he was occupied with socialist organizations and was a member of the Socialist Workers Party, the Trotskyite organization. During the war he worked as a welder. For many years after the war he worked in the public relations department of the United Jewish Appeal. He married Leatrice Rose, the painter, and had two sons. The marriage ended in divorce. In 1987, Sol died of lung cancer at age seventy-four.

For Clem, Sol was the "good brother," the middle son who gave the most and got the least. He had contracted polio as a child which affected the use of his right arm. Despite the disability, his brothers would refer to him admiringly as the best

athlete of the family. Clem could never shake the guilt he felt. He believed he had taken too much of his father's love and berated himself for not taking a stand against his father's treatment of Sol as the "damaged" son. Nonetheless, as warmly as Clem always spoke of Sol, for the many years the brothers lived within a few blocks of each other, there were few calls and even fewer visits.

MARTY

In 1938 Martin had graduated Phi Beta Kappa with a degree in English from the University of Michigan. After his war service, he was an editor for Schocken Books. In the mid-fifties he joined Clem as an editor at *Commentary*, becoming managing editor in 1957. (Clem, by then working only half days as an associate editor, was fired from the magazine in 1957.) A professor of literature, Martin is known as both a critic and a translator from the German, most recently, of Goethe's *Faust*. His first marriage ended in divorce. They have a son. Martin lives in Brooklyn with his second wife, Paula Fox, the novelist.

Clem and Marty had an increasingly volatile relationship. The distance between them became more irreversible with the years. Marty attended, but said he would be uncomfortable speaking at, the memorial held for Clem in 1995. He has, however, been an invaluable help to me with this book, what with his German expertise and, of course, his family memories. And I thank him for that.

NATALIE

"Nanny" lives on the Upper East Side of New York. Her marriage of many years to Bob Stern, a lawyer, ended in divorce. They have two children. Again, although living just across Central Park, Natalie and Clem would run into each other through the years only at formal occasions—Sol's and their father's funerals, or at a lawyer's office to settle estate matters.

TOADY (EDWINA EWING)

In the late fifties, Toady, once again living in Washington, D.C., severed all contact with Danny. She said that she was frightened of him and the break was necessary. From then on she would be reachable only through a lawyer. There was no further contact between her and Danny, nor between her and Clem.

Her inability to be a parent to Danny can be attributed to her alcoholism, a condition which was never acknowledged by Clem in these letters, though it is vividly documented in letters from her mother to Clem (see Appendix). (Clem's own alcoholism took hold some time after the years covered in these letters, but the drinking "habit" was certainly part of his relationships with Toady and, in particular, Jeanie.)

Just as Clem never reminisced in conversation about the times or places or people who figured in his earlier life—except those in his immediate family— he never spoke of Toady to me.

DANNY (DANIEL EWING GREENBERG])

Danny became a gifted writer and a troubled man, as troubled as was his highly charged, love/hate relationship with his father. The emotional and physical confrontations were many—and invariably violent—and no resolution between them was ever reached. Danny attended several colleges and attempted various jobs, but nothing stuck. Nor did his writing ever become focused. His father attempted again and again to engage him in psychoanalysis, but Danny would duck and run.

I knew him during his twenties. Tall, angular, painfully thin. Restless, a nonstop talker, frighteningly insightful and challenging. He was in and out of our lives during his twenties, supported by his father as he traveled here and abroad, until he dropped all communication with the family in 1974. I don't know when he was diagnosed as schizophrenic, but I learned recently that that was the case. Over the intervening decades, when Clem cried—as he would now and again—the tears were always for Danny and his own failure as a father.

MRS. EWING (ANNIE LEVI EDWIN)

Danny's grandmother, senile for many years, died in the late sixties. She would have been in her eighties. From a note in Clem's journal on April 4, 1988: "Annie Ewing broke out paranoiacly crazy and was taken to St. Elizabeth's Hospital in Washington and died of pneumonia two days later. They *let* her die. Antibiotics were there. Have to say they were right." Clem's aversion to "Mrs. Ewing" was as strong as Danny's attachment to her, and continued to the end.

JEANIE (BAKEWELL CONNOLLY VAIL])

Jeanie married Laurence Vail in 1946. They had been together for three years, and she had eventually obtained a Reno divorce from Cyril Connolly. (Laurence had been married twice before, to Peggy Guggenheim and the writer Kay Boyle, and had five children.) They moved to Europe, living for the most part in Paris, the French Alps and the south of France. Laurence, born in Paris in 1891 of American parents, had lived most of his life there. An occasional Surrealist painter and a poet, he had, in fact, been dubbed "The King of Montparnasse" by the Paris bohemians of the twenties and thirties. Now, with Jeanie—still supported by her family trust—they reentered that peripatetic postwar social scene.

The high life caught up with Jeanie a few years later in Paris where she died in 1950 at the age of thirty-nine. The cause of death, a stroke. Complications from an abortion when she was eighteen had taken a heavy toll. She was unable to have children and, in addition, suffered from a mild, chronic heart condition, which she chose to ignore and which was exacerbated by years of heavy drinking and smoking. A mutual friend, Marjorie Ferguson, later wrote to Clem that she had seen Jeanie at a party in Paris shortly before her death and "she seemed subdued." When Cyril Connolly saw his former wife for the last time, also a few months before her death, he noted more graphically that Jean had let herself go and had deteriorated badly. She was still drinking relentlessly, was severely overweight, and was in an overall demoralized state. Laurence Vail never remarried and died in 1968 at the age of seventy-seven.

A note on the Bakewell finances appears in Michael Shelden's biography of Cyril Connolly, *Friends of Promise*. Jean was born in Pittsburgh in 1910 to a wealthy glass-manufacturing family, and even before her father's death in 1932, she had a substantial trust fund which allowed her to live abroad from the age of 18. After marrying Cyril in 1930, she largely supported him throughout their marriage. By the time she met Clem she had dissipated a good deal of her inheritance. Only this, and the vagaries of trust funds, could account for the broad swings between her scraping by and living well, as evident in Clem's letters during their years together.

In 1947, wishing to remarry, Cyril Connolly asked Clem to act as corespondent with Laurence Vail in obtaining his divorce from Jeanie. Clem complied. (Jeanie's Reno divorce was not recognized by English law.) That year, in a letter to Cyril, Clem attempts to sort out what were for him some of the more complex and compelling aspects of their relationship. After detailing Jeanie's relationship with Vail, he adds: "Laurence's self-destructiveness is also a good deal like that of Jeanie's father, from what I gather." Clem then refers to Bakewell's sexual abuse of Jean—introducing her to sex through masturbation—and concludes: "I think she has never gotten over that. Sex remains fixed in the paternal attitude. But the father also disapproves. One of the things that attracted Jeanie to me was, I am sure, the fact that at first I had a real aversion to her, disapproved of everything about her and thought her the veriest slob; Laurence felt the same way about her. I thought you much better off without her, as I am—I could never get much done with her around and yet I could never tear myself away from the bath of the senses she represented for me." And this, a few months later: ". . . one of the most fascinating creatures to walk the earth. . . . Everyone who is ever in love with [her] contracts a mother neurosis." Clem and Cyril continued occasionally to meet and correspond, and came to

rather like each other. Cyril, who married twice again and had two children, died in 1974 at age seventy-one.

Clem continued to gnaw at the relationship with Jeanie in his journals. The obsession puzzled him into his eighties. She would remain forever the female yardstick, "good mama/bad mama—Madonna/whore," against which he would measure women.

It was inevitable that Jeanie, who moved in the world of British writers, would be re-created in their works. The three most prominent instances are in Evelyn Waugh's *Black Mischief*, obliquely in Cyril Connolly's *The Unquiet Grave*, and most graphically in Christopher Isherwood's *Down There on a Visit*: "She had that cozy quality of a subhuman and therefore guiltless creature, and she might just have emerged from a warm burrow under a hill." Auden is said to have referred to her as the only woman who could keep him up all night. (Isherwood's book, based as it is on Jeanie's 1939 visit to him in Los Angeles—while Clem pined in New York—is also much about Denny Fouts and Tony Bower, Jeanie's traveling companions and cohorts. Denny, a handsome American boy, had left for the Continent at fifteen and become the lover of many rich, and famous figures of the thirties. After the war, dissolute, drug-addicted, and erratically violent, he was found dead in a lavatory in Rome. Tony, an American expatriate, had spent much of the thirties abroad. He was a writer and in 1956 translated Camus' *The Rebel*. In the 1970s, he was murdered in his New York apartment. The crime remains unsolved.)

Despite his continued efforts to piece together what had gone on between them, the last time Clem saw Jeanie—at a party in New York in 1946—he notes it, without comment, in his date book.

ANNIE (BAKEWELL DAVIS)

In the late forties, Annie married Bill Davis, a New Yorker and "gentleman of leisure." They moved permanently to a lavish villa, La Cónsula, in Churriana near Málaga and Torremolinos on the Costa del Sol. Here, they became part of a select social enclave of expatriates. Their hospitality was as lavish as their lifestyle, and over the ensuing decades, they hosted a cultural and social who's who at La Cónsula. Stranger than fiction, they died in London in 1985 a few hours apart—he of cancer, she of a heart attack.

About "the sisters," William Phillips, who is still the editor of *Partisan Review*, adds this take: "Jeanie was slightly mad. Annie was the sweet one; gentle and sexy." Like Jeanie, Annie and Bill figure in many of the biographies and memoirs of that cultural period.

MARGARET MARSHALL

Margaret continued as literary editor of *The Nation* until the early sixties. Clem continued to write for the magazine until 1950 when, disagreeing with their political stand (Clem had long been an outspoken anti-Stalinist), he chose to disassociate himself. The matter had come to a head when the magazine refused to publish his response to the views of the columnist J. Alvarez de Vayo, which he said "paralleled Soviet propaganda." *The New Leader* published his letter and *The Nation* sued Clem and *The New Leader* for libel. The suit was settled in the defendants' favor and an apology issued, but only after a prolonged media to-do and the eventual resignation of Freda Kirchway, as editor of *The Nation*.

During the fifties, the regular exchange of dinners and gossip that he and Margaret had shared for so long dwindled. Their paths separated as Clem purposefully detached from the literary world and focused increasingly on the art world.

Clem remained fond of Margaret, however, and always acknowledged the supportive role she had played in giving him a free hand to have his say about art in *The Nation*. In 1961 Clem would dedicate his first book of collected essays, *Art and Culture*, to her. Margaret died in 1974.

HAROLD JONAS

Harold lives, as he has for most of his life, in Goshen, New York with his wife, Jean. His first marriage to Florence ended in divorce after 13 years. Forsaking law, he taught history and Asian studies. He warmly remembers "the triumvirate"—he and his fraternity brothers Clem and Chet Leopold—as close friends, "the brighter group." Perhaps because Harold was not a fraternity member and did not live on campus, Jonas has no recollection of him.

DOROTHEA (LAZARUS LEVY])

Clem received the following letter in 1991.

<div align="right">

5100 HIGHBRIDGE STREET
FAYETTEVILLE, N.Y.
Apr. 23, 1991

</div>

Let me introduce myself—I am Dorothea Lazarus Levy (Harold's sister).

I read the article in the Star section of the paper about your visit to Canastota. I immediately began to think back to the "old days" and remembered your friendship with Harold. Harold died in April 1983 in Philadelphia of lung cancer. The two packs a day took their toll. When I went to his apartment I took only the papers I could find—among

them are his translation of Tristan & Isolde or (Yseot) which was never published because somebody was first and which Harold claimed was not as good as his. And a few articles he wrote along with a few poems of his as well as a few of yours from college days. They are all in a case I have not touched for years. I am sorry now I didn't take all the books.

My husband died in 1980. I have two daughters and 3 grandchildren. I remember you had a son.

I called the library in Canastota for your address as I just couldn't resist writing to you.

If you are curious and want to go back 60 years let me know and I'll check to see what's there.

<div style="text-align: right;">

Dorothea Levy

</div>

Clem evidently responded on November 2, 1991. When Dorothea answers February 2, 1992, she has suffered a heart attack. She adds, "I would like to thank you for the compliment of my mother and myself. It was a great thing to show my family that at one time 'I had it.' I consider myself very fortunate. My husband left me financially secure, my daughters and son in laws are very good to me. . . ."

I recently tried to contact her about this book by letter and phone to no avail. She would now be eighty-eight.

HAROLD (LAZARUS)

Clem "dropped Harold" (as he would put it) in the mid-forties. They would see each other now and then, most regularly at Margaret Marshall's New Year's Eve parties. It was at one of these rather unfestive—to my mind—events in the late fifties that I first met Harold. But I recall little about him, except that he was short, slight and mustached. There was one tête-à-tête at Margaret's kitchen table, late and both of us probably a bit high. I don't recall what was said, but I do remember the moment and the dreary kitchen, and Harold's slightly sour earnestness and his sardonic take on things. On the other hand, Helen Frankenthaler remembers him in the early fifties as a witty dinner companion, wit usually with a barbed edge pointed at Clem. As Clem never really talked to me about Harold, I had no idea of the important—indispensable—role he had played in his life.

I recently spoke to a few people who might have known Harold in the thirties. Their comments are similar. "I can't say I really knew him." "Lazarus? I remember the name but I can't really place him." Martin, Clem's brother, is the exception. "Harold was a sympathetic person. I was in my early teens when I met him and surrounded by people not famous for their kindness. Harold was kind. He was thin, dark, and homosexual. I remember sessions when we dis-

cussed poetry and played games about recognizing lines of poetry. He had good manners, was very polite and, unlike Clem, gentle. He was a natty dresser; sport jacket and sweater in the academic style." Marty's fondness for the Harold of those years is unmistakable as he reminisces.

Harold taught at Temple University in Philadelphia until his death of lung cancer in 1983 (see Dorothea's letter, above). His literary output did not extend beyond the occasional piece in *The Nation* and *Partisan Review.*

Of course, this is hardly a balanced or comprehensive picture. Harold's colleagues, his many friends and students through the years, and his nieces could give the portrait its missing dimensions. But that is all beyond the scope of these Clem/Harold letters. So I will leave Harold in the surroundings where, to me, he now seems most at home.

Harold is in a deeply shadowed room. He is at a table in a pool of light from a green-shaded desk lamp. It is late. He is reading, and now and then he stops to write notes about what he reads that he will send to his soul-mate, Clem, in the morning. And there the frame freezes.

APPENDIX

I recently found the following inserted in a 1928 edition of *Beowulf* edited by Fr. Klaeber. A birthday present from Harold, it is inscribed by him and dated Jan. 16, 1934: "-he hine eft ongon waeteris ineorphan, paet wordes ord breasthord purhbraec."

 I envy you, Clem, the virgin pages of this book—so dear, so white. I send you a few instructions, despairing the while that you will follow them, but burning you should.

 1. Don't use a translation; your pleasure, your complete pleasure, will be compromised. I tried it once & found that even the most literal translation means something so absolutely different from the original that it only confuses, and tends to present finding one's own, and <u>necessary</u>, solutions to translating. However, if you find you <u>must</u> use one use one that is literal & translates into half-lines. It's an old one & I think it's Thorpe's.

 2. You must know a genitive & acc.; a subjunctive & an indefinite. Syntax still has integrity in A. S. & half of the time the syntax cannot (or shd. not) be translated since it is inherent. It's simple; there isn't much to know; learn it from the grammar I once lent you; don't worry about exceptions. Pronouns; weak & strong nouns; weak verbs & the classes of strong verbs you must know. I've said this before.

 3. Translating Beowulf is tough & don't forget it. If you get stuck 9 times out of ten it's because of a failure to grasp the style & usually the difficulty is in the failure to recognize either a delayed repetition or an understatement. You wd. make me happy were you to consult me in tough spots. I can also present you with a beautiful emendation of my own. Real [illegible] the poem comes after many readings. If you start sloppily (& I don't think you will) you'll never get anyplace.

4. Getting to read Beo easily will give you a sesame to all the rest of A. S. poetry as well as other med. Germanic stuff.

5. You'll break my heart, or rather my better faith, if you don't treat him right.

6. As for metrics & A. B. C. D. E etc. it seems complicated but it's simple, & not very necessary.

7. Translation shd. take you at least six months.

I'm sorry it has come too late [for Clem's birthday].
Enjoy it well!

Harold.

[For Clem's response see Jan. 26, 1934 letter.]

The following are the only extant letters from Harold to Clem.

3168–17TH ST. N.W.
WASH., D.C.
JAN. 16, 1940

Dear Clem,

Greetings on your birthday.

I'm sending some of Danny's drawings. He's had a recrudesence. He illustrates the stories I tell him and I'm told he has an artist's eye. When he's out and sees something he likes he remarks that he'll draw it when he gets home. And he does. He also cuts out his drawings. I gave him the ones you did for him & he colored them and cut them out. Only his own drawings are pinned on the wall. The directness of the imagination is the best. Please note illustration to the story of the 4 winds, including the large North wind, also wicked magic trees who reach out for an innocent cub, a terrible glacier monster, a beach scene, and animals, esp. the rhinoceros. For three whole days he played rhinoceros & drove the family crazy. He attaches all sorts of horn and tails to himself. He's growing older fast.

Mrs. Ewing asked when you were coming and I said probably this month. She asked if you were angry because she hadn't answered your letter—She's been but poorly.

I've been working again on the Brecht—
Did you get the Eliz. anthology?

Harold

MAY 26, 1952

Dear Clem,

This is just to announce that I'll be in New York this weekend, probably Friday night, to stay through Tuesday.

Also to say to Helen [Frankenthaler] that her new paintings made me feel

more lastingly good than anything has in a long time. I can't really "understand" their effect on me. I even dreamt about them one night. All I can remember is opening a portfolio of some paintings by someone like Manet (but not Manet) but their edges were blurred and then they extended out of the portfolio into Helen's long-long tropical landscape. It must [be] the "warm South" I long for. Or what?

As usual at the end of the school year [at Temple University], I'm depleted and devitalized; otherwise OK. Exams this week and then no more students, thank God.

Love,
H

APRIL 9, 1961
1926 PINE STREET

Dear Clem,

Ernest told me he met you and that you said you might know some people along the road of my summer itinerary. Which was a nice suggestion even if it happens that you don't.

At any rate I'm flying to Lisbon on June 6, and after a few days to Madrid. I'll be in Spain for about a month—around Madrid, then to Granada, back to Madrid and to Barcelona by plane with time enough to go, I hope to Tarragona. (I've never been to Spain before and I know no one there.) Then about July 7 I fly to Palermo and have about three weeks in Sicily, where I've been before. After that a week in Naples, my favorite large city in Italy. And then up north to the towns I've never had time for: Verona, Vicenza, Ravenna, Bologna, Padua, Brescia, and maybe etc. Finally on August 28 I take a Europabus from Venice to Salzburg for a few days, and on to Vienna for a week. To end up with a few days in Munich and Zurich and New York from there.

I know a few people in Italy, mostly Sicily and Rome (which I'm passing up this time) and in Zurich. So if you know anybody I can talk to after those late dinners, let me know. One picks up lots of people, heaven knows, while travelling alone, but not many natives.

As for me, well, to put it succinctly, I'm as well as can [be] expected, and that's not bad. The dann-und-wann weisser Elefant we used to talk about has grown spotty. And too eagerly recognized.

I hear from Margaret [Marshall] that your book ["Art and Culture"] is about to come out which is, somehow, what we all deserve and merit.

Give my best regards to Jenny [we married in 1956] and to Danny.

Yours,
Harold

Dear Clem,

I went to Syracuse for Thanksgiving to find that my sister, who had moved into a new house, had unearthed or at any rate brought to light three boxes of your old letters to me. There were so many of them, such an impressive number, that I resisted the impulse to destroy them—not to speak of sundry subsidiary reasons—and brought them back here with me. Now I want to know whether you want them, and if you do I'll send them to you. If you don't, I'll destroy them.

I spent the greater part of three days looking them over. After an initial reluctance, veils under veils of sneakiness, as if I were spying, I settled down objectively—or something like that. And objectively speaking a great many of them I'm sure you will find interesting. The act of writing comes through. They run from about 1928 to 1946 or so, and the very early ones are disappointingly dull, generic. I don't really know what I think about them except for something, some sound of something, that keeps floating around my head about the soul being so very physical. Annals, records, educations—eppure si muove! Finally, I'm superstitious about having found them; they, the superstitions, at any rate, say that they turned up at the right time. (I discovered no treasure of poems, by the way, but there are lots of drawings.) I think you should have them. But they're not my letters, written by me, thank God, so if you don't want them, say so. If they were, I'd want them, I think, only 51%.

I did see Peggy G. [Guggenheim] in Venice [written in margin: "dyed dead eyes"], and gave her your address, although she was afraid you wouldn't answer, but I didn't go any other place for which you gave me names. I suppose the most exciting painting I saw were the Goya frescoes at San Antonio de la Florida in Madrid; also the Jacopo Bellinis in Verona, and the XVIIIth century Italian landscape painters like Ricci and Zais. The most pleasant surprise was Bologna. But I loathed Madrid. Franz Hoellering whom I saw in Munich asked about you. As you know, the new Italian painting is very bad.

Val [Anderson] tells me that Jenny is expecting a baby—give her my best, and Danny too. Let me know about the letters. It's too bad they are not worth money. They ought to be.

Yours,
Harold

Dear Clem,

I finally got around to sending the letters this afternoon. It was no trouble, just a question of finding tying cord. Imagine, a carton of letters—my metaphors are not equal to it. Objectification-in-reverse?

The eighteenth century Italian landscape painters I discovered first in the Academia in Venice, in one of the last rooms one is usually too exhausted to bother much with. I also got stuck on an earlier painting by Basaiti which I could swear was a Giorgione—or at any rate as good as a good Giorgione. The Jacopo Bellinis were in the Castelvecchio in Verona—specially one of Christ risen from the dead, with wonderful dead silver grays.

I expect to be in New York next week and will call you. —Best to Jenny.

Yours,
Harold

JANUARY 15, 1964

Dear Clem,

I wonder what your plans are when you come here to lecture—whether you would like to stay overnight, or at any rate have dinner here—or what. Jenny said something about the Barnes collection which I haven't seen either.

Let me know. Best to Jenny and the baby [Sarah, born April 1963].

Harold

An unmailed, unfinished letter from Clem to Jeanie that adds further insight into Clem's Army Air Force experience. It relates to an incident he never mentions to Harold and the tone is quite different from that used when he wrote Harold on 8-11-43 about his hospital stay. I recently found this inserted in a 1930 German edition of Goethe's Faust.

7–9–43

Darlingest,

This is being written on the train during a 20 minutes stopover at Buffalo, dingiest of cities. The journey has been tearing my heart strings apart one by one. I fortify my self with bromides but while they keep me from trembling they don't do anything to dissipate the appalling depression that comes over me from time to time. All around me soldiers are talking in double negatives.

I needn't have left you & my father at the station as soon as I did. The three Battle Creek cars remained almost empty until reaching Albany. This train is rather slow & makes all the stops. When you come take the one that leaves at 6 P.M.

For the moment I feel rather well—that is, no oppression over my stomach and no daze in my head. But as I write I remind myself, by my handwriting and incoherence, of the neurasthenics for whom I used to have such contempt & feel so remote from.

The train has begun to move and I can't write any more.

I've just gone through an utter nightmare.

I arrived early in the morning, strangely calm under the influence of bromides, and reported at the base, more or less indifferent as to what was to happen to me. There the 1st Sgt. informed me that I was one day AWOL, the NY dispensary having excused me for the wrong day, and I was told to come to the orderly room to be, I suppose, punished. The punishment would have been a week's restriction, I'm quite sure. But it was all one to me. Then the barracks Sgt. wanted me to orderly for the morning and I refused, saying I was going on sick call, to which he said he would put my ass in a sling, an expression of which I'm utterly tired.

Then I went on sick call & waited 2 hrs until the major saw me and told me to come back at 3. Meanwhile as the sun rose I fell back into the awful old depression. The very sight of the base, it's cream-painted bldgs, the scrubby grass, the pebbles and dirt, the sun, the trees, and the flatness, poured awful blackness into me, awful, awful. After lunch, which I skipped, I cried without tears all alone in the library. Then at 3 I reported back to the major, who said I'd have to wait until Monday before he could send me to the hospital, that is, the right one in Battle Creek itself. I replied that I couldn't wait an hour longer, tearfully. (Really, it was shameful on my part but the agony was too much.) Finally after having told me in vain to pull myself together—which I didn't want to do—he made out an order sending me to the station hospital at Fort Custer, 5 miles or so beyond Kellogg and a 15 minute bus ride from town. There I waited 2 hours before I was admitted. Then after surrendering my clothes I marched with my bag and in my pajamas & bath robe down corridor after corridor connecting the long bungalows which are the hospital wards.

What I arrived at! In his letter sending me to the hospital the major had said I was in a state of mental anguish he couldn't understand and that he was in fear lest I do something desperate. The hospital took him at his word & behold, the ward I entered was barred off and the orderly opened a massive lock to let me in. In the corridor beyond were the loonies parading about, one third of them negroes, one with a towel on his head, crooning to himself—he does this all day—another with crazy googling eyes, the rest looking fairly normal. I was put in a room 10 ft by 6, in which there was nothing but a bed, a window with bars, and a door you couldn't close from the inside, with a little window in it. I protested madly but the three big orderlies excused themselves by saying they were in [letter ends]

And this letter from Anne Ewing—one of four—that I recently came across among mementoes of Danny's childhood, and which reveals so much about this unfortunate mother and daughter relationship.

<div align="right">

CARMEL

SEPT. 12TH, 1941

</div>

Dear Clem,

Edwina [Toady] was here a month. She is looking young well & pretty—her nerves much better—feels very bitter toward me because (1) I will not come to Gulfport (I would, except for drinks, as she knows) (2) because I have a car and (3) do not have to work. (I do 24 hours a day.) I told her she could use the car if she would omit drinks when doing so—she agreed & kept her word. All went well until the afternoon before she left.

I went to call on cousin Howard. E. was left alone with Danny. When I got home at 5:30, found she had consumed 1/2 pint of whiskey & was pretty wild.

I fed Danny & put him to bed. She then demanded the key to the car to go out. By the way she did not find any friends here & did not go out—was content with our society but drank some nights—not a great deal—she said for "amusement."

Well, to return to the story. I refused her the keys & she knocked me down (before Danny who got out of bed). E. ran out doors—Danny was in a panic. I took him in my arms & tried to quiet him. She came back—got me cornered with him back of me—pulled my hair almost out & was going for my throat but I grabbed the phone & managed to call Cousin Maud. Then she left. Maud & Ella are old & infirm—it almost killed them—I shall never face them again—I am so chagrined—I should have called the police. Well finally she went to bed after making it all pretty public.

Of course she felt terribly the next day. D & I spent the night at Ella's & the next day was a normal one for Danny's sake. She was really broken hearted over it—she had tried so hard but the fact remains that Danny must be protected in the future from such scenes and that I can never see her again for <u>it unfits me to take care of him</u>. My nerves are still shattered but he is in school now—2nd grade—fine & happy—is gaining flesh. Now my social hostiles [?] with him seem nothing at all—I am well & can take care of him all right if I do not have to see her—but I am so afraid of her. She is really insane after a few drinks & aims it all at me.

I do not feel she could hold her job if she did this much in Gulfport—she of course now knows a good deal about "alchoholism" [*sic*] from the Hospital—and says smugly that it is incurable—but I think that she <u>could</u> stop if she <u>would</u> but of course she is lonely—has no social life which she loves—gets tired of reading. She loves her job & has a "very good" rating. She is genuinely fond of Danny but has no idea of getting on with him. Probably if she had to take the care of him, she would meet it.

Please do not write her as I do not want her to know I told you. It would

upset her and she <u>must keep her job</u>. But some way will have to be thought out for her to see Danny without seeing me.

I contacted a lawyer to make a will. Also asked him about the custody of the child—she has it but I could petition for a Guardianship but of course at my death that would end. As long as I can keep myself alive it is better for Danny. I would live near you but of course I could not do so in N.Y. on my income or in Cleveland either. I am now absolutely alone here as I shall never bother this family again. It was too dreadful.

I had a nice letter from Harold. Danny had cards which he liked. Will write him when I feel able. Will write you when I see this lawyer again. Have about decided tho that I must outwit her. The car has always been at the bottom of our trouble—in Washington it did not exist. Feel I have no one to turn to but you to protect Danny from harm.

I suppose this is not a very clear letter but my nervous state will improve. She cannot get back for a year. As you know this has happened before but what makes it so terrible is that Danny saw it & he is old enough to understand.

Danny is clever in everything pertaining to reading & writing—but just plain dumb in arithmetic. [Letter is unsigned.]

JOURNALS

A few relevant excerpts from Clem's journals. As quoted in the Preface, Clem wrote to Harold in March 1933:

Nobody else in the world ever made me feel that I was living in company; that there were other travellers on earth.

Years later Clem would write another view in his journal:

JANUARY 1990
Harold Lazarus the best thing to happen to me at college, yes. But I didn't like him. Didn't like his nearness.

A harsh appraisal, but perhaps understandable if seen as a distaste for his own dependence. That and his residual guilt (expressed in several late journal references) for having "dropped" him after the war. There was also the matter of Harold's evident homosexuality, which remained unacknowledged at the time by Clem, except obliquely in a few of the letters. Naiveté, or denial? Who's to say? But it seems clear that Clem's need of Harold far outweighed a view of his sexuality that he may have found difficult to accommodate.

MAY 29, '78
Cutting off from HL: how long ago was that? What a relief. And yet I still feel a little guilt.

5 Nov. '88
The last few days: how it's come to me full on how lost, incapable, inept in intercourse I was till, say, when I began publishing in Partisan Review at age 30; and how I still stayed enough that way till analysis at age 46. That I cdn't see what I saw, that I cdn't see myself (afraid to). That I was so very timid, fearful. That I was a good deal of a mess till 30, if not after. That until I was 30 or more I couldn't get anything done that required a result or purpose. . . . Incompetence—paralysis: that was me. In conduct too: in St. Louis and San Francisco. What a mess I was.

And a day later, remembering slights in the distant past.

Nov. 6, '88
That Zellerbach girl in SF who wouldn't go on 2nd date. And Sam Yachelson from EAM who wdn't take me in his car to NY. Yet can't remember name of "nice Jewish girl" in Cleveland [Sylvia]!

16 AUG 91
In last 2 or 3 weeks how it's come clear to me how lost (?), scattered, out of hand, silly, utterly un-self-possessed I was in my twenties—especially when in St. Louis & San Franscisco (why not when in Cleveland?). How I cdn't get really "next to any girl," except the one in Cleveland (whose name I've completely forgotten). Did "succeeding" in civil service stabilize me some? I was such a chatterer, too.

POEMS

A few of the many poems Clem sent to Harold over the years.

JULY 8, 1929

Moses was a reprobate after all.
<u>Where was Moses?</u>

Where was Moses when the lights went out?
 Yea, where was he?
Among the bullrushes
Hidden where the partridge flushes
And the girls slink down at watering time

Holding the pot-bellied pots on their heads
 Blue and tawny,
 Well and grass,
Moses, hidden, saw the Egyptians pass,
From his straw cradle saw them
And not so much as wailed.
 Came Nephtopera stepping lightly.
 The pale chocolate maidens following sprightly,
Saw the kid
Where he's been hid
And lifted him from the bullrushes,
The giggling yellow Hebrew blurb,
Ringed 'round with Egypt's lashes;
The gray-haired prophet for whom
God burnt bushes.

JULY 29, 1929

From the Bottom of the Deck
"She did not wear drawers" —Rimbaud

Jimmy, Peg, Sam and his girl, Kate
On tuesday nights go to the Alhambra to skate.
Peg has a white sweater with button of red
And Kate wears a checked tam-o-shanter on her head (!)
Yes, tuesday nights at the Alhambra!
O raucous tuesdays!
O the obsessions of the electric lights . . . laugh
There is more heat in Jimmy
Than in the great horned Ram,
Perfumed devise amaze and bewilder Sam
And though their alarm clocks ring at a quarter of eight
They are as thoughtless as herrings
When they kiss Peg and Kate.

In the summer there is arid fornication:
Steve and Grace "loll" on the sands
And underneath the bathing suits
Love-juice burns like red-hot bands,
Red-hot bands and the roses of Persia are strewn on the sands.
Breasts blown up like balloons are dancing on the beach
And Steve dedicates a kiss and a bite to each . . .
Steve is not unfaithful, he is just hungry,

And Grace tho' her legs are skinny
And her hands are finny,
He would rather rest his head
On her stomach
Than on any other in the whole of Far Rockaway
Or Christendom.

SEPTEMBER 22, 1930

September

The dying month of all
The spending before the waste, the wide mouth
The haste to die
And bloom that makes all death a lie
The life that knows its end
And still must spend
Whatever the year owes to the grave
Not the dying but the seed of every death
That which devours the growing
This which devours the breath

The pleasure that must fade
More mournful than pleasure had
Once resigned no longer desired
More mournful than pleasure dead
Fixed and divined
To desire what will be given away
Death in summer, death in life
Death the parable of green—
A paragraph to what has been.

OCTOBER 1, 1930

Tes Yeux, Tes Jolis Yeux

Most delicate to search
You who said lest any watch
Be not unshaved: as the lamb
Does to the blade, avoid a stare
Beyond the eyes.
Oh sneak beneath the lids and drown therein
'Tis wherein to drown it's good.